The Cave beneath the Sea

Paleolithic Images at Cosquer

Jean Clottes and Jean Courtin

Translated from the French by Marilyn Garner

The Cave beneath the Sea

Paleolithic Images at Cosquer

Harry N. Abrams, Inc., Publishers

Project Manager, English-language edition: **Ellen Rosefsky Cohen**

Editor, English-language edition: **Ellyn Childs Allison**

Designer, English-language edition: **Miko McGinty**

Library of Congress Cataloging-in-Publication Data

Clottes, Jean.
 [Grotte Cosquer. English]
 The cave beneath the sea: Paleolithic images at Cosquer / Jean
Clottes and Jean Courtin; translated from the French by Marilyn Garner.
 p. cm.
 Translation of: La grotte Cosquer.
 Includes bibliographical references.
 ISBN 0–8109–4033–7
 1. Cosquer Cave (France) 2. Man, Prehistoric—France—Bouches-du-
Rhône. 3. Cave paintings—France—Bouches-du-Rhône. 4. Petroglyphs—
France—Bouches-de-Rhône. 5. Bouches-du-Rhône (France)—Antiquities.
I. Courtin, Jean. II. Title.
GN812.B68C5613 1996
936.4—dc20 95–24174

Editor's note: Originally inventoried and named in French, the painted and engraved images in the Cosquer cave are referred to in this book both in English and, in abbreviated form, in French. For example, the category "Horse" is also called "Chv" (short for "cheval," the French word for horse). When a particular image within the cave is meant, the text will specify it by English name, French name, and number, thus: "horse Chv 5," or "ibex Bq 7," or "hand M8." Following is a list of the abbreviated French words and their English equivalents: Chv=Horse; Bi=Bison or Aurochs; Bq=Ibex; C=Deer or Megaloceros; Chm=Chamois; F=Feline; I=Indeterminate Animal; M or MR=Hand; Ph=Seal.

Contents

Preface

In 1985 Henri Cosquer (pronounced "kos-kare"), a professional deep-sea diver from Cassis, discovered a narrow passage some 120 feet below sea level at the foot of a cliff at Cape Morgiou in southeastern France. It was not until July 1991, however, that he came to notice prehistoric paintings and engravings above the waterline in a large chamber 490 feet beyond the entrance.

These paintings and engravings have been preserved because the passageway opening into the cave slopes upward and the upper part of the walls has remained above water. Twenty thousand years ago, at the coldest point in the last glaciation, the Mediterranean was about 360 feet lower than it is now and the shoreline about 7 miles farther out. When the ice melted, 9,000 years later, the runoff produced a spectacular rise in sea level.

The authors of this book, Jean Clottes and Jean Courtin, were asked by the French Ministry of Culture to carry out a preliminary study of the cave. Jean Courtin participated in two diving expeditions, in September 1991 and June 1992, during the course of which the cave walls were examined directly. The work presented here is based on those observations, which were then amplified by intensive study of the photographic and video records brought back by the divers and by various analyses of pollen and charcoal collected at the site.

These studies established the authenticity of the art, provided dates for it, and yielded information about the human activity that took place there, in a cave where prehistoric people never lived. They made only brief excursions into the cave to make their art and, no doubt, to conduct ceremonies. The analyses established the kind of wood they used for their torches and proved the surrounding area was a cold and steppe-like landscape.

Precise dates were obtained for pieces of charcoal lying on the cave floor and for traces of charcoal lifted from drawings on the walls. These dates can be grouped into two series, one about 27,000 years B.P. (before the present) and the other about 18,500 B.P. In all, there are currently twelve radiocarbon dates, a series unique in the world for a cave with rock art. This makes the Cosquer cave the most extensively dated painted cave now known. It was visited during two periods only, with an interval of 8,500 years separating them—a fact that poses interesting questions.

The rock art of the first period is characterized by stencils of hands with incomplete fingers, made by placing a hand against a wall, curving selected fingers, and then blowing paint around the hand to outline it in red or black against the blank wall surface. Also in that period, visitors to the Cosquer cave covered the walls and ceilings with finger tracings (grooves in soft surfaces made by human fingers).

The second period saw the realization of the animal paintings and engravings. At present, about one hundred pictures of animals have been recorded. Most of these are horses, ibex, chamois, bovids, and cervids. A feline head and several indeterminate animals complete the set of land fauna. One of the most unusual features of the Cosquer cave is that sea animals are depicted as well, with eight seals, three great auks, a fish, and perhaps several jellyfish. Associated with this bestiary are geometric signs such as rectangles, zigzags, and spearlike signs on the bodies of the animals.

Study of the stylistic techniques and the methods used to represent the animals permits comparisons with the art of other caves of that period. There are particular parallels with Ebbou in the Ardèche department of France and with Parpalló in the Spanish region of Valencia. This suggests that the people of that time had wide-ranging contacts.

Scientific study of the Cosquer cave is only in its early stages, but the cave must clearly be considered one of the major painted caves in Europe and one of the most distinctive. Given the underwater entry, the controversy that ensued when the discovery was announced, and the slowly revealed richness of the ancient images in their superb underground setting of sea-washed stalagmites, the study of this cave has been a real adventure—one replete with obstacles, discoveries, and joys. This book offers the reader an opportunity to share in the adventure.

Jean Clottes
Jean Courtin

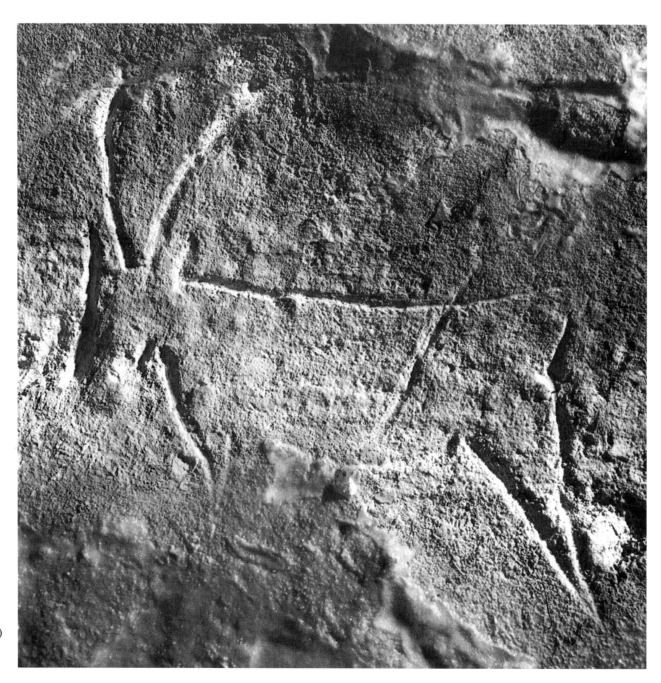

1. Most of the artworks on the walls and ceilings of the Cosquer cave are engravings, for example this ibex (Bq8) sketched in the soft limestone with a few quick strokes

1. Background

A few miles south of Marseilles, the coast of Les Calanques is an exceptional site, with high white cliffs plunging into the blue of the Mediterranean. Steeply banked coves, the *calanques,* are cut like so many miniature fjords into an impressive Urgonian limestone mass.

This very particular type of relief is due to the hollowing out of small fossilized valleys during different phases of erosion linked to variations in sea level, to the repeated play of geologic faults, and to the presence of a very important and complicated karstic network, today largely submerged. Within this chain of coves, numerous vast caverns can be found beneath the sea, today visited only by eels and shellfish. During the Pleistocene period, however, people visited and sometimes lived in them.

Thanks to the work of geologists, we know that during the Quaternary era sea level underwent wide variations because glaciations alternated with warmer phases. During the Upper Paleolithic period, at the time of the last glaciation, in the climatic period called the Late Würm (c. 30,000–10,000 B.C.), considered the most harsh from the point of view of climate, sea level fell to about 360 to 425 feet (110 to 130 m) below the present zero level.[1] Along the coast of Provence, the islands of Lérins off Cannes; the islands of Hyères along the Var shoreline; the archipelago of Riou (the islands of Riou, Plane, Jarre, and Les Congloué); and the archipelago of Frioul (Pomègues, Ratonneau, and Tiboulen) off Marseilles out to the large island of Planier, some 9 miles (15 km) from the coast, were all once connected to the continent. An immense plain, no doubt grassy and steppe-like and broken up by groves of birch, alder, and Scotch pine, made up a "forecontinent" that occupied the Gulf of Marseilles and a large part of the Gulf of Lions. The Paleolithic shore was thus located miles beyond the present coastline of Provence, Languedoc, and Roussillon.

Around 1950, to his credit, Max Escalon de Fonton, the patriarch of the prehistory of Provence, made the first prediction: "We have only a partial view of our Paleolithic; the Provençal Paleolithic is for the most part under the sea." But it was not until the 1970s that pioneering research on the submerged caves along the French Mediterranean coastline was undertaken, beginning in 1968 by Eugène Bonifay and Jean Courtin near Marseilles[2] and by Henry de Lumley along the coast of the Alpes-Maritimes department.[3]

This work was carried out by the Department of Underwater Archaeological Research (DRASM) in the ship *L'Archéonaute,* then just recently built, which belongs to the Ministry of Culture and is manned by the national navy. It consisted of recording, exploring, and studying the numerous submerged caverns from the Alpes-Maritimes in the east (the caves of Corail, Agaraté, Huet, and Mérou off Nice and Juan-les-Pins) to the Toulon area (the caves of Deffend and Pointe

2. Overleaf: Aerial view of Cape Morgiou. The Cosquer cave is located just to the left of center in the photograph, above Pointe de la Voile, the promontory at the bottom of the page. To the left is the cave of Le Figuier, 100 feet down; to the right, that of La Triperie, 82 feet underwater. These vast caverns could have been used as habitats by the artists of the Cosquer cave

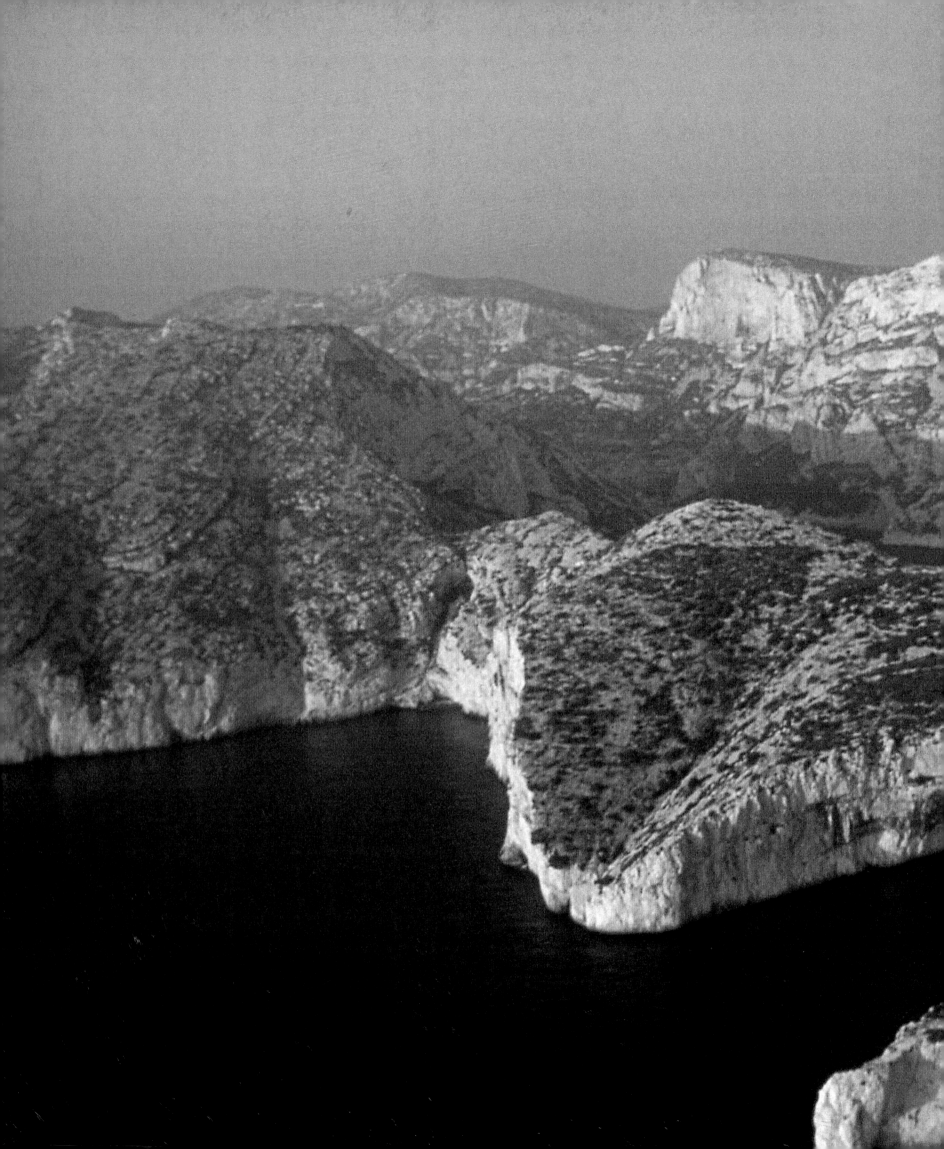

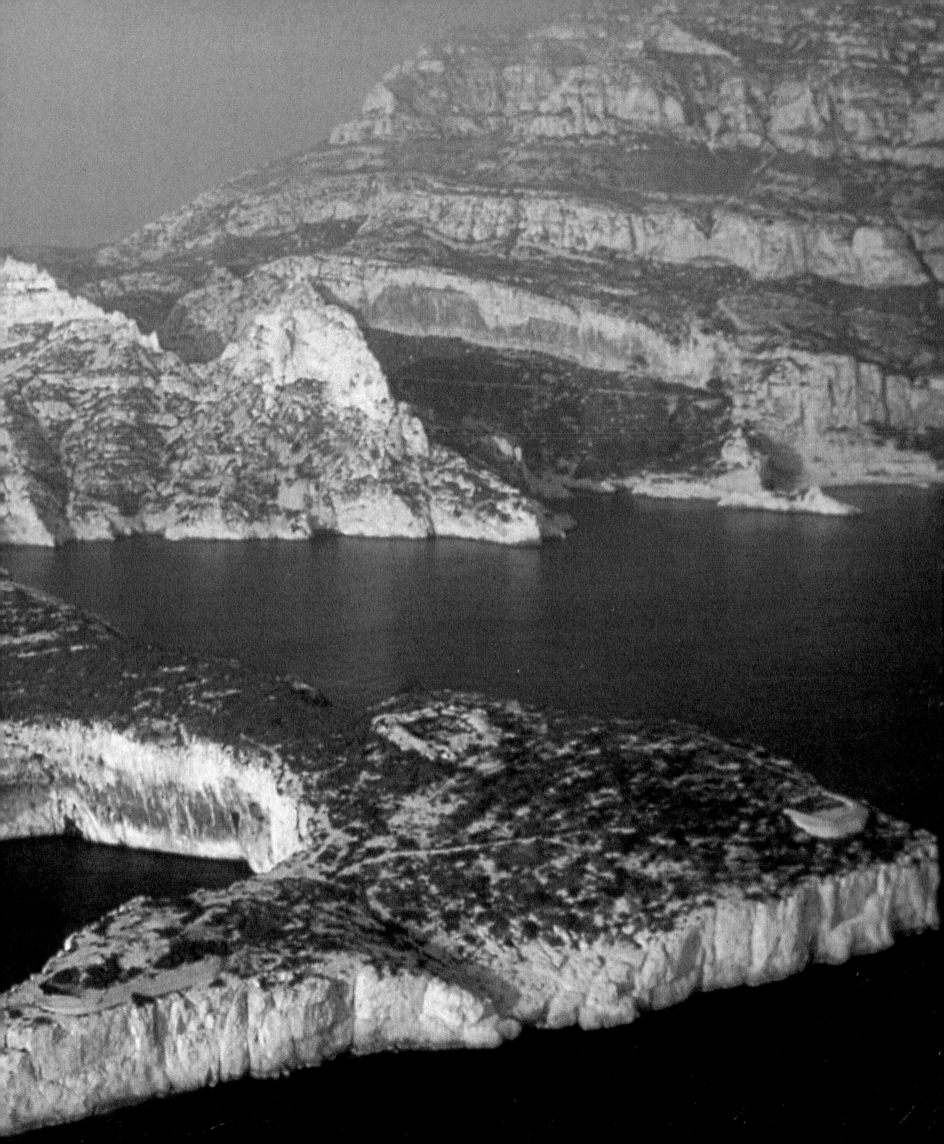

Fauconnière), and most intensively in the coves between Marseilles and Cassis (the caves of Les Trémies and Devenson, of La Triperie, Le Figuier, Sormiou, and others). Other submerged caves of lesser importance to the west of Marseilles, at Cape Méjean, were also discovered and explored.

Although subject to the harsh constraints and inevitable uncertainties of work at sea and of diving, this preliminary research still yielded some encouraging clues. For example, in the large cave of Les Trémies at Cape Cacaù in the Bay of Cassis, some traces—worked flint, charcoal, and bones—of Paleolithic occupation were discovered 82 feet (25 m) below sea level, preserved in deposits of calcite.[4] This work also provided better knowledge of the way the sea rose at the end of the glacial period and during the Holocene period.

At the same time as these first attempts at research into the prehistory of the submerged caves along the coast of Provence were being made, certain of the more spectacular underwater caves of Les Calanques were visited more or less regularly by divers who knew of them. Most often, these were scientists, marine biologists in particular,[5] but also the curious, either attracted to the mysterious or out looking for thrills. In fact, as soon as the Cousteau-Gagnan Aqualung came into general use, adventurous and often anonymous divers penetrated, sometimes deeply, into submerged caves such as that at the perilous outflow of Port-Miou beneath the sea at Cassis, where several divers were to die. A new depth record for a subterranean underwater dive, 428 feet (147 m), was set at Port-Miou in June 1993 by Marc Douchet. Before that, teams of daring speleologist-divers had conducted difficult, risk-filled explorations of important underwater networks of caves, such as that of Le Bestouan at the entrance to the port of Cassis, which has up to now been explored over a distance of several miles.

Thus, it was in an area near Marseilles, the diving capital of France, known to conceal numerous submerged caverns that Henri Cosquer was to make his surprising discovery. Despite the many more or less official explorations, however, no find relating to prehistory except for those in the cave of Les Trémies had ever come to light. And so the discovery of the Cosquer cave had the effect of a bomb dropping in scientific circles as well as in the media, where an extraordinary turbulence was produced beginning in October 1991.

The Discovery

This uncommon discovery took place in several stages. It was the fruit and the fitting reward of Henri Cosquer's curiosity, perseverance, and quiet courage. A veteran professional diver versed in the techniques of deep-sea diving, an authentic seaman, he directed a well-known diving school at Cassis.

In a tale worthy of Indiana Jones, Henri Cosquer told a thrilling story of events leading to the discovery that changed his life.[6] Familiar with the depths along the coast of Les Calanques, he had for a very long time regularly and painstakingly explored these underwater grottoes. At first he was guided by Jean-Claude Cayol, a mathematics teacher and a national diving instructor, the man Cosquer succeeded in 1980 as director of the Diving Center at Cassis.

In September 1985, chance led Cosquer to the foot of a small overhang at Cape Morgiou, at a place called Pointe de la Voile (figs. 2, 3). Here, about 120 feet (37 m) down, he found himself in front of a narrow and not very inviting entrance to the cave that—little did he know at the time— would one day bear his name and so immortalize him (fig. 5). This unremarkable hole, of which there are many like it in the area, at first glance hardly worth noticing, opens about 130 feet (40 m) below the surface not far from some vast underwater caverns, the well-known ones of La Triperie to

the east, those of the cove of Le Figuier to the northwest, and others of lesser importance. These caves are visited by divers attracted to their overhangs covered in "blossoms" of red coral and the timid crayfish hiding among the cracks.

The cave of La Triperie, which is partly above water at the end of a tunnel, had even been honored by being included decades ago in a film by Jacques Cousteau and the crew of the *Calypso*. As for the large cave of Le Figuier, with its yawning entrance opening almost 100 feet (30 m) down at the foot of the cliff, this is a chamber of impressive dimensions, the study of which was begun and then abandoned because of technical difficulties. We thought then and still do that this cave may conceal levels of prehistoric habitation protected by thick layers of stalagmites. This underwater region had thus been known and visited for a long time, a fact that made the discovery all the more surprising.

Narrow, low, and unremarkable, in that there are a number of similar openings at the base of this sheer wall, this particular hole caught the attention of Henri Cosquer and attracted him in some strange way. Little by little during the month of September 1985, he made his way along this seemingly endless dark passage with all the care his experience with the dangers of such diving had taught him. Having conquered the crawlway at the end of the entry passage and investigated the water-filled chambers with their petrified forests of stalagmites, he emerged finally into the main chamber, where no human had intruded in 18,000 years.

In October 1985, during these first visits, equipped with a single diving lamp, he noticed neither paintings nor engravings, awed and overcome as he was by the magnificence of the calcite

3. View of Cape Morgiou from the sea. The Cosquer cave is on the left in the photograph

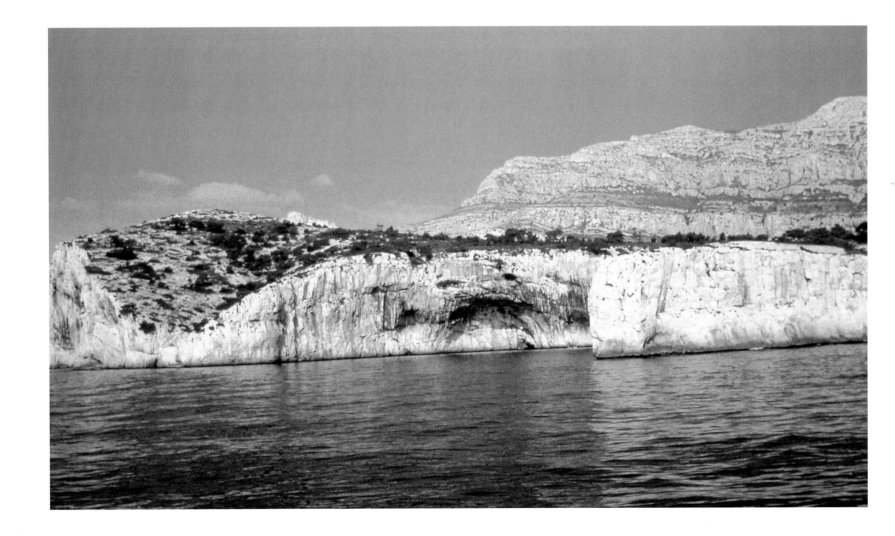

draperies, by their sparkling colors, by the crystals of aragonite in fantastic shapes, and above all by the air of mystery emanating from this cathedral beneath the sea. As he explains in his account, he began by saying nothing about his discovery, keeping it to himself, his own secret garden.

Caught up in work and travel, it was not until several years later, in the summer of 1991, that he returned to the exploration of "his cave." On July 9, 1991, he was stunned to notice a hand stenciled in red on a wall of the large chamber. Intrigued, he returned that summer with his friends Yann Gogan, Jean-Claude Cayol, Pascale Oriol, herself a diving instructor, his niece Cendrine Cosquer, and Thierry Pélissier. Amazed and incredulous at first, they then discovered most of the painted and engraved animals.

With his friends, in particular Bernard Van Espen, a Belgian speleologist-diver, Cosquer drew a cursory topographical map of the cave that was nonetheless as precise as possible and took a series of photographs as well as some images on videotape as a file to substantiate his discovery.

That same summer of 1991, at his excavation site in the Var department, Jean Courtin received a somewhat enigmatic card from Jean-Claude Cayol, Henri Cosquer's diving companion. Courtin knew him well, often having dived with him and Eugène Bonifay, especially during the work in the cave of Les Trémies. The card did not mention a cave but spoke simply of "a beautiful discovery." A diver of long standing and a regular in the diving circles of Provence, Courtin did not follow this up. Absorbed in the day-to-day problems of his excavation and by various bothersome health issues, the archaeologist thought it must involve some humdrum find of antique amphoras—which did not concern him—and that it could wait. He set Cayol's card aside, and the summer went by. On September 3, Cosquer—on the advice of Jean-Claude Cayol, who meanwhile had discussed the discovery with Jean-Pierre Bracco, a student in prehistory—decided wisely to make an official declaration to the appropriate authorities.

On September 1, however, a terrible drama had cast a pall over the enchanting site of Cape Morgiou. Four speleologist-divers from Grenoble came by chance upon the cave entrance while they were diving. Visiting the cliffs of Cape Morgiou, they were not specially equipped that day to undertake the exploration of a deep cave. In fact, they had with them only some ordinary waterproof lights, tanks without double regulators, no spare tanks, and, above all, no safety line. The lack of that essential lifeline led inexorably to the tragic death of three of them. Stirred up by the divers' flippers, the silty sediment that lay on the bottom of the passageway and the underwater chambers quickly obscured all visibility. They lost their way among the submerged stalagmites and became panic-stricken. Tragedy ensued. Only one of them managed to find his way out and raise an alarm, but too late. His three companions suffered a terrible death. Alerted, the fire brigade called in Henri Cosquer, who was said to know the area well. With his friend Yann Gogan and divers from Speleo-Rescue, Cosquer succeeded in finding the bodies of the unfortunate three.

In light of this dreadful news, it became clear that this was no ordinary dive. How surprising, then, were accusations against the archaeological authorities and the authors "of having rushed to close the cave on the pretext of a hypothetical influx of divers." Such statements demonstrate complete ignorance of the risks involved in cave diving and of the extraordinary popularity of diving around Marseilles, a diving center and training ground for excellent divers. Furthermore, it seems strange, to say the least, to come out against the protective measures taken against vandalism, conscious or involuntary, in a cave that by luck had remained inviolate for eighteen millennia.

There is no lack of sad examples of vandalism in painted caves.[7] In the south of France, the cave of Baume-Latrone in the gorge of the Gardon River has had its door forced with explosives

a dozen times, seriously damaging its paintings. In the cave of Chabot in the Ardèche department, fragments of an engraved frieze of mammoths have been detached by irresponsible intruders using hammer and burin. Also, leaving the entry to the cave accessible would surely have led to further accidents among impassioned and imprudent divers. Who would then have been held responsible?

Even after the first closing of the entrance, numerous attempts were made to break in despite the setting in place of a grill, blocks of stone later replaced by concrete cubes, and a warning sign underwater at the entrance. To give only one example, at the beginning of the June 1992 expedition, the crew of *L'Archéonaute* arrived one morning and surprised two German divers, well-equipped free-lance photographers, who were coming out of the cave, reopened just the evening before to prepare for getting the work underway. Despite the warning sign, they had forced the grill and entered the cave during the night.

But to return to September 3, 1991: that day, Henri Cosquer officially announced his discovery "of an underwater cave of archaeological interest" at the Naval Affairs Headquarters in Marseilles. He had with him a solid file of excellent photographs showing both painted and engraved animals—horses, ibex, bison, deer, birds, and a feline—and the hand stencils that had first attracted his attention, as well as maps and cross sections. Accustomed to finds of amphoras or ancient wrecks, of which there are many in the waters around Marseilles, Naval Affairs found themselves faced for the first time with a prehistoric painted cave beneath the sea. As Henri Cosquer noted with humor in his book *La Grotte Cosquer* (1992), "They had no forms for this." The declaration was sent on as required to DRASM, where the director, Robert Lequément, immediately grasped the importance of such a discovery. He conveyed the information to Jean-Paul Jacob and André d'Anna, in charge of the regional Archaeological Service for the Provence–Alpes–Côte d'Azur area, and then to Paris, to the Division of Archaeology at the Ministry of Culture. There it was brought to the attention of both Jean Clottes, who is a specialist in prehistoric art, and Jean Courtin, diver, prehistorian, and a former co-director of DRASM, who is familiar with underwater caves, particularly in the region concerned, from having studied nearby underwater caves in the 1970s.

After an initial meeting on September 9, 1991, held at DRASM headquarters at Fort Saint-Jean in Marseilles under the direction of Robert Lequément with the discoverer and two of his friends, representatives of the regional Archaeological Service, and Jean Courtin, a series of photographs taken by Cosquer were shown on September 11 to the Permanent Delegation of the High Council for Archaeological Research, and thus to Jean Clottes, for a scientific opinion. As at the September 9 meeting in Marseilles, the first reaction was cautious, as should be the case for any chance discovery not yet verified on site. Now the quite unusual conditions for entering this new painted cave required experience in cave diving. Just from examining Cosquer's photographs, however, it could be seen that the paintings and engravings were here and there covered by calcite, making their antiquity and thus their authenticity more than likely. This impression was reinforced by the difficult access to the site. It was nonetheless imperative to conduct various direct observations at the site. Jean Courtin was asked to carry out this mission.

The September 1991 Expedition: Appraisal

The September 1991 dives were carried out under the direction of DRASM, with the logistical support of *L'Archéonaute*. Specially constructed and equipped for underwater archaeological research, for

4. The small base camp above the Cosquer cave on the day it was explored by means of video camera. Jean Clottes stands on the sloping rock slab. The view is from *L'Archéonaute*. This ship belongs to the Ministry of Culture, and its crew are members of the French navy. It has been specially equipped for underwater archaeological research

recording and studying the French national underwater archaeological heritage, *L'Archéonaute* had carried out numerous missions in Mediterranean waters over the preceding twenty-five years or so (fig. 4). To this day, France is the only country equipped with such means, which endows the French with a remarkable asset for international scientific collaboration.

With Robert Lequément assuming responsibility, four members of DRASM (Luc Long, Guy Dauphin, Jo Vicente, and Albert Illouze) participated in the work of the dive, directed by Jean Courtin and guided by Henri Cosquer, with backup by seven divers from the Underwater Rescue Group (GISMER) of Toulon, a division of the French navy. Denis Metzger, also from DRASM, supervised safety measures from the surface. This operation had to be carried out quickly and discreetly, given the cave's vulnerability as long as it was open. Guided by his long experience with underwater excavations, Lequément was determined to ensure the safety and efficiency of the expedition. Because of this, he called in the GISMER team, who were trained in high-risk situations. They could provide equipment otherwise unavailable on short notice for a routine mission: in particular, powerful lights requiring cables long enough to connect the cave with the ship's electrical equipment, apparatus for analyzing the air of the cave to make sure it was safe to breathe, containers that would remain waterproof under high pressure for transporting photographic equipment, and the necessary tools for lifting and storing samples of clay, charcoal, and paint pigment to be collected for later analysis. In addition to a chief officer heading the mission, the team also included a doctor and five other divers who were experts at minesweeping and familiar with all the dangers of the sea.

Favored by good weather conditions, often an uncertain factor in the Mediterranean where the winds are capricious (as we found to our dismay during the June 1992 expedition), the official dives took place from September 18 to 20. Other dives on September 24 and 25 were made

5. The uninviting entrance to the Cosquer cave, 120 feet beneath the surface. The lifeline meant to guide the divers in the narrow passageway can be seen at right

to prepare for closing the entrance, an undertaking carried out by a firm of specialists with the help of the DRASM divers and Henri Cosquer.

On September 18, the underwater passageway, about 490 feet long, was fitted with a life-line, and lighting equipment was installed in the chamber above water as well as first-aid equipment to deal with any eventuality. This entry into the Cosquer cave took place under excellent conditions because of the meticulous preparation, the means available, and the harmony between the divers and the various groups participating. Nevertheless, it was not without second thoughts that they breached the narrow opening and entered the tunnel where only a few weeks earlier three divers had perished —all the more so because on the first day, when the equipment was being put in place, the water had quickly become opaque with all the activity, and one of the demolition divers, becoming entangled in the lifeline, did not dare use his knife to cut himself free for fear of destroying their one link with the outside. Alone in the threatening darkness of stirred-up water, he remained calm and after many long minutes was able to free himself from this life-threatening trap. This incident was chastening for everyone, already on their guard, and work proceeded uneventfully.

If moving along the gallery, which takes twelve to fifteen minutes, and getting through the crawlway provoked some apprehension, it was all forgotten on emerging into the great chamber (Chamber 1), with its pool of eternally still water, under a canopy of sparkling stalactites (fig. 6). Free of diving gear, the members of the expedition stood on the floor sealed by a flow of calcite—at times on "dry" land, so to speak, at other times with water only knee-high or waist-high—and began to explore this astonishing cave.

The ceiling of the large chamber is formed by a stratum of Urgonian limestone, almost completely covered with masses of white or ochered stalactites. The strata in the cave slope about 30 degrees to the southeast, which coincides with the slope of the entrance tunnel.[8]

From the first glance at the ceiling and walls, the number of lines covering them was striking. Henri Cosquer had spoken of numerous parallel lines, which had made us think of bear scratchings. But cave bears, those extinct giants of the glacial era, have to this day never been discovered among the Paleolithic fauna of southern Provence. Furthermore, on seeing these markings directly, it became apparent that they could not be claw marks but were in fact "finger tracings," sometimes more graphically called "macaroni," which are often found in painted caves.

Their number, the surfaces they cover throughout the cave, their position—many were found on ceilings inaccessible without scaffolding—and the fact that many of them are very patinated or are covered with a layer of calcite, which protected them at times even below the water, all were reassuring signs that dispersed any doubt as to the authenticity of the discovery.

Close examination under a strong magnifying glass of the strokes of the paintings and engravings showed that they, too, were frequently covered with a thin layer of calcite or with deposits of very hard white calcite. This was particularly true of the little black painted horses on a wall in the southwest corner of the large chamber (Chv1 to Chv4; see fig. 54); of the ibex, deer, and horses—also black—painted on the ceiling of a very low chamber a few yards away from the horses; of a large bison on the east wall (Bi1; see fig. 55); and of the hand stencils on a massive stalagmite beside a deep shaft (see fig. 50).

The number and diversity of the engravings, at first glance much more numerous than the paintings, was surprising. Horses seemed the most frequent; then came caprids (ibex, chamois?), then bovids, then cervids, as well as some elongated animals with round heads, sporting large, drooping mustaches, which we had no trouble recognizing as seals!

The strokes of the engravings, apparently incised with flint on the weathered limestone surface, also showed an ancient patina and tiny crystallizations, testifying to the great age of these works of art. Furthermore, who could have carried out work of this magnitude in a place so difficult to reach, and with what goal in mind? For those of us walking through the cave for the first time, overwhelmed and marveling, no doubt remained. The Cosquer cave was once and for all authenticated. This conclusion was to be immediately and violently contested, however, despite photographic documentation that instantly convinced several eminent specialists such as Professor Antonio Beltrán of the University of Saragossa and Michel Lorblanchet, director of research at the National Center for Scientific Research (CNRS).

On the floor of the cave, in most places sealed by calcite, there were many pieces of charcoal, sometimes covered with calcite deposits and sometimes accumulated in a hollow. Some, held in place by deposits of calcite, could be seen beneath shallow water. High up in the great chamber behind a large rock, a crack contained very malleable red clay packed with pieces of charcoal. A sample was taken for pollen analysis, as no earth could be seen anywhere else. We even gathered up some small clay balls that had fallen at the foot of a wall painted with red outlines of hands, perhaps when the hands were made. Many pieces of charcoal were collected for botanical identification and for absolute dating. To find so much charcoal on an untouched floor in a decorated cave was a rare and unexpected stroke of luck.

In the eastern section of the large chamber there remained on a flat rock a circular hearth, about a foot and a half (50 cm) in diameter, surrounded by a ring of light-colored ashes. It required a great deal of care to lift these water-soaked pieces of charcoal. We were anxious to entrust them to the physicists and to learn their verdict! In any event, the presence of charcoal on floors covered in calcite meant that the first explorers of the cave had also walked on the same calcited surfaces. There was no use at all, then, in hoping to find the footprints of our predecessors.

Our first enthusiasm never once flagged, since the significance of the site was unquestionable. This first Paleolithic decorated cave found in Provence contained numerous images, the quality and diversity of which would provide a great deal of information. Added to this was an archaeological context that would furnish valuable items for dating. At first sight, considering only superimpositions, there seemed to be at least two periods represented. The finger tracings and hand stencils often appeared *underneath* the painted or engraved animals, while the reverse situation was never encountered. As for the mysterious hand stencils, they are to be found at the northern and eastern ends of the cave, particularly near the deep shaft. There are none elsewhere in the cave. Some are on top of finger tracings but others are overlaid by finger tracings.

In addition to the samples of charcoal and clay, a minute quantity of pigment that seemed charcoal-like was also lifted from one of the painted horses and from some black hand stencils.

Through a narrow passage, there is an opening into a second chamber (Chamber 2), which leads on the right to a large submerged shaft over which there is an impressive bell-shaped dome, estimated then at about 100 feet (30 m) high, but which turned out to be a great deal higher. On the left, toward the southwest, Chamber 2 also ends in an underwater area where there is a narrow shaft that precludes passage. However, even if divers cannot pass through, marine animals do use it, since shells of spider crabs (*Maia verrucosa* and *Herbstia condyliata*)[9] littered the edges of this small narrow shaft where our lamps could not penetrate to the bottom. These crustacean remains indicate that there is some connection to an unknown underwater chamber even lower down. We named this area "The Cemetery" and the length of Chamber 2 "Crab Boulevard" ("Le Boulevard des Esqui-

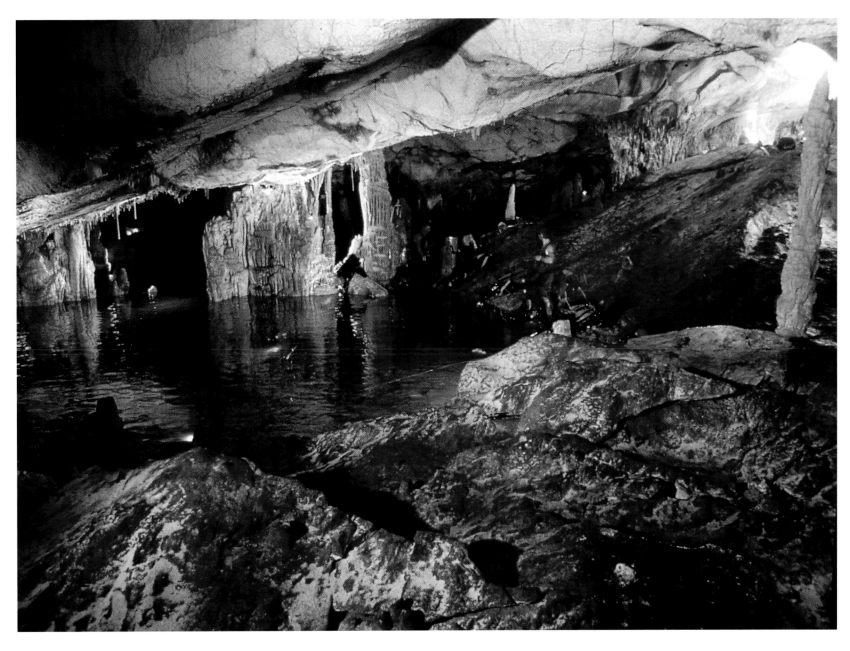

nades"), from the Provençal word for spider crab (*l'esquinado*). Along Crab Boulevard too were numerous finger tracings and engravings on the walls and overhead, and pieces of charcoal on the ground. Across from the passage, three small auks are painted in black on the ceiling. As we learned later, they are a type of penguin that lived in the Northern Hemisphere. These auks were to become as well known as the famous "Unicorn" at Lascaux cave.

In Chamber 2, we also discovered on the ground two bat skeletons covered in calcite (fig. 7). We concluded that at some early date there must have been cracks in the ceiling that opened to the plateau above.

Time spent gazing at the cave with all its treasures passed very quickly. On the second day, the team in charge of taking color photographs and filming with videotape to complete Henri Cosquer's photographs spent several hours working. This was enthralling for those in the deep silence of the cave, cut off from the rest of the world, while those who waited above on *L'Archéonaute* were little by little overtaken first by uneasiness, then by worry. What was happening? Finally the first air bubbles broke the surface and the divers climbed aboard—mission accomplished. On the

6. View of the large unsubmerged chamber (Chamber 1) from the east. The floor is a layer of Urgonian limestone. The "beach" can be made out on the right, a sloping surface covered by a calcite flow. The underwater access gallery is situated at the left

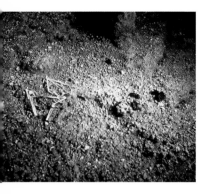

7. Bat skeleton sealed in calcite on the floor of Chamber 2. It is evidence that there are, or were, fissures opening to the plateau, which would partly explain the air circulation in the cave

ship, everyone was relieved but also convinced that on future missions a telephone link was needed between the ship and the cave.

The First Analyses

At the end of the dives, samples of charcoal from the large chamber were entrusted to different CNRS laboratories. Stéphanie Thiébault of the Laboratory of Paleobotany at Montpellier II quickly identified them. All the identifiable charcoal—some was too worn down to allow precise determination—came from a conifer, Scotch pine (*Pinus sylvestris*), a mid-mountain species which has now completely disappeared from the coastal mountains of lower Provence, where only the Aleppo pine persists, when fires have spared it. Other samples, more questionable, were thought to be Austrian pine (*Pinus nigra*). Later analyses revealed that in fact only Scotch pine was present. Nowadays, Scotch pine can be found beginning at altitudes of 1,600 to 1,950 feet (500 to 600 m) on the north faces, locally called *ubacs,* of the small mountains of Provence, such as L'Etoile chain north of the Marseilles basin, Sainte-Baume to the east, Sainte-Victoire near Aix-en-Provence, and Lubéron north of the Durance River. Its very resinous wood lends itself well to making torches or hearths for providing light. This explains the preference of prehistoric people for using it to illuminate dark caves.

On the other hand, a disappointment awaited us. In the clay samples sent to the Laboratory of Palynology at the Center for Archaeological Research at Valbonne, pollen turned out to be very sparse and sometimes absent altogether, probably destroyed by the salinity of the cave. Michel Girard (Center for Archaeological Research [CRA], CNRS), a palynologist of broad experience, succeeded nonetheless, after an initial examination, in recovering a small amount of fossilized pollen insufficient in quantity for a detailed description of the plant milieu but still significant, indicating characteristics of a cold, steppe-like environment.[10] Grass pollen was much more frequent than tree pollen. Among the trees of pine and juniper was birch (*Betula*), which has long since disappeared from the south of France. This was an additional indicator of a cold environment: a steppe covered with artemisia and birch, one already suggested by the animal representations of plains horses, bison, ibex, seals, and auks, as well as by the charcoal samples.

One of the striking results furnished by the samples gathered in the cave in September 1991 came from the charcoal analysis done at the Radiocarbon Laboratory of Claude-Bernard University at Lyons by Jacques Evin (URA 11–CNRS). Collected on the floor of the large chamber in a clay fault, these pieces of charcoal were subjected to immediate analysis. Since October 1991 we had one result that supported our observations: the date obtained, 18,440 ± 440 B.P., fully agreed with the estimates made from stylistic comparisons. This led us to attribute at least part of the art in the Cosquer cave, the painted and engraved animals, to an early phase of the art of the Quaternary, contemporaneous with the Solutrean culture, particularly in view of similarities to the engravings at Ebbou cave, in the Ardèche (fig. 8, and see the chronological chart, fig. 188).

Dating pieces of charcoal gathered on the ground in a cave does not, of course, provide unequivocal dates for the works of art themselves, as we are well aware. But it did demonstrate nonetheless the presence of humans in the cave at a very early date. Furthermore, that date accords well with the period indicated by the stylistic conventions observed for the animals represented, such as Y-shaped legs, partly twisted perspective for the horns, and stiffly fixed positions. Now the cave gave no indications of use as a habitat—such as animal remains, arrangements of stones, or discarded

flakes of hard rock. Thus it may possibly have been used as a cultural space, a "sanctuary." In that case, why not relate the pieces of charcoal, the obvious remains from burning wood for light, to the works of art?

Informing the Public and Revealing the Cave

Thanks to the discretion of Henri Cosquer and his friends, as well as to the obligatory reserve of the administration and that of the few scientists taken into our confidence, the secret had until this point been well kept. Our first concern was to preserve the discovery from any possible damage before truly effective measures of protection could be put in place.

We were surprised and concerned then, when on October 18, 1991, barely a month after the official dives, there was a leak to the local press, which suddenly divulged the discovery ("An Underwater Lascaux Discovered near Marseilles," *Le Provençal,* October 18, 1991; "Twenty Thousand Years beneath the Sea," *Le Méridional,* October 18, 1991).

The news was picked up instantly by all the media—radio, television, local newspapers and the big Parisian dailies, and both French and foreign magazines. We were literally overwhelmed by journalists from around the world. Never before had a prehistoric discovery been the object of such excitement. In addition to those directly concerned, outsiders granted interviews and expressed their opinions. Many people with little information or none at all surprised us by speaking with assurance—all of them, of course, without having set foot in the cave.

This outbreak of publicity, which we would gladly have forgone, faced us acutely and urgently with the problem of protection against the risk of vandalism and the prevention of any further accidental deaths. As a result, the Minister of Culture, Jack Lang, organized a press conference in Paris and without delay, on the day the story broke, invoked an emergency measure valid for just one year to classify the cave as a historical monument. That did not mean, as has often been said and written so unfairly, that from then on the Cosquer cave was classified officially as a historical monument, but rather that for one year from the date of the notification, all the provisions of such classification applied. The actual procedure for classification—more complicated—in fact requires input from several committees and organizations. Consulted on December 10, the regional Commission of Historical, Archaeological, and Ethnological Heritage (COREPHAE) pronounced itself unanimously in favor of classification. After various high-level meetings and following normal procedures, with the High Commission of Historical Monuments having delivered a unanimous favorable vote, the cave was classified a historical monument by decree on September 2, 1992.

Days of Suspicion: Authenticity in Doubt

After the official dives and the observations made on site, one might have thought the question would be considered settled. The very large number of depictions in the cave ruled out the hypothesis of a forgery being staged in a setting so difficult of access. The same went for the layers of calcite covering the finger tracings, paintings, and engravings. The plentiful supply of charcoal pieces, often coated with calcite, were found at times even below the water; and the carbon-14 date obtained agreed both with the style of the animals depicted and with the paleobotanical findings indicating

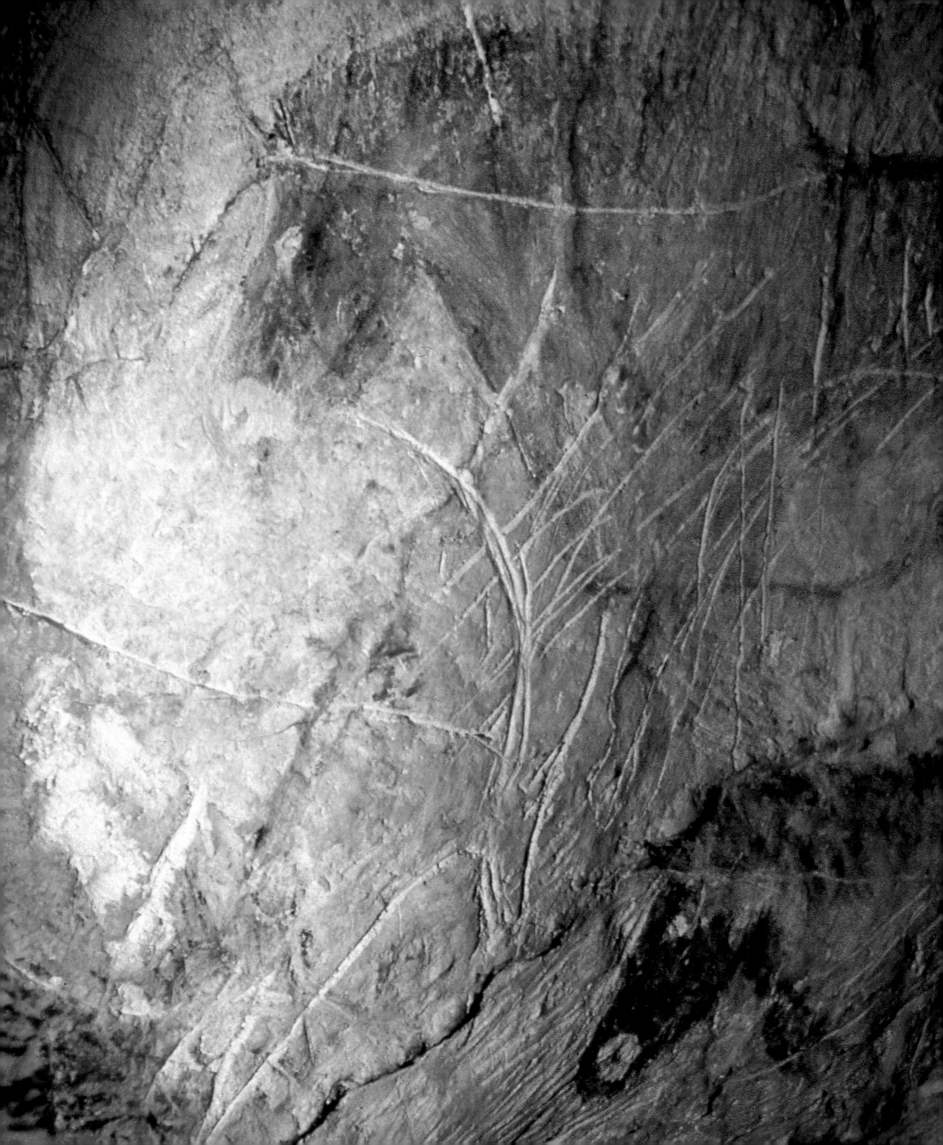

flora of a cold climate, very different from the present era. For us and for many other scientists, the authenticity was no longer in question as all of these findings taken together had swept away our last hesitations.

We were surprised then, in the fall of 1991, to see our conclusions called into question in a series of contentious articles published, notably in the daily *Nice-Matin,* in November and December 1991, as well as in televised interviews with Denis Vialou. Thus it happened that Brigitte and Gilles Delluc, after first having said that it was "a very important discovery" (*Sud-Ouest,* November 1, 1991), revised their judgment just four days later (*Nice-Matin,* November 5, 1991; *Sud-Ouest,* November 7, 1991), expressing "very serious doubts" and declaring their "strong reservations" but nevertheless still allowing for the possibility of authenticity. Denis Vialou, on the other hand, was much more dogmatic: "I am firmly convinced that it's a fake" (*Nice-Matin,* November 5, 1991). He was to renew the expression of his skepticism in various radio and television broadcasts and newspaper articles (for example, *Nice-Matin,* December 8, 1991). It should be noted that no large Parisian daily echoed these attacks. Nevertheless, doubts were sown in many more or less informed minds.

But it was a deliberately critical and controversial magazine article (Bourdial, "A Very Shadowy Cave," *Science et Vie,* February 1992) that, by taking up the arguments already put forward by Brigitte and Gilles Delluc, by Denis Vialou, and by Arlette Leroi-Gourhan, as well as those by Paul Bahn (*The Independent on Sunday,* November 12, 1991), echoed these repeated attacks and provoked a reversal of public opinion in France and at times even abroad. To our knowledge, however, these were the only specialists to have questioned publicly the authenticity of the works of art in the Cosquer cave. The article in *Science et Vie* raised a great deal of journalistic commentary, much of which did support authenticity, it should be remembered. Thus, Jean Contrucci, a senior reporter at *Le Provençal,* sided with us and consistently stood up in defense of the discovery (*Le Provençal,* March 3, 1992). Also among the defenders of authenticity was the speleologist Michel Siffre.[11]

But the harm was done: from then on, in the mind of the public the Cosquer cave was a fake. Moreover, these doubts and this suspicion persist at times even now, to the detriment of prehistoric research, despite the dates obtained since then for the paintings themselves, which are as a result beyond question.

Whether in our article of July 1992[12] or in those that followed,[13] we have always avoided aggressively taking the offensive despite the violence of the repeated attacks directed at us. Rather than engage in a sterile media battle, we preferred serenity, working calmly with the numerous documents available to us and publishing several articles in the shortest time possible. We have always tried to avoid an argumentative tone and to stay strictly with established facts and with remarks supported by references, a stance which can easily be verified.

This is how we have refuted the unfounded accusation made against us of "withholding information." The available slides, which gave infinitely more detail than could be seen in the few photographs, ever the same, published in the press, were never kept secret. Far from it. They were shown to a number of specialists and to interested members of the public, either individually as the circumstances arose, or on the occasion of a meeting of the Study Group on Paleolithic Wall Art (GRAPP), or during numerous conferences and presentations that we gave in response to incessant demand, even today, not just in France but also in the United States and as far away as Australia. The first publication, preliminary but detailed, appeared ten months after notification of the discovery. Only two months after the Cosquer cave was made known, however, Denis Vialou announced his doubts to the media, and it was on December 8, 1991, just three months after the discovery, that he

8. An ibex (Bq10) has been engraved directly on top of the painted horses in the large panel (Chv1–Chv4). At the bottom of the photograph are finger tracings, partly covered by the head of the horse Chv4

violently attacked the "withholding of information." He also declared that the opinions cited in *Nice-Matin* in November 1991 misrepresented his ideas and that he had sent a letter of denial to the journalist concerned. But no rectification was published, no "mea culpa" in the manner of the great prehistorian Emile Cartailhac, who at the beginning of the century had the decency to admit his error concerning Altamira cave.[14] Too much publicity was given to the positions taken and they are still fresh enough in memory that there is no need to elaborate. We will limit ourselves to recalling only a few significant examples of the arguments put forward.

In September 1991, one of the first observations made in the cave concerned the calcite that covered certain strokes on some of the painted animals and on a number of hand stencils. The detractors countered with two arguments: "The calcite deposits on the figures do not prove their age: many calcium deposits can be found in the tunnels of the Paris Metro,"[15] which means that calcite can be deposited very quickly in certain circumstances and so does not constitute a criterion of authenticity. "It is possible to make calcite artificially."[16] In that case, certainly possible in a laboratory, it must be imagined that the calcite was brought there in solution in a richer carbon-dioxide atmosphere than that in the cave, which would have posed serious transportation problems considering the deep-dive access and the amount of calcite needed, not to mention applying it by brush or with a syringe.[17] Now, observation at the site shows that the calcite is not limited to the works of art but rather covers large surfaces on the ceilings and walls. This is not compatible with a superficial application. Philippe Renault, a geologist who specializes in karst (CNRS, Lyons) noted that a "distinction must be made among calcite deposits in the form of stalactites, calcited edges of small pools and macaroni, all more or less dull, which can be recent (see also quarry observations), and the brilliant calcite coverings which form only very slowly and which do indicate great age."[18] One instance of this type was enough to establish the authenticity of at least a large section of the ensemble. But there are others. The engravings in fact include two distinct types, the finger tracings and the engravings incised with fine lines. The former cover dozens of square yards and are at times preserved below the waterline because of being sealed in calcite. Now, the finger tracings and the great majority of engravings are uniformly patinated, even within the stroke itself, so that under a magnifying glass crystallizations are visible. The patinated lines of the fine engravings are clear-cut, the same color exactly as the neighboring rock surfaces, something that is incompatible with recent creation and artificial aging.

The archaeological context of hearths and charcoal on the ground as well as the first date obtained both showed, as of October 24, 1991, that the cave had been visited about 18,500 B.P. This dating, troublesome for the detractors, was contested with two arguments. It was claimed that the charcoal and hearths could have been brought into the cave recently by the mysterious "forgers"![19] As if it were easy for anyone to acquire a quantity of charcoal about 20,000 years old, to transport it in a dive, and to strew it about the cave, where, in addition, it would have been necessary to coat pieces of it with calcite, at times below the waterline! Such suggestions leave one puzzled, but this argument at least has the merit of originality.

More reasonably, Paul Bahn remarked that the charcoal was evidence of visits to the cave during the Paleolithic but not necessarily at the same time as the wall art. This objection is methodologically justified, of course: the only absolute certainty that an archaeological level is associated with the art would be to obtain pigment within it, as Jean Combier did at La Tête du Lion in the Ardèche.[20] That could not possibly be the case at Cosquer since the paintings themselves were done with charcoal. Nevertheless, the complete absence of signs of habitation such as fauna, waste from

flint-knapping, and arrangements of stones, as well as the configuration of the cave itself eliminated this hypothesis from the beginning.

The skepticism voiced by some at the discovery of the Cosquer cave was based only on photographs that had appeared in the press. From mid-October 1991, however, several dozen slides were available through Henri Cosquer and Jean Courtin, at DRASM in Marseilles, at the Regional Archaeological Service in Aix-en-Provence, and at the Division of Archaeology at the Ministry of Culture in Paris, but none of our combative colleagues asked to see them before denying the authenticity of the discovery.

Their critical arguments had to do with the location of the cave, variations in sea level, the themes depicted, and the techniques used, as well as stylistic comparisons. The situation of the cave in Provence, a region where there had so far been no discoveries of Paleolithic wall art, was put forward, an argument worse than specious as there are a good number of even more striking cases of isolation: Kapovaya in southern Russia; La Fuente del Trucho in northern Aragón; Gouy in the Seine-Maritime department and Arcy-sur-Cure in the Yonne, among others. Certainly, a discovery that does not fit into a known framework is automatically suspect; it arouses an attitude of mistrust and doubt toward that which is out of the ordinary and so strikes against set habits of thinking and a certain conformity.

As for the question of sea level, it will be raised in Chapter 2; however, it should be noted, contrary to what was claimed, that the Mediterranean has not since the end of the last glaciation "climbed a number of times above the present level."[21] In fact, the sea level has never been higher than it is now and the water level continues to rise (fig. 9).

Denis Vialou and the Dellucs stressed "the absence of geometric signs." Now, engraved signs and certainly painted ones are legion in the cave (see Chapter 7), but for obvious reasons having to do with concern for the spectacular, they were never published in the press. Isabelle Bourdial made heavy fun of "the Provençal penguin," described elsewhere as a "strange beast with golden rump and short flippers" (*France-Soir*, October 21, 1991). She also wrote, "The presence of this flying creature in the Cosquer cave is surprising: for the Quaternary this is the only representation of the kind known until now."[22] However, depictions of unusual animals do exist in other caves and the rarity of a theme should not give rise to suspicion. Elsewhere, remains of the great auk (*Pinguinus impennis*) have been found in a number of Upper Paleolithic habitats in the western Mediterranean, for example, Devil's Tower cave on Gibraltar, Les Arene Candide cave in Liguria, and the Romanelli cave in Apulia (see Chapter 6).

Gilles and Brigitte Delluc found quite troubling "the absence of the ordinary graphic devices used by Paleolithic artists,"[23] along with "the almost childish mediocrity of most of the published drawings." Now, graphic devices do exist. They translate conventions in the representation of the animals: Y-shaped legs in the engravings, exaggerated horns, and twisted perspective. As for the second remark, it offers an aesthetic opinion that is quite personal and cannot conceivably constitute any kind of criterion related to the authenticity of works of art.

Finally, stylistic comparisons gave way to criticism that might at times seem laughable if it had not been for the consequences. The opponents already quoted found "mixed resemblances" to French and Spanish caves distant in time and space, and for them certain figures were "unskilled copies." Now, to argue, for example, about the representation of a tear duct on the painted deer at Cosquer and the deer at Lascaux, and to be astounded by the placement of the ears behind the antlers on the same animals,[24] does not make sense, since these are anatomical characteristics proper to all

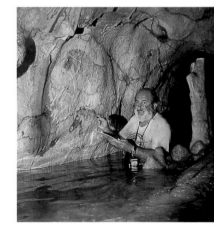

9. Jean Courtin at work, up to his waist in water, facing the panel of horses seen in figure 8. Finger tracings sealed by calcite have at times been preserved below the water, but any paintings done in charcoal have been destroyed, on the other hand, along with fine engravings

deer. What is more, the Cosquer animals, if they belong loosely to a Mediterranean style (Ebbou, Baume-Latrone, and elsewhere; see Chapter 5), nevertheless display numerous unusual characteristics, observable both in the themes (auks, seals, megaloceros) and in the techniques. This is unlikely in the work of a copyist.

Finally, to reason to the point of absurdity, for this collection to be false, the forger would have had to be extremely knowledgeable about Paleolithic art so as to commit no error in the choice of themes and techniques, while at the same time introducing spectacular innovations that were still plausible. He would have had to be an excellent diver and an equally fine artist. He would have had to succeed in reconstituting an ancient type of calcite coating not only on the paintings but on the ceilings and the neighboring walls. He would have had to patinate the engravings, procure an abundance of charcoal 18,500 years old belonging to a species of tree growing in a cold climate, and construct hearths and coat them with calcite even beneath the water. Finally, he would have had to work very discreetly (at night?) in order not to draw attention to repeated dives in a very busy location, as well as leave no trace of his activities in the cave.

If scientific discussion is normal and constructive, the same cannot be said for arguments conducted through the press that end up only sowing doubts and tarnishing a scientific discipline. This is not the first time a prehistoric discovery of the first order has been contested before being unanimously accepted. No doubt the most famous example is that of Altamira.[25] But other discoveries no less well known have also stirred up passionate argument in their day. Such was the case for Lascaux, for Baume-Latrone, and in 1956 for Rouffignac in the Dordogne. In June 1956, when Louis-René Nougier and Romain Robert discovered paintings on the wall that had gone unnoticed until then in this immense cavern, long known and visited, there was an uproar, and a long struggle ensued over their authenticity, a battle that was won thanks to the help of the Abbé Breuil. Recently, this thirst for argument has not spared even Otzi, the little Neolithic hunter who went astray and died of cold in the solitude of the Austrian Otztaler Alps and was found, miraculously preserved in the ice, 5,000 years later—coincidentally, at the same time that the Cosquer cave came to light.

In the case of Cosquer, we have benefited from progress in dating methods. The results obtained in November 1992 from the pigment samples finally put an end to all the sterile discussion.

The Scientific and Technical Committee: The Study of the Documents

Little more than two months after the discovery, the Minister of Culture set up by a decree dated November 12, 1991, a Scientific and Technical Committee for the Henri Cosquer Cave, having as its mission "to give advice on the contents, the execution of all work and study within the Cosquer cave in the commune of Marseilles" (decree published in the *Journal Officiel* for November 21, 1991). Jean Clottes, General Conservator of the National Heritage, was appointed president of the committee. The following people were named committee members:

- *Jean-Paul Jacob,* Regional Conservator of Archaeology, head of the regional Archaeological Service, Provence–Alpes–Côte d'Azur
- *Robert Lequément,* General Conservator of the National Heritage, head of the Department of Underwater Archaeological Research (DRASM)
- *Antonio Beltrán,* professor at the University of Saragossa, a highly regarded specialist in rock art (after France, Spain has the largest number of Paleolithic decorated caves)

- *Henri Cosquer,* discoverer of the cave, expert in underwater work
- *Jean Courtin,* Director of Research at the National Center for Scientific Research (CNRS), prehistorian and diver
- *Jacques Tarrête,* General Conservator of the National Heritage and General Inspector for Archaeology

It was planned from the start that the committee could call upon anyone who could contribute usefully to its work. And so, beginning in January 1992, Jacques Brunet, an engineer responsible for the Painted Caves Division of the Research Laboratory for Historical Monuments, was invited to participate in the work of the committee. He was a member of the June 1992 mission aboard *L'Archéonaute.* The committee also enrolled Eugène Bonifay, geologist and prehistorian (Laboratory of Quaternary Geology, University of Marseilles at Luminy) who, like Jean Courtin, had been co-director of DRASM and had studied the underwater caves along the coast of Les Calanques. Finally, Michel Lorblanchet, prehistorian and director of research at CNRS, a specialist in rock art who is known for his work in the painted caves of Quercy and on Australian rock art, was also included.

The study of the first available documents—photographs placed at our disposal by Henri Cosquer—and of the videotapes and on-site observations obtained from the experts' work in

10. Jean Courtin, at left, and Henri Cosquer, at right, in the Cosquer cave

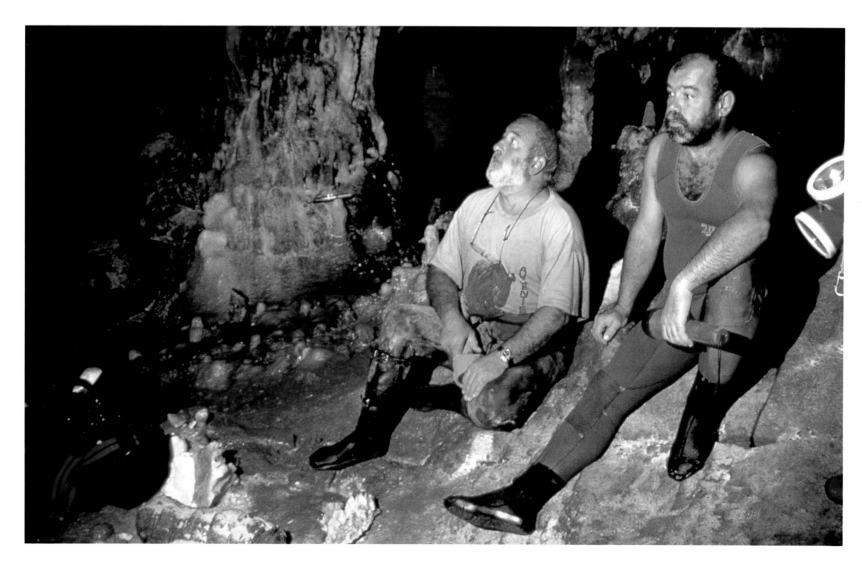

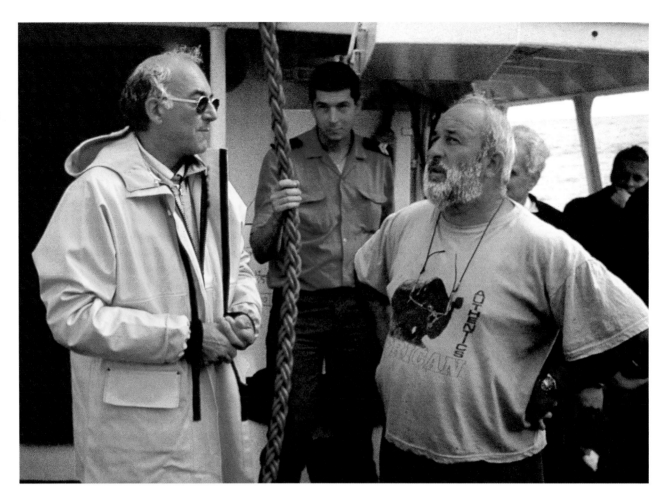

11. Jean Clottes, at left, and Jean Courtin, at right, on the bridge of *L'Archéonaute* during the June 1992 expedition. In the background, behind Jean Courtin, is Robert Lequément, head of the Department of Underwater Archaeological Research

September 1991, served to confirm and to sharpen our first impressions and preliminary conclusions. Given the fragility of the weathered limestone surface beneath most of the paintings and engravings, and an environment steeped in humidity and excessive salt, it seemed inadvisable to go ahead with direct tracings on transparent plastic sheets. It was therefore necessary to work only from the photographs, augmented by notes taken at the site.

Before we received results on the sample material collected during the next expedition to the cave, one of the major questions was whether or not the various works were contemporaneous. It was resolved, as will be seen in more detail in Chapter 9, by comparing the animals with one another for superimpositions, stylistic features, and techniques of representation.

The animal art and signs in the Cosquer cave were in this way placed in the Late Solutrean period. This conclusion was to be fully confirmed a few months later.

On the other hand, it was harder in those early days to assign a precise date to the other works, which had seemed right from the beginning to belong to an earlier period, particularly the innumerable finger tracings and the hand stencils. The only certainties were that these works had a different patina and were always found, when there were superimpositions, *beneath* the painted or engraved animals. Of course, when compared with the hands at Gargas, a cave in the Hautes-Pyrénées department, the Cosquer hand stencils, in particular those with incomplete fingers, which are very rare in the art of the Quaternary, suggested the Gravettian period. But even at Gargas, such hands have only been attributed to the Gravettian hypothetically. Finger tracings, certainly abundant at Gargas, are known to exist in decorated caves that are Solutrean (Pech-Merle) and even Magdalenian (Rouffignac, Le Tuc d'Audoubert). Was this earlier phase, or Phase One, at Cosquer—

stratigraphically situated beneath Phase Two, that of the animal art—close in time to Phase Two or far removed? In the spring of 1992, this was impossible to know, even after several months spent studying the first documents collected in the Cosquer cave. A new expedition came to be seen as indispensable.

The June 1992 Expedition: New Evidence and Results

For several decades, because of the deterioration noted in a number of painted caves, usually the result of too frequent visits (as at Lascaux), priority has been given to conservation of this renowned heritage, the art of the Quaternary, which is not simply regional or national but in fact belongs to all humanity.

In the present case, given the difficulty of access to the Cosquer cave, it became necessary to reconcile conservation and scholarship, taking advantage of each mission to acquire the largest possible amount of data on the cave: topographical description, photographic coverage, video images, a complete list of the works of art, measurements of all kinds, and new samples of charcoal from the ground, of pigment from the paintings, of clay for new pollen analyses, as well as geological, climatological, and biological observations.

A new series of dives was thus decided upon. They were to take place over three weeks from June 1 to June 23, 1992. A few additional days would be needed to close up the cave. Despite atrocious weather conditions, the results nevertheless met all expectations.

As in 1991, Robert Lequément, representing DRASM, organized and supervised the expert campaign down to the last detail. The dives were from *L'Archéonaute,* under the command of Captain Alster. The direction of the scientific operation fell to Jean Clottes, while Jean Courtin, assisted by Luc Long, was charged with coordinating work in the cave (fig. 11). Out of concern for safety, the passageway was fitted with a rope attached to the ceiling to serve as a guide and with flashing lights. Participating in the dives to the cave were Antoine Chêné, a photographer specializing in underwater archaeology (CNRS, Centre Camille-Jullian, Aix); Jacques Collina-Girard, prehistorian and geologist (University of Bordeaux I); Pascale Oriol; Henri Cosquer; Jean Courtin (CNRS); Guy Dauphin, Luc Long, and Jo Vicente (DRASM); Catherine Dovis, Bernard Rebatel, Gilles Sourice, and Gilles Bour, film makers (Fanny Broadcast Company); Jean Vacelet, CNRS biologist (University of Marseilles II, Center for Oceanology); and Michel Girard, palynologist (CRA, CNRS). Technical assistance was provided by divers from SERMAR. Jean Clottes coordinated the scientific activities.

In accordance with the agreement made by the Ministry of Culture, further filming was done by Gilles Sourice and his team. This film, *The Secret of the Cosquer Cave,* was shown on French television ("Reportages," on Channel TF1) on October 24, 1992.

The filming gave rise to an experiment as original as it was fascinating: a three-way audiovisual system of communication was installed to connect the team on *L'Archéonaute,* the operator in the cave, and Jean Clottes on shore. In this way, we could follow the exploration live, directing the camera shots from a monitor transmitting the images. This exploration by camera intervention lasted several hours and was filmed itself to serve as a document for future work.

Under the instruction of Jacques Brunet, who several times came on board *L'Archéonaute,* the divers proceeded to sample air and earth for microbiological tests and other measurements (air

temperature, carbon-dioxide level, relative humidity). The temperature in the cave varied between 66°F and 70°F (18.7°C and 21.2°C) and the humidity was constantly above 90 percent. As for the carbon-dioxide level—below 0.2 percent in the beginning, it was only 0.3 percent by the end of two weeks of work in the cave. The results of these tests showed that the cave was not polluted and that the environment remained stable after a number of people had passed through. These preliminary measures are only a first "check-up" on the cave while waiting for the installation of a long-term remote measurement station, the goal of a future mission.

With the help of Jo Vicente and Jacques Collina-Girard, Luc Long worked out a more detailed map of the cave, locating on it most of the works of art and the archaeological evidence.

The biologist, Jean Vacelet, was able to make interesting observations on the submarine fauna (see Chapter 3).

But the most important results were those concerning the works of art and the archaeological context. Jean Courtin and Luc Long, with the help of Jacques Collina-Girard and Michel Girard, measured the figures and their placement in relation to the ground, making numerous detailed sketches. A descriptive inventory of the hand stencils brought their number from 23 to 46. With the aid of the powerful lighting needed for filming, new engravings were discovered on the walls and ceilings, doubling the total number of animals previously recorded. A panel of very fine engravings featuring animals of scaled-down dimensions (doe C3, 5½ inches long; ibex Bq15, 4¹⁵⁄₁₆ inches long; see Chapter 5) overlying black hand stencils was thus discovered on a ceiling near the large shaft. Strange engraved animals were located at several points. For example, a small horned quadruped with long neck and protuberant muzzle (indeterminate I6; see fig. 57) is engraved near the small shaft at the western end of Chamber 2 beside a potbellied seal different from the other depictions of this animal. A large aurochs (or bison?) was discovered engraved on the ceiling at the top of the large chamber about three yards from the ground (Bi9). Cervid antlers, also engraved on the ceiling beyond reach, were located beside large masses of stalagmites in the southwest section of the large chamber. Each day spent in the cave led to new discoveries of previously unseen engravings of animals, rectangular signs, and signs made of painted dots.

Jean Courtin had the joy of discovering underwater, at the foot of a panel of little horses painted in black, a blade of black flint and then, in crevices on the ground, four other blades, one of which was 4¼ inches (11 cm) long. In Chamber 2, Jacques Collina-Girard also picked one up. Were they the tools of the engravers or simply knives lost by men as they moved about the cave? This point would be cleared up by an examination for possible microtraces with an electronic scanning microscope (see Chapter 3).

We carefully lifted samples of charcoal pigment from one of the painted horses (Chv1) as well as from the horse Chv5 perpendicular to it (fig. 14); from a painted ibex (Bq1; see fig. 56); from a bison (Bi1); from the megaloceros painted on the low ceiling in Chamber 2 (Mé1; see fig. 57), from the head of a feline (F; see fig. 57); and from a black hand on the east wall of Chamber 1 (MR7; see fig. 50). A whole series of charcoal samples was collected from several locations on the ground, particularly where there was risk of damage by the divers passing through. Samples were also taken of clay from cracks, of pigment on the red hands, and of calcite on the walls and ceilings. Michel Girard collected a number of clay samples in order to try new pollen analyses.

No bone fragments were observed either on the ground above water or underwater, except for some bones of a large fish found underwater at the edge of the large shaft. They were identified by Jean Courtin as belonging to a grouper (*Epinephelus guaza*), a determination later

12. Near the cliff, divers swim toward the Cosquer cave, surrounded by fish

13. Underwater landscape near the cave. Caught in the beam of a flashlight are purple sea-fans, sponges, and corals

confirmed by Jean Desse, a CNRS specialist at CRA in Valbonne (see Chapter 3). Also found under stones were some remains of small rodents and in a fault in Chamber 2 the skeleton of a small bird.

A very large number of photographs were taken by Henri Cosquer, Jacques Collina-Girard, and especially Antoine Chêné, who undertook a systematic inventory of the figures, in black-and-white and in color, work that could not be completed because of lack of time and which must be continued in future campaigns.

The Death of an Argument

Despite the reservations of some, the first observations at the site and study of the evidence collected in the autumn of 1991 had already established the authenticity of the works of art. The new samples were taken not so much to confirm authenticity as to narrow down the periods during which the cave was visited and the different phases of work there, phases intuited from the superimpositions and the stylistic conventions. Phase One, with the hands with incomplete fingers and the finger tracings, recalled Gargas and thus the Gravettian period. Phase Two, with the painted and engraved animals as well as the signs, fitted into the framework of André Leroi-Gourhan's Style III (see fig. 188). We had proposed a chronological range of 17,000 to 20,000 years B.P., supported by comparisons with Ebbou in the Ardèche and the engraved plaquettes of Parpalló in Spain. The first carbon-14 date obtained in Lyons was 18,440 B.P., fully consistent with the styles of this Phase Two.

In addition to the new charcoal samples collected from well-defined spots on the ground, samples of paint pigment were entrusted to the Weak Radioactivity Laboratory (Laboratoire des Faibles Radioactivités) at Gif-sur-Yvette (CNRS, Commissariat à l'Energie Atomique), under the supervision of Hélène Valladas. These samples, purposely minute, were dated by the carbon-14 method using the Tandétron, a mass-spectrometry accelerator, a method already used to date paintings at Altamira and El Castillo caves and at Niaux in the Ariège department.[26] A few months later, the results were in, confirming in a striking way our first deductions and silencing definitively the die-hard protesters.[27] The hand stencil yielded a date even older than we had expected, more than 27,000 years B.P. There we had, besides *the oldest date in the world obtained directly from a wall painting*, indisputable proof that the hand stencils with incomplete fingers dated back to the end of the Aurignacian period or more probably to the Gravettian. These civilizations are well represented in the east of Provence in the Var department,[28] but they are much less in evidence in western Provence (see Chapter 2).

With regard to Phase Two, that of the animal representations, the results allowed us to narrow the range proposed. Five similar dates place it between 18,500 and 19,000 B.P., a millennium and one-half before Lascaux (see Chapter 9).

Rapidly summarized, these are the major findings of the June 1992 mission. However, despite their considerable implications, they do not in any way mean that the cave has been studied in an integrated and definitive way. Far from it.

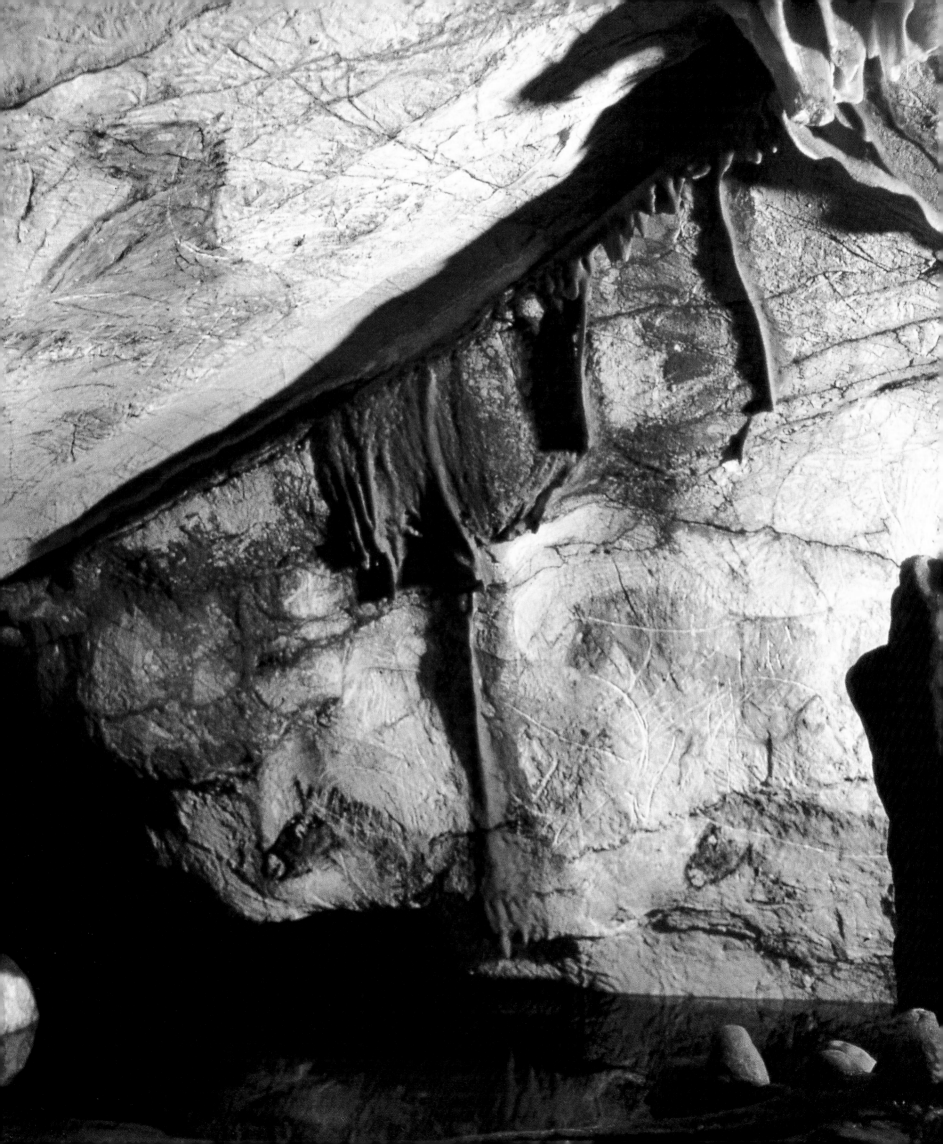

2. The Natural Setting

The Countryside, the Animals, and the People in the Days of the Cosquer Cave

Sea Level and Shoreline in the Upper Paleolithic Period

The hunters of Provence during the Upper Paleolithic had before their eyes a landscape far removed from the present one. Not only did the climate, the vegetation, and the fauna have little in common with that of southern Europe in the twentieth century but the geography itself differed from that familiar to us.

As was said in the preceding chapter, the severe climatic conditions of the Quaternary era brought with them considerable variations in sea level. Roughly 20,000 years ago, at the height of the Quaternary cold, ice caps several thousand feet high covered North America and Eurasia, resulting in a lowering of the sea level by about 360 feet. A large part of the North Sea was dry, as was the English Channel and a wide strip of land along the coasts of Brittany and Aquitaine, while what we call the British Isles formed a whole with the west of France. Beringia, an isthmus about 620 miles wide and swept by glacial winds, then connected the Siberian border to Alaska, with vast stretches of Siberia and Alaska remaining free of the glaciers. The Japanese archipelago was attached to the Asian continent by the Korean peninsula and by Sakhalin Island. Tasmania, Australia, and New Guinea formed one immense continent, Sahul, separated from the continent of Asia by the Strait of Weber. As for Indonesia, it formed just one large landmass in southeastern Asia, the headland of the Sonde at that time joining the Philippines, the Moluccas, Java, Sulawesi, Sumatra, and Borneo.

In the south of France, the Gulf of Lions was partly above water. The shore was situated far from the present coast of Languedoc, Roussillon, and southern Provence, about 35 miles (55 km) beyond the modern cities of Agde and Sète, some 9 to 12 miles (15 to 20 km) beyond Marseilles, and 7 miles (12 km) south of the massif of Les Calanques (fig. 15).

To the east, from the Var to the Alpes-Maritimes, the continental shelf angled sharply downward and the coast did not lie far from where it is today. We saw, however, that the Hyères Islands were then connected to the massif of Les Maures, and that the Paleolithic coast extended beyond the peninsula of Saint-Tropez, where the gulf was above water, as was the Gulf of Fréjus.[1]

For a long time, marine encroachment and regression have been the object of numerous specialized studies. It has often been prehistoric studies that have allowed refinement of the chronology of the various phases of the rise and fall of the sea. Nowadays these phenomena are relatively well known.

If for the most part the main cause of these variations in sea level stems from climatic upheavals that occurred during the Quaternary, other factors cannot be ignored. In particular, there

14. Today the large panel of horses (Chv1–Chv4) is bathed by the sea. Above left is a panel covered with finger tracings, on which another black horse (Chv5) has been painted. Samples of charcoal pigment lifted directly from these paintings furnished dates of about 18,800 B.P.

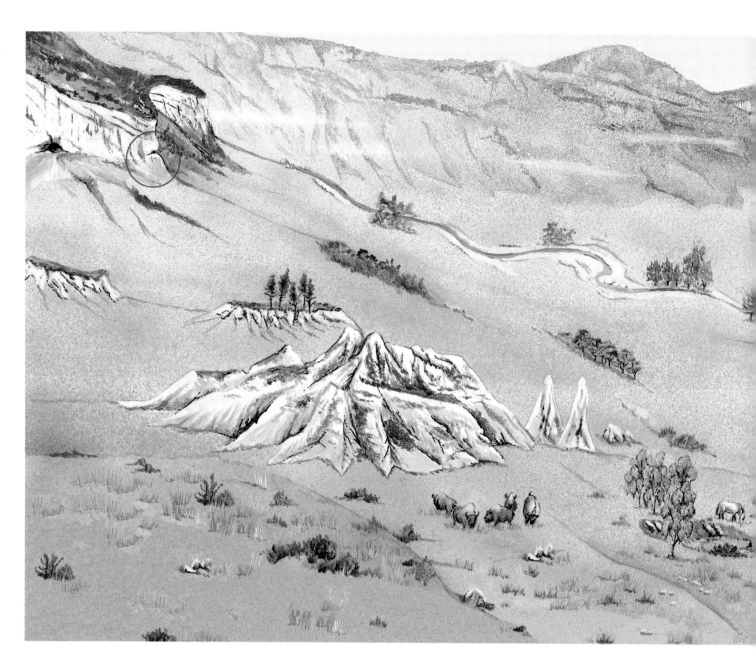

15. Reconstruction drawing of the countryside near the Cosquer cave as it looked to the people of the Upper Paleolithic. A key to the illustration appears on page 35

are tectonic movements, faults or reworking of faults, subsidence phenomena due to alluvial deposits, and perhaps orogeny and underwater volcanism.

For the Upper Pleistocene, specialists place the maximum for the Würm regression of the sea, which corresponds to the maximum cold, in the Late Würm (Würm III–IV), about 22,000 B.P., between the milder interstadials of Tursac (about 24,000 B.P.) and of Laugerie (about 20,000 B.P.). As for Phase Two at the Cosquer cave, it would have occurred at the end of the Laugerie interstadial and before that of Lascaux (about 17,000 B.P.), during a second period of increasing cold that began about 18,500 B.P. This agrees perfectly with the dates obtained at Cosquer for the animal paintings. As for the earlier period, Phase One, it occurred during an equally cold period, thus at a time when the sea was regressive, about 27,000–26,000 B.P., between the Kesselt interstadial (28,000 B.P.) and that of Tursac.

It is otherwise known that during the Aurignacian period, the sea was already very low. Thus, gravel and coastal sand discovered 360 feet (110 m) off the shore of Roussillon have been dated to 35,000 B.P. In the Gulf of Fréjus, in the Var, fossil beaches have been noted about 330 feet (100 m) down, marking a maximum lowering of sea level on the coast of Les Maures and of L'Estérel. This

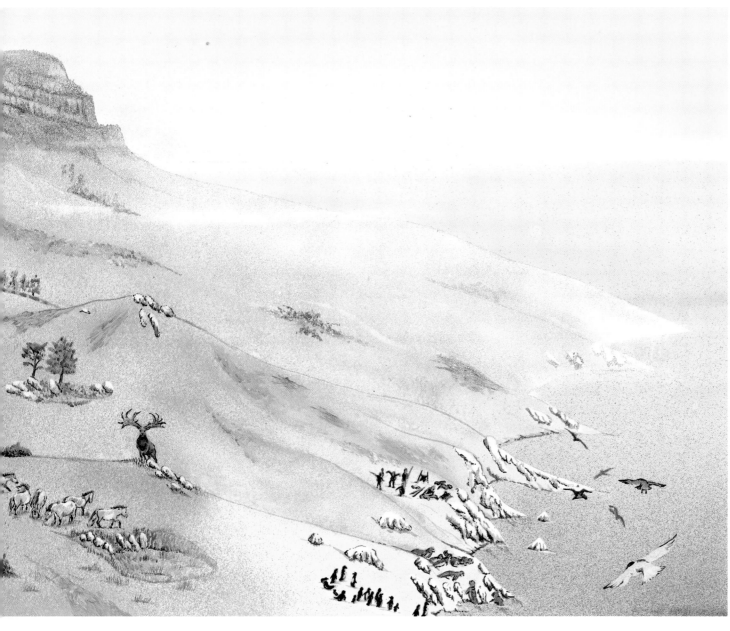

16. Monk seals

1. Entrance to the Cosquer cave
2. Cape Morgiou
3. Entrance to Le Figuier cave, today 100 feet below sea level
4. Morgiou River
5. Cape Canaille
6. Grove of alders
7. The present island of Jarre
8. The present island of Plane
9. Grove of Austrian pine
10. The present Imperial reefs
11. Grove of Scotch pine
12. The present island of Riou
13. Herd of European bison
14. Birch
15. Steppe vegetation: grasses, artemisia, and juniper bushes
16. Herd of Prjewalski's horses
17. Sinkhole
18. Megaloceros
19. Scotch pine and alder
20. Hunters cutting up and drying skins
21. Monk seals
22. Colony of great auks
23. Arctic tern
24. Shoreline

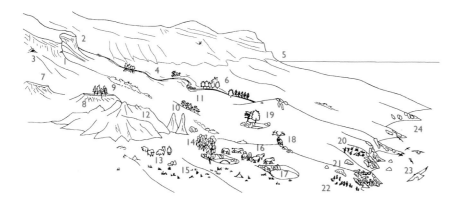

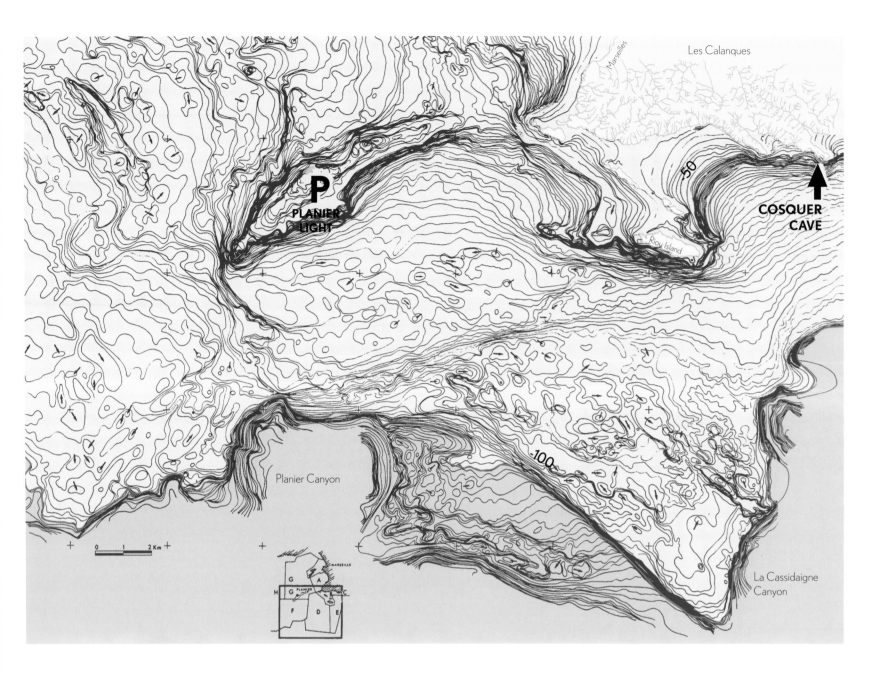

17. Modern marine survey chart of Les Calanques region. The topographic lines indicate depth below sea level. Yellow areas are dry land. Twenty thousand years ago, the coast was at the fault in the continental shelf (orange line), miles beyond the present shore

is confirmed by the remains of cold-water marine mollusks of the Nordic type gathered by dredging: *Cyprina islandica, Buccinum groenlandicum, Hyalina balthica,* and others. The quantity of oxygen (18:16) in these shells indicates for the northern Mediterranean of that time average temperatures that were very low: winter average 45°F (7°C) according to some, 39°F (4°C) around 24,000 B.P. according to other sources.[2]

Along the coast of Roussillon, the shore would have been located about 295 feet (90 m) lower around 18,300 B.P., which corresponds chronologically with the animal art (Phase Two) of the Cosquer cave.[3] This is confirmed by recent studies, still partially unpublished,[4] according to which the coast of Provence at the time of the maximum glaciation was situated even lower, about 395 to 425 feet (120 to 130 m) down, which coincides with the edge of the continental shelf (from the canyon south of Le Planier in the Marseilles harbor, to a steep slope south of Riou, to the canyon of La Cassidaigne in the Bay of Cassis)[5] (fig. 17). Thus, for the duration of Würm III–IV, the Cosquer cave was some 6 to 7 miles (10 to 12 km) away from the Pleistocene shoreline, situated then well to the south of Riou Island.

Off Cape Antibes, there are shoreline deposits with eroded shells marking an ancient bank. They have been located 330 feet (100 m) below this Paleolithic bank, dated to 14,000 B.P.[6]

Off the Roussillon coast, a Paleolithic bank located 280 feet (85 m) down has been dated to 13,500 B.P. Another bank, 230 feet (70 m) down, dates to 12,900 B.P. Finally, a third one, 200 feet (60 m) down, was dated to 10,500 B.P. There would then have occurred during the Preboreal (the first postglacial climatic period) a relative stabilization in the sea level at around 165 feet (50 m) below the present level, followed during the Boreal period by a rapid return to encroachment. A level measured at 100 feet (30 m) below the sea surface has been dated to 8,250 B.P. in the Gulf of Les-Saintes-Maries-de-la-Mer.[7]

At the end of the last glaciation, the rise of the sea during the Versilian transgression (also called Flandrian) seems to have come about in a relatively rapid way. If it took 40,000 years for the sea to go down 360 to 425 feet (110 to 130 m), it took less than 10,000 years for it to return to the present zero level. At the same time, the average water temperature rose steadily.

In the harbor of Marseilles, ancient submerged banks, fossilized when the sea rose again, have been observed at 330 feet, 295 feet, and 165 feet (100 m, 90 m, and 50 m) down.[8] Furthermore, these levels are to be found throughout the western Mediterranean. According to some researchers, there must also have been periods of rest at 80 feet (25 m) down during the Mesolithic and at 26 feet (8 m) down during the early Neolithic period, around 6,500 B.P. Finally, opinion agrees on dating the rise in sea level to present zero to the Iron Age, around 700 B.C. Thus, from the beginning of the Holocene period, the sea level has never stopped rising and has never been as high as at present. According to some geologists, it still continues to rise.

In any case, contrary to what has at times been said,[9] the sea along the Mediterranean coast has never during the Holocene "climbed in numerous places and at various times above its present level."[10] A rise, however slight, above current zero could only have been very local, a possible consequence of a recent neotectonic phenomenon. The discovery of the Cosquer cave allows certainty on this point and contradicts such interpretations. If the sea had risen higher than the current level, the large charcoal hearth and a number of other charcoal deposits would have been destroyed. The walls of the large chamber would show traces of corrosion above the current waterline, which is not the case.

Along the coast of the Marseilles region, made up for the most part of hard Urgonian limestone, variations in sea level have moreover left indelible traces, specific markers. These are the "sidewalks" of limestone algae (*Lithophylum tortuosum*) and the perforations caused by limestone-eating bivalves such as *Lithodomus lithophagus,* the "sea date," a delicious mollusk well-known to the gourmets of Marseilles.

Another consequence of the marine regression during the Würm is the presence, along with more ubiquitous species, of shells characteristic of northern seas, often used for personal adornment by the Cro-Magnon humans who lived in the caves at Menton. Contrary to a theory already old, according to which these mollusks came via long-distance trading with Paleolithic populations from the Atlantic world, the shells of these marine creatures (for example, *Buccinum undatum, Arctica islandica, Chlamys islandica,* and others) could in fact easily have been collected on the shoreline strip of the northern Mediterranean forecontinent, then above water.[11] These cold-sea species have long been observed furthermore from the dredging done in the Bay of Cassis and at Les-Saintes-Maries-de-la-Mer along the Paleolithic banks today situated 330 to 425 feet (100 to 130 m) underwater.[12]

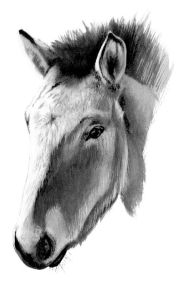

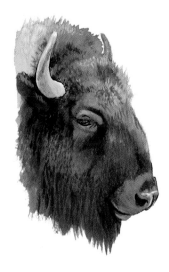

The Geographic Setting: Flora and Fauna

The study of climate change in Provence during the recent Würm has given rise to different interpretations, sometimes diverging according to the approach taken, related to sediments, fauna, or palynology. Furthermore, in southern Provence and in the Rhône region of Provence, sites from the early Upper Paleolithic (Aurignacian, Gravettian) are lacking (see fig. 21), which deprives researchers of indispensable stratigraphic data.

What seems certain, however, is that the Late Würm in Provence included two very cold phases, separated by a brief, relatively temperate interim period. The first phase, marked by deposits of clayey sand, would have been more humid and warmer than the second, which is characterized by cryoclastic gravel and by sand and aeolian silt, such as loess from the valley of the Durance River or the important deposits of gravel and aeolian sand from the Berre depression.

Whether 27,000 or 18,500 years ago, the hunters of Cape Morgiou lived in a universe that is very hard for us to imagine, since it was a cold Provence, a Provence devoid of fragrant scrubland and the songs of cicadas.

The hilly Les Calanques area, which rises more than 1,800 feet (564 m at Mont Puget, the massif northeast of the Morgiou inlet), was then covered with dense woods in the dark colors of Scotch pine and juniper,[13] sheltering numerous and varied fauna, such as ibex and chamois, forced by the glaciers to leave the high mountains, and bears and felines. At the foot of the mountain, in front of the caves where humans took shelter, extended a vast terrain of plains and low hills, grassy solitudes broken up by copses of Scotch pine. This forecontinent, with the coast situated 6 to 7 miles to the south and even farther away to the west and southwest,[14] was dotted by massifs such as Le Frioul, Planier, or Riou, which rises to 625 feet (190 m). It was then a vast grassy steppe with plants of the Compositae family (artemisia, chicory, *Anthemis*), broken up by small, wet depressions bordered by alder and birch, the fossilized pollen of which have been recovered in the Cosquer cave.[15]

According to Michel Girard, this plant landscape (grassy steppe, with artemisia and Gramineae, forestation of Scotch pine, alder, birch, and juniper) fits with a cold climate, the severity of which is emphasized by the birch and Scotch pine. For the moment, however, it is impossible to specify whether the pollen recovered from samples of the clay collected on the cave floor belong to Phase One or Phase Two. In fact, the countryside could have been more or less the same during both phases, since in Languedoc as in Liguria (evidence from the Mocchi shelter), post-Aurignacian levels have yielded almost identical floral evidence (cold steppe landscape) and at La Salpêtrière shelter near Rémoulins (Gard department) the levels dating between 22,000 and 18,000 B.P. have also supplied charcoal from Scotch pine and birch, and so permit the conclusion that a cold, dry climate existed throughout this long period.

On the steppes that then extended from Cape Morgiou to the hills of Riou and the Paleolithic shoreline, there grazed horses, bison, and aurochs, as well, no doubt, as saiga antelope (*Saiga tatarica*), known from the end of the Paleolithic in the Cornille shelter at Istres (Bouches-du-Rhône department), and which today survive only on a few desert steppes in central Asia, near the Caspian Sea and the Gobi Desert. The small, more humid valleys, wooded with deciduous trees, were populated by cervids: deer and megaloceros.[16] The aurochs must also have moved about the clearings and the more humid valleys.

Among the rocks along the shoreline, one could spot seals, discover penguin-like auks and other seabirds, and collect shellfish.

18. Horse, bison, and ibex are the most frequently depicted animals in Paleolithic art

19. The reindeer was one of the main animals hunted by Paleolithic people during the last glaciation, but it is not represented in the Cosquer cave. In fact, the reindeer and the mammoth were not among the Paleolithic fauna of Provence

For the various reasons mentioned above—the rarity of early Upper Paleolithic sites and ground unfavorable for the preservation of bones—we know only imperfectly the fauna that lived along the shores of Provence in the Late Würm. In Provence, that Arctic association of fauna called "classic," then well represented in the Dordogne, the animal trilogy of the cold—reindeer, mammoth, and woolly rhinoceros—seems to have existed only sporadically, rarely together, and above all marginally within the confines of the area being discussed. Thus, the reindeer, frequent in Languedoc and as far east as the caves and shelters of the Gard (La Salpêtrière), is extremely rare in the Vaucluse department and has never been reported in southern Provence, even during the height of the glaciation. There could perhaps have been some reindeer remains in the Var at Les Baumes-Rainaudes. Such remains have been identified in the Grimaldi caves, where they are not at all abundant. The same is true of the woolly rhinoceros and the mammoth, present as far east as the Gard, and also of the musk ox, present in the Dordogne but never discovered in Provence at sites from the Late Würm (fig. 19). This does not in any way permit the conclusion that it was less cold than elsewhere in the southern Mediterranean, since bison and saiga antelope have been found from Late Würm in the Cornille shelter at Istres, as well as marmot, hare, and blue fox at L'Adaouste cave in the Bouches-du-Rhône.[17]

Even more than the geographic obstacles that the Rhône and the Durance could have proved to be, paleontologists think that a climatic barrier in Provence, a climate drier than elsewhere,

stopped the large species that were wedded to the cold yet needed a substantial covering of vegetation to survive.

Given the rarity of data for the fauna during the Late Würm in southern Provence, the animal depictions in the Cosquer cave gain an increased importance because they demonstrate the association of very different species living in diversified environments. Thus, ibex and chamois, species that then inhabited the coastal massifs, may have been neighbors to deer and megaloceros, inhabitants of the hardwood forest and the grassy clearings. Infrequent, indeed extremely rare among bone remains found in southern habitats, the large cervid megaloceros, also called the "giant deer of the peat bogs," is represented several times, painted and engraved, on the walls of the cave. It was a powerful animal, over 5 feet (1.6 m) tall at the withers, and impressive, with antlers reaching or even exceeding 9 feet (3 m) in width.

The painted and engraved bison at Cosquer probably represent the bison of the steppes (*Bison priscus*), still present in Provence at the end of the Würm (Cornille shelter at Istres; Baume Goulon at Salernes in the Var, where it is accompanied by the megaloceros). The aurochs (*Bos primigenius*), more adaptable, survived into the postglaciation and its bones have been recovered from sites, for example, at Sénas on the Durance River, where it was the object of selective hunting during the Mesolithic and in the early Neolithic (Cardial at Fontbrégoua, about 7,000 B.P.). On the steppe there also lived horses, a species actively hunted in Provence during the Upper Paleolithic, as well as ibex. At La Bouverie and Les Baumes-Rainaudes in the Var, it is a large-sized horse akin to *Equus germanicus,* that is found in Upper Paleolithic layers.

On the other hand, in the Upper Paleolithic levels at Istres a small equid and an ass coexist. The horse is small in size, very sturdy, and, according to Marie-Françoise Bonifay, sufficiently different from the horse of Solutré to constitute a local race, *Equus gallicus minor,* well adapted to the often swampy plains of the lower Rhône. The wild ass, *Equus hydruntinus,* a species common in the southeast, would indicate less severe climate conditions. It is, however, associated with the reindeer at La Salpêtrière (layer 14a, Gravettian dated to 28,000 B.P.). In fact, its presence seems more closely linked to dry environments than to a possible warming. In the Cosquer cave it seems that horses and not asses are represented, with a dominant percentage that accords with the place occupied by this genus as much in the bestiary of Paleolithic art as among the fauna hunted in Provence in the Upper Paleolithic. In fact, the horse and the ibex were the game of choice for the Cro-Magnons of Provence, and here they held the place occupied by the reindeer in the rest of France as far south and east as Languedoc. In the Var, at Les Baumes-Rainaudes, around 20,000 B.P., it is the horse and the ibex that dominate, accompanied by deer and chamois, which then inhabited the rocks of L'Estérel and Le Tanneron.[18]

Even though little hunted by humans, and underrepresented in rock art, carnivores were numerous, which should not be surprising, given the number of herbivores available as food. Present in the gorges of the Gardon River—for example, at Baume-Latrone—the cave bear seems rare or absent in Upper Paleolithic Provence, while it has been reported at the Grimaldi caves. It is true that during the Late Würm this giant was becoming increasingly rare in western Europe. The brown bear, on the other hand, though its remains are seldom found in human habitats, was more common. It will be found up to the Neolithic (gorges of the Verdon River). Other predators took shelter in the rocky massifs: the cave hyena, the cave lion, the cave lynx, the wildcat, the wolf, and the panther. All these species have been found in the caves at Menton and so could have been found in Provence. In the Cosquer cave, the head of a feline painted in black evokes a lioness or a panther (see fig. 110).

The Chronological-Cultural Setting: The Upper Paleolithic Period in Provence

Given its profound and undeniably particular character, stressed for a long time and justly so by Max Escalon de Fonton and then by Gérard Onoratini, the Upper Paleolithic in Provence should not be identified with and, even less, confused with the cultures called "classic" in the Atlantic zone.

It is this singularity that has justified the creation of a regional terminology, linked to a concern for better specifying the origin and evolution of Upper Paleolithic cultures east of the Rhône.[19] In addition, the lower Rhône region of Provence is somewhat poor in Upper Paleolithic habitats (see fig. 21), perhaps because of violent erosion phenomena at the end of the glaciation, something which especially complicates the situation.[20] As for possible shoreline habitats, almost absent in the region being considered, it can be supposed—although it is an easy solution—that they are to be found today beneath the sea. We are far from possessing all the data to be wished for, and thus the necessity at times for extrapolation.

To this day, no site attributed to the Gravettian, nor for that matter to the Aurignacian, has been discovered in the Marseilles basin or in the neighboring region. Only some scanty evidence exists in the Vaucluse, while on the other side of the Rhône, the Aurignacian is well represented in Languedoc. The Gravettian, on the other hand, is relatively unknown there.[21]

This gap in the evidence for western Provence could be due only to inadequate research, since a coastal site discovered by chance at Carry-le-Rouet west of Marseilles, and still unpublished although excavated for several months in 1992, contains an important Upper Paleolithic sequence with early levels perhaps partly contemporary with at least one of the artistic phases of the Cosquer cave. However that may be, the Var sites are only about sixty miles away from the Cosquer cave, which is the equivalent of a three-to-four-day walk, at most.

In fact, farther to the east in Provence, the Aurignacian, the Perigordian, and the Late Perigordian or Gravettian cultures are known in the Var: at open-air sites in the Argens valley (sites of Les Gachettes near Les Arcs-sur-Argens and La Lieutenante at Puget-sur-Argens) and especially in the volcanic coastal massif of L'Estérel (sites of La Cabre and Le Gratadis at Agay, Le Maltemps at Saint-Raphael, L'Aille at Vidauban, the caves of La Bouverie at Roquebrune-sur-Argens and Les Baumes-Rainaudes at Le Muy; in the Alpes-Maritimes: at the sites of Baral at Mandelieu and Les Luchous at Cabris).[22]

Also situated in the Alpes-Maritimes, the little cave of La Baume Périgaud at Tourrette-Levens, excavated in 1950, furnished important material attributable to the Aurignacian (notably a dozen bone spearheads including one with a split base) as well as to the Gravettian, associated with the remains of very numerous ibex and marmots.[23]

The ensemble of these sites in eastern Provence ties in culturally with the Aurignacian and Gravettian sites of Italian Liguria, with which they display strong affinities. Unhappily, the acid soil of L'Estérel, formed mainly of rhyolites, did not allow preservation of fauna, with the exception of some remains of horse and ibex found at Les Baumes-Rainaudes. But it is known, thanks to excavations at La Baume Périgaud and especially at the caves at Menton, that in the area the fauna was cold-loving, including among others ibex (very abundant), chamois, and marmot. Reindeer, while very rare and unusual east of the Rhône, was identified at Menton and perhaps in L'Estérel as well as at La Baume Périgaud. In the coastal valleys there lived deer, roe deer, and aurochs as well.

As for the Solutrean culture, so abundant in the Ardèche, it is unknown in southeast France. It would be replaced in the lower valley of the Rhône by its homologue, the Salpêtrian,

0 5 cm

20. A Late Perigordian or Gravettian industry from eastern Provence: flint tools from layers 5–6 in the cave of La Bouverie (Roquebrune-sur-Argens, Var)

which, however, has never been found south of the site after which it is named, the large shelter of La Salpêtrière at Rémoulins. The Salpêtrian would take the place of the Late Solutrean and the Early Magdalenian.[24]

In central and eastern Provence, in place of the Solutrean one finds the Arenian, a culture of Italian origin contemporary with the Solutrean and the Early Magdalenian. Characterized by its unifacial points, always associated with numerous La Gravette points, the Arenian takes its name from the vast habitat in the cave of Les Arene Candide near Finale Ligure.[25] It is in fact abundantly represented in northern Italy, notably at the Grimaldi caves and as far as northern Tuscany.[26]

In eastern Provence, the Gravettian tradition remained very strong, and the prehistoric cultures underwent a development quite close to that of the Italian Upper Paleolithic, creating lithic industries rich in short end-scrapers and in small backed points.

At first called Proto-Romanellian and Romanellian after the Romanelli cave in southern Italy, the cultures that followed the Arenian at present bear the names Proto-Bouverian and Bouverian, the most representative being the caves of La Bouverie at Roquebrune-sur-Argens near Fréjus[27] (fig. 20). The Bouverian industry includes La Gravette points and very abundant microgravettes, shouldered points with abrupt retouch, and short end-scrapers, which became more and more abundant as the Bouverian evolved. Bone or antler tools are on the other hand nonexistent, which is the case for almost all the Upper Paleolithic of Provence, with only very rare exceptions. Culturally, the Bouverian can be placed in parallel with the Epigravettian of Italian prehistorians. Chronologically, it would be contemporary with Middle and Late Magdalenian.

In the Provence of the Rhône and the Durance (departments of Bouches-du-Rhône, Vaucluse, Alpes-de-Haute-Provence), it is rather a classic Magdalenian that is present in some natural shelters or at open-air sites. In some unusual sites, as for example the cave of L'Adaouste at Jouques,[28] a bone industry unusual in Provence has been discovered: needles with eyes, spears, and harpoons with one row of barbs. Some rare harpoons exist as well in Vaucluse (Chinchon shelter, Saumanes), but it must be recognized that the Magdalenian of Provence is as a general rule singularly poor in objects of bone or antler. As for portable art, so brilliantly represented elsewhere, it is total-

21. Upper Paleolithic sites in south-eastern France and Liguria, Italy, mentioned in the text

1. Cosquer cave (Marseilles, Bouches-du-Rhône)
2. Le Rouet shelter (Carry-le-Rouet, Bouches-du-Rhône)
3. Cornille shelter (Istres, Bouches-du-Rhône)
4. La Salpêtrière shelter (Rémoulins, Gard)
5. Baume-Latrone cave (Russan-Sainte-Anastasie, Gard)
6. Caves of the Ardèche River gorge (Saint-Martin, Bidon, Vallon-Pont-d'Arc; Ardèche)
7. Chinchon shelter (Saumanes, Vaucluse)
8. L'Adaouste cave (Jouques, Bouches-du-Rhône)
9. Sites in the Argens River valley (Les Arcs, Vidauban, Puget-sur-Argens; Var)
10. Caves of La Bouverie (Roquebrune-sur-Argens, Var)
11. Caves of Les Baumes-Rainaudes (Le Muy, Var)
12. Site of La Cabre (Agay, Var)
13. Site of Le Gratadis (Agay, Var)
14. Site of Baral (Mandelieu, Alpes-Maritimes)
15. Baume Périgaud (Tourrette-Levens, Alpes-Maritimes)
16. Caves of Menton or Grimaldi, also called I Balzi Rossi (Italy)
17. Cave of Les Arene Candide (Finale Ligure, Italy)

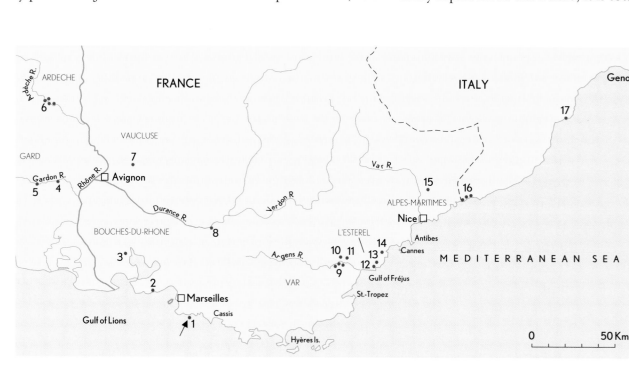

ly unknown here except for a spear fragment from L'Adaouste bearing incisions. It is thus under the aspect of a very impoverished culture that the Magdalenian of the southeast presents itself. That is perhaps due to particular conditions of the environment, very different from the southwest in the same era. Deprived of reindeer, their favorite game, and having become by force of events hunters of ibex, the Magdalenians of Provence, cut off from their sources, changed progressively and developed quite different Postpaleolithic cultures: Azilian in the Vaucluse and Valorguian in southern Provence. Beginning in 12,000 B.P., as the environment changed with a warming climate, the end of the world of the great hunters was approaching inexorably.

Given the present state of knowledge, however, it would be in vain and in any case premature to claim to establish a strict parallel between the art of the Cosquer cave and this or that culture of the Upper Paleolithic in Provence. At most, one can allow that Phase One is contemporary with the Gravettian as the dates obtained indicate, as well as culturally near it, if one considers the painted hand stencils with incomplete fingers, which resemble those discovered at Gargas cave (see Chapter 4).

As for Phase Two, also well dated at present, it corresponds chronologically and stylistically with the Late Solutrean of the Ardèche. Can it be related, given the absence of the Solutrean in Provence, to one of its regional homologues, the Salpêtrian or even the Arenian, though they themselves are absent from southern Provence?

Objectively, we can go no further without one day having the luck to discover in the vast submerged caves near Cape Morgiou, Upper Paleolithic levels preserved by calcite. But that, Rudyard Kipling would have said, is another story—or rather, another story for prehistory.

The People

Who were these people, the first to go deep inside the Cosquer cave? What were they like? How were they dressed? So many questions, so many puzzles.

Certainly, we can only regret that in addition to the diverse depictions and signs they did not leave us their self-portraits. Human representations, always rare in Quaternary art, are here totally absent, except for the rather schematic silhouette of the Killed Man (see Chapter 8), which is not a great help in reconstructing the physical appearance of the people of Provence toward the end of the glacial era.

No Upper Paleolithic site in Provence has to this day yielded any burial place or even any isolated human remains. But a little farther east, on the Italian Riviera, a number of skeletons were discovered at the end of the nineteenth century and at the beginning of the twentieth in the famous caves at Menton, on the French-Italian border.

Often called the caves of Grimaldi, Baoussé-Roussé, or Balzi Rossi, this famous group of coastal caverns includes Les Enfants cave, the Lorenzi shelter, the Florestan cave (excavated from 1846 by Florestan I, prince of Monaco, alas with the methods, or rather the absence of methods, of the time), the Mocchi shelter, Le Cavillon cave, the Barma Granda, the Barma da Baousso da Torre (today destroyed), the cave of the Prince, and two other shelters that contained no trace of human occupation.

These caverns long ago yielded a remarkable anthropological series made up of a dozen skeletons, of which nine were in an excellent state of preservation. The remains are of individuals

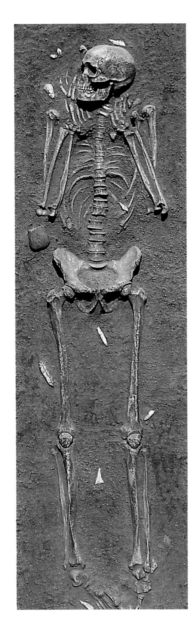

22. Cave of the Children, Grimaldi caves (Liguria, Italy): Masculine burial in Level H (Gravettian). These remains are those of an adult 74 inches (1.88 m) tall. He was buried on his back, head turned to the right, arms bent up at chest level

belonging to the classic Cro-Magnon type and, despite stratigraphic uncertainties inherent in excavation conditions back then, specialists agree, at least most of them, to place them in an early phase of the Upper Paleolithic, in the Gravettian or Epigravettian.[29] They would thus be more or less contemporary with the first works in the Cosquer cave, those of Phase One, the finger tracings and the hand stencils (see Chapter 4). As for Phase Two, that of the painted and engraved animals, chronologically and culturally close to the Upper Solutrean of the Ardèche, there are no known contemporary skeletons in the neighboring region. The only one would be the Solutrean child from Le Figuier cave (Ardèche), very badly preserved. In fact, the people of the Solutrean are almost unknown, with the exception of some isolated remains: the child found in the Labattut shelter in the Dordogne and the child at Le Figuier. All that can be said is that they were certainly modern humans (*Homo sapiens sapiens*) of the Cro-Magnon type; that is, people quite similar to us, although better built, much more sturdy, and without a doubt psychologically better adjusted.

It was in 1872 that Emile Rivière discovered in Le Cavillon cave the skeleton that would become famous as the Man of Menton. Only four years earlier, in 1868, the Old Man of Cro-Magnon had been discovered at Les Eyzies in the Dordogne.

The Man of Menton, a young male about eighteen years old and 69 inches (1.75 m) tall, had been buried with rich ornaments. On his skull were 200 nassa shells (*Cyclonassa neritea*) and 22 deer teeth (atrophied canines), which originally must have been sewn onto a bonnet or a net. He also wore leggings made of pierced nassa shells (*Cyclonassa*) and had been given two large flint blades and a "dagger" nearly 7 inches (17 cm) long made from the radius of a deer.

In 1873, in the cave of Baousso da Torre, Rivière discovered two adults and a child about fifteen years old. The child had been buried without any adornment, but the man, about 71 inches (1.8 m) tall, wore a net of nassa shells and shell bracelets at the elbows and wrists. The skeleton of the woman also bore numerous shell and deer-teeth ornaments: a necklace, bracelets at wrists and elbows, and leggings.

In a nearby cave, since named the Cave of the Children, Rivière was to unearth the moving remains of two young children, the one aged three to five years and the other two to three years, buried side by side. They wore neither necklaces nor bracelets, but they must have been dressed in loincloths decorated with hundreds of nassa shells sewn on a skin that covered the pelvis and the upper part of the thighs.

The same cave held the body of a relatively old woman buried tightly entwined with a young man wearing a shell net (see fig. 189). In spite of their claimed "negroid" characteristics, an interpretation due, in fact, to a faulty first reconstruction of the skulls, these skeletons have since been recognized as typical Cro-Magnons and are dated to Perigordian V (c. 25,000 B.P.).

From 1884 to 1894, five other skeletons were found in Barma Granda. These included a man 74 inches (1.88 m) tall, also richly attired in shells and deer teeth (fig. 22), and a young woman and an adolescent. These Cro-Magnons were tall in stature. The average was 71 inches (1.8 m) for men—some of them surpassing 6 feet (Barma Granda I, Cave of the Children)—and 65 inches (1.66 m) for women. In comparison, the Cro-Magnons from the original site at Les Eyzies measured about 71 inches (1.8 m) for the Old Man and 65 inches (1.66 m) for the woman.

Anthropologists have also emphasized the great sturdiness of the Grimaldi men. Their muscular insertions indicate remarkable vigor and power. Their lower limbs were more developed than their upper limbs, the shin longer than the thigh, a characteristic in keeping with their way of life. As these great hunters endlessly covered a very diversified area with contrasting topography, it is

not astonishing that the morphology of their skeletons exhibits a perfect adaptation to walking in hilly terrain.

Hunters of large game, they were also "men of the coast," enjoying fish and shellfish from which they also chose in abundance their body ornaments. Their unusual cranial capacity (the man from Barma Granda had a cranial capacity of 2,000 cubic centimeters), the care they took of their dead, their pronounced taste for ornament, and their portable art—the little female statuettes in steatite called the Venuses of Grimaldi—point to an elaborate and complex mental life.

It was probably people of this type who were the first to risk venturing to the back of the cave at Cape Morgiou to take possession of it and leave their finger tracings and handprints 27,000–28,000 years ago. They would be followed there a few thousand years later by other people, just as adventurous, who in their turn would mark their passage, but this time by drawing on the walls of the cave the animals that were part of their daily universe (fig. 23) as well as geometric signs carrying a message the mystery of which remains inviolate.

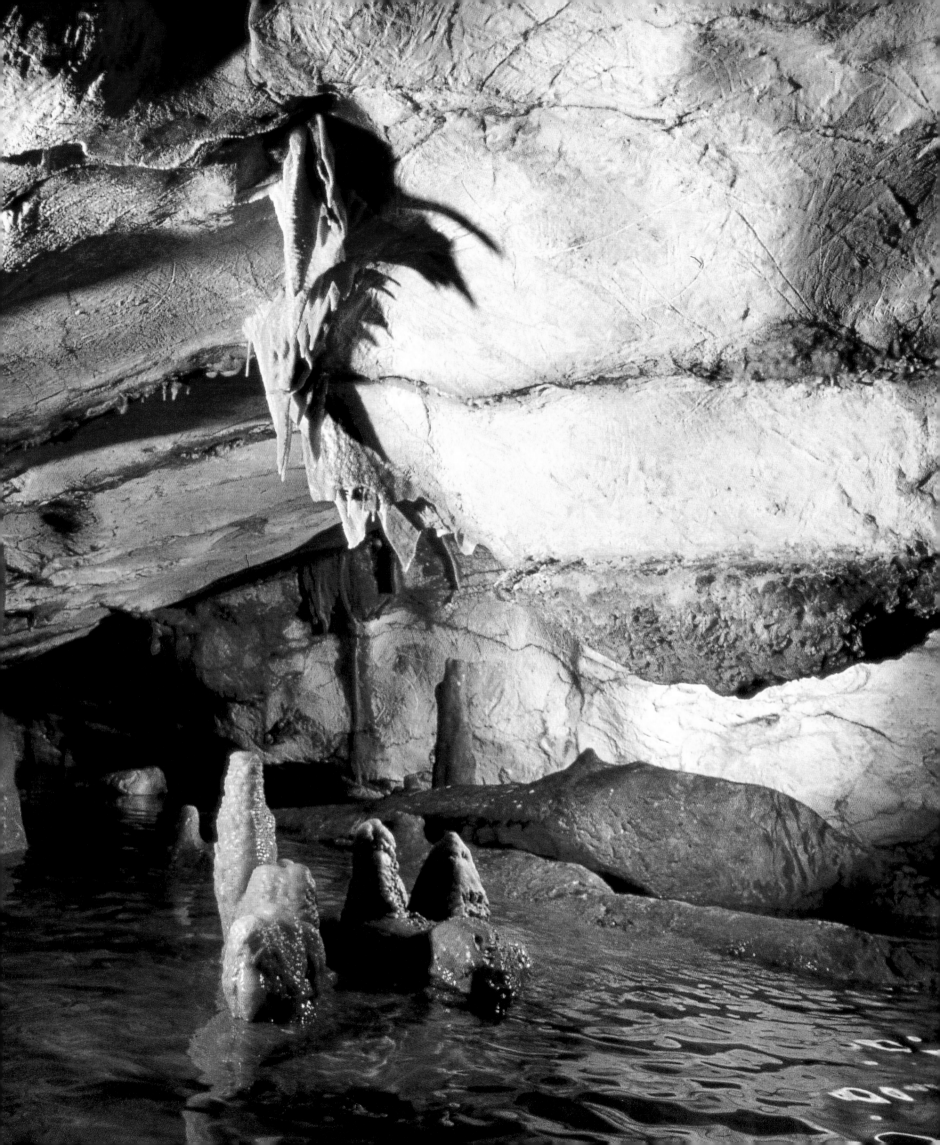

3. Description of the Cave

Of all the numerous submarine caves known in the coves around Marseilles and Cassis, the Cosquer cave is certainly the most vast. Some underwater networks, such as that of Le Bestouan at the entrance to the port of Cassis, or that at the outflow of Port-Miou in the cove of the same name have been explored over several miles and do not contain chambers as impressive as those in the painted cave at Cape Morgiou.

The underwater cavern known today around the world as the Henri Cosquer cave is situated in the commune of Marseilles (and not in that of Cassis as has so often been written in the press), at the southwest tip of Cape Morgiou, 5 miles south of Marseilles. It opens to the southwest of Pointe de la Voile, 100 feet out from the cliff at the foot of a small drop about 32 feet high, at a depth of 120 feet. In front of it extends a slightly sloping, flat expanse strewn with rocks that spreads out at a depth of 137 feet and beyond. In the Paleolithic, then, access to the cave was easy (fig. 24).

The entrance, narrow and low, measures only 4 feet (1.3 m) maximum height over more

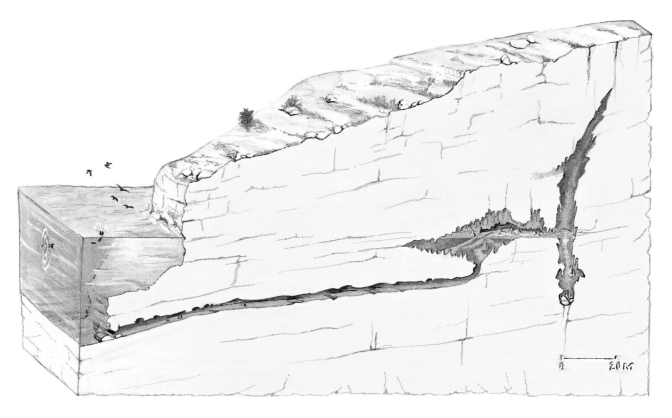

23. Opposite: The panel of horses (Chv 1–4) is visible at the bottom of the photograph, slightly to the left, in its overall setting. On the upper walls a frieze of engraved animals, including ibex, chamois, and seal, can be made out

24. Left: The Cosquer cave seen in cross section

than 10 feet (3 m) of total width, but in fact, the width of the passage is little more than 3 feet. This opening is not very noticeable because there are several others similar in appearance at the foot of the same drop. In addition, it is half hidden on the right by a considerable rock fall made up of enormous blocks. It is not certain that during the Paleolithic the entrance was as low as at present. In fact, when the locked grill was put in place, the metal piles hit bedrock under 3 feet of sandy sediment. Thus, at the time the cave was in use, an entry of modest dimensions allowed one to stand upright.

Past this narrowing, the ceiling rises rapidly and the corridor that follows measures between 6½ and 10 feet (2 and 3 m) high, with its width varying from 6½ to 10 feet (2 and 3 m), on average. The ground is at first muddy and sandy; then, a few yards from the entrance, there are stalagmitic floors that may seal over archaeological deposits. The passageway faces north. At first oriented 15 degrees north, it turns after about 130 feet toward the northeast, returning north after another 100 feet. This underwater gallery rises rapidly and regularly, apparently following the slope of the strata (about 30 degrees). More than 260 feet (80 m) from the entrance, at a depth of 46 feet (14 m), a rocky sill formed of fissured blocks (a collapsed stratum?) reduces its height considerably. This narrow passage, about 50 feet (16 m) long, measures less than 3 feet high, its ceiling formed by the structural surface of the stratum. The ground here is covered with a very fine colloidal clay that the divers passing through inevitably put into suspension, blocking all visibility. Because of this, it is vitally necessary to follow a safety line without letting go. The gallery itself measures 390 feet (120 m) long; in all, the underwater distance totals 490 feet (150 m).

One then reaches submerged chambers with enormous stalagmitic pillars towering up. The ground is everywhere covered with a layer of clay or fine silt. The walls and ceilings of the corridor are covered with sponges (Spongia), with worms with limestone tubes (Serpulidae), and with Bryozoa. This fauna thins out quickly as one moves through the pitch black. In the submerged chambers there are only limestone tubes of dead Serpulidae on the rock. In the entrance gallery, the rock is often covered with black deposits of iron and manganese oxides, usual in dark areas of underwater cavities. These oxide crusts are absent in the underwater sections of the large chamber and in the large shaft at the end where the rock is covered with limestone tubes.[1] Even without the destructive action of saline corrosion, these organisms would have been enough to mask engravings that might have been preserved on the submerged walls. We have seen, however, that the calcited finger tracings did survive at times below the water, and Jean Vacelet found some engraved lines on a large stalagmitic pillar.

As for unattached fauna, they are very few; a number of small crayfish (Palinurus vulgaris), a large lobster (Homarus gammarus), some galathea (Galatea strigiosa), as well as some fish of the genus Anthias, familiar denizens of underwater caves, usually in the first yards near the entrance. In the deep part of the passage and the submerged zones of the large chamber, we came across only rare holothurians, an ophiuran, and some small crustaceans, species already identified in dark underwater caves, as well as a small fish, Grammonus ater, a classic inhabitant of these same environments.[2] We have already mentioned the sea-spider remains found near the small northwestern shaft and the grouper bones discovered in the large shaft at the northeastern end of Chamber 2.

When one finally emerges into the part of the cavern above water, one finds oneself in a vast chamber the ceiling of which, formed by a limestone stratum, slopes steeply to the south, about 30 degrees. This chamber measures 230 feet (70 m) along its east-west axis, 180 feet (55 m) along the north-south. But occasional surveys carried out by Bernard Van Espen in the submerged sections show that at the southwest extremity, for example, the ceiling sinks underwater keeping the same

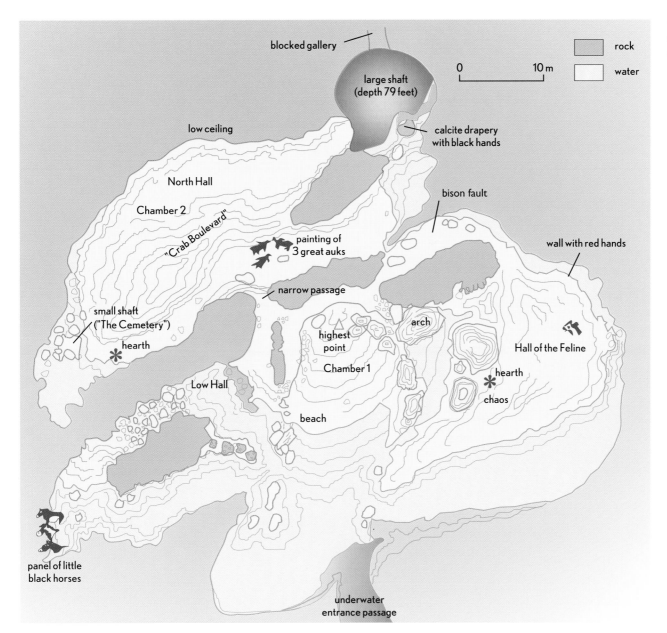

25. Map of the Cosquer cave showing the main topographical features in the unsubmerged sections (mapped by Luc Long)

blocked gallery

large shaft (depth 79 feet)

rock

water

0 10 m

low ceiling

calcite drapery with black hands

North Hall

Chamber 2

bison fault

"Crab Boulevard"

wall with red hands

painting of 3 great auks

narrow passage

small shaft ("The Cemetery")

arch

hearth

highest point

Hall of the Feline

Chamber 1

hearth

Low Hall

chaos

beach

panel of little black horses

underwater entrance passage

slope to a depth of 40 feet (12 m) over an expanse 115 feet (35 m) long (June 13, 1992, dive). On the other hand, there does not seem to exist any continuation beyond the restricted passage near the small painted horses. In the southeastern part of the chamber, the ceiling also slopes downward to a depth of 33 to 40 feet (10 to 12 m), enlarging the present size of the cave considerably. Thus, one can imagine in the beginning a chamber measuring close to 330 feet (100 m) on its long axis (fig. 25).

The southwest part of the large chamber (Chamber 1) includes an area where the ground is made of calcite-covered floors and small pools with calcited edges located under 12 to 40 inches (0.3 to 1.2 m) of water. This section is divided up by sizable stalagmitic masses, often fissured by the action of salinity. Some have sunk in response to drainage phenomena or to small seismic shocks[3] (fig. 26). These concretions have developed especially along the edges of the arrival "beach," which is, in fact, a sharply sloping stalagmitic floor that takes up all that part of the chamber above water and continues underwater at a steep pitch in the south and southeastern sections.

This floor seems to cover a chaos of voluminous blocks resulting from an ancient collapse of a stratum. In the eastern part of the chamber, furthermore, one must climb a pile of blocks sealed

26. Overleaf: The Cosquer cave contains many very beautiful stalagmitic concretions

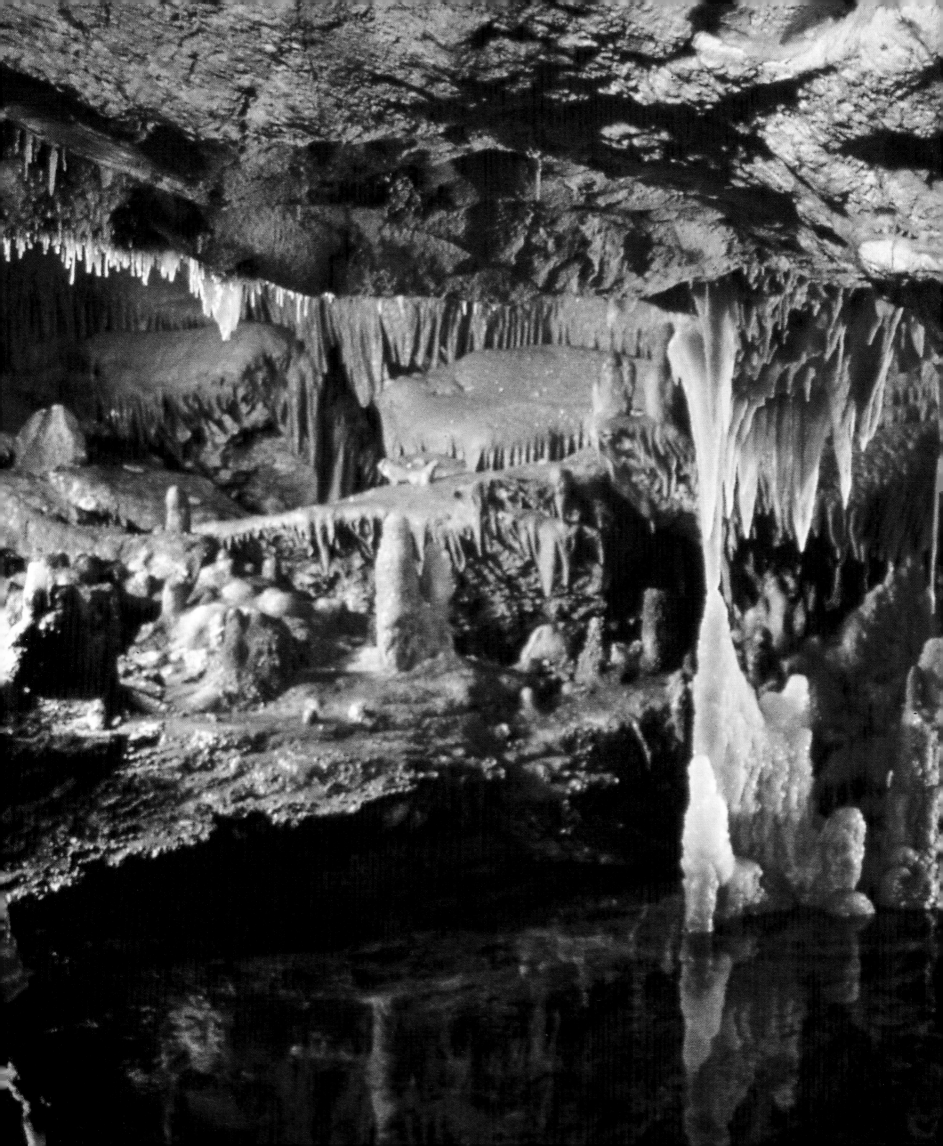

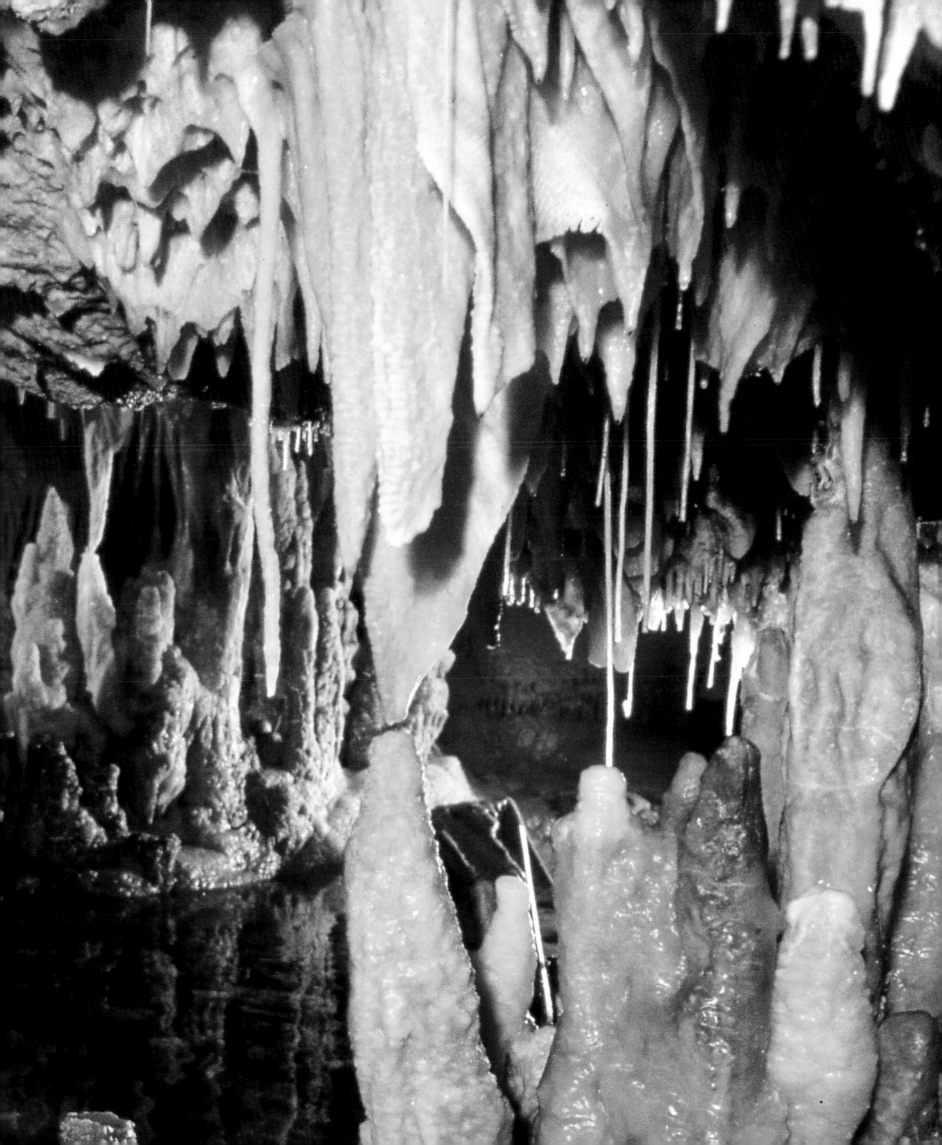

27. A number of animals and signs have been drawn on low ceilings. Here in the northern part of the cave, an indeterminate animal (I1) has been painted on a ceiling that is also covered with engravings, near a large megaloceros painted in black (Mé1)

by deposits of calcite. In places this chaos almost reaches the ceiling, where paintings are visible (head of a feline, head of a horse) and quite numerous engravings and finger tracings (see fig. 25).

The ceiling of Chamber 1 reaches 16 to 20 feet (5 to 6 m); at the highest point it is only 10 feet (3 m) from the ground because of the steep rise of the calcited floor and the chaos of blocks. From this first chamber one reaches Chamber 2 through either of two narrow passages, one to the northeast along the wall with the painted bison, the other to the north above a calcite layer. The latter is a porthole 3 feet (0.9 m) in diameter, which opens directly into the middle of Chamber 2, or Crab Boulevard, oriented from southwest to northeast. Across from this passage, several panels of engravings, notably horses, can be seen on the ceiling as well as the three auks painted in black. It is possible that this passage was marked by a stalagmite circled in black near its base (see fig. 152), visible on the left after crossing the narrow entrance.

The ground in this part of the cave, as elsewhere, is covered with amber streams of very hard calcite. To the southwest, the ceiling reaches the water. An engraved deer (C5) is located at the waterline, the ground here being about 3 feet underwater. A small, very narrow shaft, less than 31 inches (0.8 m) in diameter, has been explored to a depth of 26 feet (8 m) by Henri Cosquer and Jean Delafosse (SERMAR), who could go no deeper because of an ever-increasing narrowing. This pothole continues, however, and must communicate with another submarine cavity, as indicated by a colder current of water and by the presence of sea spiders crawling all along the passageway.

Chamber 2 is cut across its long axis by a rise in the ground, a chaos of rocks that reduces its height to about 3 feet in the entire northern part—for example, in the area of the painted megaloceros (Mé1; fig. 27). Beyond that, to the north, narrow passages blocked by stalactites open up. They were not explored because of the lack of time.

To the northeast, the network of spaces ends at the large shaft, a sinkhole 33 feet (10 m) in diameter under 79 feet (24 m) of water. The bottom, explored by diving, is filled with shattered blocks and stalagmitic pillars; it is also very muddy. The shaft descends almost vertically for 56 feet (17 m), then obliquely to 79 feet (24 m). Above the water, the shaft continues up to an imposing bell-shaped dome that rises to 148 feet (45 m). In both the upper and the underwater sections, the walls of the shaft display exuberant concretions, calcite draperies that can be seen all the way to the bottom of the shaft. The entrance to a narrow gallery, nearly entirely blocked by silt, has been noticed on the north wall, nearly at the bottom of the shaft.

An examination of the organisms attached to the walls, empty Serpulidae tubes, indicates an isolated environment with stagnant water or an intermittent influx of fresh water.[4]

28. Jean Courtin kneels beside one of two small hearths preserved on the calcite-covered floor of the cave. Containing charcoal from Scotch pine, such fires were intended to provide light and belong to Phase Two

The Distribution of the Works of Art

Given the extent of the submerged sections of the cave, it might seem misleading to attempt a precise study of the distribution of the works of art. We are, in fact, very certainly deprived of a great many paintings and engravings destroyed by being submerged. We had hoped at first to find underwater engravings that had been preserved by having been incised more deeply than others. But over the millennia, corrosion and sea organisms have done their work. However, at shallow depths and at some rare points—the southwest section of Chamber 1, for example—finger tracings were observed beneath the water, preserved by a film of calcite. Similarly, at the base of a panel of painted horses (Chv1 to Chv4), some engraved lines continue beneath the surface. But these are very unusual.

The distribution of paintings and engravings in the areas above water does not seem to obey strict rules, except perhaps for the hand stencils grouped around the large shaft and along the east wall of the large chamber (see Chapter 4). The finger tracings are present everywhere that the limestone is soft from weathering, at every level of the walls and ceilings.

The painted animals seem at first sight more numerous in the southwest section, with the panel of horses and the ceiling of the low chamber bearing a deer (C1), an ibex (Bq1), and others; then to a lesser degree, on the northeast wall, with the bison fault. However, it is possible that in the beginning the northwest wall bore more paintings, as is indicated by black or truncated lines (horns?) at several points on the bison fault. Done in charcoal, these paintings have not always resisted the streams of humidity. As for the three auks drawn on the ceiling facing the narrow opening into Chamber 2, for what reason were they represented at this precise place?

The engravings do not seem to have been given preferential locations (see Chapter 5); walls, ceilings, and outcroppings from the ceiling have all been used at human height, but ceilings high enough to require ladders or scaffolding have also been used at times—for example, the bovid engraved at the highest point of the large chamber (Bi9), 10 feet from the ground. Other figures have been depicted on low ceilings, as for example the bison Bi6 and Bi10 in Chamber 2, situated a yard from the ground. In the eastern part of Chamber 1, a horse's head (Chv26) has even been engraved on the ground (see figs. 54 and 73).

The Archaeological Context

Access having been sealed by the postglacial encroachment of the sea, the Cosquer cave offers the rare advantage of not having been entered during the Holocene; thus, precious archaeological testimony remains intact on ground undisturbed by either hunter-gatherers of the Postpaleolithic or by farmer-herders of the Neolithic or the Bronze Age.

The most abundant vestiges of human presence in the cave are pieces of charcoal, in a very variable state of preservation. Their quantity struck us from our first visit. These charcoal pieces, often sizable and at times coated with calcite, are scattered on the surface and in the irregularities of the ground, as much in Chamber 1 as in the north section of the cave. There are none in the Low Hall where the deer C1, the ibex Bq1, and the horses Chv7, Chv8, and Chv17 are to be found painted on the ceiling, because the calcite-covered ground slopes slightly here and must have undergone a leaching process. However, at the far end of this chamber, the calcite streams are colored by charcoal, a frequent occurrence in the cave, notably in the area of the narrow passage to Chamber 2.

Charcoal is abundant in the eastern area of Chamber 1, in the faults and at the top of the blocks near the feline head and at the foot of the wall of bison and of the wall of the red hands. It is just as plentiful in Chamber 2, and there is as much around the great shaft as beneath the low ceiling where the megaloceros Mé1 and the bison Bi6 and Bi10 are represented. Although fragile because saturated with moisture, it could be collected without difficulty and become the object of specific identification (Scotch pine). Certain pieces, fragments of torches, were an inch or two long.

The presence of charcoal or of charred traces on top of the broken stalagmitic pillars has already been mentioned. One of these "fixed sources of light" is located beneath the engraved seals Ph1 and Ph2 (see fig. 135); another, 45 feet (15 m) to the southwest, beneath the auks. A third marks Chamber 2 at its southwestern extremity near the small submerged shaft, 66 feet (20 m) from the sec-

ond one. This strengthens the hypothesis of an organized lighting system, as suggested by Michel Girard and Jacques Collina-Girard.

On the other hand, calcite-covered piles of charcoal on the ground or in small depressions beneath the large drapery of black hands at the edge of the large shaft or beneath the wall of bison could represent pigment residues from making the paintings.

Pieces of charcoal are covered in calcite beneath the water, often in small calcited pools, in the southwest area near the panel of horses Chv1 to Chv4, Chv5, and Chv6 and beneath the engraved ibex Bq16 to Bq18 (see fig. 56), as well as in the central area of Chamber 1 north of the hearth in a flooded fault near the "arch."

Besides the circular hearth, 20 inches (0.5 m) in diameter, preserved on a flat spot 3 feet above the water in the eastern part of the large chamber (fig. 28), some smaller hearths about 10 and

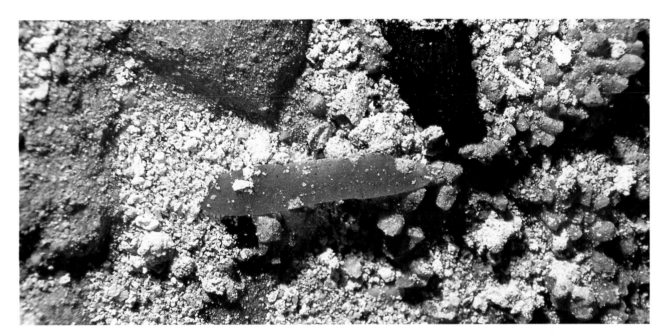

29. This flint blade is one of six discovered in the cave, tools abandoned or lost by the Paleolithic artists. This blade is of light chalcedony (see fig. 30, no. 2)

12 inches (0.25 m and 0.3 m) in diameter exist in the west and central areas of Chamber 2. Nowhere is the rock reddened, so these were probably small, short-lived fires built for lighting. At several points in Chamber 2, torch smudges stain stalagmitic pillars: at the end of the narrow passage leading into Chamber 2, at the far ends, in the low section to the north, and at the edges of the large shaft.

Lithic Material

With the exception of six pieces of flint discovered in June 1992 (figs. 29 and 30), no pebble, no plaquette, no other fragment of rock foreign to the geological context, Urgonian limestone, has to this day been found in the cave, but neither the numerous crevices in the areas above water nor, obviously, the submerged areas could be examined exhaustively and so they may still hold surprises.

By chance alone we found some flint objects: a small bladelet under 40 inches of water at the foot of the panel of black horses (Chv1 to Chv4; fig. 30, no. 4), the other artifacts on the ground itself or in crevices. Thus, the blade with unworked back (no. 1) found by Jacques Collina-Girard was covered in calcite on the ground at the western end of Chamber 2, not far from the chalcedony blade

The Tools in the Cosquer Cave

1. Asymmetric blade with unworked back; fine-grained gray flint; length 6 cm, maximum width 13 mm; polished by use on the right side.

2. Wrongly identified on site as a burin. It is a small blade of light chalcedony, 56 mm long, 10 mm wide; polished on the right end tip.

3. End fragment of a large blade (broken from use, from impact?) of zoned gray flint with traces of cortex. Length of fragment 26 mm, width 29 mm. Retouched all along the two edges; only the right side shows polish from use.

4. Blade of reddish flint, discovered underwater; length 29 mm, width 12 mm; no sign of use.

5. Large blade of zoned flint; length 11.1 cm, width 37 mm. When discovered, it was stained with clay and charcoal. It shows signs of use on both sides, but only on the lower halves.

6. Crested blade of reddish zoned flint; length 9 cm, width 15 mm. The right cutting edge displays a polish indicating that this tool "was probably used to cut skins or tough meat tissue."[5]

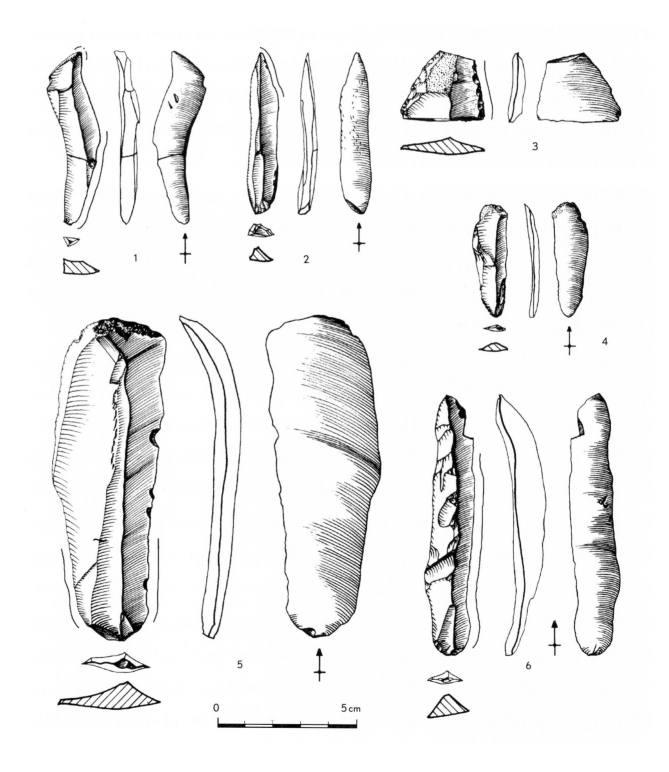

0 5 cm

30. The flint blades found in the Cosquer cave

(no. 2) collected with the five other artifacts by Jean Courtin, among the scattered pieces of charcoal. The end fragment of a large blade (no. 3) was also found on the ground of Chamber 2.

A large blade, no. 5, the longest found, was placed (intentionally?) under a stone on a flat area rich in charcoal, beneath the feline head in the east section of the large chamber. Not far from it, a ridged blade, no. 6, was visible in a fissure between two blocks of rock.

Since the cave was not suitable as a habitat, given its topographical configuration, a fact confirmed by the total absence of bone fragments and waste from knapping, we were hoping to find there some of the tools used in creating a part of the engravings or, at least, some scrapings. And so these tools, wrapped with care and spared any cleaning, were entrusted for trace studies to Hugues Plisson at the Center for Archaeological Studies of CNRS at Valbonne. Great was our disappointment when this specialist, after microscopic inspections, could not uncover "any trace that can be attributed to action on a mineral material, such as grooving the surface of a wall or scraping ocher. The only clear usage is related to soft material, probably meat."[6]

However, given that the limestone of the cave is considerably softened by weathering, Plisson considers it possible that these tools "have been used in executing some engraved motif, without, however, clearly being marked by contact with material that soft." Tests of the limestone in the cave itself will be necessary before any unqualified conclusion can be drawn.

In spite of the disappointing results of these first microscopic analyses, it is not impossible that the artifacts, in spite of everything, were used to engrave or to scrape the weathered limestone, transformed into a chalky paste too soft to produce any wear whatsoever on the edges of flint blades that were otherwise used by their owners to cure skins or to cut meat outside the cave.

None of these objects allows precise attribution to a particular culture. They are atypical products of mediocre blade-working. As for the original siliceous material used, four flints of different coloring and texture, it may perhaps be possible to situate them geologically and localize the flint deposits. The blade of light chalcedony (no. 2) could come from the range of La Nerthe west of Marseilles, where deposits of highly colored flint from the Tertiary period are known to occur near the village of Saint-Julien-des-Martigues. The other blades do not correspond on first examination to varieties of flint found in southern Provence. But we must not underestimate the importance of the now submerged forecontinent, where people of the Upper Paleolithic could stock up from various types of flint deposits.

One thing is certain: these blades were not knapped in the cave, where no flint chips have been discovered. The traces of wear observed by Plisson, indicating butchering cuts, do not imply that these activities took place in the cave. In that case, in fact, we would have found the remains of large fauna. It may seem surprising that simple knives for carving then served to make engravings in a place that from all evidence was a sanctuary. Is it implausible to suppose that these blades were not used for engraving, but only for scraping the soft limestone, or *mond-milch,* which because of its consistency left no sign of usage on the cutting edges?

As for the remains of fauna discovered, we have seen that none are related to possible traces of a meal, nor even to human supplies contemporary with the works of art. They are exclusively the bones of stray animals that died accidentally in the cave, probably after it filled with water: grouper bones in the large shaft, unidentified bat skeletons in Chamber 2, bones of small rodents (apparently the garden dormouse, *Elyomis quercinus;* Patrick Bayle's identification), and bones of a small bird, unidentified because not removed. The bat, dormouse, and bird could all have entered through fissures in the ceiling, perhaps through the dome that overhangs the submerged shaft.

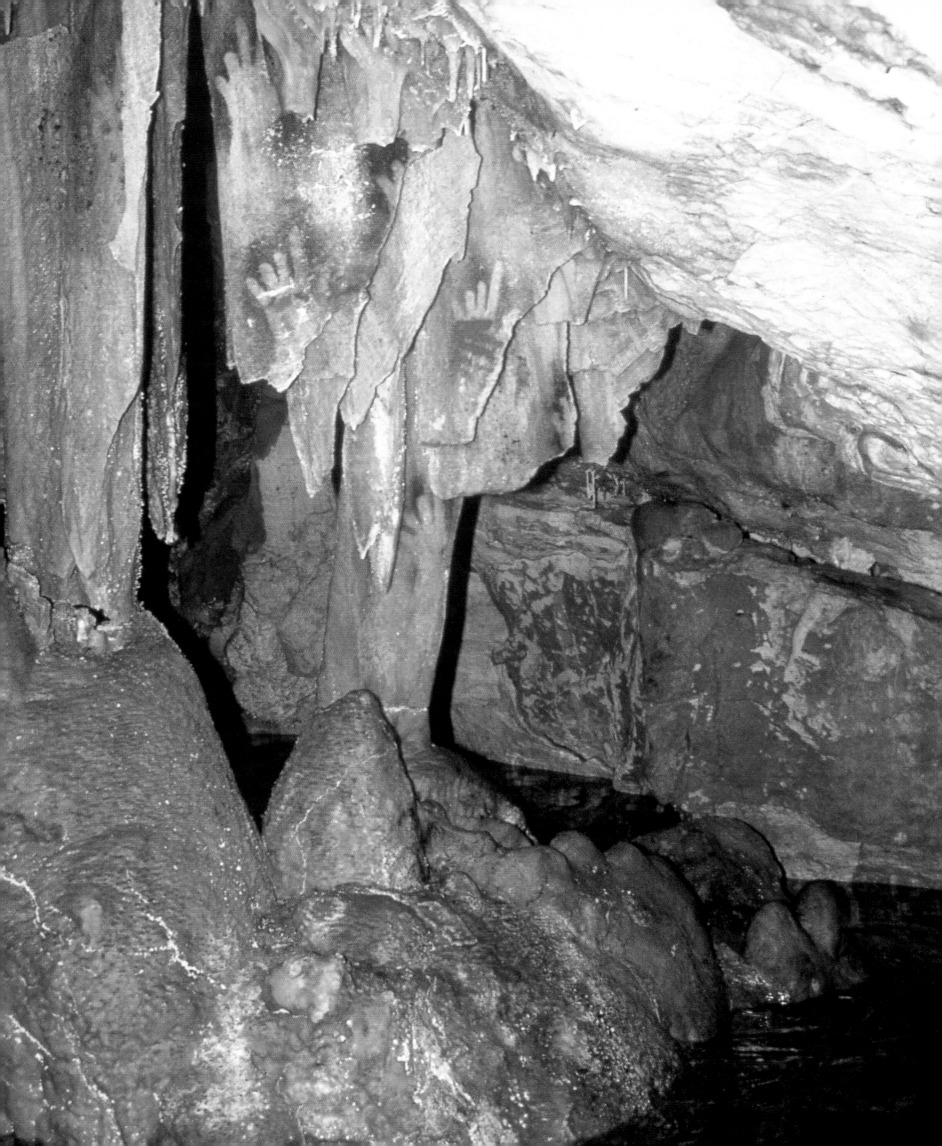

4. The Finger Tracings and the Hands

Among the things that struck us beginning with our first visit to the cave was the importance of the innumerable nonfigurative marks engraved with wide strokes that appear almost everywhere on the walls and ceilings, including in the low chambers and difficult-to-reach nooks, as well as on ceilings situated sometimes out of reach.

Finger Tracings

Everywhere that the Urgonian limestone was superficially somewhat softened by weathering, something that happens often in deep caves and is the case in the Cosquer cave, the people of the Upper Paleolithic covered entire panels with lines drawn with their fingers. These parallel lines are sometimes straight, most often curvilinear, vertical, oblique, or horizontal, and more rarely sinuous, winding, and interlaced.

It should be made clear that with the study of the Cosquer cave in only its early stages, these finger tracings have not yet been systematically surveyed or even generally studied. The few remarks that follow should not be compared, then, to exhaustive studies such as those devoted to the finger tracings of Pech-Merle,[1] where Michel Lorblanchet has over the years indexed and studied 140 square yards of tracings executed with fingers.

The Cosquer cave certainly contains an equally important ensemble, but since its study remains to be done we will confine ourselves to general considerations in light of the observations made during the dives of June 1992. We must point out that though this campaign was spread over three weeks, the actual working days were limited to thirteen and the days of scientific work, strictly speaking, to nine, because of bad weather that at times precluded mooring *L'Archéonaute* or abruptly cut short time spent in the cave.

We should also like to remind our readers that while land-based caves are less difficult of access than the Cosquer cave, barely a quarter of the finger tracings in some seventy European Paleolithic painted caves has been the subject of surveys and precise analyses.[2] This clearly has to do with the indifferent aesthetic appeal of these depictions, with the technical difficulty their study presents, and with the uncertain and often insufficiently gratifying results that the researcher can expect at the conclusion of the task.

Among the French sites where these representations are to be found, the most noteworthy are Gargas, Les Trois-Frères, L'Aldène, three caves in the Basque region (Erberua, Oxocelhaya,

31. Eight hand stencils (M1–M8) on a black background have been painted on a stalagmitic mass right at the edge of the large shaft at the northeast end of the cave. Seventy-nine feet deep, this shaft is at present filled by the sea

and Etxeberri), Pech-Merle in the Lot, Rouffignac, La Croze-à-Gontran, Bara-Bahau in the Dordogne, and Baume-Latrone in the Gard.

In Spain, finger tracings occur at Altamira, Las Chimeneas, Hornos de la Peña, Quintanal, La Pileta (near Málaga), and La Clotilde de Santa Isabel (near Santander). The last is distinguished by having only finger tracings on its clayey walls.

The most abundant finger tracings are to be found in the cave of Gargas and of Rouffignac, with about 300 square yards at each of these two sites (at times, as many as 600 square yards are mentioned for Rouffignac[3]); at Pech-Merle (about 144 square yards); at Altamira; at Baume-Latrone; and at Les Trois-Frères. While not yet measured, those of the Cosquer cave are to be placed without hesitation in this top group.

Finger tracings are known in very numerous caves on the Australian continent, where they are spread over a very wide chronological range. The tracings in one cave in the south of Australia, Koonalda cave, have been attributed to a very ancient period. They are situated in the darkest part, about 650 feet from the entrance to this cave rich in flint nodules set into the walls, as at Rouffignac. According to Australian archaeologists, these finger tracings could have been part of rites to accompany the extraction of flint.[4]

At the beginning of the century, the Abbé Breuil remarked when speaking of finger tracings, "It is often difficult to decide if the line has been made with a finger, or with an instrument with multiple tips." In the Cosquer cave, while grouped under the general heading of "finger tracings," these lines exhibit varied appearances in their details. The depth of the stroke is always insignificant (from 2 to 3 millimeters), but width is more variable. The bottom of the groove is most often flat or has a very wide U shape, which fits the hypothesis of engravings executed by finger, but it is sometimes more irregular, displaying parallel striations, suggesting the use of an instrument, perhaps the tip of a flint blade with retouches or nicks or, quite simply, fragments of stalactites or stalagmites picked up on the floor of the cave.

In fact, many stalactites were broken long ago and lie on the ground, often caught in the calcite and stained with charcoal. These breaks seem to be the act of humans, since large stalagmites have been broken off a few inches from the base and then pecked so as to level the truncated tops. On this tip are sooty traces or charcoal covered in calcite, which, as we said, suggest some kind of fixed lighting system in the cave. Since the few flint blades recovered did not on first examination display clear microtraces linked to working the rock by engraving or scraping,[5] it is not impossible that prehistoric people used fragments of calcite to scrape the weathered rock.

The multiple tracings that cover the walls and sometimes the ceiling of the cave cannot, in fact, all be considered finger tracings in the strict sense. In many places the layer of soft rock has been scraped over sizable areas. The most likely hypothesis is that the scrapers wanted to collect the weathered limestone, a chalky white paste, relatively malleable and sticky, called *mond-milch* or, by Italian specialists, *latte di monte*. Logically, this chalk should be found in great quantities on the ground, particularly in small depressions, where it would have escaped leaching, since charcoal is found there in abundance. Now, in places on the ground one can observe a fine, grayish white, powdery film fallen from parts of the ceiling that have flaked off as an effect of the salinity, but there are no accumulations. Thus, the people must have collected and carried out the fallen chalk. They also must have taken away the red clay that fills various fissures, for this, too, has been systematically scraped. One can surmise that this clay served as a coloring agent, especially for outlining at least some of the hand stencils. But the quantity extracted seems far too great for the small number of "red

hands" preserved; however, more hands may have existed in the submerged chambers, today destroyed by the rise of the sea. We can only guess at why the chalk was collected. Was it for body painting or domestic use? Was it used as a binder for the pigment of other wall paintings? Or was it taken to the submerged chambers and so destroyed? On the ground in several places near scraped areas, we found pellets of chalk and, above all, of red clay, visibly worked with fingers; one of the pellets, stuck to the wall painted with red hands, displays finger marks.

The distribution of these tracings and scrapings in the cave does not indicate at first glance any special placement, unlike the hand stencils, which are all grouped near the shaft at the northeast end of Chamber 2 and along the east wall of the large chamber, and none of which occurs in the west and central sections of the cave. On the whole, the finger tracings are found on walls or low ceilings within reach of a man of average stature. But there are also a great many on very high ceilings. This is the case, for example, at the highest point of the large chamber, near the forequarters of an aurochs (Bi9) engraved about ten feet from the ground. It is also the case on the ceiling formed by the surface of a slanting stratum that slopes about 30 degrees to the south, where it plunges into the water, becoming the ceiling of a major part of the large chamber (southwest section; see fig. 25). There, above the underwater entrance to the cave, finger tracings have been engraved on the ceiling several yards up, which must have required setting up rudimentary ladders (trunks roughly stripped of branches?). At several points, where the stratum plunges into the water, finger tracings covered with a film of calcite are preserved below sea level. They have survived as well under 20 inches of water beneath a small overhang at the base of the painted horse Chv1.

In some cases—on ceilings near the painted horses, for example—the finger tracings are next to the tops of stalagmitic concretions that could have been used to facilitate climbing or to put ladders in place. The tracings are particularly abundant in the southwest section (wall of small painted horses Chv1 to Chv6 and area with engravings of chamois Chm4 and Chm5, ibex Bq14); and in the east section (wall of painted bison Bi1 to Bi5 and engraved ibex Bq2, Bq3, Bq6), especially on the wall of the red hands near the large submerged shaft (ceiling with engraved ibex Bq4 and Bq5 and seals Ph1 and Ph2). However, one observes them as well in the northern sections in very low areas of Chamber 2 (ceiling of the black megaloceros Mé1) and on Crab Boulevard, in particular near the small submerged shaft in the neighborhood of the indeterminate animal I6 and the potbellied seal Ph8 (see fig. 135).

In fact, the finger tracings and the scrapings mark the walls and ceilings everywhere the rock surface has undergone sufficient weathering to be transformed into soft chalk or *mond-milch*. We observed no attempt to scrape hardened surfaces (ceiling of the Low Hall where the paintings of Bq1, C1, Chv7, and Chv8 are located; panel of great auks, calcite drapery with black hands; and others).

Made with three or four fingers held more or less together or only slightly separated, the finger tracings in the Cosquer cave are much more diverse than they first appear to be. They can be extended or intertwined: both cases can be found, for example, on the panel of painted horses, on the ceiling of the black megaloceros Mé1, on the wall with the painted horse head Chv18, on the east wall near the engraved horse overlaid with an engraving of a seal (Chv25, Ph4), and on the panel of the "horse-bison" (indeterminate I2).

But they are also sometimes short and arranged parallel to each other, as in the east part of the large chamber on a vertical wall across from the feline, above Bq9 (fig. 32). Elsewhere, as on the wall of red hands, they are disorganized and intertwined. Nowhere, in any case, do they recall the serpentine double tracings of Rouffignac or the well-known "ceiling of hieroglyphics" at Pech-Merle, or

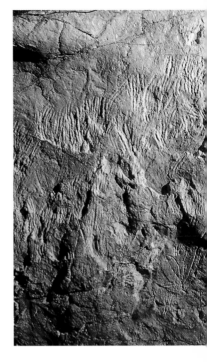

32. Above ibex Bq9 at the lower right, a whole series of finger tracings has been made more than 6 ½ feet above the ground

the figural outlines in this same cave[6] or at La Pileta. It is not impossible, however, that studying them in detail will lead to surprises and that figurative lines will be identified among these enigmatic graffiti.

A very simple technique adapted to a particular type of medium, finger tracings have been considered an archaic expression of drawing belonging to an early phase of Paleolithic art. The question how they should be dated has in fact been asked since the beginning of the century. But is it not a little excessive to speak of "art" with regard to these apparently undefined signs that certainly conceal meaning but surely not aesthetic value?

Some, notably those at Gargas, but also those at La Pileta and Baume-Latrone, as well as

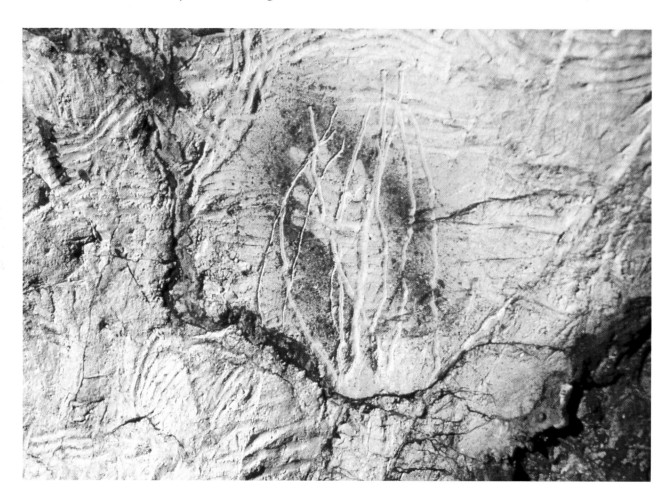

33. This red hand stencil (MR16) was drawn on a wall covered in finger tracings. It was then slashed with a whole series of lines with a lighter patina than that of the finger tracings, as if to erase it

some of those at Pech-Merle, have been attributed to the Gravettian period. An Aurignacian date has even been proposed for those at La Croze-à-Gontran. In regard to Baume-Latrone, numerous researchers have been struck by apparent similarities between the techniques for making the finger tracings and for making the very curious paintings—mammoths in a very unusual style, equids, and a fantastic monster with the body of a reptile and the head of a feline, all attributed to the Gravettian.[7]

On the other hand, some finger tracings are more recent: some from the Solutrean era (Pech-Merle), others Magdalenian (Le Tuc d'Audoubert, caves of the Basque region, Rouffignac). These attributions, it must be acknowledged, rest only on assumptions, and it would be improper to assign the value of chronological marker to a very simple technique that could have been done—and indeed has been done—during very different periods.

These considerations quite naturally underline the importance of the Cosquer cave, where for the first time in the world Paleolithic hand stencils and, at the same time, finger tracings

could be dated by the rigorous techniques of nuclear physics (see below). We were able to determine in September 1991 that the finger tracings and the hands always underlie the painted and engraved animals. In fact, there are very few animals, painted or engraved, that do not overlie more ancient finger tracings, the patina of which displays, furthermore, a very different appearance from that of the lines of the engraved animals. These finger tracings are very frequently covered with a film of calcite—for example, those intersected by the ibex Bq12, by the chamois Chm3, by the chamois Chm4 and Chm5, by the horse Chv19 and the seal Ph3, by the horse Chv13, and by the horse Chv20.

We have already noted that in the large chamber, finger tracings on the ceiling are sealed by calcite and preserved beneath the water. Earlier than the animals of Phase Two, the finger tracings of Cosquer are in numerous cases overlaid by hand stencils from Phase One, dated to 27,000 B.P. This is the case for the red hands MR1 and MR2, for the large red hand MR4, and for MR5, MR6, and MR7, all on the east wall of the large chamber. One might thus have thought that the finger tracings were even older than the hands, but several hands are intersected by finger tracings. On the east wall, this is the case notably for MR1, MR2, and MR10. The finger tracings that overlie the hands have a different patina from the deep incisions made with the evident intention of obliterating the hands, of destroying them (see below and fig. 33). The conclusions that prevail are that the finger tracings and the hand stencils are almost contemporary and both of them date from the Gravettian period.

As for the meaning of the finger tracings, which are present, as we have seen, in numerous painted caves in Europe and also in Australia, that remains and will remain obscure. Are the finger tracings the aesthetic manifestation of an abstract ideology? Did the people who made them limit themselves simply to primitive techniques of a rudimentary graphic expression, in caves with walls either weathered or covered with malleable clay? What could their purpose be, except to mark the presence of people in the depths of the earth—to take possession of these places, as mysterious as they are frightening, where for all we know no one before them had dared venture?

Hands

Of all the testimony, graphic and not, left in the caves by the people of the Paleolithic, the most moving is incontestably the imprints of their hands, printed by chance in the clay or more often traced deliberately on the rocky walls of remote subterranean chambers.

Handprints

In a good number of caves, footprints have many times been pointed out and, more exceptionally, handprints left by prehistoric people in the clay of deep galleries. Thus, in the cave of Fontanet (Ariège department), human and animal prints were discovered, among them those of a young fox "associated" with handprints of children and adolescents on blocks of clay. At Fontanet as at Montespan (Haute-Garonne department) there exist also fingermarks made by lifting the clay.[8] Other handprints often mentioned—such as those identified by André Glory at Niaux, those of Roucadour (Quercy department), and those of Lascaux—are very controversial with regard to the hypothetical "mutilations" they are supposed to display. The few prints in clay at Gargas cave, often used to support different arguments, were shown upon examination to be very questionable, and, in fact, they might be short finger tracings.[9]

Of completely different significance are the hand stencils. Hands of hunters, hands of flint-knappers, hands of craftsmen in bone or antler, hands of anonymous artists from forgotten ages, these "paintings," if we can call them that, since one can hardly term them "art" in the strict sense, take their place among those traces of the past that most deeply move us. Even more than the painted or engraved animals on walls and ceilings, they appeal to our imagination and sensibilities (fig. 34) by calling up directly a living human, of whose presence there remain most often only indirect traces—some stone or bone tools, vestiges of meals, evidence of fires—or at best a skeleton or fragments of a skeleton.

Prehistorians also call "handprints" those images that have been applied to the wall by a hand simply coated with coloring material. This procedure, while very simple and easy to do, was rarely used by prehistoric people. Very often the colored handprints at prehistoric sites have been the object of critical examination, and their authenticity is often considered doubtful.

By contrast, the images called "hand stencils," made by placing the hand against the rock and outlining its contour by blowing, or sometimes by dabbing liquid pigment, are numerous and present in many prehistoric caves (see fig. 36).

These hand stencils are symbolic representations, even if their meaning escapes us most of the time, present just about everywhere in rock art, with a very wide distribution chronologically, geographically, and culturally. One comes upon them as frequently in the Paleolithic art of the Old World—essentially in the caves of France and Spain (fig. 36)—as one does in Australia, from the Pleistocene to current aboriginal art, in Indonesia, in America in the art of the ancient hunters of the Argentine Cordillera or the sacred caves of the Maya, and in the Sahara region during a recent period of prehistory.

On the immense Australian continent, where representations of animal prints (of birds, kangaroos, and reptiles) have been recorded, there exist very numerous hand stencils at thousands of rock-art sites (see fig. 186) all over the continent. There even exist complete human outlines done by a stenciling process.[10] Some of these hands could be indirectly dated to about 20,000 B.P.; others postdate the European colonization; some are even current.

Certain handprints, prehistoric or not, could be an expression in a language of gestures. This is very probably the case, especially for the incomplete hands with fingers folded according to some code, a coded language connected with the hunt and with various rites, observed and described among the Australian aborigines and the Bushmen of the Kalahari in the nineteenth century.

In Indonesia, hand stencils have been reported on the island of Sulawesi (Celebes) in the cave of Undjung Pandang; however, they have not been dated with precision.

In Argentine Patagonia, it is not in the interior of deep caves but rather under overhangs or in rock shelters, in particular in the well-known Cueva de las Manos Pintadas in the province of Santa Cruz, that hundreds of hands, both prints and stencils, were discovered. They display all the fingers complete and from the context date back to 8,000 or 9,000 B.P., thus to a period related to an age of hunter-gatherers on the South American continent.[11] In North America, it is also in rock shelters (in the southwestern United States—Arizona and New Mexico) that hundreds of handprints (see fig. 185) and hand stencils were drawn, going back to different periods of prehistory. The most recent are attributed to the Pueblo culture.

In the Sahara, there are large numbers of hand stencils but more handprints and drawings of hands. Reported in the 1950s by Henri Lhote, these representations have rarely been depicted or published, eclipsed by the abundance, diversity, and aesthetic appeal of the hunting or herding scenes

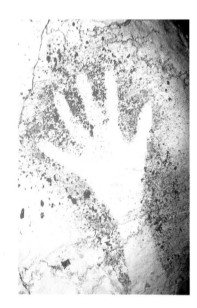

34. This red hand with complete fingers and part of the forearm depicted was, in fact, the first work of art to attract Henri Cosquer's attention. Dubbed "the historic hand," it is more prosaically known as MR4

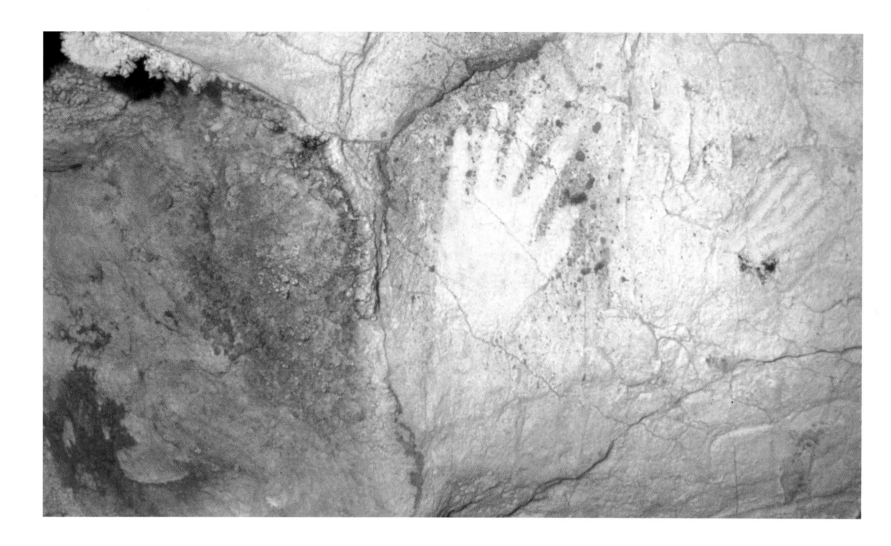

in Neolithic African art. They are known, however, from the Tassili (Sefar, Jabbaren) to Wadi Djerat, and as far as Acacus in Fezzan. In the Tassili in particular, some display incomplete fingers. There is agreement on attributing these hands to a probable "Neolithic age," but it should be acknowledged objectively that there is still a singular lack of precise data about them.[12]

In Mesoamerica, hand stencils were made in the sacred caves of the Maya in the Yucatán, in deep caverns near the great cultural center of Chichén Itzá, in particular in Acum cave, where there are handprints and numerous hand stencils, some with incomplete fingers. In other cases, the folded fingers represent the heads of animals.[13]

Handprints are irrelevant to our purpose, for none has been observed in the Cosquer cave, except perhaps for a smudge of fingers and an unclear palm print (?) applied in red on a ceiling in the vicinity of the submerged shaft. The supposed "red handprint" that horizontally overlies one of the black hand stencils on the shaft drapery (hand M5) is in fact a series of five distinct red strokes (figs. 31 and 43).

There exist 3 handprints at Bédeilhac in the Ariège, several at Le Combel in Pech-Merle, and another print recently pointed out in the Grande Grotte at Arcy-sur-Cure;[14] in Spain at Altamira (1), at Pindal (1), and at La Fuente del Salín (2). Curiously, in Mediterranean France, only handprints have been noted until now and they are few in number; thus, the 6 brown-red handprints of the Bayol cave (Gard) and the 5 hands, also brown-red (clay from the cave), from Baume-Latrone, situated a few miles from each other, both in the gorge of the Gardon.[15] Like the painted or engraved

animals in these caves, the handprints have not been dated with precision, but writers concur in attributing them to an early Upper Paleolithic period: late Gravettian or Solutrean. Their authenticity has often been questioned, although the reasons are unclear; it is true that these two sites have over and over again been vandalized.

Finally, one must recall the handprints made at the back of the Paglici cave on Mount Gargano (Apulia), Italy, an important site, the entry to which was occupied during the Gravettian and the Epigravettian.[16]

Hand Stencils

In Franco-Cantabrian art of the Quaternary, hand stencils are represented in the caves of the Pyrénées (more than 230 at Gargas/Tibiran, 5 at Les Trois-Frères, 3 at Erberua near Isturitz) and of the Dordogne (5 at Font-de-Gaume, 1 at Les Combarelles, 2 at the cave of Le Bison, 4 at Bernifal, 1 at the shelter of Le Poisson, 1 on a detached block found in a stratigraphy at Labattut shelter).[17] In the Quercy region, one can count 12 at Pech-Merle, 12 at Les Fieux, 6 in the cave of Les Merveilles at Rocamadour, 9 at Roucadour, and 2 in the Corrèze department, at Moulin-de-Laguenay. In the Yonne, just recently 6 barely visible hand stencils have been discovered in the Grande Grotte at Arcy-sur-Cure, with the notable aid of infrared photography; made by spraying ocher, they are all left hands with fingers intact, except for one displaying incomplete fingers.[18] In Spain, the cave of El Castillo revealed 64 hand stencils; La Fuente del Salín includes 13 in a deep chamber discovered in 1985 behind a water-filled entrance. The forearm is often shown on the latter, as it is on some in the Cosquer cave. Altamira contains 3, and there are also some at La Pasiega and in the caves of Asturias. At Maltravieso in Estremadura, 24 have been counted, all with incomplete fingers (the fifth finger is missing as often on left hands as on right hands, which comforted the partisans of the ritual mutilation theory—see below). At La Fuente del Trucho in Aragón, 14 hand stencils, several of them with incomplete fingers, have recently been discovered.

First place is held by the famous cave of Gargas in the village of Aventignan (Hautes-Pyrénées), with a count of 231 hands,[19] 143 of them black[20] with 80 red, 5 ocher, 2 blackish brown, and 1 white. In fact, only 124 are clearly identifiable as left or right and as to the details of the fingers.[21] Of these, 114 display incomplete fingers, folded or "mutilated" according to different authors, a surprising proportion if one accepts the mutilation hypothesis—ritual or pathological. Nevertheless, this hypothesis is often put forward, as its tragic character has strongly impregnated imaginations. At Gargas, the digital contours display considerable shortening or folding; most often, three and even four fingers are reduced to one phalanx. Thus, on 38 percent of the hands four fingers (all digits except the thumb) are shortened.

A few hundred yards separate Gargas from the cave of Tibiran, which contains 10 red hands, all with incomplete fingers. In fact, the depictions of hands with incomplete fingers, the hands termed "mutilated" that have fed so much controversy, exist only at Gargas/Tibiran in the Hautes-Pyrénées, at Maltravieso, in Estremadura, and in the Cosquer cave in Provence, which adds to the mystery surrounding them. Among the recent rock-art discoveries in the Grande Grotte at Arcy-sur-Cure (Yonne) is a panel composed of 6 hand stencils, all left and all red (ocher). Under the depiction of a large herbivore (Red Frieze), one hand displays incomplete fingers, with the exception of the middle finger, which is extended and particularly long.[22] Whatever the case may be, the panel of hands at Arcy-sur-Cure enlarges remarkably, after Cosquer, the area of European distribution of these representations.

36. Distribution of Paleolithic painted caves with hand stencils in France and Spain
1. Gargas/Tibiran
2. Erberua
3. Les Trois-Frères
4. Cosquer
5. Pech-Merle
6. Les Fieux
7. Les Merveilles at Rocamadour
8. Roucadour
9. Moulin-de-Laguenay
10. Les Combarelles
11. Font-de-Gaume
12. Le Poisson shelter
13. Bernifal
14. Grotte du Bison
15. Labattut shelter
16. Roc-de-Vézac
17. Grande Grotte at Arcy-sur-Cure
18. Altamira
19. El Castillo
20. La Fuente del Salín
21. Maltravieso
22. La Fuente del Trucho

The Question of "Mutilated Hands"

Since their discovery at Gargas cave at the beginning of the twentieth century, the representations of hands with incomplete or "shortened" fingers (to use the term "mutilated" already implies taking a position) have intrigued researchers and given rise to a number of hypotheses. They have also, as is often the case in archaeology, set off and fed heated and interminable controversies. The example of the Cosquer cave shows that this very French tradition is still alive and not near extinction! These controversies, at times violent, have been just as concerned with techniques used as with the nature and origin of these strange shortenings of fingers. Authors have at various times suggested accidents and pathological causes, or ritual mutilations, a magic explanation often invoked in prehistory—unanswerable because unverifiable—that relies most of the time on comparative ethnology and often does not take into account chronological, geographic, and cultural gaps. Here, they invoked bloody customs among Amerindian tribes and human groups in Papua–New Guinea.[23] And in this way "the apparent mutilations of Gargas . . . thanks to some ethnographic examples of widows who cut off their phalanges when they lost their husbands, have entered into the prehistoric literature as a curious Paleolithic custom."[24]

37. Gargas cave (Aventignan, Hautes-Pyrénées): On a rocky overhang, three red hand stencils with incomplete fingers appear. As with some of the hands in the Cosquer cave, they have partial forearms

Later, other researchers, in particular doctors, challenged the theory of voluntary mutilations and suggested mutilations of pathological origin premised on the supposed harshness of living conditions in the Upper Paleolithic. The Gravettians of Gargas might have lost their fingers following frostbite leading to necrosis of the phalanges, or might have contracted Raynaud's disease, a circulatory ailment brought on by cold and stress in which vasoconstriction affects the extremities and untreated can lead to necrosis. These devastating results might have been aggravated by nutritional deficiencies. Leprosy was mentioned, as well, though we do not know if it existed at all during the Paleolithic, and various diseases such as ainhum, a hereditary ailment characteristic of endogamous groups, which involves necrosis of the fifth finger.

This hypothesis of pathology was defended by Dr. P. A. Janssens[25] and particularly by Dr. Ali Sahly, who made it the subject of his doctoral thesis.[26] This theory was also adopted by various prehistorians.[27] One of the arguments advanced was the presence of "mutilated" fingerprints in the clay of the caves, particularly at Gargas itself. Now recent studies have shown that these prints are highly questionable,[28] and Jean Clottes, examining them in 1990, saw only erosion phenomena there. Some even imagined that in order to soothe and care for the hands of unhappy hunters stricken by incurable frostbite, the prehistoric people of Gargas coated the finger stumps and the palms with ocher or with clay and pressed them on the cave walls "to facilitate healing." Were the caves at Gargas and Cape Morgiou prehistoric "hospitals"?

Now, there is one strong argument against both systematic amputations and pathological mutilations, namely, that no skeleton known from the Upper Paleolithic displays hands with incomplete, amputated, mutilated, or deformed phalanges. As for pathological mutilations, it is hard to see why frostbite or circulatory ailments would have spared the thumb, which is always intact at Gargas, as at Maltravieso and at Cosquer. Dr. R. Tardos, at the end of a pertinent critical analysis of the arguments for pathology, separates the hypothesis of Raynaud's disease or ainhum from that of frostbite,[29] but then reverts to that of voluntary mutilations! Furthermore, the Cosquer cave now provides a new fact that counters the hypothesis of pathological lesions. In fact, if this hypothesis were accurate, one would have to assume that two groups of people, living more than 250 miles from one another in different environments, contracted the same rare disease at about the same time and reacted to it in the same way, that is, by immortalizing their amputations on cave walls using identical techniques.

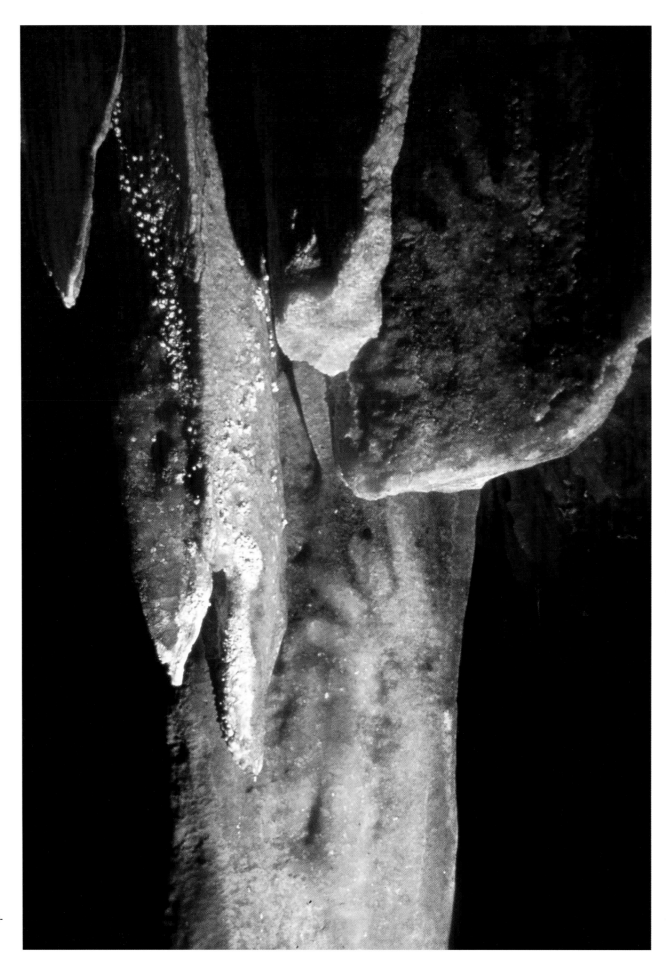

38. This black hand stencil with incomplete fingers (M8) is located near the large submerged shaft

However, already at the beginning of the twentieth century, a more rational explanation had been proposed.[30] It supposes neither cruel mutilations nor sequelae of serious diseases, nor severe frostbite, but quite simply hands with fingers bent according to the code of a gestural language that can also be supported by ethnological examples. This silent language, represented by folding fingers, exists in fact among hunters, in particular among the aborigines of the great Australian desert and among the Bushmen of the Kalahari. This code of expression is connected with the hunt and also with the handing down of initiation stories. Regarding this explanation, which has the advantage of uniting ethnological examples and simple good sense, prehistorian André Leroi-Gourhan concluded: "That the hunters cut off all their fingers to have better luck hunting or that, to the same end, they cut off those of future hunters who were their children, is not an economically defensible step, even and above all in primitive groups. That they lost their fingers for pathological reasons is not after all impossible, but agrees poorly with the structure of the whole. That they invented, as have many hunting peoples, finger games to signal the presence of this or that animal does not go beyond the limits of the plausible."[31]

Furthermore, at Gargas (see fig. 176) and at Pech-Merle, there are series of folded thumbs, seen in profile, stenciled, that support the hypothesis of bent fingers and should have won the support of the last skeptics. This rational explanation has however been resisted, and still is, by the partisans of mutilation, who object that it is impossible by simply folding fingers to reproduce experimentally the prehistoric representations of hands. However, several researchers have tried it with success and have demonstrated that with simple techniques (blowing liquid pigment with the mouth, lips tight, or spraying by means of two tubes placed at right angles), one can without difficulty replicate every instance known at Gargas and elsewhere. One can cite on the subject, after the experiments of André Leroi-Gourhan, those of Michel Lorblanchet[32] and of Marc Groenen,[33] and those of Claude Barrière, who reached different conclusions.[34] In particular, the very methodical research conducted by Marc Groenen amply demonstrated "that it is not only possible to reproduce experimentally the numerous hands on which one or more fingers are 'reduced' to one phalanx, but also the hands where one or more fingers are reduced to two phalanges, by curving the finger a little and pressing it against the wall, and even to less than one phalanx by folding it as far as possible into the palm."[35]

After the well-known sites of Gargas/Tibiran in the French Pyrénées and of El Castillo (64 hands), of Maltravieso (24 hands), and of La Fuente del Trucho (14 hands) in Spain, the Cosquer cave in Provence with its 46 hands ranks among the painted caves richest in hand stencils, representations until now unknown east of the Rhône, since in the Paglici cave in Apulia only handprints were discovered.

Still, in a recent article by Gilles and Brigitte Delluc[36] one reads: "Mediterranean France has only handprints," a reference to some representations in the caves of the Gardon, already mentioned. It is surprising that in this article, otherwise very well documented, the numerous hands and countless finger tracings in the Cosquer cave are discreetly passed over in silence, despite our publication of July 1992.[37]

The Hand Stencils of the Cosquer Cave

Following the usage established earlier in the numerous publications dealing with this subject, we

will agree to call "left hands" those depictions where the thumb is located on the right and "right hands" those, very rare here, where the thumb is on the left. In doing this, we do not wish to claim or implicitly assume a particular method for carrying this out, knowing that at times it might have been hands turned over, their backs against the rock. However, the topography of the walls and ceilings most often allows us to dismiss the hypothesis of such a procedure for doing them. For this reason, we prefer to speak simply of "right hands" and "left hands." The same conclusion applies furthermore at Gargas cave, where only left hands and right hands with the palms pressed against the wall are found. The form of the images precludes the possibility of hands with their backs placed against the rock.[38]

The hands against a black background near the submerged shaft (Groups I to V) have been designated M1 to Mx. The other hands, for the most part against a red background, located on the east wall of the large chamber, to the south of the preceding series (Group VI) have been designated MR1 to MRx. For brevity's sake, we will speak of "black hands" for those outlined by spraying charcoal pigment, and of "red hands" for those made with red clay.

There are thus a minimum of 46 hand stencils discovered in the Cosquer cave. It is in no way impossible that others should be found during the coming explorations, since some are very hard to see, either because of later scratching or scraping or because of weathering of the walls caused by salt-laden atmospheric activity. We remain persuaded that the east wall was covered with many others, now vanished because destroyed by the rise in sea level.

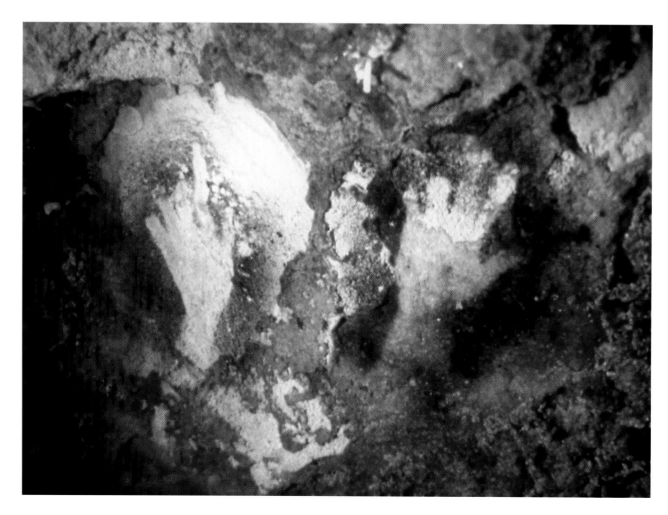

39. These two black hand stencils with incomplete fingers (M18 and M19) were photographed during the first expedition by divers of the French navy. The stencils are located above the south edge of the large shaft

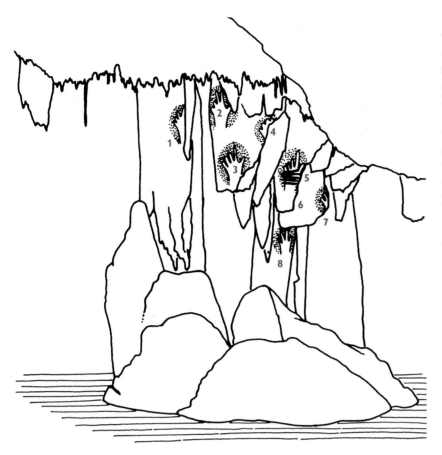

THE GROUPS OF HANDS AND THEIR LOCATIONS

I. On the calcite drapery of the large submerged shaft, 8 black hands (fig. 31): M1 to M8.

II. In a small concavity in the wall beside the mass of draperies, 3 black hands intersected by the panel of small engraved animals: M9, M10, M10'.

III. On a wall sloping toward the water, to the immediate east of the preceding panels, 9 black hands: M11 to M19.

IV. On the ceiling at the edge of the large shaft, panel of 7 black hands partly intersected by a large engraved horse: M20 to M26.

V. Another group to the right of this ensemble, 3 black hands: M27 to M29.

These five groups make up what we have called the Large Shaft series, in total 30 hands, all black and all but one left hands.

VI. Several yards to the south of the shaft ensemble, on the east wall of the large chamber (see fig. 50), 16 hands, 10 of them red and 6 black: MR1 to MR16.

GROUP 1

At the southeast edge of the shaft at the end of the Cosquer cave network (shaft 79 feet deep beneath a cathedral dome 148 feet high), a mass of large draperies on several levels bears a group of 8 hand stencils on a black background of pulverized charcoal (fig. 40). All these hands are left hands, with fingers shortened, and are for the most part encrusted by formations of very hard, brilliant white calcite. At least two (M4 and M7) are incomplete since the draperies beneath them were broken after they were made—but at a very ancient date since the calcite has formed over the breaks. The same could be true for M3 and M5, placed at the edge of a break that has cut into and destroyed a part of the blackish halo. In the middle of M1 there are five large blackish marks ¾ inch (2 cm) in diameter. May one call to mind here the hand stencils associated with dots at the caves of Gargas, Pech-Merle, and Les Merveilles at Rocamadour?[39]

The hands will be described from left to right and from top to bottom on the panel:

M1: left hand, black; the wrist as well as the beginning of the forearm are depicted; middle, ring, and little fingers shortened; index finger and thumb are complete. This hand is overlaid with five large blackish dots (fig. 41).

M2: left hand, black; ring and little fingers shortened. The ring finger is abnormally thick, which could well mean that it is a question of folded fingers; middle and index finger and thumb are complete. A line drawn in red with a finger overlies the wrist.

M3: left hand, black. The wrist, very visible, is twisted to the left, which shows that it is indeed a left hand and not a right hand placed in a dorsal position (in supination). The lower right section is affected by an ancient break in the drapery. Thumb and index finger are complete, the index finger being particularly long and tapered; the three other fingers are shortened. Here again the ring finger is thick (bent finger?). A white calcite concretion covers the hand at the base of the fingers. A thick horizontal red line and another perpendicular one overlie the hand.

M4: left hand, black; only four shortened fingers remain, the rest of the hand having been destroyed by a very ancient break in the drapery. Like the others, this break does not seem natural, for it required a violent impact to break the drapery; here again, the break is covered in calcite, which shows its great age. Another hand could underlie this one, because there remains a wide black ring on the edge of the break (fig. 42).

The Panels of Hands in the Cosquer Cave

40. Drawing of a group of left hands on a black background (M1–M8) painted on stalagmitic draperies near the large submerged shaft

41. Hand M1 overlaid with dots

42. The hand M4 at the center of the photograph has been partially destroyed in what seems to have been a deliberate act

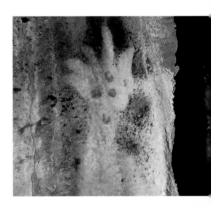

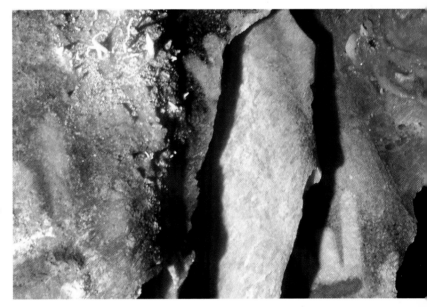

43. A black hand slashed by five red strokes (M5), on the stalagmitic mass at the edge of the large shaft

M5: left hand, black, with the wrist and the beginning of the forearm visible; to the right, the drapery has been broken, which destroyed part of the blackish halo. The index finger and thumb are complete, and the three other fingers are shortened. Like M1, M3, and M4, the index finger is long and very tapered; it could be the same individual. This hand is barred crosswise with five red horizontal lines that, using the photographs published in the press, some have at times wrongly interpreted, wanting to see in them a "handprint."[40] Examination on the spot shows no such thing. It is a matter of lines drawn with a finger or brush as for M2 and M3 (fig. 43).

M6: left hand, black, masked in part in the photographs by the drapery of M5; the ring and little fingers are shortened, the three other fingers are intact (fig. 31).

M7: left hand, black; the halo of sooty coloring is spotted and quite faded. This hand is incomplete since it is located on a drapery that was later broken, as is the case for M1, M3, M4, and M5. The little and ring fingers are shortened (folded?); the middle finger is intact. The other fingers were destroyed by the ancient break in the concretion; as with M1, M3, and M4, concretions are observable on the break, which they thus "fossilize."

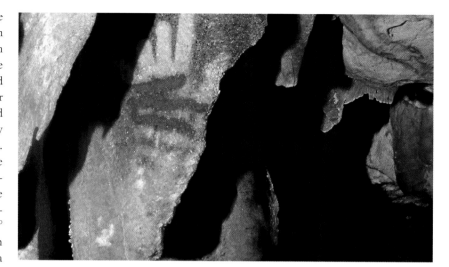

M8: left hand, black; the lowest of the ensemble on the drapery panel; little, ring, and middle fingers are shortened or folded (fig. 38).

All these hands could be made without great difficulty since the mass of stalactites is easily accessible and simple to climb up to, thanks to the stalagmitic base with its complex contours. The hands are located between 4 and 5 feet (1.2 and 1.5 m) from the ground, which is itself presently 23 inches (60 cm) beneath the water. Nonetheless, blowing paint on certain draperies situated in the background—hands M6 and M8, for example —must have been more of an acrobatic feat, even though not presenting a major difficulty.

GROUP II

Still at the edge of the underwater shaft, to the east of the mass of draperies (Group I), the east wall of the cave slopes down toward the water at a very pronounced angle over a distance of 16 to 20 feet (5 to 6 m). On this wall, 6 feet (1.9 m) from the ground (submerged), there is a small concavity sheltering a confused frieze of engravings, skillfully done with fine lines, representing horses, does, and ibex. These are the smallest engravings in the cave: one doe measures only 5½ inches (14 cm) in length and an ibex 4¹⁵⁄₁₆ inches (12.5 cm) in length. This engraved frieze from Phase Two partly overlies three black hand stencils, not clearly visible but which can be studied with adequate lighting. From left to right:

M9: left hand, black, placed at the top of the recess, above the frieze of small

engravings, to the right of the small doe, whose neck is intersected by a red line; the particles of black pigment projected by blowing can be clearly made out. Only the little finger is shortened; all the other fingers are extended and intact. The hand measures 7⅞ inches (20 cm) from the tip of the index finger to the wrist, which suggests the hand of a sturdy man (fig. 44).

M10: left (?) hand, black; the thumb is erased, but the position of the other fingers suggests a left hand. The hand is slanted to the right; all the fingers are intact. This hand is overlaid with several small engravings of entangled animals (horses, cervids).

M10': left hand, black; almost erased, difficult to read.

GROUP III

To the southeast of the drapery of the large shaft, 9 black hands appear on the wall that slopes sharply into the water, here not very deep. They will be described from left to right:

M11: left hand, black; fingers extended and intact; small, rather diffuse traces of red coloring (ocher? clay?) are visible on this hand.

M12: left hand, black, all the fingers intact and extended; deep grooves apparently incised with a flint tool overlie this hand at the base of the fingers, slanting left.

M13: left hand, black; this hand is located at the lower extremity of the sloping wall, just 15¾ inches (40 cm) beneath the waterline. The ring and little fingers are folded, the other fingers intact.

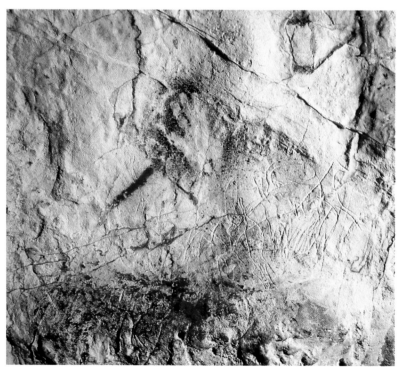

44. A black hand (M9) above a small engraved doe (C3) to the east of the large submerged shaft

M14: left (?) hand; black, very faded (for this reason there is doubt as whether it is right or left). This hand, like M15, is placed near M13, to the right on an almost horizontal surface; no details visible.

M15: left (?) hand, black, also very washed out, beside M14; no details visible.

M16: left hand, black, fingers intact (fig. 45).

M17: left hand, black, little to read because very washed out; overlaid in the middle by much scratching (fig. 45).

M18: left hand, black; placed on the ceiling above the panel of the engraved horse (Group IV). Three fingers are folded: the little, ring, and middle fingers (fig. 39).

M19: left hand, black. Here again, little, ring, and middle fingers are folded. This hand is 7⅞ inches (20 cm) to the right of M18 (fig. 39).

GROUP IV: GROUP OF THE "WOUNDED" HORSE

Some yards to the west of the calcite drapery (Group I), also at the edge of the large submerged shaft, is a panel in a ceiling recess, 6 feet (1.9 m) from the ground (here partially covered with water) with 7 black hands, 6 left and 1 right. This group is overlaid in part by a large engraved horse (Chv24, 3 feet long), whose chest is overlaid with a long sign barbed at both ends (fig. 46). This engraved horse intersects hands M23 to M26. To the back of this panel, incised on the ceiling, are several animal engravings from Phase Two. They include the large ibex Bq4, the ibex Bq5, and the seals Ph1 and Ph2.

Although they belong to two quite distinct and chronologically different phases at Cosquer, the placement of these groupings of, first, hand stencils and, then, of animals right at the edge of the large shaft cannot be by chance. The large shaft, today submerged, certainly played a role in the organization of the sanctuary. Making necessary allowances, one can call to mind the shaft under the great ceiling at Rouffignac cave and deplore the encroachment of the sea, which here has irrevocably destroyed possible representations on the walls of the shaft.

All the hands of Panel IV, against a black background, could have been made without too much difficulty, the ceiling being located 3 to 6½ feet (1.9–2 m) above the ground, presently submerged under 20 inches (50 cm) of water. The ceiling was thus accessible to the outstretched arm of someone of average height, including the maker or makers of M22, which is horizontal, and right. It should be noted, however, that the artist would have had to stand with back turned to a shaft 79 feet deep, on a narrow ledge at the lip of the abyss. It is even more remarkable that this "high risk" site was favored during two periods, first to make the hand stencils there and then, several millennia later, to engrave the large "wounded" horse there.

All the hands on this panel are left hands except M22, which is a right hand. Its horizontal position pointing toward the left in fact precludes the possibility that it could be a left hand with back turned against the rock.

The hands are described from left to right:

M20: left hand, black; all the fingers are intact and extended.

M21: left hand, black; it is slanted toward the right, to the left of the head of the engraved horse. The ring and little fingers are shortened or folded, while the middle and index fingers and thumb are extended and intact.

M22: right hand, the only one among the black hands, with a black halo.

All the fingers are intact. It is placed horizontally, in front of the muzzle of the engraved horse, pointed to the left. Given its position, it cannot be a left hand placed back to front, its back against the rock: this would have required a difficult contortion and the intervention of a second person to blow the paint.

M23: left hand, black, slanting right. It is cut through at the level of the base of the fingers by the forehead of the engraved horse. All the fingers are intact except for the little finger, reduced to the first phalanx.

M24: left hand, black. The ring and little fingers are folded; the wrist is represented. Like several other hands on this panel, it is placed on a slant toward the right, a logical position for a standing artist, arm raised to reach the ceiling. It is intersected at the level of the base of the middle and index fingers by the chest of the horse and the large barbed sign.

M25: left hand, black, almost vertical, slightly inclined to the right. The ring and little fingers are folded, the other three fingers extended, as on many of the hands in the Cosquer cave. It is located level with the chest of the horse and is slightly overlaid with the end barbs of the engraved sign.

M26: left (?) hand, black; the thumb is hard to see and almost erased by corrosion, but the position of the index finger, very elongated, hardly leaves

45. Two black hands (M16 and M17) with fingers intact. M17 has been heavily scraped

46. Drawing showing a horse (Chv24) engraved over a group of black hands at the edge of the large submerged shaft

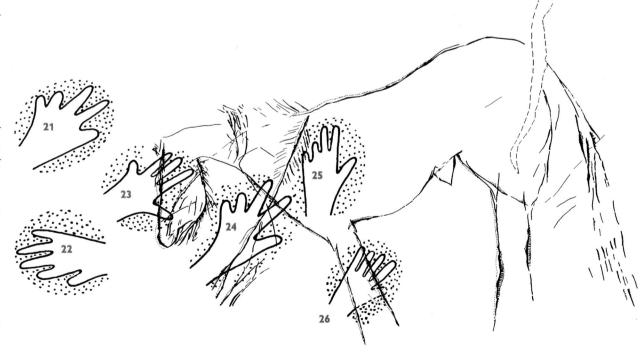

47. On the east wall among ten red hands are six black hands. This one (MR7) was dated to 27,000 B.P. at Gif-sur-Yvette laboratory

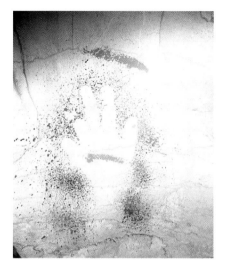

room for doubt. All the fingers are intact. Like M21, M23, and M24, this one is placed on a slant, pointing right. It is intersected at the level of fingers and palm by the spindly front legs of the engraved horse.

GROUP V

Small grouping of 3 black hands, placed to the right of the preceding ensemble, still on the ceiling and at the edge of the submerged shaft, 6 feet (1.9 m) from the ground.

M27: left hand, black; ring and little fingers bent.

M28: left hand, black; ring and little fingers bent.

M29: left (?) hand, black, hard to see because very faded; however, one can distinguish ring and little fingers folded, the three other fingers intact.

All the hand stencils near the submerged shaft, without exception, were made by spraying black, sooty pigment. In this part of the cave there are no red hands. The hands are almost all left hands (29 out of 30); only M22 is a right hand.

GROUP VI: EAST WALL GROUP (WALL OF THE LARGE RED HAND)

Another series of hand stencils, 16 in all, is situated along the east wall of the large chamber, on a sloping wall that descends into the water, south of the series called the Large Shaft series (see fig. 50).

Here hands on a red background predominate since, out of a total of 16 hands, only 6 are against a black background.

On this wall, the hands are distributed in quite a loose way and do not make up groupings in the same way as near the large shaft. They are not, however, very far from one another. This wall is abundantly covered with finger tracings, often curving or horizontal; at times these lines run through the hand stencils or lie beneath them.

The hands will be described from left to right, that is to say, from north to south—and from top to bottom (fig. 48).

MR1: right hand, red; the thumb is clearly situated on the left and, given its position, the hand could not be turned over. The background of red paint shows very clear spots (spraying by blowing), visible on many of the hands in the Cosquer cave. This seems to indicate blowing the color directly by mouth, lips tight—and not spraying by means of two right-angled tubes, which produces a more uniform halo. The outline of the fingers is very sharp; all the fingers are complete and extended.

MR2: right hand, red, with fingers complete, situated 5⅞ inches (15 cm) beneath MR1. The paint shows the same spotting and is thicker around the fingers. This hand overlies some finger tracings, while other, horizontal, lines have cut into the tips of the index and middle fingers. That seems to confirm that the hands are contemporary with a part at least of the finger tracings, many of which display an ancient patina or are covered with a film of calcite.

MR3: right hand, red, placed a little more than a yard to the right of MR2. On this hand, though, the fingers with the exception of the thumb are reduced to the first phalanx. It is one of only two hands in the Cosquer cave that display this characteristic, which is frequent, however, at Gargas. At Cosquer, there are most often only two to three fingers "shortened."

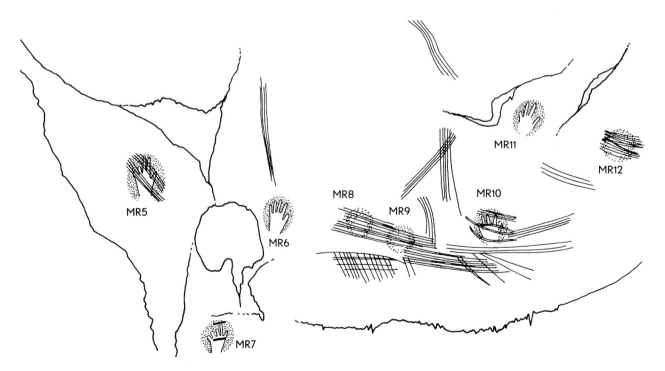

48. More than half the hands of the East Wall Group are red. In the section shown in this drawing (MR5–MR12) there are five black hands among the red ones

These three hands must be right hands, and not left hands in supination since, placed horizontally and facing left, they would have posed insoluble acrobatic problems for the artist; furthermore, in that case the wrist would not be in the same position.

MR4: The divers called this the "large red hand" or "the hand with the watch strap" because of a vein of calcite that crosses the base of the wrist (fig. 34). It is a "historic" hand since it is the first representation Henri Cosquer noticed, the one that led him to examine the walls closely and to discover on them the painted and engraved animals. It is a left hand, red, with long and tapered whole fingers, quite splayed. The red paint is evenly spread on the rock, with identical particles outlining the hand. This hand is made longer by a wrist and a slender forearm. Precisely because of the forearm, some have used this hand as a negative argument in their campaign of controversy as to the authentic nature of these representations (Bourdial, "A Very Shadowy Cave," *Science et Vie,* February 1992). Now, such hand stencils elongated by wrist and a part of the forearm do exist, both at Gargas (fig. 37) and also at La Fuente del Salín.

MR5: left hand, red, placed beneath and to the left of a deep crevice in the wall. The ring and little fingers are folded. The middle and index fingers are very long. This hand bears two series of four lines incised at a 45-degree angle, from left to right and from top to bottom, as if someone had tried to destroy it, to get rid of what it represented.

MR6: left hand, red; all the fingers are intact and extended. It is a wide and sturdy hand with short fingers. The index and middle fingers are about the same length. The red halo displays here again particles of paint and, at times, even small pellets a few millimeters in diameter under calcite on the wall. This hand is placed to the right of a fault, almost opposite MR5, on the other side of a deep recess (fig. 35).

MR7: left hand, black, on which the ring and little fingers are folded (fig. 47). It is crossed horizontally in the middle at the height of the thumb by a red line drawn with a finger; another red line, also horizontal, has been painted above the fingers. These enigmatic red lines are comparable to those observed on the hands near the shaft (M2, M3, and M5, which is crossed through with five red lines). Hand MR7 strongly resembles hand M2 on the large shaft drapery and hands M21 and M24 on the panel of the "Wounded" Horse.

MR8: black hand; whether right or left is uncertain. In fact, it has been almost erased by very close horizontal scratches (twelve incised lines) that make the details of the fingers and their position illegible, the paint having been so scratched off. This hand is to the right of MR6 and on the same level.

MR9: black hand, placed to the right of and beside MR8. Like MR8, it has been scratched to the point where the thumb can no longer be distinguished, nor details of the fingers; it is thus impossible again to say precisely if it is a right or a left hand. It has been erased by the same series of twelve lines that overlie MR8.

MR10: left (?) hand, red. While it has also been heavily scratched crosswise, one can distinguish the thumb on the right, which permits seeing it as a left hand with all the fingers extended and intact. Furthermore, the wrist can be clearly distinguished, slanting to the left. It is placed to the right of and on the same level as hands MR6, MR8, and MR9.

MR11: left hand, black, above MR10 and near a crack in the wall. It is heavily erased by scratching. One can see, however, that the ring and little fingers are bent, the other fingers intact.

MR12: black hand, to the right of MR11. Scratches have made it virtually illegible. One can no longer distinguish fingers or the position of the thumb; this could, then, as easily be a left hand as a right hand.

MR13: black hand (left? right?), it is also entirely scratched and illegible.

MR14: This consists of a circular, red, scratched area where a halo of spots of red paint remains with traces that seem to resemble a hand placed horizontally (perhaps a right hand?). One can say no more, as it is so hard to see (fig. 49).

MR15: left hand, red, on which the ring and little fingers are folded.

MR16: left hand, red; here, too, the ring and little fingers are folded. This hand—vertical as are most of them—is surrounded by a dense halo in which can be seen large particles of paint sprayed on the rock. It has been, like so many others, overlaid by slanting scratches: at least 10 wide incisions apparently drawn with a stone tool. Finger tracings occur beneath the paint halo; they also have been cut through by later scratchings.

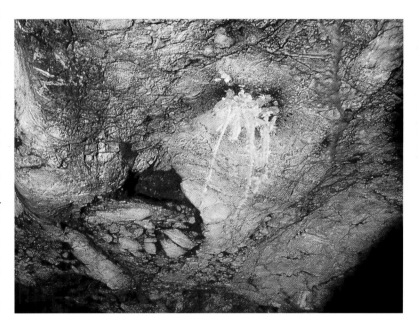

49. Red hand MR14 almost entirely obliterated by later engraved lines

50. Locations of hand stencils in the Cosquer cave. Most of them are found near the large submerged shaft

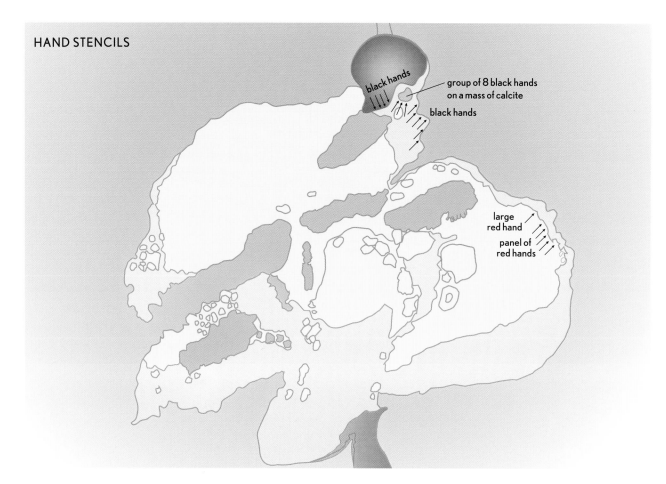

HAND STENCILS

black hands

group of 8 black hands on a mass of calcite

black hands

large red hand

panel of red hands

Of these 46 hands, 34 (or 74 percent) have been made against black backgrounds ("black hands"), and only 12 (26 percent) against red backgrounds ("red hands"). Of the 38 that are identifiable (some are too defaced and deteriorated by later scratching for one to be able to discern the position of the thumb and so to be precise about which hand it is), one can distinguish 34 certain left hands (that is, 89 percent) and 4 right hands. Thus, we have about the same proportion as at Gargas, where there are 136 left hands and 22 certain right hands. It is thus left hands against a black background that strongly predominate, though we cannot draw any conclusion as to the meaning of this, except that since most people are right-handed, they would tend to keep that hand free as a matter of course.

The hands showing incomplete fingers that are "shortened" or folded number 25, which represents a significant percentage (66 percent). Among these hands, the largest number—that is, 15 (60 percent)—have two fingers bent, the ring and little fingers. Only 6 display three incomplete fingers, the little, ring, and middle fingers. On 2 hands, only one finger, the little one, is shortened. Finally, only 2 hands, one left and one right, have four fingers folded. The thumb is always intact.

What can be said about these observations? The notable frequency of hands with incomplete fingers, in particular those where the two last fingers are folded, that is 15 out of 25, could well indicate a particular meaning for this "sign," but can one reasonably say more?

At Gargas, further studies[41] have shown that of 231 hands counted (143 of them black), of which in fact only 124 are sufficiently clear and well-preserved to allow accurate examination, 10 show complete fingers, with 114 "mutilated."[42] As for Marc Groenen's inventory, it shows 192 certain hand stencils and 20 "probables."[43] Still at Gargas, the finger positions display significant short-

ening or folding. Most often, in fact, three or four fingers are reduced to one phalanx. According to Claude Barrière, of all the hands with incomplete fingers, 52 percent show four fingers, not the thumb, shortened in this way.[44] We have seen that at Cosquer the shortening of four fingers is exceptional and occurs in only two examples.

In the Cosquer cave, taking into account only the cases that can be identified with some certainty—that is to say, setting aside the hands that are too faded or too damaged by scratching—one can group the hands that can be studied into seven categories (see fig. 51):

51. Types of hand stencils in the Cosquer cave. Hands hard to see (badly scratched or faded) have not been included in the tallies. Type 4 (two fingers folded) occurs most frequently

Type 1: complete left hand (10 definite examples)
Type 2: complete right hand (3 examples)
Type 3: left hand, little finger folded (2 examples)
Type 4: left hand, little and ring fingers folded (15 examples)
Type 5: left hand, little, ring, and middle fingers folded (6 examples)
Type 6: left hand, all fingers folded except the thumb (1 example)
Type 7: right hand, all fingers folded except the thumb (1 example)

whole hands with fingers intact, left	10
whole hands with fingers intact, right	3
left hands, little finger folded	2
left hands, little and ring fingers folded	15
left hands, little, ring, and middle fingers folded	6
left hand, four fingers folded (not the thumb)	1
right hand, four fingers folded (not the thumb)	1

It is the fourth type (two last fingers folded) that is most frequent among the hands with incomplete fingers. As at Gargas and at Tibiran, the thumb is always intact. In short, one finds at Cosquer only 2 cases of hands (right and left) on which four fingers are folded. These digital positions are fairly different from those observed at Gargas, where the examples are much more diversified (16 types, according to Barrière). At Gargas, hands with four fingers folded predominate, while there are only 2 at Cosquer. If then—and this is the hypothesis to which we have turned—it is a question of a code language expressed by folding the fingers, the codes were different at Gargas and at Cosquer, which would not be surprising given the geographical distance between the two sites.

Dating the Hand Stencils

From our very first visit to the cave, in September 1991, we noticed clear and repeated superimpositions. These indicated, from the first observations, that there were obviously several phases for the art of the Cosquer cave, something which the photographs made by Henri Cosquer had already predicted. Thus, the countless finger tracings that covered whole sections of walls and ceilings always underlay painted or engraved animals, without a single exception. Examining the walls directly, we were able to see that it was the same for the hand stencils; many of them were cut off or overlaid by engraved animals. On the other hand, several hands were superimposed on finger tracings or at times underlay these tracings, indicating a near contemporaneous age for these types of representations. Thus, there are apparently two distinct phases in the Cosquer cave: finger tracings and hand stencils representing the oldest phase, and painted or engraved animals, as well as signs, making up the more recent phase.[45]

The campaign of June 1992 allowed us, with the help of Jacques Collina-Girard and Michel Girard, to complete the inventory of hands, almost doubling their total, from 26 to 46, and confirming the first observations: the hands are really part of the most ancient testimony to the passing of humans through the cave. But what is their age?

Concerning Gargas, several authors have put forward the hypothesis that the hands and engravings could be contemporary, the engravings of the cave in the Pyrénées being attributed to the Late Perigordian (Gravettian) period. The Abbé Breuil had already ranked the hand stencils among the most ancient artistic manifestations of prehistory and placed them in the "Aurignacian-Perigordian," relying on cases of superimposition of archaic figures, paintings, or engravings over hand stencils, notably at Font-de-Gaume and at El Castillo. Modern methods of absolute dating have just confirmed this inspired intuition of the most renowned of the leading lights of prehistory.[46]

A strong argument had already been furnished from the excavation of the Labattut shelter in the Dordogne, with the discovery in the stratigraphy, in a Gravettian level, of a detached block from the ceiling showing a hand stencil on a black background; up to now it is the only hand stencil truly fixed from the point of view of chronology.[47]

In June 1992, in addition to numerous charcoal samples from several places on the ground in the Cosquer cave we took minuscule samples (from 10 to 50 milligrams) from the paintings of the animals and from one of the black hands situated across from the feline head, on the east wall of the large chamber (hand MR7). It is from this last sample of charcoal that Hélène Valladas, of the Centre des Faibles Radioactivités at Gif-sur-Yvette (CNRS, CEA), obtained a date of $27,110 \pm 390$ B.P. (Gif A 92,409). A second analysis done on the same sample, which had been divided in two, supported the first: $27,110 \pm 350$ B.P. (Gif A 92,491).[48] These very early dates are particularly interesting as they definitely place the hand stencils at the very beginning of Quaternary art and prove that hunters of the Gravettian were present on the shores of southern Provence.

Now, this culture, represented in Liguria, on the Riviera (caves of Grimaldi at Menton), and along the shores of the Var (caves of La Bouverie and of Les Baumes-Rainaudes at Roquebrune-sur-Argens, the sites of Les Gachettes at Les Arcs, of Le Gratadis and La Cabre at Agay in L'Estérel),[49] has until now not been found in any cave or shelter around Marseilles. The discovery of the Cosquer cave and the chronological position of its art in Phase One allows us to surmise that related habitats are now submerged. Thus, vast underwater caves along the coast of Les Calanques could hold, if they have been preserved since the rise in sea level, deposits containing Gravettian tools. Whatever the

case, the hands in the Cosquer cave represent the oldest directly dated wall paintings in the world.

By one of those happy coincidences that at times occur during the course of research, the hands of Gargas, the age of which until now could only be assumed, could at last be dated with precision. This, thanks to the discovery at Gargas by Jean Clottes of small bone splinters embedded in some cracks in the wall next to the hand stencils, notably next to Panel VI of Chamber I, a panel of black hands and red hands (see fig. 177). Submitted to the verdict of the Tandétron at Gif-sur-Yvette, these splinters furnished a date very near that of Phase One at the Cosquer cave: 26,860 ± 460 (Gif A 92,369).[50] Thus, the dates obtained at the Cosquer cave and Gargas cave situate in time these enigmatic hands with incomplete fingers, found in fact, as we have seen, at only a very few sites.

One can thus at present confirm that hand stencils, at least the oldest among them, were painted in the Franco-Cantabrian caves during the Gravettian, 27,000 years ago. This does not in any way mean, of course, that this distinctive motif did not still occur widely during the Upper Paleolithic, as André Leroi-Gourhan[51] suggested. Spanish prehistorians have been able, thanks to a providential hearth, to date the hand stencils of La Fuente del Salín: they are more recent by several millennia, with a date of 22,340 B.P.[52] This remains, however, within the Gravettian[53] cycle, and uncertainty persists as to when the motif of hand stencils disappeared from Paleolithic art.

At Cosquer, one can certainly ask the question whether the black and the red hands are the same age. It was a black hand, done with charcoal, that could be dated by the Tandétron. No direct dating is presently possible for the hands on red backgrounds. On first analysis, the placement of red and black hands in the cave could indicate a chronological difference, since in the area of the large shaft one finds only black hands, and on the east wall, more to the south, one finds red ones. But this panel of red hands also includes some black hands; the separation is thus not as absolute as it might seem at first glance.

For the moment, given our state of knowledge and the progress of work in the cave, no argument permits a conclusion. The only remark one can make is that out of 34 black hands, only one is a right hand, while 3 out of the 12 red hands are right hands. Is this observation significant? Whether the hands are black or red, most of the time they overlie the finger tracings, though in some cases they lie beneath them. The hands that have been "neutralized," "destroyed," or erased by scraping, scratching, or incisions, or by breaking the support (drapery of the large submerged shaft) or by painting dots or lines over them, are indiscriminately black hands and red hands. Finally, all the hands are situated in the eastern part of the cave; there are none at all in the rest of the network remaining above water, vast and complex as it is.

To conclude, it does not seem to us in any way unrealistic to say that the hand stencils in the Cosquer cave are the same age, without putting a date to the period of their realization. As for their meaning, we have discarded the hypothesis of mutilations, whether voluntary or pathological, and accepted the hypothesis of folded fingers, symbols in a language of gestures that over the millennia tries to send us a message that no one—and that is the one certainty—will ever decipher.

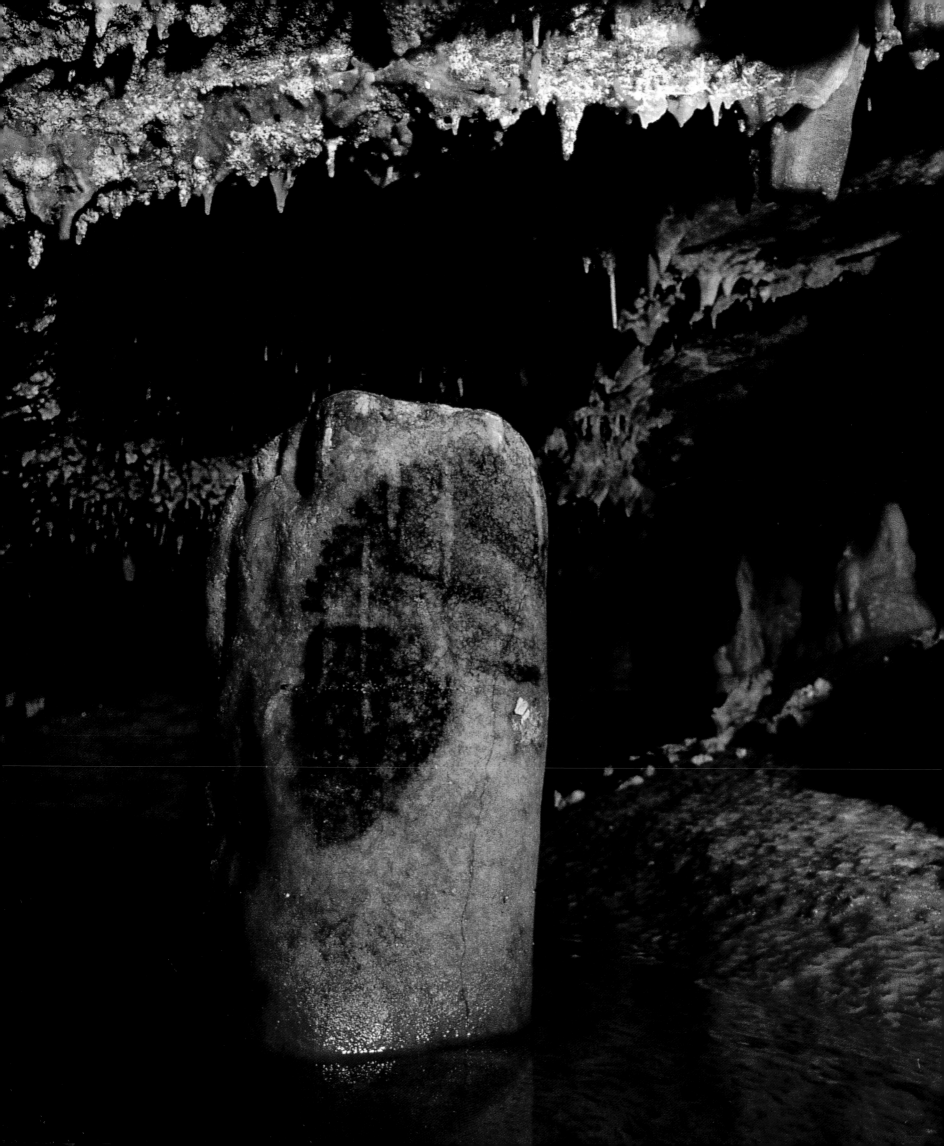

5. The Land Animals

In the Cosquer cave, 87 painted or engraved land animals have now been recorded, and the examination of the walls and ceilings is far from finished. Other engraved animals, more difficult to spot than the painted ones, are sure to be discovered in the course of the next dives. Some of those presented in this book were only seen during the very last minutes of the work done in June 1992.

Discovered at the end of the last century, the Paleolithic wall art of western Europe owes its just renown to the large number, the variety, and the quality of its animal representations. The human figures—often grotesque—along with the geometric signs and the indeterminate lines so numerous in most caves, are all an integral part of the same discourse by prehistoric artists and probably embody just as much of the meaning and symbolism as do the animals. However, they remain much more mysterious, move our imaginations less, and arouse less interest among nonspecialists.

Despite appearances to the contrary, identifying the animals, naming them precisely, is a delicate process full of pitfalls. It is important to review this process before describing and analyzing the animals depicted in the Cosquer cave.

Identifying the Animals in a Decorated Cave

When we say, "This engraving represents an old male ibex," such a simple affirmation is the outcome of a certain number of presuppositions and of a mental process the nature and stages of which must be defined in order to avoid errors in identification.

Striving for a specific identification, especially when seeking the greatest possible precision, implies that one implicitly assumes prehistoric artists were concerned primarily with representing living animals as they were, in a naturalistic manner that we would today describe as "photographic." This is a possibility, without being either self-evident or inevitable. After all, conventions and stylization do transform the reality observed; in some cases, ambiguity could have been deliberately sought. Nevertheless, this step is indispensable. Not to begin with it would amount to answering the question on a priori grounds and assume that this art is only appearance, illusion, and a deliberate transformation of the real. This conclusion cannot be ruled out, of course; but it can be accepted only after the naturalism of the figures has been tested.

The constants one observes in Paleolithic art, like the comparisons that can be made with contemporary hunter-gatherers in different parts of the world, show that this art is neither unmotivated nor abstruse. It communicates a message even if, in the most extreme case, that message was

52. Horse's head (Chv17) perfectly centered on a stalagmite, the base of which is now bathed by the sea

81

only comprehensible to a small group for a brief period of time. "The meaning of the figures, even the most abstract, remained clear from beginning to end for the users."[1]

The Paleolithic message includes multiple components, the most important of which are the animals. What could be more natural for big-game hunters who depended on them for survival? These animals constitute a "bestiary, that is to say the conventional assemblage of a fauna linked to precise socio-religious traditions."[2] This bestiary is represented—which was not self-evident—in a largely naturalistic way, so that 20,000 years later we are usually able to recognize the animals.

The artists projected mental images of animals with which they were familiar onto the walls of the caves and concretized them. From their unlimited store of images, they set about choosing themes and postures and deciding if their subjects would be complete or not, whether they would be stylized or detailed. The reduction of reality is inherent in all art. The choices made are a function of the artist's intentions but also of the conventions of the age, and so they reveal to us precious information about both.

The Paleolithic artists did not share our concern with zoological exactitude, and their criteria of identification were not necessarily the same as ours. For example, we will see with the animals of Cosquer that the artists often represented a part for the whole and were content to sketch a head or forequarters instead of depicting the entire animal. In some cases, they exaggerated certain distinctive morphological traits, such as cervid antlers, the horns of male ibex, and the long necks of does and horses, or they specified details ordinarily invisible from the angle of representation chosen. All that without concern for scale: horses or bison can very well be smaller than ibex on the same walls.

Other concerns played a part. The personal expression of the artist is not the least of these. Certain animals display a perfection in the rendering and a multitude of details beyond what was necessary to identify the species, and this strongly suggests aesthetic enjoyment, a taste for work well done. Conversely, many works appear stiff and awkward. Must one attribute their apparent clumsiness to a lack of ability or to inexperience on the part of the artist? Would such works have had a lesser symbolic value than the others? Deciding one way or another often involves subjective choices.

In a cave, space is limited and even more so are the material possibilities for painting or engraving. Some walls are corroded, cracked, or covered in calcite. Others lend themselves better to drawing, painting, or engraving. The nature and quality of the surface controls choices to a large degree. In a given space, a whole line of animals could be placed, whereas in another space there was only room for an isolated head or an incomplete animal. The frequent use of natural outlines such as cracks or contours of the walls to represent a nose, a line of the back or belly, or legs demonstrates that the artist's freedom was not total. One wonders in numerous instances if the wall did not suggest the work, thus further limiting their options.

It is clear that these images of animals were intelligible in the beginning to those who created them and to at least some of the artists' contemporaries; they may be much less so for us, and thus could prove to be a source of error and confusion.

The test of time makes things worse. Since the Upper Paleolithic, the same walls have been reused on different occasions. This occurs in the Cosquer cave as in numerous others. When two animals are superimposed (for example, Chv13 and Bq7; see fig. 53), were they done at the same time to make a scene or because a ritual required their association, or is one a much later addition without connection to what went before? If lines overlie them (for example, Ph4 and Chv25), are they related to only one of the animals, and to which one? Or to both? Or are they independent of those subjects?

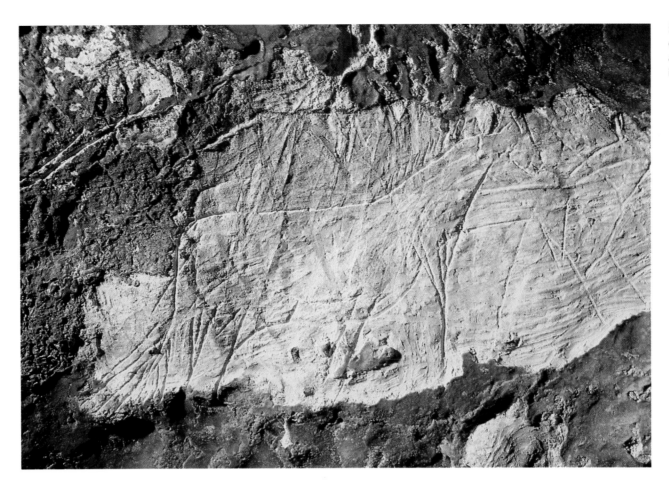

Since their creation, the works have undergone numerous changes. Calcite formation, water flow, and drafts have damaged or faded some; others may have disappeared. It will never be known how many works in the Cosquer cave were destroyed by the rise in sea level, nor what they could have contributed to our understanding of the wall art as a whole.

Since its conception, the words of the Paleolithic message have been garbled at times by the factors mentioned or obscured by nature, but it must still be deciphered. This can be done at different levels.[3] The first distinction to establish concerns the three major categories of wall art: humans, animals, and signs. That seems easy a priori but ambiguities may persist or have been deliberately sought; we will see this with the Killed Man, an image that shares certain characteristics with the seals (see Chapter 8). Paleolithic artists often played with form,[4] and it is not always easy to choose between the hypothesis of animal or that of man, as in the example mentioned, or between that of animal and that of sign, as in the frieze of the ibex-seals-chamois (see fig. 102).

When we are reasonably certain that we are dealing with an animal, we make every effort to identify the species as precisely as possible. In this regard, it is important to note that the rules of taxonomy, the science aimed at an exhaustive classification of living beings, hardly applies to Paleolithic art. The artists have at times contented themselves with representations identifiable at only the very general level of class—for example, fish (one case in the Cosquer cave) and reptiles— even though the genus (*Bison, Bos*) and at times even the species (of horse and ibex) or indeed the subspecies (ibex of the Alps or of the Pyrénées) are often determinable. There again, ambiguities are possible for different reasons, as will be seen with the ibex and the chamois.

For the artists, the sex of the animals drawn may have had an importance we do not suspect; it was probably evident to them that this animal was male and that one female.[5] These distinc-

54–57. Location of painted and
engraved land animals and the Killed
Man in the Cosquer cave

HORSES (Chv)

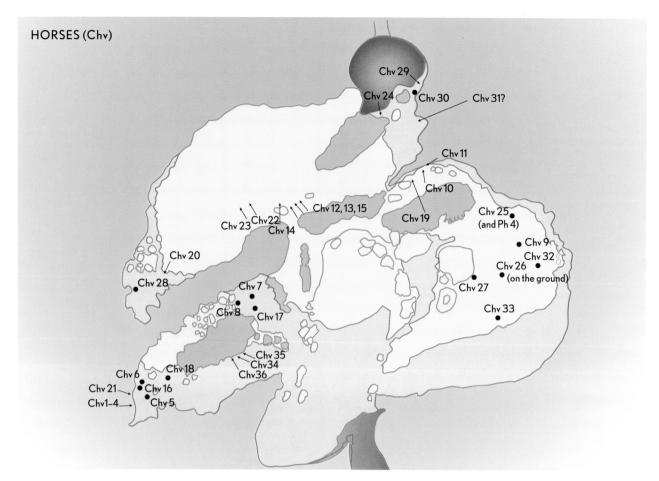

BISON AND AUROCHS (Bi)

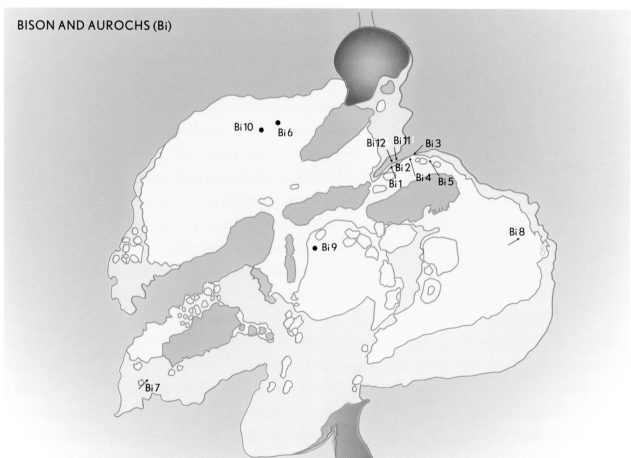

84

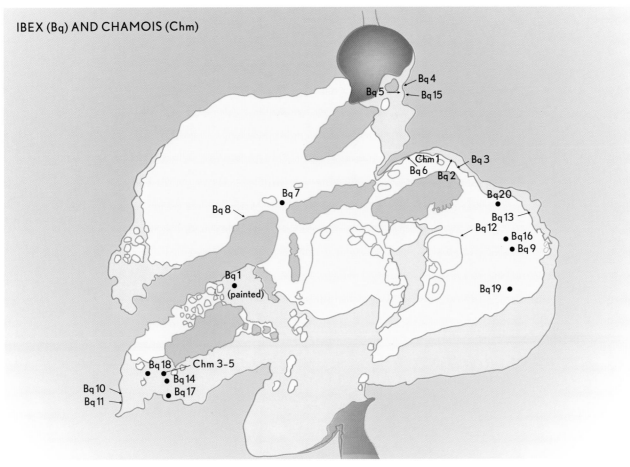

IBEX (Bq) AND CHAMOIS (Chm)

Bq 4
Bq 5
Bq 15
Chm 1
Bq 3
Bq 6
Bq 2
Bq 7
Bq20
Bq 8
Bq 13
Bq 12
Bq 16
Bq 9
Bq 1
(painted)
Bq 19
Bq 18
Chm 3-5
Bq 10
Bq 14
Bq 11
Bq 17

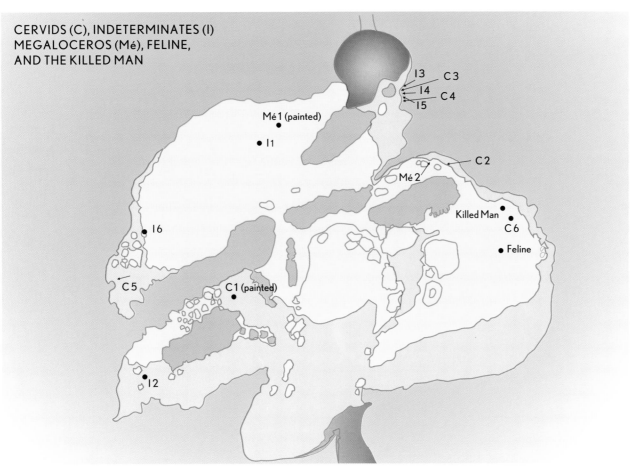

CERVIDS (C), INDETERMINATES (I)
MEGALOCEROS (Mé), FELINE,
AND THE KILLED MAN

I3
C3
I4
C4
I5
Mé 1 (painted)
I1
C2
Mé 2
C5
Killed Man
I6
C6
Feline
C1 (painted)
I2

tions are less obvious to us, except in some quite rare cases. Though at times they depicted the penis of the male, the vulva or udder of the female is almost never shown. No doubt, Paleolithic people identified animals from a distance by their outline rather than by observing their primary sexual characteristics. Thus, a male ibex can be recognized from far off by the marked development of its horns and a male bison by the massiveness of its forequarters, though the sexual organ itself is not visible. The prehistorian, even a specialist in wall art, would not in any case possess the expert knowledge of the Paleolithic hunter, and so he no doubt fails to recognize the distinction, even making mistakes or arbitrary choices. For example, stags that have lost their antlers after the rutting season could be confused with does. And yet, archaeologists classify does as a distinct category, which is not the case for cows or mares or for she-goats. Why wouldn't Paleolithic people have attached as much symbolic value to a bull or stallion or he-goat as to a stag?[6]

The identification of age in the animals represented in Paleolithic caves is an extremely delicate undertaking because of conventions that can distort the interpretation, and because of the lack of scale in the wall art. The horns of male ibex thicken and become longer with age; an ibex with very long horns would thus be very old. There are examples of this (see figs. 86 and 89). In such cases, the artist wanted to convey at least two ideas, that of "ibex" and that of "male." But does exaggerated development of horns really signify "old male bison," as we have a tendency to think, or is it only a graphic device for emphasizing sexual difference?

The positions of the animals are of some interest. In certain areas such as at Les Trois-Frères in the Ariège, they are shown in all sorts of postures—leaping, running, and charging. In the Cosquer cave, as we will see, they are more often fixed, immobile, as though suspended in air. Did the artists want to represent the animals at rest, or simply to convey a stereotyped image of bison, horse, or ibex?

The difficulty of the analytical task is apparent, as are the pitfalls of subjective decisions. The process of identification depends on various factors. The intrinsic characteristics of the animals, that is, their morphology and their poses, are what we use to form our mental images; these differ from one individual to another depending on the observer's culture, and they no doubt differ from those of Paleolithic hunter-gatherers. Faced with an animal depiction, we say, "This is a bison," or, "This is a horse," when the work of art coincides with the image we have in our minds. For each person, this image results from observation of living animals in nature or in films, literature, or even Paleolithic art itself. It will vary considerably as a function of personality and experience. The immediate characterization is thus an instinctive process with relative value, properly speaking.[7] In numerous cases, very happily, the Paleolithic depictions are sufficiently close to reality so as to be instantly recognizable, at least at an elementary level. To make the identification rational, to give it a solid basis, and to push it as far as possible, we call on ethologists, specialists in the animals under consideration, or we turn to comparative documents. All this serves to reinforce the observer's field of mental images so that they better coincide with the work being studied.

Two temptations threaten: that of rejecting the unintelligible and that of pushing the identification to extreme limits. These are tendencies common to all and sources of error. "Faced with a confusion of lines made with fingers or engraved, the mind seeks . . . instinctively for forms and motifs. It rejects at the outset the unintelligible. This can lead the prehistorian to biased interpretations."[8] This insidious temptation is all the more risky for the specialist, who has in mind a series of mental images based largely on a personal knowledge of Paleolithic art. The specialist's tendency is, quite naturally, to project these images on artificial or even natural configurations in the

caves. Without an ever alert critical spirit and constant questioning, it is inevitable that mistakes and confusion will occur.

The second universal instinctive tendency is to push an identification to its limits. The mammoths depicted at Pindal (Spain) and at Cougnac (Lot, France) were once attributed to a long-extinct species of proboscidean, the ancient elephant, because of an absence of hair, a feature probably attributable to the schematic nature of the animal representations. It is advisable in such cases to strike a balance between the argument for literal representation and that for artistic license.

In conclusion, it is clear that subjectivity is inherent in the identification of figures and that their classification will never become an exact science. There must always remain a hazy area of imprecision and undeniable mystery.[9]

Horses

Of the 36 equids recognized up to now in the Cosquer cave, none can be attributed to a species other than that of horse. No wild asses have been identified there.

Paleolithic Horses

The horse, along with bison and reindeer, was one of the most frequently hunted animals during the Upper Paleolithic period. It much prefers steppes or prairies to forests; it is an animal of open spaces and adapts to many different climates even though, when it is predominant among the fauna, the tendency is to consider it a "cold-adapted" species, referring to the landscape of plains and steppes that suits it best.

Since the end of the nineteenth century various attempts have been made to distinguish subspecies among the representations of horses in wall and portable art, as reflected in variations in mane, coat, and shape. These attempts were abandoned because of the contradictions that arose over the postulated coexistence of numerous different subspecies. The variations noted are instead attributed to the degree of skill and interest of the artist. At present it is believed that the horses hunted and depicted must have been quite close to certain subspecies that have persisted to our day, such as Tarpans, Pottioks, Merens, and above all the Prjewalski's horse, which still runs wild (but for how much longer?) on the steppes of Mongolia.

In Quaternary art, the horse greatly predominates, since it accounts for about a third of the animal representations. This statement must nevertheless be qualified at both a geographical and a chronological level. In fact, depictions of horses are very much in the majority throughout the Middle and Late Magdalenian periods, from 15,500 to 12,000 B.P. However, in the Pyrénées, for example, their frequency decreases consistently from west to east as the frequency of the bison increases. Horses are less numerous in the Early Magdalenian, from 17,000 to 15,500 B.P. During the Solutrean, from 21,000 to 18,000 B.P., the period to which the animal art at the Cosquer cave belongs, horses abound in the cave of Le Placard in the Charente department, while they are in a minority in the art of Quercy and the Ardèche. Choices were made that did not always reflect changes in the fauna itself, but rather preferences of a cultural nature.

Among the representations of horses, the most elaborate, with all details of hoofs and coat shown, are found next to the most schematic, sometimes on the same panel (for example, at Niaux in the Ariège). The horses are always depicted in profile, although seen face on they would

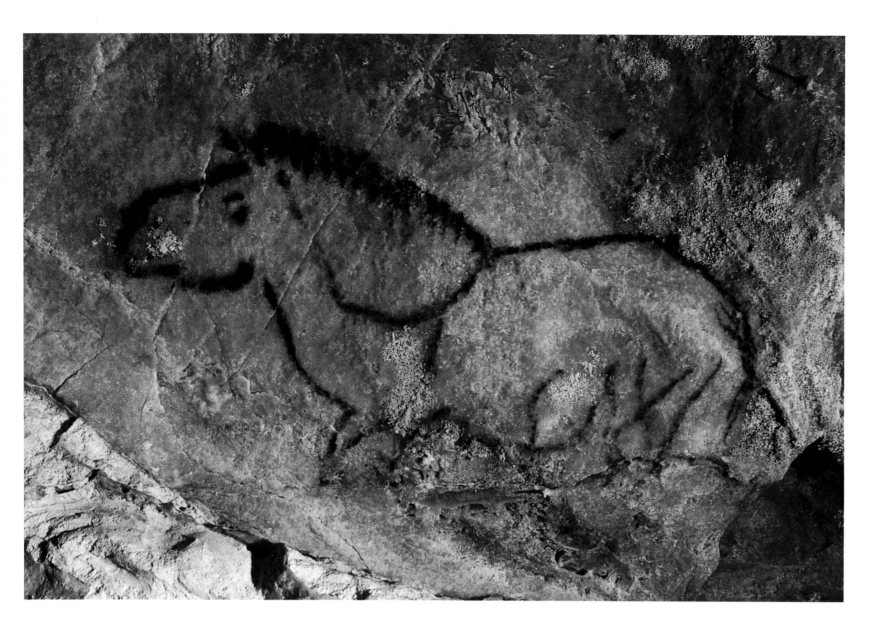

58. Large black horse (Chv7) painted on a low ceiling

have been equally distinctive. It is rare that the sex is indicated and when it is, the penile sheath is shown in only a cursory way, an astonishing discretion for hunters to whom the impressive sight of a rutting stallion must have been quite familiar. Some horses with rounded underbellies have at times been interpreted as gravid mares, until André Leroi-Gourhan rightly remarked that horses, whatever their sex, have "big stomachs" when they eat damp grass in the springtime.

The postures of the horses vary according to the cave: jumping at Bruniquel in the Tarn-et-Garonne department, falling at Lascaux, and galloping or neighing at Le Mas d'Azil in the Ariège department, among others. Only one coupling is known, at La Chaire-à-Calvin in the Charente. The coat, when shown, lends itself to variations: certain long-haired, bearded horses at Niaux could have a seasonal connotation. Others bear on their bodies a line in the form of a flattened M, indicating a difference in coat color between flank and underbelly. This convention is especially frequent in the Middle and Late Magdalenian, at Niaux, Le Portel (see fig. 172), Les Trois-Frères, Labastide, Ekain, and others. During the same period, the shoulder lines are sometimes drawn repeatedly in exaggerated numbers.

The conventions of representation vary, then, according to the period. While horses are portrayed in a very naturalistic fashion during the Magdalenian, when they are so numerous, those of the Solutrean and the Early Magdalenian display very small heads shaped like duck bills (Le Portel, Pech-Merle), and those of the Gravettian, from 25,000 to 21,000 B.P., heads that are overly elongated (Gargas). However, they generally remain distinctive enough even when reduced to an isolated head or to a head and cervical-dorsal line, with or without a mane, as to be fairly easily recognized.

At the end of the nineteenth century, a well-known prehistorian, Edouard Piette, put forward the idea that horses had been domesticated during the Upper Paleolithic because of works of art where he thought he made out harnesses or leads—in other words, means of guiding the animals. This hypothesis, demolished by specialists of the time such as Henri Breuil and Emile Cartailhac, was abandoned for a long time before being taken up a few years ago by Paul Bahn.[10] This prehistorian cited a few perplexing examples in wall and portable art to support the idea of controlling horses and pointed to teeth displaying a particular pattern of wear due to "crib biting," a damaging habit of confined horses who become restless and bite on any wood within reach.

In fact, the domestication of the horse is far from being established definitively for such long-ago periods: none of the examples cited is really convincing enough to support a definitive conclusion. It is very doubtful that horses were domesticated in our modern sense of the word, but even if most or all of the animals depicted are apparently wild horses, it is nonetheless possible that occasional attempts were made at the time to tame isolated individuals. It happens today that hunters catch fox cubs or very young badgers and raise them as pets. That does not mean that the fox and the badger are domesticated animals.

59. Left: Forequarters of a bearded horse (Chv20), superimposed on finger tracings

60. Right: Horse Chv5 painted on a wall covered with finger tracings. Below right, the top of a crudely painted horse (Chv16) with a "porcupine" mane can be seen

61. Overleaf: Large panel of horses (Chv1–Chv4)

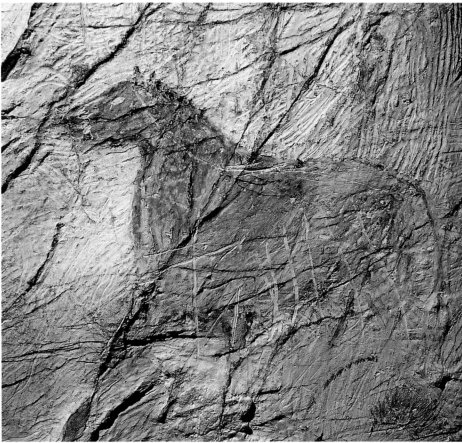

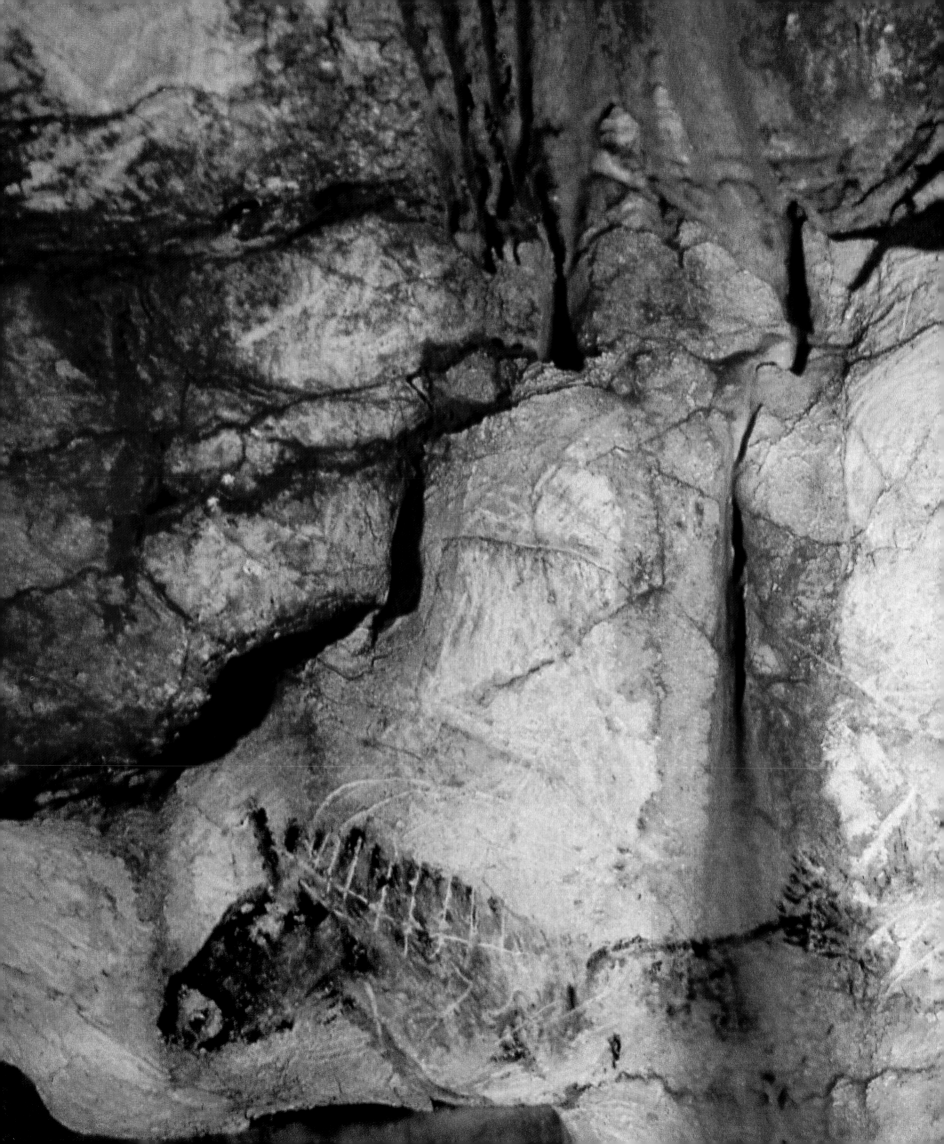

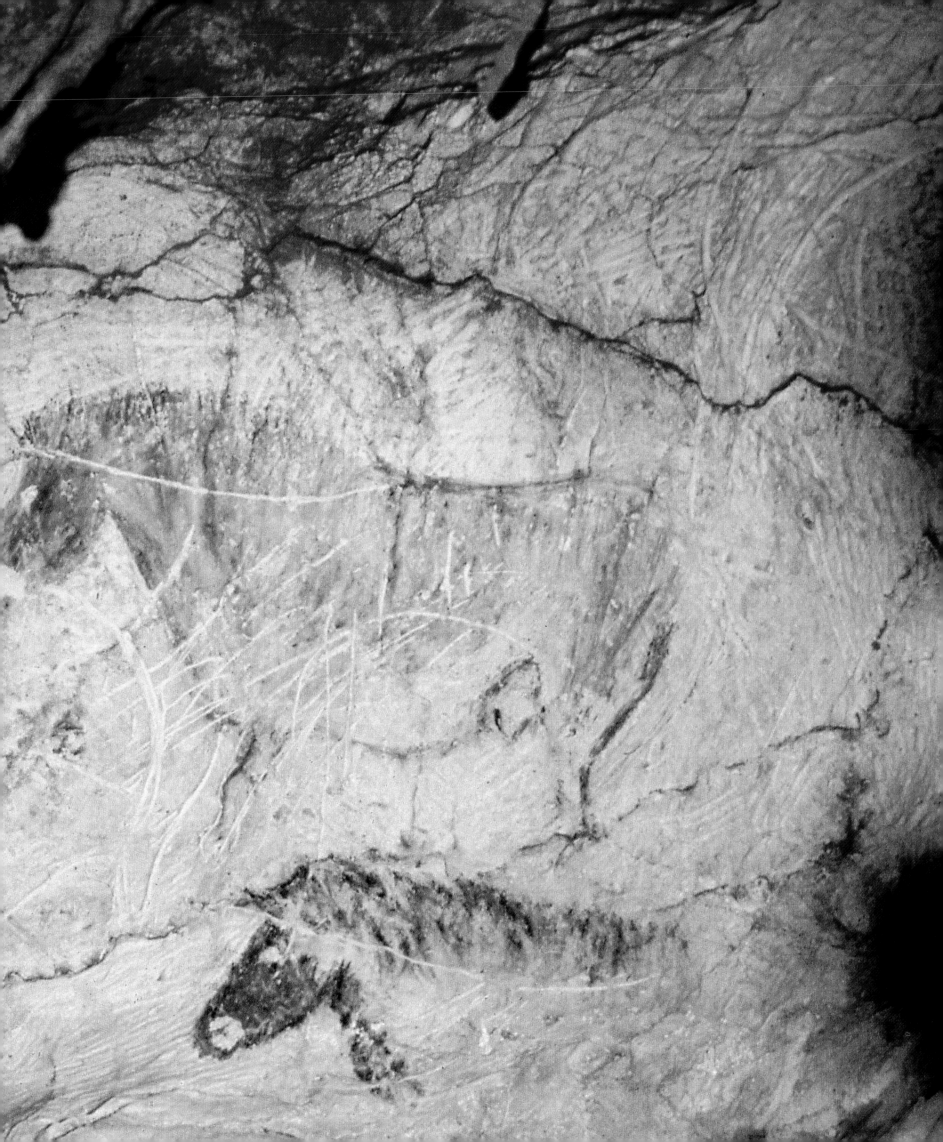

The Horses in the Cosquer Cave

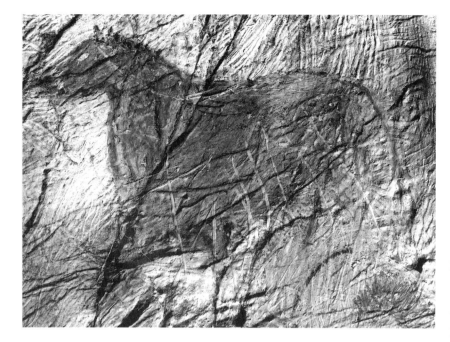

Chv1 (figs. 14, 61): Drawn in charcoal at the extreme southwest side of Chamber 1 on a large panel with 3 other horses (Chv 2–Chv4) and 2 engraved ibex (Bq10, Bq11) on the same wall, bathed by the sea. The ground, presently underwater, lies about 4½ feet (1.4 m) below (fault). Only the head and neck of the animal, turned to the left and framed by the edge of the wall, appear. The head and the upper part of the neck are a solid color. The eye and nostril have been left blank, with a small black line outlining the latter. The mane is erect, indicated with thick heavy strokes overlaid with engraved lines that repeat the paint strokes more or less faithfully. The neck and shoulders are done in broad strokes. Length: 27½ inches (70 cm). A sample lifted at the edge of the nostril was used for two separate datings by mass-spectrometry accelerator. The results were: 18,820 ± 310 B.P. (Gif A 92,417) and 18,840 ± 240 B.P. (Gif A 92,416).

Chv 2 (figs. 14, 61): On the same panel as Chv1, partially covering the base of its neck and shoulders. Like the first horse and Chv3 to Chv10, it is done with black lines. Turned toward the right, about 5 feet (1.5 m) above the ground. A single heavy line indicates the hindquarters. Mane done with multiple lines that extend along the top of the body. The line of the nose is barely discernible, since the forequarters are very eroded, in an area with many later engravings. The lines of this horse (end of the mane and hindquarters) pass over a large, brownish red flow of calcite.

Chv3 (figs. 14, 61): To the right of Chv2, but in a notably higher location, the mane being about 6 feet (1.8 m) from the ground. Complete, with a very long tail reaching the bottom of the leg; a quite voluminous underbelly; only the near fore- and hind legs shown; a quite obvious fold of the groin with the sex indicated by two converging lines in a V shape. The head is very similar to those of Chv1 and Chv2, with the eye and nostril left blank. Outlined with more or less heavy lines and the mane done with short strokes. The interior of the body is shaded, but the underbelly is left blank, a technique well known in the Pyrénées, in Cantabria, and at Lascaux. Length: 27½ inches (70 cm).

Chv4 (figs. 14, 61): Beneath Chv3, turned to the left, about 4½ feet (1.4 m) above the ground. Only the forequarters have been drawn or preserved, the lower part of the body having most likely disappeared due to the effects of salt water. Very similar to the other horses on the panel, with its head a solid color, the eye and nostril left blank, and a long mane of slanted lines extending along the entire upper body. The breast has been depicted by means of two or three divergent lines. Length: 20⅛ inches (51 cm).

These naturalistic horses greatly resemble one another, showing the same techniques and the same workmanship. They were probably done by one artist. The 3 lower ones are cut off at the same height, about 4½ inches above the maximum current water level, which has eroded the rock along this strip. They are all overlaid with numerous engravings.

Chv5 (figs. 60, 62): In the same part of the cave as the first 4 horses and in their immediate neighborhood. On a wall perpendicular to the one on which they are painted. This wall was entirely covered with finger tracings at the time the painting was done. About 5 feet (1.5 m) above the ground. The outlines are simple, the interior of the body is a solid color or done with lines now blurred. The two ears are in frontal perspective. The single blank eye and the nostril have been made by scraping, but the effect is the same as for the first 4 horses. Hindquarters and legs are barely visible. Some lines seem to have been smeared on this soft wall after the painting was done; they are noticeable on the tail, the Y-shaped hind leg, and the front of the breast. The two front legs are far apart. The animal is overlaid with engravings, among which can be made out eight long slanted parallel lines across the whole flank and under them a few perpendicular lines, and a long concave line, made with consecutive strokes, which begins at the top of the head, crosses to the curve of the back and extends to the end of the back; it is reminiscent of the similarly painted concave lines found on horses Chv7 and Chv8. On the back part of the underbelly two parallel, curved, painted lines can be seen—like horns, but isolated and out of context. Length: 32¼ inches (82 cm).

Chv6 (fig. 63): Head turned left, isolated on a rocky overhang, facing the panel of horses Chv1 to Chv4, about 5 feet (1.5 m) above ground. Naturalistic proportions; line of the nose and lower jaw in a continuous heavy line; one ear; four slanted lines indicate the mane; the three-quarters head is filled in with lines, partly eroded, that form a black mass, a bit lightened around the nostril. Length: 17¾ inches (45 cm).

62. Horses Chv5 and Chv16 (lower right)

63. Head of horse Chv6. Note the infill within the outline of the muzzle

Chv7 (fig. 58): Large horse, complete, turned to the left, on a low ceiling near the large ibex (Bq1); simple outlines; mane painted with short parallel strokes; lower jaw very clear, as is the eye (two short lines one above the other); long tail shown as two converging lines. The legs (all four are shown) are quite crude. The front legs are stiff, the hind legs slightly bent (attempt at animation?). Two lines curve from the underbelly toward the interior of the body, parallel to the rear legs. In front, the line of the shoulder is drawn with a long curve leading almost to the ear. Another line connects this one to the top of the right front leg and is covered by a large patch of calcite. Also covered with calcite are a part of the nostril, the top of the right front leg, and the midsection of the body; the hindquarters are covered by a thin layer of calcite. Length: 26 inches (68 cm).

Chv8 (fig. 75): Turned to the right, complete, on the same low ceiling as Chv7, 2½ feet (0.8 m) above the ground. Usual technique of simple outlines and short, thick paint strokes for the mane. Only the near foreleg and hind leg are shown, barely sketched, with two lines each for the upper part; long tail; long slanted line from the dorsal line to the head, difficult to see beneath granular white calcite that covers it as well as part of the front leg and the neck. The underbelly is rounded, a large part of it covered in calcite. Length: 23⅝ inches (60 cm).

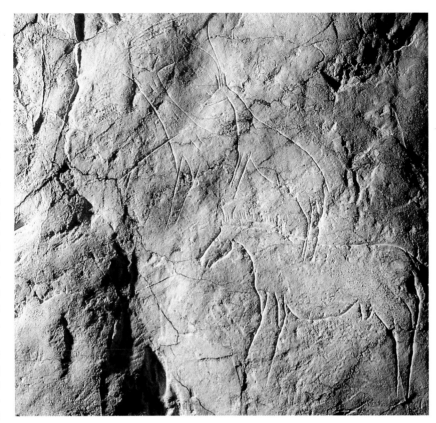

with black lines. The mane is done with long thick parallel lines, and the breast is sketched with a single line. The eye is missing because a large patch has flaked off. That patch looks as weathered as the rest of the wall but fell off after the drawing was done. The lines appear quite eroded. Length: 21¼ inches (54 cm).

Chv9 (fig. 65): Head and neck turned to the right, on a ceiling covered with finger tracings in the east section of the large chamber, not far from the feline head. It is about 4 feet (1.2 m) above the ground. The head is completely filled in

Chv10 (fig. 76): Head and shoulders, turned left, painted above the hindquarters of a bison (Bi2). Chest with multiple lines that are quite eroded. The mane, also eroded, is barely visible. The nostril has been left entirely blank, as for

horses Chv1, Chv3, Chv4, and Chv5.

Chv11 (figs. 64, 100): At the top of the bison fault. Turned left, engraved near both a chamois that overlies it and a doe. Good proportions, voluminous underbelly, long tail, sex very apparent, indicated by two V-shaped converging lines, as for the horse Chv3. The four legs are Y-shaped, very spindly. The dorsal line, a little curved, is repeated over the hindquarters by another line, which becomes the mane, done with short lines perpendicular to the second line. The head is delicate, with a round eye and a nostril. The lines are relatively deep, cut with a sure hand. Length: 17¾ inches (45 cm).

Chv12 (fig. 68): Engraved on a ceiling directly south of the panel of great auks. Turned left. The forequarters and the head are in a flaked-off area covered with finger tracings, while the lines of the back and the underbelly are cut into the reddish coating of the wall. The hindquarters have not been engraved because the area they would have occupied has a very rough surface with a reddish crust. The line of the nose is very straight, following the flaked-off area exactly, so that the act of engraving could well have precipitated the flaking. The line of the jaw is strong. No eye or nostril is visible. The breast joins the top of the

64. Animals engraved on the same panel, right to left: horse Chv11, chamois Chm1, and doe C2

65. The head and neck of a black horse (Chv9) have been painted on a wall with a soft surface

66. Horse Chv13

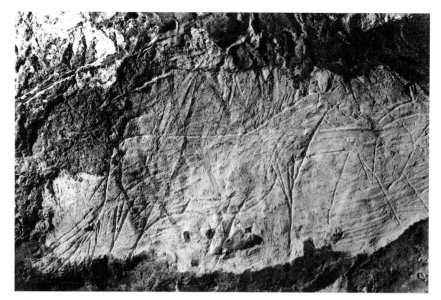

67. Far right: Horse Chv15 (drawing)

68. Below left: Forequarters of engraved horse Chv12 (drawing)

69. Below right: Horse Chv15 has been engraved immediately in front of Chv12

Y-shaped front leg, drawn more vigorously. The mane is done with short slanted lines. The body is overlaid behind the front leg with long curved lines that join the back and underbelly. They could represent the coat, as could a dozen finer short parallel lines on the neck. Short lines have also been engraved all along the lower outline of the head. The head measures 9⅞ inches (25 cm) and the body about 27⅝ inches (70 cm) in length.

Chv13 (figs. 53, 66): Engraved immediately to the right of and above the horse Chv12, across from the passage leading to Chamber 2, between 5 and 6 feet (1.5 and 1.8 m) above the ground. Turned to the right. In a flaked-off area like the panel under the horse Chv12, on a wall covered with uninterpretable lines and finger tracings. This complete horse has one foreleg and two hind legs—all three Y-shaped—a long tail, and a mane standing up toward the front from the line of the neck. The rounded underbelly overlies two long lines. Numerous lines converge around the tail in a tuft. Length: 21⅝ inches (55 cm).

Chv14: In Chamber 2, on the same low ceiling as megaloceros Mé1, immediately beneath a large zigzag sign

and perpendicular to it, the forequarters of an engraved horse can be seen, the head turned to the left, precisely drawn with two firm curving lines, one line for the chest, a partly repeated line for the back, two stiff lines for the Y-shaped front legs, which are barely sketched and too short, and the beginning of the underbelly cut through by a vertical line.

Chv15 (fig. 67): Placed just in front of the horse Chv12, with which it forms part of what is really a frieze of engraved horses that also includes the horse Chv13, facing right, and Chv12 and Chv15, facing left. Only the forequarters of Chv15, with part of the back and the underbelly, are represented. The head is well done, with the lower jaw well delineated and the nose outlined twice. The ears are super stiff, like caricatures, and the rest of the animal is extremely sketchy: under the line of the breast, two parallel lines indicate the front leg; the

Chv15

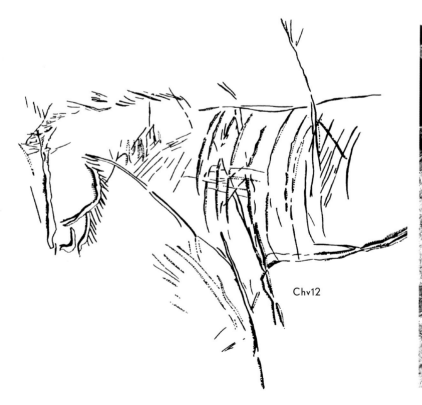

Chv12

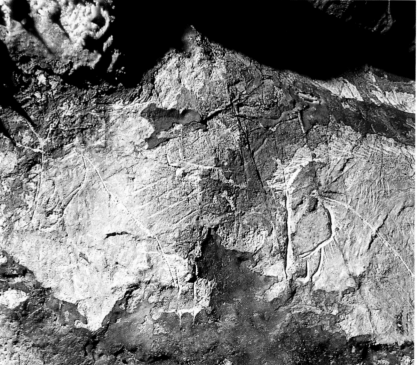

dorsal line perhaps done in two strokes. The interior of the body is marked with four slanted lines. This horse quite closely resembles horse Chv12, its neighbor; like Chv12, the body is filled in, and extra attention has been given to the lower jaw.

Chv16 (fig. 60): Beneath the tail of horse Chv5, and also placed over numerous finger tracings, are painted the head and neck of a horse turned to the left. The head, from the top of the nose to the angle between neck and breast, is sketchy, but the mane is bushy, a little reminiscent of the mane of the nearby horse Chv2, and this makes it somewhat resemble a hedgehog. Length: 16⅛ inches (41 cm).

Chv17 (fig. 52): Nearly 10 feet (3 m) below the low ceiling with the ibex Bq1, the deer C1, and the 2 painted horses Chv7 and Chv8, a stalagmitic column not quite 2 feet high displays the head and shoulders of a horse, well-centered, turned left, with solid black paint for the head, short lines for the mane, and thick black strokes for the breast and the interior of the body. The effect is quite unexpected and striking. On the other "side" of the same column, the base of which is under the water, some blackish lines could be the traces of another animal now disappeared. Length: 11¹³⁄₁₆ inches (30 cm).

Chv18 (fig. 72): Painted in black on a wall 5½ feet (1.7 m) above the ground at the west side of Chamber 1, facing horses Chv1 to Chv4. The wall is covered with finger tracings, which are overlaid with numerous fine engravings, among which are an ibex and some geometric signs. Only the forequarters, turned to the left, are shown. The finger tracings are misleading, as the eye tends to

take in certain ones as part of the animal, but there does seem to be a head with a large eye made by two converging lines, a beard, a bushy mane marked with numerous painted and engraved lines, and the breast. There seem to be other black lines beneath this horse (leg?). Length: 19⅝ inches (50 cm).

Chv19 (figs. 121, 122): In the bison fault, to the left of Bi1, on the wall, about 5½ feet (1.7 m) from the ground are the forequarters of a horse turned to the left, opposite a seal (Ph3). The two animals are in vertical position. The head is engraved with deep, vigorous strokes, with one ear as a continuation of the nose. The muzzle is indicated, and the outline of the cheek is strongly emphasized. The line of the breast continues on to become the front of the Y-shaped front leg; the other front leg, seen head-on, is similar. The underbelly and the dorsal lines are barely visible. On the other hand, the mane is quite apparent, a whole series of short parallel lines that extend beyond the ear to the top of the line of the nose.

Chv20 (fig. 59): On a ceiling 5 feet (1.5 m) from the ground, in the northwest part of the cave, immediately to the south of The Cemetery shaft. Engraving of the forequarters of a horse turned to the left, superimposed on numerous finger tracings. It very much resembles the horse Chv19, with the cheek clearly marked, the nostril indicated, and the Y-shaped front legs in head-on perspective. The ears are cursorily sketched with two stiff lines, like the horse Chv15, and there are some short lines to indicate a beard, as for the horse Chv12. The curved dorsal line is repeated above with a finer line, at the top of

which some slanted lines depict the mane. For once, a specific line connects the breast with the front leg, which gives the animal a somewhat more supple look. Length: 15¾ inches (40 cm).

Chv21 (figs. 70, 113): In the southwest part of the cave, the cursorily engraved forequarters of this horse, turned right, are located on an extension of the panel of horses Chv1 to Chv4, on the same wall, about 4 feet (1.2 m) from

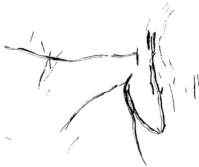

the ground, which is presently underwater. The water level is about 10 inches (0.25 m) below the horse, on average (June 1992). In this area, two vertical lines extend underwater. Head with few details, two stiff lines for the ears (as for Chv15 and Chv20). The line of the nose is repeated at the top. A wavy line extends down beneath the neck, and there seem to be two short converging lines in the middle of the back. Length: 17¾ inches (45 cm).

Chv22: On the ceiling to the northwest of the great auks, 5¼–6 feet (1.6–1.8 m) above the ground is the rather crude engraving of the forequarters of a horse, turned left. The head is too large, but the jaw is well-defined and recognizable. Y-shaped legs. Wide crosshatches on the back, which seems not to be otherwise indicated. These crosshatches extend onto the head. Length: 13 inches (33 cm).

Chv23: Turned right, engraved in vertical position in front of and above the horse Chv22, with its head very low. Schematic sketch, done with five lines: back, breast, nose, jaw, and nostril. A line cuts through the breast. Length: 13 inches (33 cm).

Chv24 (figs. 46, 71): Right at the edge of the large shaft, on the ceiling, 6½ feet (2 m) from the ground, which is underwater, this complete horse, turned left, has been engraved over 4 black hand stencils (M23–M26). The head is relatively detailed, with a large eye indicated by a semicircle curiously connected to the line

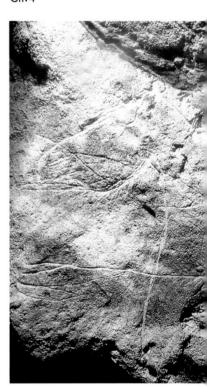

70. Left: Horse Chv21, shown here in a drawing, was engraved immediately to the north of painted horses Chv1–Chv4

71. Horse Chv 24

72. Left: Head and neck of horse Chv18, a cursory engraving on a wall entirely covered with finger tracings and fine engravings

73. Horse Chv26, very cursory, engraved on the floor of the cave

of the nose. The jaw is stressed, as is the beard. The four Y-shaped legs are in frontal perspective. The mane is done with slanted lines connected to the dorsal line. Long and very shaggy tail, in a tuft. The sex is V-shaped, as for the horse Chv3 and the ibex Bq4. Several lines cross on the nostril. A large sign, barbed at both ends, crosses the animal at breast level. Some other signs, in the other direction and very much shorter, feathered at one end only, are parallel to the large sign. A wide smear from a torch is present beyond the tail.

Chv25 (fig. 124): Engraved at the northeast side of Chamber 1, on a ceiling covered with finger tracings, 5¼ feet (1.6 m) above the ground. Many pieces of charcoal are scattered on the ground here. This complete horse, turned to the left, is well proportioned. Its ears are erect, without touching each other; the jaw is well defined. The mane is isolated between the top of the head and the dorsal line, which extends into a long stiff tail. The four legs, seen from the front, are Y-shaped. A seal (Ph4) is superimposed on this horse inside the body, as are some long intersecting lines. Length: 20⅞ inches (53 cm).

Chv26: Head and neck of a horse turned to the left, engraved on the ground (the slope of a large calcited block), in the east section of Chamber 1, south of the feline. Quite poorly done, though an ear and eye are indicated. The top of the breast is depicted by multiple lines, and there are two slanted parallel lines on the neck. Length: approx. 11¾ inches (30 cm).

74. Horse Chv31, a crude depiction

Chv27: Fairly crude engraving of the forequarters and underbelly of a horse turned to the left. The head is done with wide lines, with a line in the middle for the nostril. The mane is scraped, while the forequarters, the legs, and the underbelly are done with fine lines. Hard to see, since the surface of the wall is very uneven and the animal is superimposed on numerous finger tracings.

Chv28: On a wall at the west end of Crab Boulevard, behind the cervid C5 there is possibly the head of an engraved horse, turned left.

Chv29 (figs. 98, 99): On a ceiling at the edge of the large shaft, 6¼ feet (1.9 m) from the ground, this engraving of a complete horse, turned right, cuts through the black hand M10. The animal has Y-shaped legs, with only one foreleg. The tail does not touch the hindquarters. The animal is crudely made and is cut through by other lines. In this area there is a confusion of many very fine engravings. Length: 9⅞ inches (25 cm).

Chv30 (figs. 98, 99): On a ceiling at the edge of the large shaft, 6¼ feet (1.9 m) above ground, on a panel with numerous small superimposed animals, this engraving of a complete horse turned to the right, with an inordinately elongated body is located beneath the ibex Bq15. No detail, neither eye nor ear. Only one foreleg, done with two diverging lines. Rounded underbelly. Hind legs at a very definite angle. Wide slanted lines on the underbelly. This animal is a borderline case but can still be classified among the horses because of its elongated body and the absence of horns or antlers. Length: 12³⁄₁₆ inches (31 cm).

Chv31 (fig. 74): Superimposed on black hand M12, near the large shaft,

on a wall with an uneven surface. Only the forequarters of this horse, turned right, have been engraved. Detached head, extended by a long line for the ear. The back is more or less flat, cut through by slanted lines indicating the mane. The bulging underbelly has a line superimposed on it. A front leg is depicted by two parallel lines.

Chv32: Head and neck of a horse turned to the right, almost 7 feet (2.1 m) from the ground in the east part of Chamber 1. Head well engraved, with an eye. Mane indicated by two short, nearly vertical lines. Length: 11⅜ inches (29 cm).

Chv33: In the east part of Chamber 1, to the left when facing the large shaft. Forequarters of a horse facing right, 6½ feet (2 m) from the ground. Fairly crudely engraved. Elongated body and head, the latter surmounted by two erect ears and with a mane. The front legs are indicated with two simple parallel lines. Length: 21¼ inches (54 cm).

Chv34: About 6 feet (1.9 m) above ground, on a ceiling in the western section of Chamber 1, about 40 feet east of black horses Chv1 to Chv4. Head and neck turned to the left. Very finely engraved, covered in calcite. Crudely made, but can be identified. The eye is depicted and the mane is done with short parallel lines. Length: 13¾ inches (35 cm).

Chv35: On the same ceiling, immediately behind Chv34 and also turned to the left. Very cursorily engraved head and neck, with the ears depicted but with neither eyes nor mane.

Chv36: Above Chv34 and Chv35, on the same ledge between ceiling and wall, is an engraved sketch of the head and neck of a horse turned to the right.

Characteristics of the Horses in the Cosquer Cave

Numbering 36 in all, horses constitute the predominant theme. Two-thirds of them (24) are engraved and one-third (12) are painted. Despite individual variations, they all bear a family resemblance to one another, whichever technique is used. Their proportions are naturalistic, and the distortions of head and neck seen in other art of the same period are never observed. They are represented as immobile, static, with no suppleness of limb, giving them a characteristic air of stiffness. The legs of 10 animals that are complete are indifferently depicted in pairs at both ends (5 cases: nos. 5, 7, 11, 24, 25) or with only one in front and with one (nos. 3, 8) or two (nos. 13, 29, 30) at the back. The hoofs are consistently missing in both the paintings and the engravings. All the animals are depicted in profile, but the ears, and no doubt the legs when they occur in pairs, are seen head-on, in frontal perspective, which is reminiscent of the technique used for the horns of the ibex, chamois, and bison. With only 2 exceptions (vertical animals: nos. 19 and 23), the horses are in a normal position with respect to the ground.

Details of the bodies are missing most of the time. Only a mane is frequent, represented by parallel slanted strokes, connected or not to the dorsal line. An anatomical detail as important as the eye is present in only 11 out of 36 cases (nos. 1, 3, 4, 5, 7, 11, 18, 24, 26, 34, 36). In the case of the painted animals, the eye (1, 3, 4, 5) and, more often, the nostril (1, 3, 4, 5, 6 (?), 9, 10) are depicted by means of a space left blank on the head, which is otherwise an even black color. This device is found with some frequency only at Lascaux (see fig. 184). A beard, sketched with a few lines, occurs only rarely (nos. 12, 18, 20, 24). The tail is depicted with a single line, except for horse Chv24, where it is a bushy tuft. Only 3 horses have the sex depicted (nos. 3, 11, 24), and in that case the penile sheath is formed by a V. This fairly rare convention for depicting the sex occurs whichever technique is used, painting or engraving. This precise detail appears as well on the engraved ibex. No horse has

75. This large horse (Chv8) was painted on the same low ceiling, partially covered in calcite, as horse Chv7 and other animals

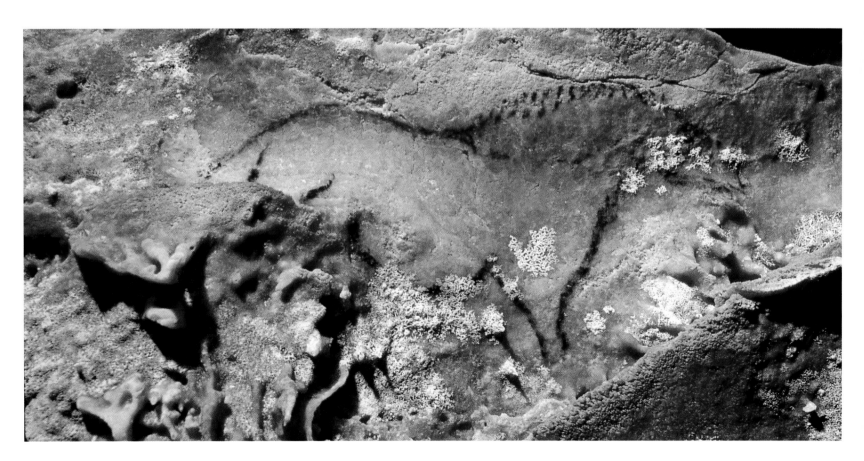

an extremely large underbelly. The message transmitted is reduced, then, to the idea of "horse," rarely of "stallion" and never of "mare." The filling-in of the body and the details of the coat are absent, with the exception of horses Chv12, Chv15, Chv17, the latter painted and the others engraved: parallel lines sketch a cursory coat. The back of horse Chv22 and the interior of its head are marked with crisscrosses reminiscent of those inside the bodies of several of the ibex. The horse Chv3 presents a special case, with its underbelly shaded in a flattened M-shape. We have seen that this way of representing the difference in coloring of the coat between back and belly for equids was very widespread in the Middle Magdalenian, especially in the Pyrénées and in Cantabria, to the point where it is regarded as specific to this period. Nevertheless, the convention is also found at Lascaux (the "Chinese Horse"; see fig. 183), around 17,000 B.P. The horse Chv3 in the Cosquer cave is now the oldest example of this convention recorded.

Complete horses account for less than a third (10 cases) of the depictions; the others are divided almost equally between depictions of head and neck or the head with a sketch of the breast (11), and head and forequarters (13), with only 2 isolated heads. The Cosquer cave horses are neither very large (only 3 more than 27 inches long) nor very small (only 2 less than 12 inches long). For 25 horses the dimensions of which we know, complete or not, the average measurement is 18½ inches (47 cm). This makes them quite visible and does not allow for their having been placed just anywhere. They are drawn indiscriminately on the walls (13 out of 24) or on the ceilings (11), except for one (Chv26) engraved on the rocky ground, which is extremely rare, and another (Chv17) painted on a stalagmite, equally so. In numerous cases, as for example Chv17, they are carefully centered in the available space. Two-thirds (24) are turned to the left, and only 12 toward the right. The techniques used—painting or engraving—do not affect this choice of orientation. Their position with respect to the ground (24 measured) makes it apparent that they were by and large drawn by upright adults: 16 are between 5 and 7 feet (1.5 and 2.1 m) up. Several (6 cases) were done on low ceilings or low on a wall, less than 51 inches (1.3 m) from the ground.

Only one horse (Chv24) carries a barbed sign. Ten or eleven others (nos. 1, 2, 3, 4 (?), 5, 14, 25, 26, 29, 30, 31) are marked with different indeterminate lines.

The association of horses with other animals varies. The most frequent type is that of horses in close proximity to one another. Certain associations are quite obviously planned and constitute true scenes: for example, the four horses Chv1 to Chv4 painted on the same panel, in all likelihood by the same hand. The horse Chv5 could be added to this group, since it is very close by, on a panel perpendicular to the first. The horses Chv12, Chv13, and Chv15 form a frieze, with two animals facing in one direction and the third in the opposite; the horses Chv34 and Chv35, both turned to the left, appear to follow and are next to the horse Chv36. On the other hand, the proximity of the horses Chv15 and Chv16 and that of the horses Chv22 and Chv23 could be unintended.

At different points, horses are associated with other species of animals. Here again, the deliberate character of these relationships, at times incongruous (horse-seal), cries out: the horse Chv19 facing the seal Ph3 (figs. 121 and 122), a theme repeated and thus confirmed by the seal Ph4 superimposed on the horse Chv25 (fig. 124). The horse Chv11 forms a unit with a chamois (Chm1) and a doe (C2), these animals of different species being not only next to one another but depicted by an identical technique. On the other hand, the horse Chv30 (next to the ibex Bq15), the horse Chv18 (with the ibex Bq18), the horse Chv10 (with the bison Bi2), the ibex Bq10 (superimposed on the horses Chv1 to Chv4), and the horse Chv13 (superimposed on the ibex Bq7) are all not necessarily directly related to the animals close to them.

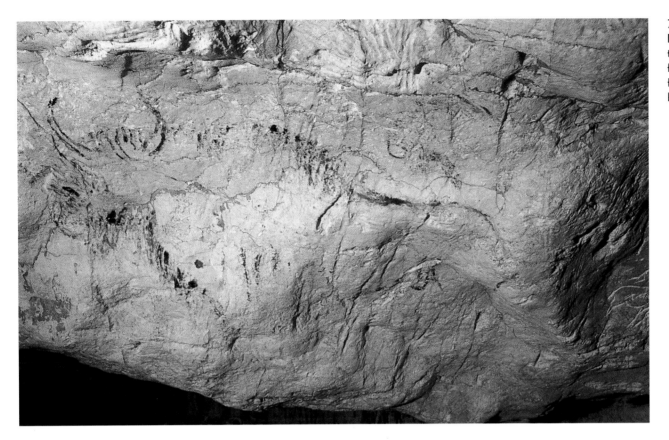

76. The body of this bison (Bi2), turned left, is in profile, its head turned in three-quarters view, and its horns seen frontally. Above its hindquarters, a very faded horse (Chv10) with its nostril a blank can just be made out

Bison and Aurochs

The bovid genera represented in prehistoric art are *Bison, Bos* (aurochs) and *Ovibos* (musk-ox). The last, not having been depicted in the Cosquer cave, is mentioned only for the sake of completeness.

The Bison

The prehistoric bison was *Bison priscus*. It has become extinct and is known only from numerous skeletal bones at Paleolithic habitation sites (it was one of the most hunted animals) and from depictions in portable and wall art. It comes second, immediately after the horse, with respect to frequency of representation. The European bison or *Bison bonasus,* its descendant, still exists, on the other hand. This splendid animal almost disappeared from having been hunted too intensively. Two wild herds were still in existence in two places, the forests of Bialowieza in Poland and in the Caucasus until the war of 1914–18.[11] Then they were all killed. The herd of Bialowieza was reconstituted from individuals that had been kept in zoos. But during the 1950s, an outbreak of distemper wiped them out. Once again, the captive bison were used to rebuild herds, which were then released. At present, several hundred bison roam the Polish forests, where they are jealously protected. In the last few years, about twenty of them have been imported into France. They live in limited freedom in the park of La Margeride in Lozère.

 The *Bison priscus* was an impressive animal, the male at times reaching a length of from 10 to 11½ feet (3 to 3.5 m), with a shoulder height of 6½ feet (2 m) and weighing 1,760 to 2,200 pounds (800 to 1,000 kg). The European bison is a little smaller, but the dominant male in the La Margeride herd, "Postum," stands over 6 feet (1.9 m) high at the shoulder.

77. This is how the artist must have done the large bison Bi1

78. Bison (Bi7) charging, head low-
ered, turned right

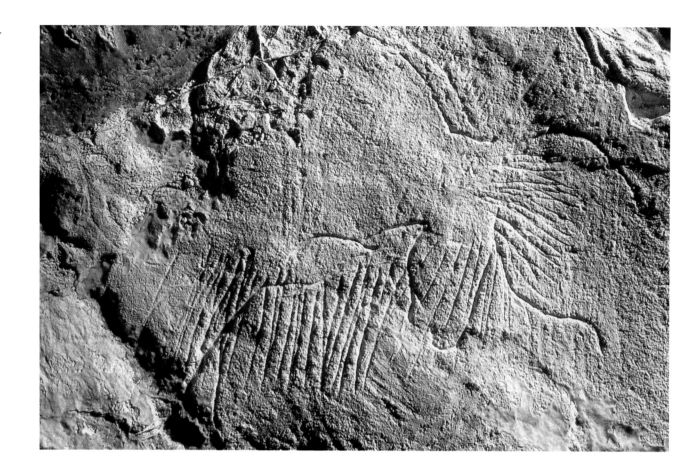

Bison are characterized by a massive silhouette, with hulking forequarters surmounted by
a prominent hump formed by long bony spines on the vertebrae. The hindquarters are notably more
slender, the legs quite short, ending in distinctive cloven hoofs, often represented with precision in
prehistoric art. The head is held low, the line of the nose is curved, and the eye sockets protrude so
that the eye is quite visible. The horns are short, S-shaped, with the tips pointing toward the back,
unlike the aurochs. The bison's coat is long over the forequarters and covers part of the legs. The ani-
mal has a beard and hanging dewlap, with a heavy mane on top of the skull and on the neck. The
females are smaller and less massive. Their coat is shorter and less thick, their legs longer, and their
hump less pronounced, so that they can quite easily be distinguished from adult males.

Bison bonasus of the present day lives in forests and feeds on bark, leaves, and grass, while
the biotope of its extinct predecessor was the steppe. Like the last of the bison recently observed,
Bison priscus must have lived in sizable herds made up of females and calves with one bull, the older
males living alone and rejoining the herd only for rutting. The bison is a fast animal, "climbing well
over rocky terrain and on steep slopes. It gallops head low and tail drawn up, leaping as high as 3
meters or more, and clearing high obstacles."[12] It likes to roll in the mud and to play, and the males
to challenge other males.

The bison was one of the favorite themes of Paleolithic artists. It even predominates in
the rock art of the Pyrénées of the Ariège department. The animal is never represented from the
front, though a frontal perspective is used at times for the horns. In wall art, it is also never shown
with its head turned to the rear, a position bison often take when licking their flanks. The
Magdalenian artists many times depicted them this way in portable art (La Madeleine) in order to
take advantage of the restricted space. This means that when the surface was sufficiently large not to

constrain them, the artists preferred to create the erect silhouette of the bison according to a stereo-typed convention. This silhouette is, in fact, fully characteristic, with hump and horns major elements in its identification.

The penile sheath, on the other hand, is only rarely depicted on the males, and the udder is almost never shown on the female. Even in the coupling scene at Le Tuc d'Audoubert (the Clay Bison), the male, identifiable by his massiveness, is not sexed, while the female, more slender, has vulva indicated and tail lifted.

In general, bison are depicted in static poses as if resting in midair. Ethologists specializing in bison behavior can read in these images many more details and much more information than can laymen. In certain caves, such as Les Trois-Frères, the bison charge, run, display defensive postures, look interested, play, and rut. Elsewhere, as at Niaux, some are depicted dead, on their sides like felled game.[13] Scenes are rare but several are known: bison charging and losing its entrails at Lascaux, facing a man who is falling backward; coupling clay bison at Le Tuc d'Audoubert; young bison chasing and playing at Montespan; a maternal scene, with a calf and its mother, while an old male moves off, in the cave of Le Portel.[14]

Often the bison are individualized. This was not strictly necessary. After all, the idea of "bison" could have been communicated by means of a stereotype, always the same, as in Chinese or Egyptian ideograms. We have seen that the choice of a profile view was made. However, these bison seen in profile differ from one another through the treatment of the eyes, horns, and/or coat. In the cave of Niaux, for example, where painted bison are legion, none are identical. The fantasy of the artists, their talent, and their aesthetic pleasure are given free rein and explain the variations on a common theme. The individualizing of the figures, more evident for the bison than for any other animal, translates true artistic intention, a freeness that transcends simple religious or material concerns.

The Aurochs

The aurochs, often confused with the bison, was an imposing and formidable animal, about 6½ feet (2 m) high at the shoulder, more than 13 feet (4 m) long, and weighing a ton. It disappeared forever in the seventeenth century, even though for a long time hunting this noble game had been the exclusive right of kings. Since then, the species has been reconstituted by genetic manipulation, and at present there exist quite presentable aurochs in some European zoos, such as the one at Gramat in the Lot.

The aurochs can be distinguished from the bison by its straight dorsal line, without the hump so characteristic of the bison. The aurochs' horns are very developed, from 16 to 31 inches (40 to 80 cm) long, and grow toward the front, a distinctive characteristic reproduced by Paleolithic artists. The horns are set in a well-defined tuft of hair often accentuated in Paleolithic art (Pech-Merle).

Differentiation between the sexes is quite well depicted, with the massive males of Lascaux, close to 16 feet (5 m) long, or the bull and the two cows of Teyjat in the Dordogne. Sometimes shown moving (Teyjat, Lascaux [see fig. 184], Trou de Chaleux in Belgium), the aurochs is elsewhere depicted in a static position (La Tête du Lion, Bidon in the Ardèche [see fig. 175], Niaux). Images of the aurochs are quite rare in Paleolithic art, as are its bones among the fauna consumed (though some aurochs bones may have been wrongly identified as bison bones). It was undoubtedly less often hunted than the bison, as its massive size, its aggressiveness, and its liveliness made it a fearsome animal. It must have been held in great awe, as was the case during the historical periods. The cult of the bull, so widespread among the ancient Mediterranean civilizations, and modern bullfights bear witness to this.

79. Forequarters of the large bison (Bi1) with its head seen in three-quarters view

The Bovids in the Cosquer Cave

80. Head and neck of an engraved aurochs (Bi10), turned right (drawing)

81. Probable aurochs (Bi8), a massive beast, turned to the right

Bi1 (figs. 79, 191): About 3 feet from the ground, in a large fault that runs the length of the east wall of Chamber 1. Large, complete painted bison turned to the left. The contours of the body are done with a simple line, drawn with charcoal. The hump and the forequarters, abundantly filled in, are depicted with short parallel lines. The tail is curved, quite long and arced, not flattened against the rump; the hind legs are seen in perspective, accomplished with a single line for the right leg, which is farthest away. The legs are unfinished. The absence of hoofs is characteristic of all the painted and engraved animals in the Cosquer cave (it will not be mentioned again). The nostril and the line of the nose are done with a blurred line. The horns are seen in frontal perspective. The eyes are indicated: the left one is in the middle of the face and the right one stands out on the line of the nose, so that the animal's head seems to be three-quarters turned. The sex, more emphasized than is customary, has been shaped in the soft surface of the wall. Some extra lines are found on and outside the bison, which is cut through by very fine engraving that does not form a discernible motif. Above the forequarters and at two points on the forequarters themselves, a portion of the *mond-milch* was lifted off—as can be seen—by scratching with a finger on a small area of the surface. This is the largest painting in the cave. Length: 4 feet (1.2 m). A sample from the mane was used for two separate datings. The date of 18,010 ± 190 B.P. (Gif A 91,419) seems to us less plausible, because of a less stringent decontamination of the sample, than the second date obtained: 18,530 ± 180 B.P. (Gif A 92,492).

Bi2 (fig. 76): To the east and not far from Bi1, in the same fault, turned to the left, this painted bison is not complete. One can distinguish the head, forequarters, and hump done with short slanted lines, and the rump sketched with a single line, as well as a hind leg and the beginning of the underbelly, in a large concavity on the wall. The sex, badly placed, is drawn with two lines, parallel at first, then slanted and joining at the end. An ear is indicated. The horns are in frontal perspective. On the head and forequarters there are seven large patches of heavy black; two of them could indicate the eyes, which in that case would be moved back, giving the impression that the bison's head is turned to the left. This

hypothesis is supported by the presence of a pronounced ridge just above the eyes, which probably looked like the forehead and so was used for it. Four parallel strokes of decreasing length from left to right mark the forequarters. Immediately behind this bison are the head and neck of a horse (Chv10). There are numerous finger tracings and engravings in this area.

Bi3: Two horns of a possible bison painted in frontal perspective, and some lines. In front of the ibex Bq2, in the bison fault. An unfinished or partially destroyed animal.

Bi4: In the bison fault, the forequarters of a painted bison, turned right, overlaid by an ibex engraved with deep lines that stand out white against the reddish wall (Bq2; fig. 88). Horns in frontal perspective, large eye, rounded line for the nose and the muffle, bushy beard. The dorsal line as well as the hairs beneath the neck are barely discernible.

The front leg, in short parallel lines, is made hard to see by later engravings. Isolated horns, in front of and below the head, could belong to another incomplete or erased animal.

Bi5: In the same area as Bi1 and Bi2. Incomplete painted head, with two horns in frontal perspective, and hairs on top of the head; overlaid by an engraved whitish ibex (Bq3; fig. 87). Length: 7⅞ inches (20 cm).

Bi6: Fairly crude head of a bison, turned to the left, engraved on a ceiling in Chamber 2 covered with engravings, beneath the front legs of a megaloceros

(Mé1; fig. 109). The horns are in frontal perspective with a blank space between them, one joining the beginning of the dorsal line and the other, the head. This has been sketched rapidly with one bell-shaped line depicting a rounded muffle, which passes over the finger tracings.

Bi7 (fig. 78): On a wall in the southwestern part of the cave. Engraved bison turned right, head held low and forward, as if ready to charge, with the horns in twisted perspective. Only the forequarters are depicted, with the head and the breast covered with long hair, as is the crown of the head, indicating a bison rather than an aurochs. The line of the underbelly is indicated, and a double line for the back rises quite abruptly (hump?) and is covered by a series of short lines to represent the coat. The front legs are indicated; they are done with double converging lines. The lines of the animal disappear at the level of an uneven area

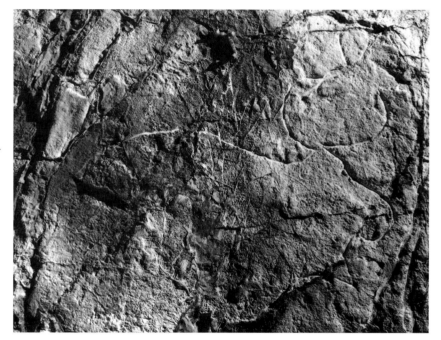

covered in calcite, which covers them over. In a small area, the calcite has flaked off and a line reappears. It is thus not impossible that this bison was complete. It cuts through finger tracings.

Bi8 (fig. 81): Aurochs or bison, engraved on the east side of Chamber 1. Has a very rounded dorsal line, but without the crest of a hump. Turned right. The horns are in frontal perspective, lyre-shaped, not touching one another. The nostril is very wide and rounded. Neither eye, nor legs, nor line of the underbelly is discernible.

Bi9 (fig. 82): On the ceiling of

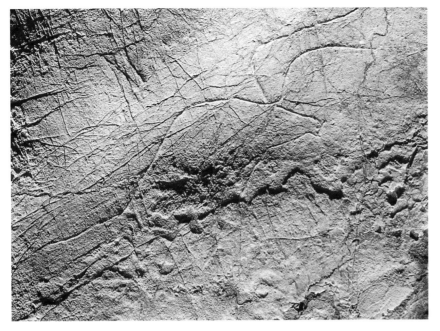

frontal perspective, with some straight hairs suggesting a short and prickly mane. The front legs are an open V. Length: 6¹¹⁄₁₆ inches (17 cm). In this fault, the ground level slopes downward. The animals are easy to reach by leaning on small ledges.

Bi12 (fig. 84): Near Bi11, an awkward silhouette is engraved with a few lines. Inordinately elongated (height: 2⅛ inches [5.5 cm]; length 9⅝ inches [24.5 cm]), it is recognizable as a bovid from the single horn projecting forward, dominating a cursory head surmounted by three lines depicting the tuft at the top of the skull. The animal (complete) faces left. The body, ineptly drawn, includes the hind leg, the tail, and the lines of the underbelly and the back.

the large chamber, at its highest point, 3 yards from the ground are engraved the forequarters of an aurochs or a bison with disproportionately large horns pointing forward. The animal is turned to the right. The lower horn is drawn as just one line with the dorsal line, which describes a large hump. This would suggest a bison but the large forward horns, an aurochs. The eye is a simple dot. Squared nostril on a short, massive head. Only the forequarters are represented, without legs, and they give an impression of massiveness (a male?). Length: 4–5 feet (1.2–1.5 m).

Bi10 (fig. 80): On a low ceiling, in the area of the "fish-vulvas," to the west of Mé1, about 4 feet (1.2 m) above the ground, are the head and neck of an aurochs turned right, engraved with wide lines. The head with a nostril that stands out is typical, as are the horns in frontal perspective pointing forward, joining, respectively, the line of the nose and the dorsal line. The ear is indicated, behind the horns. Not far from here, some ocher pigment was lifted in prehistoric times from the ceiling. Length: 11¹³⁄₁₆ inches (30 cm).

Bi11 (fig. 83): On the ceiling of the large bison fault, not far from Bi12, Bi1, and Bi2 is an engraved bovid turned to the left, the body limited to the forequarters and the dorsal line. Horns in

82. Left: Probable aurochs (Bi9) with long horns pointing forward, engraved on a ceiling about 3 yards high

83. Engraved forequarters of bison Bi11 (drawing)

84. Possible sketch of a bison (Bi12), on the same ceiling as Bi11 (drawing)

Characteristics of the Bison and Aurochs in the Cosquer Cave

Bovids are thus relatively few in number in the Cosquer cave. One of them is certainly an aurochs, Bi10, with its long horns pointing forward, and 2 others are either a possible aurochs (Bi9) or a probable aurochs (Bi8). The others are bison. All the animals are depicted with horns in frontal perspective. Only 2 are complete (Bi1, Bi12); the others consist only of the head or the horns in isolation (3 cases), the forequarters (6) or the head and neck (1), proving the evident fact that bison and aurochs are distinctive enough that there is no need to render them completely in order for them to be identifiable. The horns and/or the hump are amply sufficient for this. Rare are those that were identified sexually (Bi1, Bi2). The sex organ of Bi2 was badly placed, which demonstrates a lack of interest in the accuracy of this anatomical detail. The eyes are not depicted except in the case of Bi1, Bi2, Bi4, and Bi9.

These bovids are very different in size but 2 of them, very close to one another, are the largest animals in the cave: Bi1 measures 4 feet (1.2 m) long and Bi9 approximately 4¼ feet (1.3 m) long. They are painted (5) or engraved (7), on walls (6) and on ceilings (5), and are oriented right (5), left (5), or frontally (1).

A few bison are of particular interest for several reasons. Bi9 was engraved at a height of 3 yards above the ground, which necessitated the use of scaffolding or of a ladder, recalling the animals placed equally high at Lascaux. Bi7, head low and horns pointing ahead, is in a charging position, which is quite infrequent in wall art, though it does occur (scene in the shaft at Lascaux; see fig. 169). Bi1 and probably Bi2 are exceptional in having the head in three-quarters perspective. For Bi2, this perspective is rendered by shifting the position of the eyes, identical to that on the head of the feline (see fig. 110). For Bi1, the technique differs somewhat, with one eye depicted *outside* the line of the nose. We know of only one identical example, the small head of a horse next to the Black Cow (Vache Noire) at Lascaux, which overlies it (see fig. 190). In addition, the artist who painted the head of Bi2 used a natural outline in the rock for the forehead. This bison is marked with four strokes. Bi1 is marked with various uninterpretable lines.

Association between animals is indisputable only for Bi1 and Bi2, painted in the same fault. Two other possible associations occur with some ibex (Bi4 and Bq2; Bi5 and Bq3), a horse (Bi2 and Chv10), and a megaloceros (Bi6 and Mé1).

Ibex and Chamois

Ibex and chamois belong to the subfamily of caprids. The ibex is frequently found at Upper Paleolithic sites, both in the remains of fauna consumed and in wall and portable art, where it is in

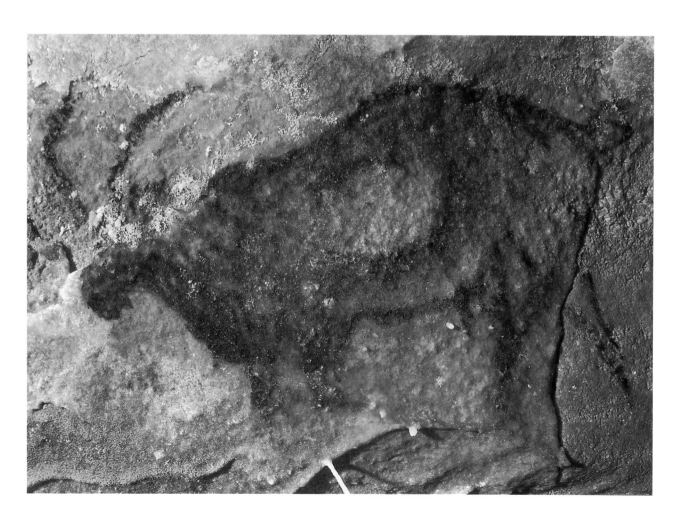

85. The only painted ibex (Bq1) in the Cosquer cave, on a low ceiling with other animals also painted in black

86. In the center of the photograph, a large ibex (Bq5) with disproportionately large horns can be seen, turned left. Above its right horn (top left) is seal Ph2, its hindquarters overlaid by a long line

fourth place after horse, bison, and mammoth. Two species of ibex can be distinguished: the ibex of the Pyrénées, recognizable by its horns that turn up at the ends in a short sinuous curve, and the ibex of the Alps, with horns shaped in an arc. These animals occur in the wild, both in the Alps and on the Spanish side of the Pyrénées.

The ibex has a liking for rocks and uneven terrain, over which it moves with ease and sureness. During the last glaciation, because of the presence of the glaciers, it was to be found at lower altitudes, but always in regions of cliffs and rocks. Males and females live in separate groups and come together only at rutting season. This observation was turned to good account by the Magdalenians, who at times undertook specialized hunts for ibex in the Pyrénées (Les Eglises in the Ariège, Belvis in the Aude department) and even in Provence (Riaux at L'Estaque, Marseilles).

The ibex's silhouette is massive, and the male especially gives the impression of power. The legs are relatively short. The head has a straight or slightly concave line along the nose; the ears are small; and horns grow on both male and female, although the male's are much more developed. On the outer side, the horns of the male have quite visible nodes. All these details were noted and transcribed by the Paleolithic artists in the Cosquer cave, as elsewhere.

The chamois, called "isard" in the Pyrénées, is a mountain animal that was much less frequently hunted and depicted than the ibex during the Pleistocene. It is not altitude that it seeks, as is generally believed, but steep places. Without the presence of humans, it would probably inhabit all the lower European mountains.[15] It is more graceful than the ibex and is distinctive both in its slenderer body and in its horns, which, in both sexes, are short and not very thick and which grow vertically before curving abruptly into a hook at the ends. The line of the nose is concave.

The chamois measures about 4 feet (1.2 m) in length, the ibex 5 feet (1.5 m). The chamois is lighter, about 65 pounds (30 kg) for the female and an average of 90 pounds (40 kg) for the male,

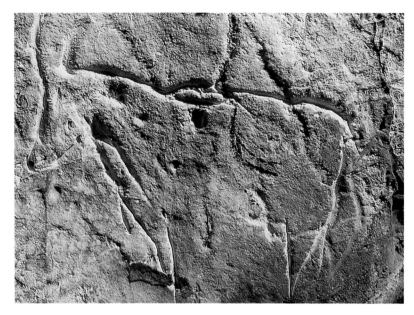

The Ibex in the Cosquer Cave

All the ibex except Bq1 are engraved.

Bq1 (fig. 85): Complete, turned to the left, on a low ceiling in the southwest part of Chamber 1, beside the deer C1 and the painted horses Chv7 and Chv8. Painted in black. Massive body, well-proportioned. Long horns in semifrontal perspective, one an arc but not turning up at the end to indicate an ibex of the Pyrénées; the other bent at almost a right angle. The short tail is raised. The sex is indicated by a single short line, as is the beard. The left hind leg is superimposed on the right, which renders the perspective well; these hind legs are each done with two simple lines that converge at an acute angle; they are complete. While the forelegs may have been complete, their lower parts have been eroded and have disappeared, unless the animal was depicted about to kneel down. The inside of the body is filled with broad applications of black paint that leave blank areas on the back, the rump, and the bottom of the underbelly. Patches of white calcite cover parts of the head, the horns, and the body. Two black lines can be seen outside the animal, above the hindquarters. Length: 22 inches (56 cm).

Bq2 (figs. 88, 125, 126): Complete ibex, turned right. Near Bi4, at the end of the painted bison fault, on the ceiling, 4½ feet (1.4 m) above ground. Massive body with two Y-shaped front legs and only one hind leg shaped in a sharp V. The forelegs are in frontal perspective as are the horns, which are set in the middle of the head with blank spaces between and on each side of them. The head is sketched in a cursory but effective

87. Above top: Complete ibex (Bq3), deeply engraved, superimposed on the head of a bison (Bi5)

88. Above center: Ibex Bq2 with crosshatched belly, turned right. There is a seal (Ph7) immediately above it

89. Right: Male ibex Bq4, complete, with very long horns and sex indicated. He is followed by a seal (Ph1)

way. The tail, as usual, is an extension of the dorsal line and not attached to the hindquarters. Engraved on the middle of the body is a series of crosshatches (like that on Bq4) that could represent the coat. The lines stand out, very white against the reddish wall, which seems to have been hammered over quite a large area beneath the animal. Above, a cursorily sketched seal (Ph7) and some scraping. Length: 14⅝ inches (37 cm).

Bq3 (fig. 87): Centered at the edge of a ceiling overhang, at the east end of the painted bison fault is a complete ibex, turned to the left. Very deeply and firmly engraved on the bison Bi5, with deep, wide lines that again stand out as white against the reddish wall. The body is massive and stiff, the tail short. A short vertical line depicts the eye. The breast is indicated by two parallel lines, the exterior one also forming the front line of the only foreleg, which is V-shaped. A third line, short, touches the middle of the breast. There is no line for the underbelly, while the dorsal line is repeated in the middle by a short concave line. The hind leg has been awkwardly doubled by two converging lines that without doubt show the right hind leg in false perspective. The horns, in semifrontal perspective, do not join. One is connected to the line of the nose, from which it extends, and the other to the dorsal line.

Length: 17¾ inches (45 cm).

Bq4 (figs. 89, 97): On a rounded ceiling, 5½ feet (1.7 m) from the ground, to the east of and a few yards from the large calcite drapery covered with hands. Old male ibex, turned to the left, sex heavily emphasized by V-shaped lines. Very long horns in three-quarters perspective, one of which extends beyond the end of the back, as far as the end of the tail: it is done with a long, very sure line in an arc surmounted by a wavy line indicating the nodes. The right horn, equally developed, is a simple, curved line drawn with a firm hand, while the left horn has been rendered with its thickness and its rings. The horns are set in the skull exactly as for the ibex Bq2 and as in that case, a series of crosshatches mark the middle of the body. The four legs are Y-shaped, and the line of the breast is extended to make the front of the foreleg. The tail is quite long. The head is seen in three-quarters perspective, like the bison Bi1 and the feline, giving the impression that the animal is turning its head. This effect is rendered with a slanted line that runs from the base of the left horn to the bottom of the head. The underbelly is shown with a double line. The ibex cuts through some finger tracings or earlier engravings, as well as a large vertical double line at its upper extremity. Length: 19⅝ inches (50 cm).

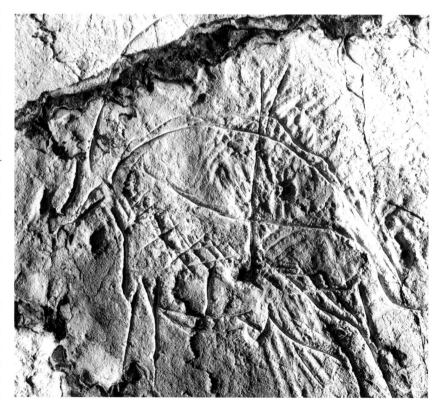

Bq5 (fig. 86): This complete animal is situated a few inches from the ibex Bq4 but facing the other way, on the same ceiling, beneath the seal Ph2, and it is superimposed on numerous finger tracings. Turned to the left. Tail horizontal. The four legs are Y-shaped. The head is small and triangular. The animal has exaggerated horns, in semifrontal per-

spective. The left one, done with two lines, cuts through the lifted tail and goes beyond it. The right one rises vertically before curving back gradually. It extends from a line depicting the face, while the other horn connects with the dorsal line, and a space separates the bases of the two horns. The forequarters are indicated, as are as the two front legs (with converging lines), the wide line of the underbelly, and the two Y-shaped hind legs. The whole flank is covered with crosshatching. This ibex is cut through on the top of its back by two long lines next to one other, at least one of which is feathered at the end away from the beast. These lines resemble a long slender leg with its hoof, isolated.

Bq6 (fig. 108): On a ceiling, 4 feet (1.2 m) from the ground, above the large black bison (Bi1) at the top of the bison fault, in the east section of Chamber 1, in front of the megaloceros Mé2. Young ibex turned to the right. Massive body engraved with very simple lines, with the left hind leg Y-shaped, and the foreleg X-shaped. The tail is well indicated but not the horns. Length: 7⅞ inches (20 cm).

Bq7 (fig. 66): In Chamber 2, immediately beneath the head and in front of the horse Chv13 and touching its breast, is this complete ibex turned to the right. The head, low, is sketched with two lines; two horns are set on top of the skull in frontal perspective. The neck, very long, is also done with two lines. The outline of the body can barely be

distinguished beneath the horse Chv13, which has been superimposed on this animal. A slightly oblique straight line reaches the base of the neck. Another seems superimposed on the nostril.

Bq8 (figs. 1, 90): On the left side of the larger passage into Chamber 2, about 33 feet (10 m) beyond the great auks, on a ceiling-like wall, about 6 feet (1.8 m) above the ground. Complete, turned left. Done with only ten lines, but the proportions are good, and it is very typical of this animal. The face, horns, and ears are in frontal perspective. Only two lines sketch the face, one of which is prolonged to make the ear. Two lines set the horns atop the skull, with blanks on either side and in the center. Just one line depicts the hindquarters and the back of the hind leg. The animal, not sexed, has only one leg in front and behind. These legs are done with lines that converge at an acute angle. The foreleg is covered in calcite. The hindquarters are cut through by a slanted stroke. Length: 8⅝ inches (22 cm).

Bq9 (figs. 32, 91): In the east section of the large chamber, on a wall covered with finger tracings, some of which are much higher than the engraved animal, above the chaos of blocks, 16 to 20 feet (5 or 6 m) southwest of the feline, are the forequarters of an ibex turned to the right. The rocky ground is 3½ feet (1.1 m) below. The head is done with two converging lines outlining a pointed muzzle. The two forelegs, X-shaped, are sketched with four or five lines that intersect. As usual, just one line has been used for the breast and the front of the foreleg. The horns are long and begin vertically before diverging sufficiently for the species to be in no doubt. A forked sign 15¾ inches (40 cm) long cuts through the top of the head. The hindquarters have not been drawn, no doubt because of the presence of a large area of old calcite that the dorsal line partially cuts through. Length: 9⅞ inches (25 cm).

Bq10 (figs. 8, 178): The panel of painted horses Chv1 to Chv4, in the southwest part of Chamber 1, is overlaid with numerous engraved lines that cut through the animals. About in the center of the panel, one can make out the forequarters of an ibex turned to the right. Its legs and underbelly are superimposed on the horse Chv2. The head is done with just one deep line for the line of the nose and with several parallel lines for the jawline. The head is surmounted by two

horns in frontal perspective, separated by a space: one is short, done with only one line; the other, in three lines, is quite curved and more than twice as long. The dorsal line, just one, stops at an old stalagmitic patch, as does the line of the underbelly, so that the hindquarters are missing. A single line sketches the neck, the breast, and the front of the V-shaped foreleg. The second foreleg is Y-shaped. One line beneath the breast. This ibex is superimposed on numerous slanted lines that mark the entire forequarters of the horse Chv3. This panel was done, then, in four distinct stages: finger tracings, painted horses, lines on the horses, ibex. Length: 15¾ inches (40 cm).

Bq11 (fig. 61): On the same panel, just above and behind the horse Chv3, 6 feet (1.8 m) above the ground, one can see the very cursory but typical forequarters of an ibex, with two horns in semifrontal perspective, converging quite low, above a long head. A single dorsal line and another for the breast. Length: 15¾ inches (40 cm).

Bq12 (fig. 93): Forequarters, also extremely cursory, of an engraved ibex

90. Ibex Bq8, sketched in a very cursory way, but very naturalistic (see also fig. 1)

91. Ibex Bq9, struck high on the line of the nose by a very long barbed sign

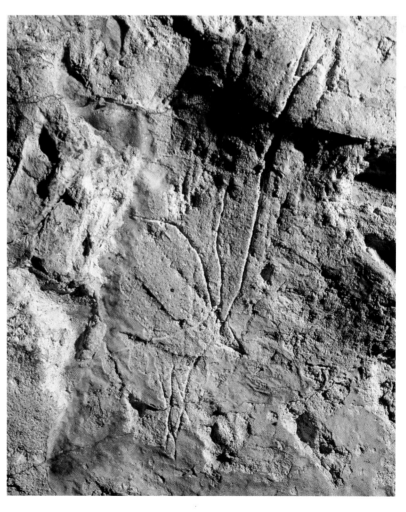

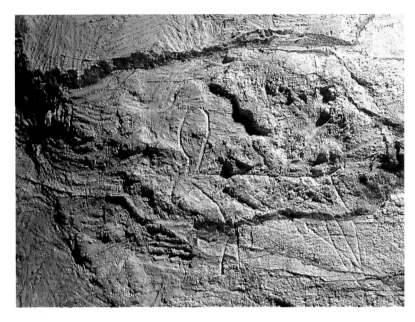

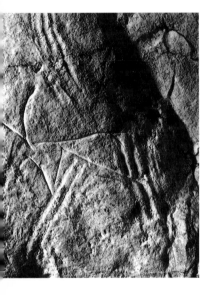

92. Above top: Engraved ibex Bq16, turned left

93. Above: The forequarters of this small ibex (Bq12), hurriedly engraved, seem to emerge from a crack

94. Right: Ibex Bq20 has a possible sign above it (drawing)

turned to the left, superimposed on finger tracings in the east part of Chamber 1. The horns, in frontal perspective, converge above the skull in a very open V. The head is triangular, with a pointed muzzle done with two strokes to show the line of the nose and another line extending upward almost to the dorsal line. The breast is engraved with a single stiff line.

Bq13: Placed in the large eastern fault, under the large red hand, 5½ feet (1.7 m) from the ground. This complete ibex is turned right. The body is depicted with a concave dorsal line, a line first convex then concave for the hindquarters and the hind leg, the front of which is done with a single stiff line, and a slightly convex line for the underbelly. The proportions are normal. On the other hand, the head and forequarters have been done carelessly: one line for a very stiff horn, partly repeated at the top by a second convex line, and one stiff line for the other horn and the head. Perhaps it is a sketch of the foreleg, in which case the head would not exist. The fact remains that this ibex looks very strange because, depending on the interpretation, it is missing either head or foreleg. Of course, the horns are not connected one to the other. Length: 13⅜ inches (34 cm).

Bq14 (fig. 102): Situated between the chamois Chm4 and Chm5, in a sort of frieze of engravings, 5¼ feet (1.6 m) from the ground in the southwest part of Chamber 1. Turned to the left, this ibex has long horns, spreading apart, in frontal perspective, set without touching the top of the skull. Concave dorsal line. Two

short converging lines for the head, one for the breast. A series of crosshatches over the whole flank. V-shaped foreleg, formed in part by the line of the breast. Neither the underbelly nor the hindquarters are indicated, because of a rough surface with indentations and some old calcite. Length: 10⅝ inches (27 cm).

Bq15 (figs. 98, 99): Complete animal turned to the left, 6¼ feet (1.9 m) above the ground. Part of a panel of small, very finely engraved animals superimposed on several black hands, M9 and M10, at the edge of the large shaft, near the calcite drapery covered by hands. Very small, it has a massive body surmounted by two parallel horns in perfect arcs, different from those of the other ibex. Breast done with a wavy line, the back with several lines; four Y-shaped legs in frontal perspective, raised tail, perhaps one ear indicated. If it differs a great deal from other animals of its species in its horns, it resembles them in the technique used for the legs and in the absence of detail. Length: 4¹⁵⁄₁₆ inches (12.5 cm).

Bq16 (fig. 92): On the east side of Chamber 1, 4 yards to the west of Chv9, on a ceiling 5½ feet (1.7 m) from the ground, this complete ibex is turned to the left. The flank carries a wide band of crosshatching. The legs are X-shaped and Y-shaped. The head is sketched with two lines. The tail is lifted—usual for ibex—and short. The horns are strange: the front horn goes straight up for several inches and then traces an arc that curves inward; the other also starts out straight and curves up just at the top. It is most probably a badly drawn ibex, but the horns are truly atypical. Length: 14⅛ inches (36 cm).

Bq17: In the southwest part of the cave, on a ceiling to the south of the frieze with the ibex Bq14 and the chamois Chm4 and Chm5, above black lines that resemble jellyfish (see fig. 135), 5¾ feet (1.75 m) from the ground. Complete, turned right. Quite slender body. Enormous horns in frontal perspective, with the usual blanks in between them. Hind legs Y-shaped. Forelegs superimposed. Tail indicated by the extension of the dorsal line. Crosshatching on the flank. A feathered line beneath the underbelly and four others, parallel, in front of the animal. Length: 23⅝ inches (60 cm).

Bq18: On a wall in the southwest part of the cave with many finger tracings, signs, and the painted horse Chv18. Forequarters turned left, with a fine, tri-

angular head surmounted by two horns in twisted perspective, the right one done with a single curved line, the other with a straight line surmounted by a second curved line. The breast is there but the dorsal line disappears beneath a geometric sign.

Bq19: On a sloping wall in the east part of Chamber 1, to the south when facing the large shaft, a complete ibex turned to the right has been engraved 5¼ feet (1.6 m) from the ground, within 16 inches (40 cm) of the horse Chv33. The ibex is crudely drawn, with the horns in frontal perspective and the usual blanks between and beside the horns, a single line for the breast and foreleg, the legs linear. Length: 28⅜ inches (72 cm).

Bq20 (fig. 94): To the west of the Killed Man are the head and neck of an ibex, quite elegant, with two long horns in semifrontal perspective, turned left. The right horn forms a single line with that of the nose. The left horn is simply set on the skull, with blanks on both sides of it. Triangular head with the eye well indicated. The breast and the dorsal line are barely indicated. Various lines (signs?) in the area of this engraving. Length: 15¾ inches (40 cm).

while the male ibex weighs 165 to 250 pounds (75 to 110 kg). Ibex and chamois prefer the same type of environment and frequently coexist.[16]

The chamois are all engraved, turned left—except for Chm3—and complete, except for Chm2. They are distinguished from ibex by their slighter, slenderer bodies, as well as by their typical horns, which develop vertically at the top of the skull and then curve right at the end rather than describing an arc. However, for all the chamois except Chm2, as for certain ibex, the length of the horns is very strongly exaggerated. They are always shown in frontal perspective, as are their legs and the ears when they are depicted.

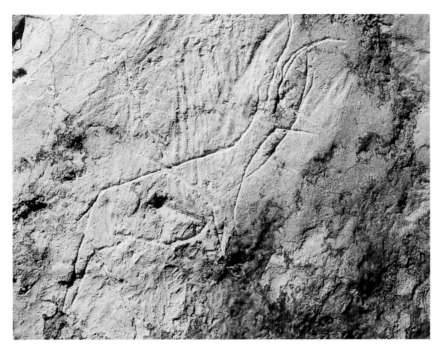

with the same line, without bending, the inner line of the leg being depicted with a converging line. The three other legs are Y-shaped. The dorsal line is briefly repeated above the neck and extends into the tail, which is separate from the back of the hind leg. A long line with outer feathers reaches the top of the breast. Length: 24⅜ inches (62 cm).

Chm5 (fig. 102): In the same area as Chm4. The body is slim. The forelegs are Y-shaped and the hind legs are X-shaped. The dorsal line is surmounted by a series of slanted strokes that change direction halfway down the animal's back. The head is done with two converging lines that do not meet. There are no ears. The horns are set on the top of the skull with a blank between them and on each side. Superimposed on two engravings. Length: 17¾ inches (45 cm).

The Chamois in the Cosquer Cave

95. The engraved outline of this chamois (Chm3) is crossed by several lines, two of which are barbed. The line cutting through the nostril seems to have been drawn before the animal was

96. First chamois (Chm4) in a line of engraved animals, including a chamois (Chm5), an ibex (Bq14), and seals (Ph5 and Ph6)

Chm1 (figs. 64, 100, 101): At the top of the bison fault, 5 to 5¼ feet (1.5 to 1.6 m) from the sloping ground, just above the horse Chv11, which it partly cuts through, this chamois strongly resembles Chv11 because of the Y-shaped legs, with a double line for two of them; the identical V-shaped sex; the simple linear engraving; the lack of details; and the stiff appearance. The short tail is indicated. The horns are set between two ears, with a blank between. The ears are connected, respectively, with the line of the nose and the dorsal line. Length: 13⅞ inches (35 cm).

Chm2 (figs. 64, 100, 101): This animal was classified among the chamois in our initial article on the cave,[17] although we had also entertained the hypothesis that it might represent a doe. Having worked on the new documents, we are now persuaded that this second interpretation is really the correct one. The animal will thus be described and counted among the cervids (see C2).

Chm3 (fig. 95): Complete, turned right. Superimposed on finger tracings in the southwest part of the cave. Slender body despite a pronounced underbelly. Slim neck. Vertical horns separating at the top; like the ears, they are in frontal perspective, with a blank at the level of their attachment. Elongated head done with two lines, the lower one extended from the line of the breast, which descends down the front of one of the X-shaped forelegs. A single hind leg done with two parallel lines. The tail is indicated. A curved line with a feathered base, which seems to cut through the nostril and the breast, was in fact drawn before the animal. On the other hand, the chamois is cut through by two later lines, a feathered one that stops at the dorsal line, and a simple one that crosses the body on a slant.

Chm4 (fig. 96): The first animal in a series with chamois Chm5, ibex Bq14, and seals Ph5 and Ph6. Superimposed over numerous engravings and/or finger tracings 5¼ feet (1.6 m) from the ground in the southwest part of the cave. The horns converge into a V at the top of the skull. The breast and the front of the foreleg are done

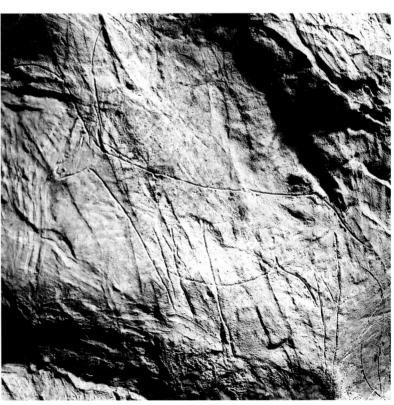

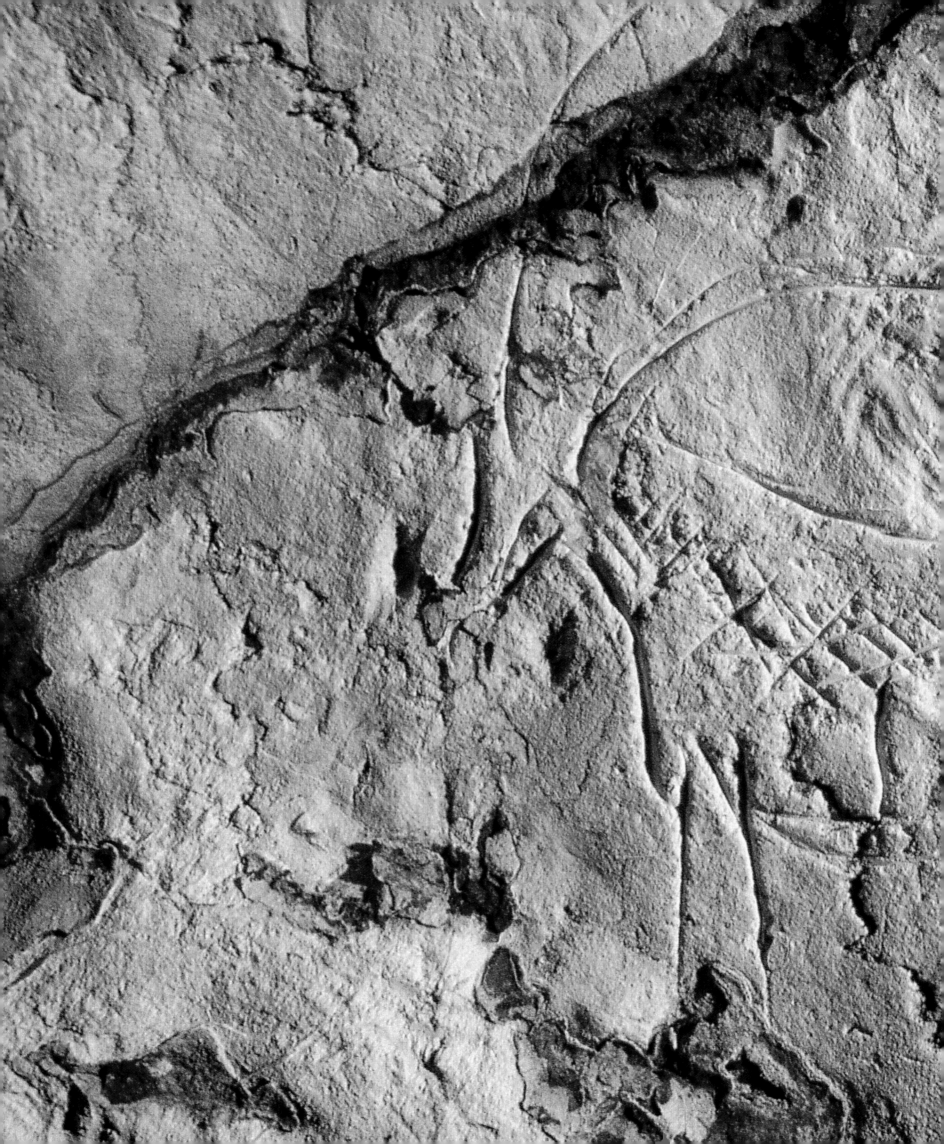

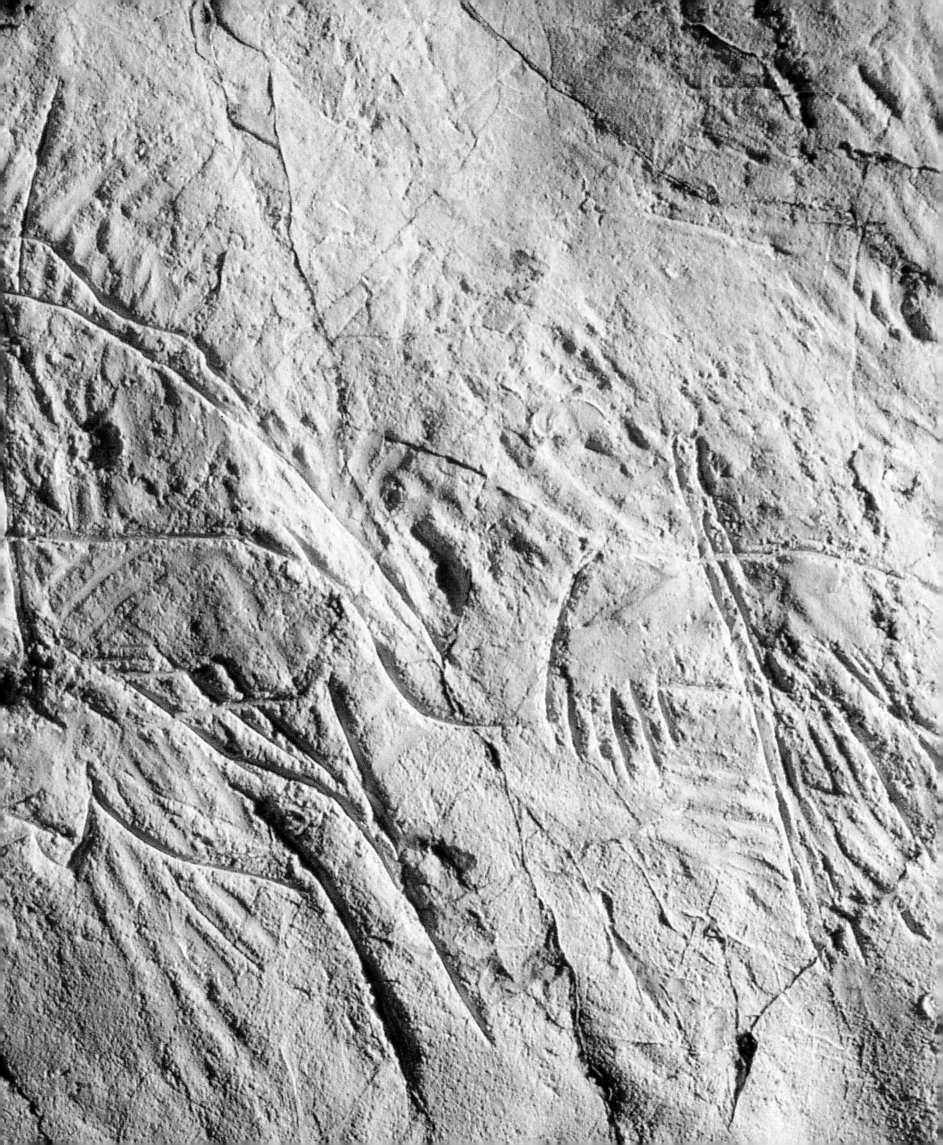

97. Preceding pages: Male ibex Bq4, with very long horns and sex indicated. He is followed by a seal (Ph1)

98. Right: A whole series of small animal figures are entangled on this panel near the large submerged shaft

99. Below right: Tracing from a photograph of the small engraved animals seen in figure 98

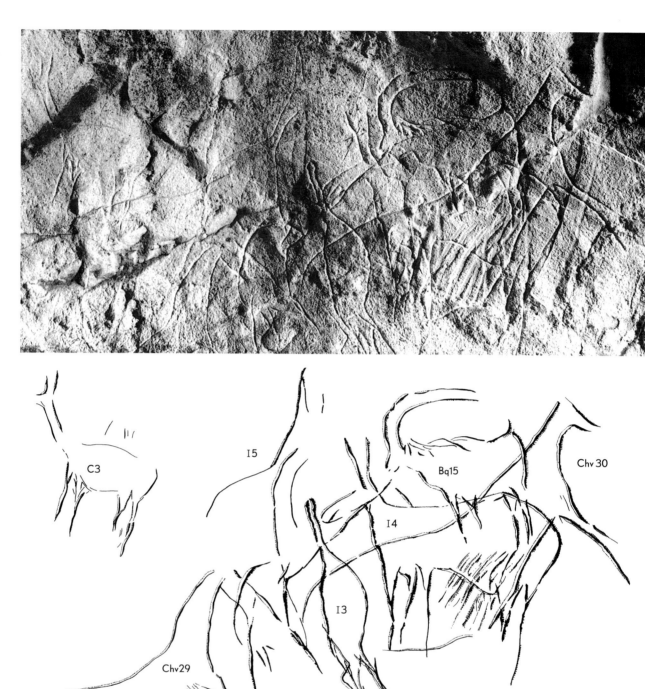

Characteristics of the Ibex and Chamois in the Cosquer Cave

Ibex (20) and chamois (4) are in second place for the most numerous animal group in the cave. We will study them together since some, such as the ibex Bq1 to Bq4, or the chamois Chm4 and Chm5, are easily classifiable, while others can be attributed to one species or the other according to how much importance or discriminating value is attributed to which criterion. In fact, the Cosquer artists represented the horns in a conventional manner somewhat removed from reality. The horns of the chamois in the cave do grow vertically from the head, but they are too long and the hook at the end is not as clearly marked as it should be. On the other hand, their bodies are less stocky than the ibex's, and their horns do not diverge as markedly.

Rarely is the sex of these animals indicated, so that when it is (Chm1, Bq1, Bq3, Bq4), one can think that the artist wanted to insist strongly on the maleness of these animals. When seen from a distance, their sexual organs are largely invisible, while the sex is obvious from the horns; those of the ibex Bq4 and Bq5 are even highly exaggerated. The Paleolithic hunters depicted what they saw, and their choice of conventions was determined by observation of the animals in nature. Only one young animal (Bq6) has been depicted. The horns are most often shown in frontal perspective, sometimes semifrontally (Bq1, Bq3, Bq5, Bq11, Bq20), rarely in normal perspective (Bq15), always on a body seen in profile.

All these animals resemble one another greatly because of the identical techniques of their depiction. Ibex and chamois have well-proportioned bodies, drawn with great economy of means, with a few simple lines. The head is often sketched with two lines that connect at an acute angle, and the horns are set on top of the skull with a blank area between them, or even a blank area between them and the head, on the one hand, and the dorsal line, on the other. More rarely (Bq20), the horns are in the form of a V. When formed as an arc, they are those of the ibex of the Alps. The eye is represented on only one animal (Bq20). Several have the same crosshatching on the flank (Bq2, Bq4, Bq5, Bq14, Bq16, Bq17), meant to depict the coat or the line of the underbelly. The short tail of these ibex and chamois is not generally connected to the hindquarters; it is simply an extension of the dorsal line. The ibex Bq4 has its head turned three-quarters of the way around, which makes it resemble the bison Bi1 and the feline.

All these animals, with the notable exception of the ibex Bq1, are engraved, which differentiates them from the horses, a third of which are painted. Another difference: 17 (13 ibex and 4 chamois) are complete. Of the incompletes, 6 show the forequarters, 1 shows head and neck.

On the other hand, their measurements are very close to those of the horses, the smallest and largest measuring in length, respectively, 4$\frac{5}{16}$ and 28$\frac{3}{8}$ inches (12.5 and 72 cm); their average length is 40 centimeters for the 19 measured, compared with 47 centimeters for horses. The actual size of the animals was not a determining criterion, then, in their depiction. The caprids are found on ceilings (9) and walls (13). As with the horses, more are turned to the left (16) than to the right (8), and they were for the most part drawn by upright adults (10 out of 14 measured are more than 5 feet from the ground). A quarter (6 out of 24) are marked with signs, sometimes multiple, feath-

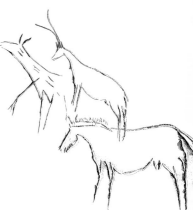

100. Detail of the panel near the bison fault with a horse (Chv11), a doe (C2), and a chamois (Chm1)

101. Drawing of the animals seen in figure 100

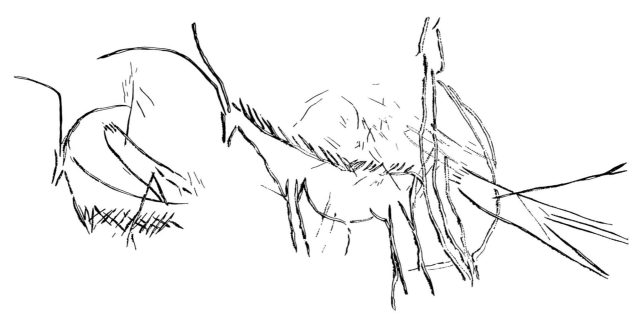

102. Drawing of part of a large frieze of engraved animals. Left to right, an ibex (Bq14), a seal (Ph6), a chamois (Chm5), an indeterminate animal or a sign, and a seal (Ph5)

ered (Bq5, Bq9, Bq17, Chm4) or not (Bq8, Bq20). This proportion is much higher than that generally noted in the Paleolithic painted caves.

Ibex and chamois occur together only on the frieze Bq14, Chm4, Chm5. Three times they are found near seals (Bq2 and Ph7; Bq4, Bq5, and Ph2; the frieze just mentioned and Ph5 and Ph6), seven times near horses (Bq1 and Chv7 and Chv8; Bq7 and Chv13; Bq10 and Chv1–4; Bq11 and Chv3; Bq14 and Chv4, and Chv5; Bq19 and Chv33; Chm1 and Chv11), three times near a bison (Bq2 and Bi4; Bq3 and Bi5; Bq6 and Bi11), and once near a megaloceros (Bq6 and Mé2), a doe (Chm1 and C2), and a male deer (Bq1 and C1). These associations do not suggest a pattern of pairings. Let us just say that ibex are found near any one of the other species represented in the cave.

Cervids

Cervids, certain among them at least, played a large role as themes in Paleolithic art, but an even larger one in the Paleolithic economy. Roe deer and fallow deer, present in small numbers among the hunted fauna, were never depicted. The large megaloceros is very rare and, even more so, the eland (which appears at Gargas) but, reindeer and red deer and does have been depicted in numerous caves.

Red Deer

Among the large wild mammals of the Paleolithic, this one has thrived best since the end of the glacial period for two reasons. An animal of temperate climates and forests, more frequent in Spain than in France during the Paleolithic, it multiplied above all during warming periods, especially at the beginning of the Holocene, when for a long time it constituted a basic source of food. It declined during the colder periods. Since the Middle Ages, it owes its survival to the fact that it was consid-

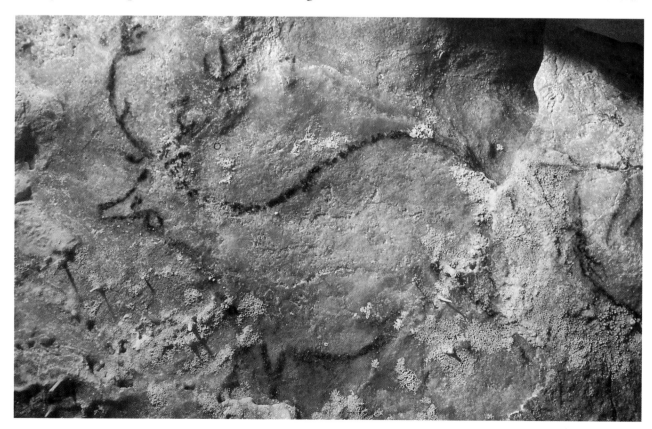

103. Large red deer C1 painted in black on a low ceiling

ered noble game and was jealously protected in order to serve the pleasures of the great, long before it was protected for moral or ecological reasons.

The red deer measures from 5½ to 8¼ feet (1.65 to 2.5 m) in length. It can reach 5 feet (1.5 m) at the shoulders and surpass 440 pounds (200 kg). It is characterized by a straight dorsal line, long legs with narrow feet, and a short tail. The head, long and slender, with a short nose, is carried high. The tear ducts are quite apparent. The antlers of the male are well developed. The beam (main stem) is attached to the skull at the crown. Branches, the first being the brow tine with others higher up, are regularly spaced over the entire length, up to the final palmate top points. The number of tines increases with age, at times surpassing ten.

The doe of the species has a tapered muzzle, long pointed ears, and a very elongated neck. Paleolithic artists have at times exaggerated these characteristics to avoid any ambiguity between does and stags without antlers at the end of the winter. Does are more frequent in Spanish cave art, where they represent one of the major themes. André Leroi-Gourhan placed them in sixth position numerically and stags in seventh. We mentioned at the beginning of this chapter the lack of logic in classifying stags and does in different categories when such a distinction is not made for other species. This apparent lack of methodological rigor is explained by a pragmatic approach: the artists distinguished the two sexes with sufficient clarity too often for the deliberate nature of this choice not to be very apparent. There was definitely a doe subject and a stag subject, while nothing that clear-cut can be noted for other mammals. Cervids have been represented singly (at Las Chimeneas, in Cantabria) or in herds (at Massat and Lascaux [see fig. 179]), complete or reduced to a quite recognizable head, or even to antlers alone.

104. Cougnac cave (Lot): Large red megaloceros facing left, overlaid with a wounded man in black and a small red ibex

Reindeer

This is the animal that was consumed most often by humans during the Würm glaciation, a time therefore named the Age of the Reindeer. Its economic role was of primary importance, and use was made not only of its meat and skin but also especially of its antlers, which were cut and shaped into many different objects, particularly spear points. A migratory animal, it always took the same routes, which must have facilitated specialized hunts.

Reindeer prefer the cold and flourished throughout the last glacial period. When it ended, the new climatic conditions were not suitable in southern and central Europe, and the herds moved north, following the retreat of the ice. Reindeer are still numerous in the north of Scandinavia and in Lapland. Some must have lived for a rather long time in more southern latitudes by taking advantage of particular biotopes, for example in mountain areas. Near Foix in the Ariège, a reindeer that had fallen into a chasm at Saint-Martin-de-Caralp has been dated to 9150 ± 1,000 B.P.

The reindeer measures about 6½ feet (2 m) long, with a shoulder height of 4 feet (1.2 m) and a weight of 265 to 330 pounds (120 to 150 kg). It has shorter legs than the red deer, with large hoofs. The head, with a square, thick muzzle, is most often held low (see fig. 19). The tear ducts can hardly be seen. Both sexes have antlers, strongly curved in an arc. The brow point, in front, is immediately surmounted by the ice point. The reindeer back has a prominent hump. In wall representations these cervids are a little less common than red deer and does. They are found at about twenty French sites and at rarer Spanish sites, with about 130 individuals shown.[18] As with the representations of red deer, there is everything from complete and detailed animals (Les Trois-Frères) to isolated racks of antlers (Le Portel). At times, variations in the coat have been indicated by crosshatching or by spots (Les Trois-Frères, La Mouthe, La Forêt).

Megaloceros

This extinct animal was remarkable above all for the extraordinary expanse of its antlers, which in the male could reach more than 9 feet (3 m) in width, and for its enormous dorsal hump, comparable only to that of the eland. It is distinguished from the latter both by its antlers and by the form of the head, which in the eland is particularly rounded.

The megaloceros was rarely represented. The largest number of representations reported —painted or engraved—are to be found in the Lot, in the caves of Cougnac (see fig. 104), Pech-Merle, and Roucadour. In addition, there are megaloceros in La Grèze in the Dordogne and in Pair-non-Pair in the Gironde department. The identification of these animals has always been based either on the development of the antlers or, more frequently, on the prominence of the hump.

The Cervids in the Cosquer Cave

C1 (fig. 103): Complete, turned left, painted on a low ceiling 31½ inches (80 cm) from the ground, to the northeast of the horses Chv1 to Chv4. Antlers quite branched, shown in frontal perspective. The brow tine is depicted, as is an ear. The head is graceful, with the eye placed a little low; a very small line could depict the tear duct so evident among red deer. The neck displays a kind of goiter. The concave dorsal line is that of a red deer and not of a reindeer. The two forelegs are clear, each indicated by two simple converging lines; only one hind leg, done according to the same convention, is visible. The hindquarters are, in large part, covered by extensive sheets of calcite; a fistulous stalactite has even developed on this calcite about at the position of the animal's sex. This deer is situated behind the horse Chv7. Length: 21½ inches (70 cm).

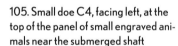

105. Small doe C4, facing left, at the top of the panel of small engraved animals near the submerged shaft

106. Large cervid C5 turned right, head lowered

C2 (figs. 64, 100, 101): Near the bison fault, on the panel with the horse Chv11 and the chamois Chm1 is another engraved animal turned to the left, with a tapering neck, a lifted triangular head, without details, with the nostril a little curved, surmounted by two ears drawn in exactly the same way, separated by a blank. We had earlier classified it among the chamois (see the description of Chm2). Only the forequarters are depicted, no doubt because of crowding by the chamois Chm1. The forelegs are Y-shaped. From the head to the forequarters, this animal is marked by a series of three sets of two short parallel lines. A long line, feathered at the base, cuts through the lower neck. This deer is probably a doe, recognizable by the absence of antlers and by its very long neck extended upward.

C3 (figs. 98, 99): This cervid is on a ceiling, 6¼ feet (1.9 m) from the ground, in a panel of small, fine engravings near the large shaft, to the north of the horses Chv29 and Chv30 and the indeterminate animals I3 to I5, above and to the east of the calcite drapery with the negative hands. Probably a doe, complete, turned to the left, endowed with two long erect ears prolonging a minuscule head on a long slender neck, slashed by a thick red line, short and oblique. Four legs in frontal perspective, Y-shaped. Length: 5½ inches (14 cm).

C4 (fig. 105): Same placement and same general appearance as C3; this engraved cervid is therefore probably also a doe turned to the left, even though the neck is a little shorter. The long erect ears do not touch. The underbelly is rounded. No bodily details. Only one foreleg and two hind legs, very long. In this instance, the legs have been depicted by means of parallel lines and not as Ys. About 5 inches above the hindquarters is a series of about 30 vertical parallel lines. Length: 11¹³⁄₁₆ inches (30 cm); height: 9⅞ inches (25 cm).

C5 (fig. 106): On a wall covered with finger tracings, at the west end of Crab Boulevard in Chamber 2, near the small submerged shaft, 3 feet (1 m) above the ground is a complete cervid, turned right. Slender head surmounted by antlers seen in frontal perspective, one connected to the line of the nose, the other very close to the dorsal line, before which an ear is inserted. The antlers, well developed, converge in an open V atop the skull. The front antler rises almost vertically. The other leans and has the brow tine raised. The tines are found only at the ends of the antlers, as with a young animal. No detail for the head. The dorsal line is interrupted by the expanded withers, generally typical of reindeer. The head is not lifted as is general for deer. It is extended forward, a bit low, which may explain the bulging withers. Only one V-shaped leg is shown on each

side. The sex is depicted by some lines. The tail is short and separate from the hind leg. A curved line cuts through the hindquarters vertically. At the bottom of the flank there is an oval sign. The head and antlers are typical of a deer. The dorsal protuberance is more characteristic of reindeer. However, we think this engraving is more likely a deer.

C6 (fig. 107): On a wall covered with finger tracings, in the east area of Chamber 1, to the right when facing the large shaft, 17¾ inches (45 cm) from the underbelly of the horse Chv25 and just

ognize a megaloceros, painted with a few lines on a ceiling covered in finger tracings and engravings that it cuts through. The head is relatively slender, with a short line for the nostril. It is very different from the head of an eland, the only Upper Paleolithic animal that has a comparable hump. The body is very massive, with two Y-shaped, parallel forelegs. The line of the breast is extended to serve as one of the front legs. These two identical conventions are found, as we have seen, on a good number of engraved animals. Length: 3½ feet (1.1 m).

107. Red deer C6 turned right, engraved on a ceiling overhang (drawing)

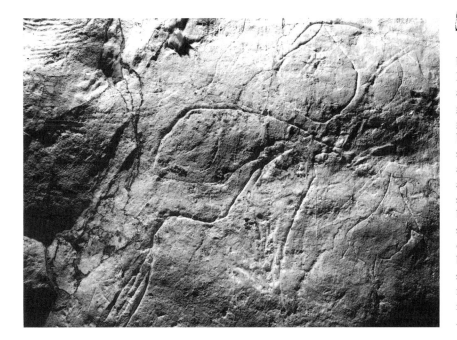

Mé2 (fig. 108): At the top of the bison fault, not far from the large bison Bi1, very near the ibex Bq6, on a ceiling, about a yard (90 to 100 cm) above the ground, there is a large, complete, engraved animal, turned right, with massive body and elongated neck, and with a short head surmounted by long curved antlers, immediately above which there is another U-shaped line done with the same technique, which may or may not belong to the animal. If it belongs to it, as seems possible, this would confirm the cervid's classification as a megaloceros, based, as for Mé1, on the very large dorsal hump. Breast and front side of the foreleg done in one line. The legs are in frontal perspective, drawn as Ys. Length: 4 feet (1.2 m).

108. Left: Large engraved megaloceros (Mé2). On the right, a young ibex (Bq6), also engraved, can be seen

109. Large megaloceros (Mé1), recognizable by its enormous hump, painted on a ceiling covered in finger tracings

about facing the feline. This complete, engraved deer, turned right, is placed 6¼ feet (1.9 m) above ground. Long neck ending in a head with few details, without an eye but with an ear. The antlers, done with heavy lines, are seen in frontal perspective, and one of them has the brow tine connected to the top of the line of the nose and surmounted by the next tine. Typical dorsal line. Tail barely indicated. The sex is absent. Only the right legs shown—the hind leg in converging lines, the foreleg in two parallel lines. The shoulder has been drawn taking advantage of a natural protuberance in the rock. All the engraved lines are deeply incised. Length: 27½ inches (70 cm).

Mé1 (fig. 109): Painted in black on a ceiling, a yard (1 m) above the ground, where pieces of charcoal were found, in Chamber 2, almost facing the great auks. This complete animal, turned left, we first termed indeterminate,[19] but the enormous dorsal hump made us rec-

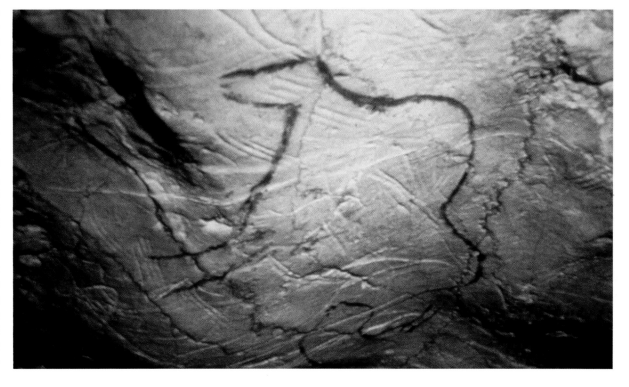

Characteristics of the Cervids in the Cosquer Cave

Relatively few in number—8 in all—or 9 percent of the land animals, the cervids are divided into three distinct subjects, each of which poses its own problems of classification.

Heads high, typical antlers, straight dorsal line, they are unmistakable except for C5, the head of which is low with the withers bulging, as for reindeer. The slender head, unlike the more massive one of the reindeer, and the characteristic antlers identify it as a deer, however. We concede the subjective nature of this conclusion, since we are giving greater weight to two criteria, form of the head and antlers, than to two others, carriage of the head and dorsal line. This deliberate choice is based on the conviction that the antlers would constitute one of the major elements in identifying a species, as much in nature as in art, while the protruding withers can be explained by the bent position of the head.

These details are important, for no reindeer has ever been discovered among contemporary fauna in Provence, and its presence in the bestiary of the cave would have posed the question of the origin of the image—either that the reindeer was present despite all the evidence to the contrary in southeastern France, or that the Paleolithic people of Provence depicted an animal seen one hundred or so miles from there.

Three does (C2, C3, C4) have been identified. There is no doubt about them. In each case, the artist has rendered the distinctive long ears and tapered neck, perhaps to avoid confusing them with stags after shedding.

Finally, the 2 megaloceros have been identified as such because of their large humps. These are not elands, judging from the shape of their heads. One (Mé1) is painted and has no antlers (female, or male having shed his antlers). The other (Mé2) is engraved and has antlers. The resemblance of these creatures to each other means we can discard the hypothesis of a chance malformation of the dorsal line in Mé1: these are certainly animals with a large dorsal hump that the artist (the same person?) wanted to depict using two different techniques.

As a group, the 8 cervids are no different from the other animals. All but one (7) are complete, the eighth being reduced to the forequarters; 5 are turned to the left and 3 to the right. The legs are just as spare and spindly as those of the ibex or horses. Bodily details are also missing: the sex is depicted on only one deer (C5) and the eye on one other, along with the tear duct (C1); noteworthy are the sets of twin lines on the neck of C2, indicating details of the coat. Three cervids have been placed between 6¼ and 7 feet (1.9 and 2.1 m) from the ground, the others at less than 4 feet (1.2 m).

Associations occur with ibex and, above all, with horses, which is logical if one takes into account the preponderance of equids in the cave: C2 with Chm1 and Chv11; C3 and C4 with Chv29 and Chv30. In addition, C1 is not far from Chv7, Chv8, and Chv17 and C6 from Chv25.

Finally, a doe (C2) bears a sign in the form of a feathered line at the base of its neck and a stag (C5), an oval sign on its flank.

Feline or Bear

Among the carnivores of the Upper Paleolithic, felines and bears have a special place. They were formidable competitors with men, who struggled against them for occupation of cave entrances.

Apart from the lynx and the wildcat, not depicted in art, the group of felines important to this discussion was essentially the cave lion, larger by a third and more robust than present-day

lions. This species was in evidence until the end of the last glaciation, since it is depicted in a good number of Magdalenian caves (Les Combarelles and Lascaux in the Dordogne, Les Trois-Frères and Labouiche in the Ariège). In the paintings, their heads, with square muzzles and round ears, often show the teeth, sometimes exaggerated. No image of a Paleolithic feline has a mane. Felines are relatively rare in art, perhaps, as Count de Saint-Périer suggested,[20] because these animals are less edible than the others and more difficult to hunt and to observe (however, this opinion has been criticized by Léon Pales).[21]

Two species of bear are known in the European Upper Paleolithic: the cave bear and the brown bear. The first became extinct with the last glaciation. It measured more than eight feet (2.5 m) in length, with a skull 23⅝ inches (60 cm) long, and weighed over 800 pounds (400 kg). Tens of thousands of its bones have been found in numerous caves (Lherm, Aubert, Bouichéta in the Ariège, L'Aldène in the Hérault department, among others). Unfortunately, this abundance caused the destruction of sites, either through innumerable clandestine digs that ravaged the caves or else, at the end of the last century, through exploitation by small industrial concerns that transformed the bones into phosphates sold for fertilizer.[22]

The cave bear hibernated, and some would die during the winter, which helps explain the profusion of remains in certain caves. At the time, the Magdalenians exploited the remains. At Le Tuc d'Audoubert, several cave bear skeletons have been stripped of their canine teeth, which, no doubt, were used to make impressive pendants, acquired without risk. In deep caves, where traces of cave bear activity remain as markings on the walls (scratches) or in the clay floors (wallows and chutes where they amused themselves by sliding), the bones collected. Studies show many lesions in these bones due to arthritis, and some think that the proliferation of these lesions contributed greatly to the disappearance of the species.

The brown bear, smaller and with slighter bones, replaced the cave bear during the Magdalenian period. It persisted in the wild until the present day. Now it is on the way to extinction. At the end of the 1960s, there were still about sixty in the Pyrénées.[23] Now there are barely half a dozen, and they completely disappeared from the Alps before World War II. Until the nineteenth century, there were so many in the Pyrénées that some villages made a specialty of raising cubs to tame them and later display the adult beasts at feasts and fairs. The bear tamers ("oussaillés") of Ustou in the Ariège were famous. We will never know whether during the Paleolithic, bears were "domesticated" in a similar way but it is likely, so close in many qualities and abilities is the bear to man.

In prehistoric art, bears occur more frequently than felines. They are depicted at times singly, at times in groups (Les Trois-Frères, Ekain), rarely in a scene, as on an engraved bone from Péchialet, where a bear stands upright facing two humans. It is difficult for us to say if such paintings represent cave or brown bears. Apart from size, which we have no way of estimating without a scale, the only decisive morphological difference is the more rounded forehead of the cave bear, with a ridge that marks the protrusion from the lower face, while the line of the nose for the brown bear is almost straight.

The lone carnivore head in the Cosquer cave, with its rounded ears, could belong either to a feline, as we intuitively concluded at first, or to a bear. If the latter, it would more likely be a brown bear with a straight forehead than a cave bear. Despite the lack of certainty, we will continue to classify it as "feline," the identification that seems most probable to us, as well as to the ethologists consulted. Apart from the interest in seeing a rare species depicted, this head is remarkable above all for the three-quarters perspective chosen, accomplished by the placement of the eyes.

The Feline in the Cosquer Cave

110. Head of a feline (F) shown in three-quarters perspective

F (fig. 110): On the ceiling of Chamber 1, near horse Chv9, 4 feet (1.2 m) from the ground. The head is turned right and seen in three-quarters perspective, with its ears and eyes set unevenly, rather like those of the bison Bi1. The mouth is emphasized by a double line. The whole is quite crude but still characteristic of a feline or maybe a bear. It is superimposed on finger tracings. Length: 11¹³⁄₁₆ inches (30 cm). Drawn with heavy lines with charcoal used as a stick or "pencil," which broke at the base of the neck. A sample lifted from here gave a radiocarbon date of 19,200 ± 220 B.P. (Gif A 92,418).

Indeterminate Animals

The idea of the indeterminate is of necessity vague and ambiguous since, on the one hand, what is undetermined for one person is not necessarily so for another and, on the other hand, one never knows in principle if an indeterminate outline will remain so forever, nor whether the artists deliberately cultivated vagueness.

Specialists classify among the indeterminate animals all the representations sufficiently precise to be recognizable as animals even though at present the identification cannot be refined further.[24] Thus, a wavy line will not necessarily be called a snake or a cervico-dorsal outline, and disorganized lines will not be included in this category. The category is entirely pragmatic: a fish, identifiable only at the level of class, will not appear there, and we arbitrarily consider it sufficiently identified. However, we will place among the indeterminates some silhouettes of herbivores, since mammals are generally detailed and determinable at the level of species in Paleolithic art.

The terms that we use, "identifiable" and "indeterminable," reflect the mental process of a modern person confronted by prehistoric art, trying to relate it to present reality. Thus, being indeterminate can be intimately connected to the figure itself or can be external to it, when for example it has undergone damage that renders it less understandable.

Being indeterminate is intrinsic to an animal figure when at its depiction it was ambiguous or not clear. There can be different reasons for this. The lack of skill of the person doing it is one. Not all the Paleolithic works of art are masterpieces, even if publications, consciously or not, highlight the successes and the most spectacular representations. Another possible reason: some figures, obscure to us because of our temporal and cultural distance from Paleolithic art, could very well have been completely clear to people of the time or to certain initiates. Finally, the artists could have deliberately cultivated non-differentiation on different occasions. They have sometimes in the same figure mixed human and animal characteristics or characteristics of animals of different species. In the latter case, the nature of what is indeterminate departs radically from those preceding; it then stems from a fundamental spiritual attitude expressing a conception of the world where beings interpenetrate without clear-cut distinctions, where the worlds of animals and humans are indissolubly connected and consubstantial with one another. It is the opposite pole of naturalism.[25] In cultures closer to ours chronologically, such spiritual attitudes have given birth to beliefs in werewolves and in leopard-men.

The Paleolithic representations with physical characteristics belonging to different animals were often called monsters or fantastic animals, such as the "Unicorn" of Lascaux, or even, improperly, hybrid animals. We prefer to speak of "composite animals."[26] "Composite beings" or "composite creatures" will designate those figures in which human and animal features are mixed, such as the "Sorcerers" of Les Trois-Frères and Gabillou. Finally, we will use the terms "fantasy animals" or "unreal animals" when animals are assigned morphological characteristics that do not exist in nature.[27]

The intensive study of such strange creatures present in a good number of caves, including the Cosquer cave, shows that with a few rare exceptions (the composite beings mentioned at Les Trois-Frères and at Gabillou), they do not resemble one another. It is not a matter, then, of a precise theme or symbol but rather of a state of mind. These figures, furthermore, are neither crude nor chance; their deformation is deliberate. Some are placed just before a major difficulty in the underground route, such as the fantasy animals of Le Tuc d'Audoubert and Le Portel, which are drawn immediately before very narrow passages.

These strange forms are in the domain of the imaginary. Thinking of them, one cannot help but recall the recent interpretive theories of David Lewis-Williams and Thomas Dowson[28] on shamanism. Shamans or sorcerers in South Africa, the American Southwest, and many other places in the world had as their essential function to serve as a link between the world of the living and that of external powers from whom they sought aid. Shamans communicated with that other world during trances induced by different means, such as hallucinogenic drugs, rhythmic movement and sounds, and conditions of extreme fatigue or of fasting. In a trance state, the shaman first perceives geometric forms, which could explain the signs that are so numerous in Paleolithic art, perhaps including some of those discovered in the Cosquer cave (see Chapter 7). Then, in a second phase, he begins to put these visions in order; finally, in a third phase, he sees the forms of concrete animals or spirits, naturalistic or deformed, that seem to him real. The Paleolithic wall paintings and engravings could be reproductions of these phenomena, perhaps conferring on them a greater life force and increasing their practical efficacy.

With the rigor of present research, the category of indeterminate animals tends to take on an increasing importance. Michel Lorblanchet[29] is concerned that it will be transformed into a sort of catch-all where the "discards" are relegated, while, in fact, it conceals multiple realities and expresses different mental processes. Its hetereogenity is indeed troublesome, and one must try to distinguish what is hidden within it. However, its existence is indispensable, since it permits the use of statistics to verify the degree of naturalism in the art of a given cave. If the percentage of intentional indeterminates is high, that means that at the site under consideration the imaginary took precedence over realistic depiction.

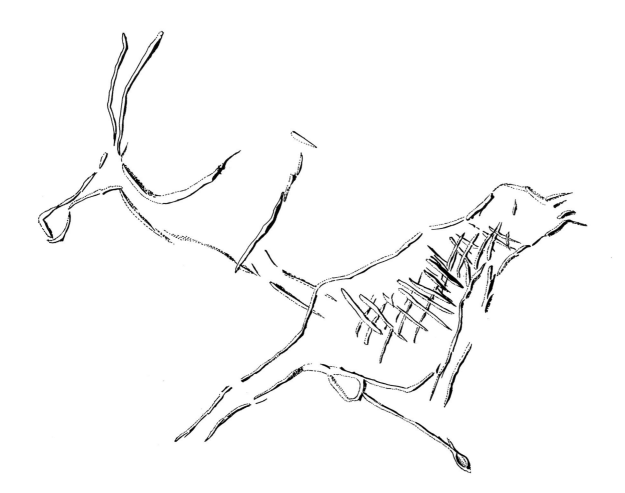

111. On the left, indeterminate animal I 6, a sort of ibex with the head intentionally deformed. On the right, a seal (Ph8) (drawing)

The Indeterminate Animals in the Cosquer Cave

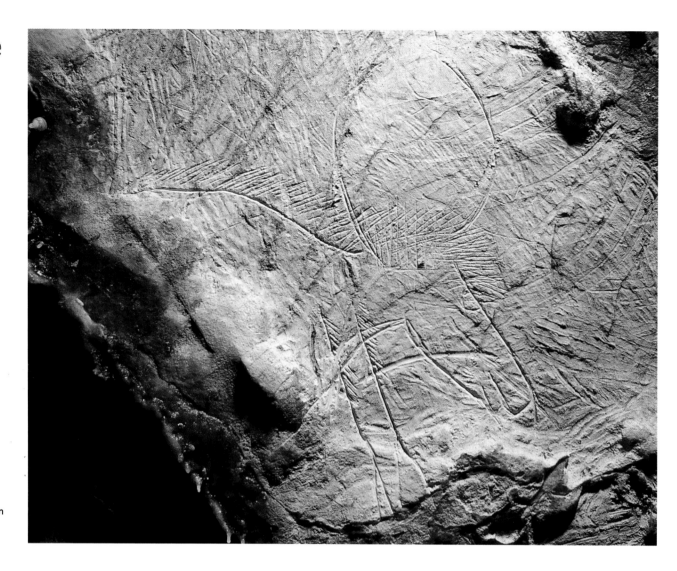

112. Fine engraving, superimposed on finger tracings, of a strange animal (I2) struck by two barbed lines

I1 (fig. 27): In Chamber 2, beneath the hindquarters of the megaloceros Mé1, there are two painted forelegs, one of which is Y-shaped, and the roughly painted forequarters of an indeterminate animal with a disproportionate head, turned upside down.

I2 (fig. 112): (We called this a horse/bison in our initial article on the cave.[39]) Not far from the jellyfish, facing the horses Chv1 to Chv4, on a ceiling in the southwestern part of the cave, 4½ feet (1.4 m) from the ground is engraved an animal, perhaps composite, turned right, with an elongated horse's head but endowed with two horns in frontal perspective. The front horn has a series of small lines on the outside. These are not exactly comparable to bison horns, though they are similarly curved. Between the horns, long, straight hairs are depicted. The dorsal line curves into a slight crest. It is surmounted by a series of fine oblique strokes representing the coat. Two signs barbed at each end cut through the breast. Their Y-shaped base is classic in the Cosquer cave, but their point, barbed on each side, is unusual. This animal is superimposed on a whole ensemble of ancient engravings. Length: 23⅝ inches (60 cm).

I3 (figs. 98, 99): On a ceiling beside the large shaft, on the panel of small, entangled engravings, 6¼ feet (1.9 m) from the ground is a rangy animal with a flat back and large underbelly, two Y-shaped legs, and a slender, disproportionate neck, and without apparent head. It is a fantasy animal that somewhat resembles a bird. It is superimposed on the horse Chv30. Longest measurement: approx. 7⅞ inches (20 cm).

I4 (figs. 98, 99): On the same ceiling and the same distance from the ground as I3 and slightly to the left, a complete animal is turned to the left. It cuts through the ibex Bq15 and is cut through by the horse Chv30. Very elongated head with enlarged nostril coming into contact with I3, surmounted by two long vertical horns (or ears?) that do not touch. Fairly massive body with four Y-shaped legs. A poorly executed ibex? Chamois? Eland?

I5 (figs. 98, 99): On the same panel, above and to the left of the two preceding figures. Forequarters barely sketched with two lines that extend to outline a very long neck and a long ear. Some other lines might indicate a fairly wide head. Perhaps it could be a doe?

I6 (fig. 111): On the ceiling and to the right of the small submerged shaft in Chamber 2, 4 feet (1.25 m) above the ground is engraved an animal turned left. The erect head displays two long horns that immediately make one think of an ibex, but this head is deformed, with a protruding muzzle and a neck very much too long for an ibex. The hindquarters are on a protrusion in the ceiling. The tail is indicated. Y-shaped legs. This animal appears purposely deformed and should thus be classified among the indeterminates. Length: 9⅞ inches (25 cm).

Characteristics of the Indeterminate Animals in the Cosquer Cave

The six animal representations classified as indeterminate can be placed in two distinct categories. I1, I4, and I5 have a crude and badly executed look (I1, I4) and/or are incomplete (I1, I5). The indeterminate element, in these cases, may result either from the lack of skill of the artist, or from our inability to interpret the figures for lack of sufficient information, or from both.

On the other hand, in the cases of I2, I3, and I6—to which, perhaps, should be added the curious figure inserted between the seal Ph5 and the chamois Chm5, in the long ibex-chamois-seal frieze (fig. 102), which could be either a fantasy animal or a complex geometric sign—the distancing from reality seems deliberate. Thus, not only does I2 display a horse's head and horns in an arc, but one of the horns—the form of which is reminiscent of a bison's, with the short frontal mane of a bison also drawn—bears a series of unintelligible slanting short lines on the outside. If it is a cervid, the antlers would be quite strange. I2 is then a composite animal, while I3 and I6 are unquestionably fantasy animals, the first (I3) with its disproportionate neck—a characteristic found again and again among the unreal animals in other caves (Pergouset, Le Portel)—the second (I6) also with too long a neck and a head deliberately given a most curious prominent bump. Furthermore, the figure I6 is associated with a seal, which seems itself to be deformed. In this respect, the mental attitude of the artist was the opposite of the will to naturalism that appears in the other animal representations.

Conclusions

The 87 land animals in the Cosquer cave, to which will be added 1 human and 12 sea animals, certainly do not represent the final total of animal depictions. They do, however, provide a solid statistical base for studying the choices made by the artists. The tables below are the basis for some significant generalizations:

1. VIEW OF ANIMALS

	Chv	Bq-Chm	Bi	C	F	I	Total	%
complete	10	17	2	7	0	3	39	44.83
forequarters	13	6	6	1	0	3	29	33.33
head-neck	11	1	1	0	0	0	13	14.94
head	2	0	3	0	1	0	6	6.90
TOTAL	36	24	12	8	1	6	87	100

2. PLACEMENT OF ANIMALS

	Chv	Bq-Chm	Bi	C	F	I	Total	%
ceiling	13	9	5	5	1	5	38	43.68
wall	10	13	6	3	0	0	32	36.78
other	2	0	0	0	0	0	2	2.30
not recorded	11	2	1	0	0	1	15	17.24
TOTAL	36	24	12	8	1	6	87	100

3. DIRECTION ANIMALS FACE

	Chv	Bq-Chm	Bi	C	F	I	Total	%
right	11	8	5	3	1	1	29	33.33
left	25	16	5	5	0	2	53	60.92
front	0	0	1	0	0	1	2	2.30
not recorded	0	0	1	0	0	2	3	3.45
TOTAL	36	24	12	8	1	6	87	100

4. TECHNIQUE USED

	Chv	Bq-Chm	Bi	C	F	I	Total	%
engraved	24	23	7	6	0	5	65	74.71
painted	12	1	5	2	1	1	22	25.29
TOTAL	36	24	12	8	1	6	87	100

5. AVERAGE LENGTH (IN CMS) AND NUMBER OF COMPLETE ANIMALS MEASURED

	engraved	painted	combined
Chv	41.8	70	54.33
no.	5	4	9
Bq-Chm	38.85	56	40.40
no.	10	1	11
Bi	24.5	120	72.25
no.	1	1	2
C	58.5	90	69
no.	4	2	6
I	35	0	35
no.	3	0	3
combined totals:	41.78	79.5	51.51
no.	23	8	31

That ceilings were the preferred position is certainly surprising, for in most caves a great majority of animal figures are found on walls. Several explanations are conceivable: the configuration of the chambers at Cosquer, with many low passages; the flooding of all the lower level of the cave that destroyed the works that were probably located there, so that the ceilings would be over-represented with respect to the original ensemble of works of art. Perhaps there are also less prosaic reasons: the low passage decorated with a whole series of paintings (horses, ibex, deer) was chosen by design. This attraction to secret corners and restricted places, to low areas that one can slip into only with difficulty, has been remarked upon in other Paleolithic caves. It expresses the desire to penetrate to the farthest depths of the cave, whether in the course of initiations or to leave one's mark—or in order to reinforce the power of the representation, which at times can seem to rise out of a fault as if the animal had been a prisoner of the rock and was freed from it by the artist. The drawings done on the ground and on a stalagmitic column (which is exceptional), and those done on the easily accessible and plainly visible walls, generally by upright adults, are the product of different thought processes.

The distribution of the animals in the Cosquer cave does not seem to express particular choices, unless it is that of a suitable surface. Horses, bison, deer, and others are found throughout the areas above water with no systematic pattern. We do not observe a "gallery of bison" and another "of horses," as at Le Portel, even if several bison—the two large, black, bison Bi1 and Bi2 and the bison Bi11 and Bi12, were drawn in the same fault. Panels with ensembles set down at the same time (the frieze of ibex-chamois-seals, the panel of horse-doe-chamois, the panel of horses Chv1 to Chv4) are obvious, but on the scale of the cave as a whole, at least in the part preserved, no grand thematic structure in the wall arrangements seems evident. That certainly does not mean that the images were drawn at random and that no compositions exist, for the examples cited well demonstrate the contrary. However, an exhaustive study of the walls and ceilings remains to be done, and it would be imprudent to draw definitive conclusions about the problems of thematic construction given the present state of our knowledge.

Two out of three animals are turned to the left. For this preference the reasons escape us. Almost half the animals are complete. Complete animals are most numerous in the caprid and cervid categories. Bison and horses are often shown in abbreviated views—the head, the head and neck, or the forequarters. Here a choice based on some requirement other than recognizability must have been made, since ibex and deer are equally recognizable from just their heads and horns or antlers.

The average length of the 31 complete animals measured (see Table 5) is indexed by techniques and themes. Bison and cervids, especially the megaloceros, have dimensions significantly greater than those of horses and caprids, and the indeterminates are small. For each group, the painted animals are notably larger than the engraved figures, twice as large on average, which again poses the problem of the comparative value of techniques and of their cultural meaning.

Numerous decorated caves have a specific character when it comes to technique. For example, in the Magdalenian caves of the Ariège, Niaux and Le Portel essentially contain painted animals, while in Les Trois-Frères, engravings very much predominate. In the Cosquer cave, the disproportion is not as large but it is still three to one in favor of engravings. Certain animals relatively rare in wall art (feline, chamois, and, as we will see, seals and auks) have been represented with just one or the other of these techniques. On the other hand, the more common species (horses, bison, ibex, cervids) were both painted and engraved. This general observation must be qualified, since on the one hand the numerous ibex in Cosquer are all engraved, with just 1 exception (Bq1), and on the other, the does are never painted while the stags are, and of the 2 megaloceros, rare animals, 1 was

painted and the other engraved. These techniques were not used successively by different people, as the example of the megaloceros demonstrates. Above all, the animals display the same stylistic characteristics, which recur no matter what the manner of representation: V-shaped sex, Y-shaped legs, absence of hoofs and bodily detail, horns and ears seen from the front, among others. Thus they all bear a striking resemblance to one another.

The count of naturalistic themes comes at present to a total of 100 units, so that percentages are easy to calculate: horses, 36 percent; caprids, 24 percent; bovids, 12 percent; sea animals, 12 percent; cervids, 8 percent; indeterminates, 6 percent; feline, 1 percent; human, 1 percent. Subdivisions are possible: among the caprids, 20 ibex and 4 chamois; among the bovids, 9 bison and 3 aurochs; among the cervids, 3 red deer, 3 does, and 2 megaloceros.

This thematic ensemble is easily integrated into Franco-Cantabrian art in the broad sense. The horse predominates, as in the majority of Paleolithic caves. Its companion the bison, which according to André Leroi-Gourhan is very often associated with the horse in cave art, holds a respectable position in this bestiary. Ibex, chamois, and sea animals express the importance of the environment in the choices of the artists. The Cosquer cave was in Paleolithic times in the middle of a karstic limestone network, in a region of cliffs where caprids must have been plentiful. As for cervids, does, red deer, and megaloceros, they suggest a relatively temperate climate. Even at the height of the glaciation, the latitude of Provence was the same and the climate there was less harsh than elsewhere; these animals bear witness, then, to the inevitable weight of environment and its material contingencies on the bestiary chosen.

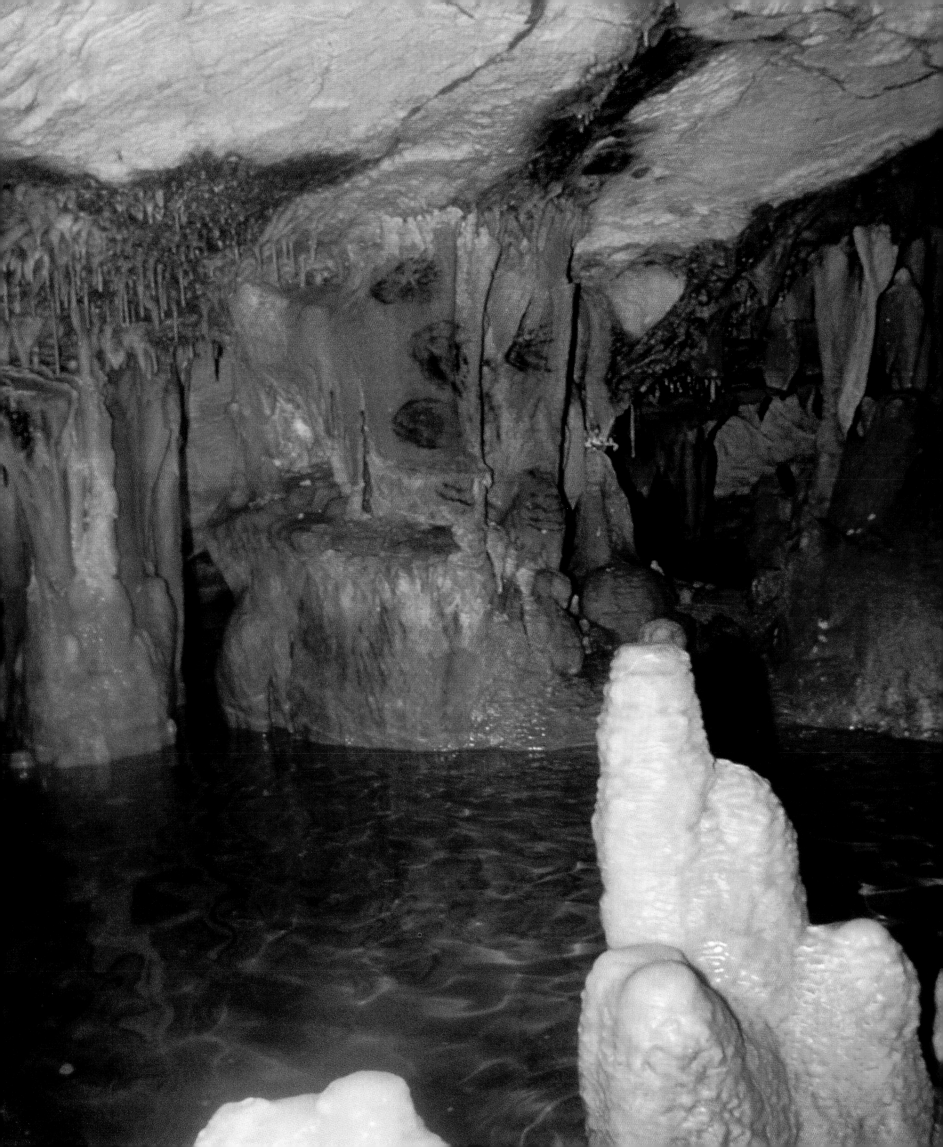

6. The Sea Animals

Aside from a few fish, no sea animals have been depicted in other known Paleolithic decorated caves. In the Cosquer cave, they make up a fairly significant proportion of the total number of animal figures: 12 percent, counting the auks, the seals, and one fish. This is highly unusual.

Auks

Among the first set of photographs we had in hand were some of strange-looking birds (fig. 114) that seemed to be penguins but were, in fact, auks, as we learned later. Penguins inhabit the Southern Hemisphere and auks the Northern Hemisphere (see below). This photograph increased our initial doubts, since we believed this was the very first time that such birds had been depicted in Paleolithic art. Could there have been auks in the Mediterranean during the Upper Paleolithic? We were completely ignorant on the subject and had only the vague ideas of Mr. Average Citizen about the ques-

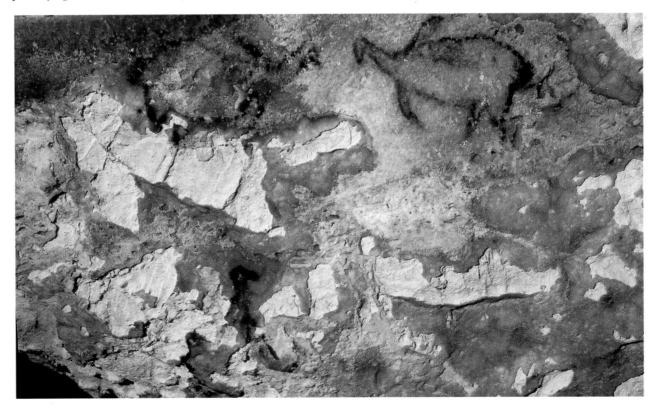

114. Opposite: Black shapes reminiscent of jellyfish have been painted on a stalagmitic mass now bathed by the sea

115. Left: The three great auks of the Cosquer cave. The one at left and, even more so, the one at lower left have been damaged by the ceiling flaking off

tion. In our minds, the auk was a seabird that could only live in a cold biotope. It belonged in the Arctic or at least at latitudes much more northern than that of the Mediterranean. Had it lived here after all during the glacial periods? And if not, did that mean that some Solutrean traveler had seen auks on other shores and had then brought back the image? After all, even if the ensemble of paintings and engravings in the cave turned out to be authentic, simple precision demanded that all the depictions be verified in detail lest some joker had added works of his own invention.

Examination of the photographs, followed by Jean Courtin's visit to the site, reassured us on this last point. The birds had an "old" look about them, due to erosion of the painted lines as well as to a fine film of calcite that covered them. Furthermore, on the ceiling where they were found, the film of ancient calcite on which they had been painted had flaked off in patches, diminishing the bird at top left and cutting off a large part of the one below. The patches of bare rock did not have that fresh look left by very recent scaling, and no trace of flaking at all was found on the ground. These were really prehistoric auks, then—a first. Until then, pictures of only two birds of this species had been reported. The first, a wall engraving[1] (fig. 118), was identified by the Abbé Breuil in the cave of El Pendo, not far from the coast of Cantabria. The second was engraved on a block of rock in the Paglici cave in Apulia. Its classification was based on its spindle-shaped body and a head with no large details except for an eye and ending in a large beak (fig. 119). The authors of a study on the Paleolithic of Mount Gargano, Franco Mezzena and Arturo Palma di Cesnola,[2] considered two possible species of auk, the great auk (*Pinguinus impennis*) and a smaller one (prehistoric depictions of animals are done without regard to scale, so the criterion of size cannot apply). This engraving was also crude, and so had remained largely unknown to specialists. Its identification as auk has since been challenged by Francesco d'Errico,[3] who sees it instead as a large predatory bird.

The birds in the Cosquer cave, painted in black, were much more detailed, recognizable as great auks by their massive, bulky body topped by a small head and large beak. The neck is quite long. Their short wings spread out against the body in frontal perspective; their abbreviated tail; and their small legs treated in the same style as the quadrupeds—Y-shaped, like crutches—gave them a characteristic look. Their semiprone position was not the one historically given to penguins, which are almost always depicted standing on their hind legs, as one sees them at their breeding sites. The dimensions of the three birds at Cosquer are remarkably similar. The one on the right, the best preserved, measures 10¼ inches (26 cm) from top of the head to tip of the tail. It faces another a little larger—about 10½ inches long (27 cm)—turned toward it, with its body, legs, and wings in the same positions. Located beneath the second great auk, the third—also 10½ inches long—was often forgotten in the accounts of the discovery that appeared in the press because it has almost entirely disappeared where the superficial coating of calcite has come off the wall. Only the head and the upper body remain, along with the tip of the tail; legs and wings are no longer visible.

Francesco d'Errico, in an excellent recent article ("Birds of the Cosquer Cave," *Rock Art Research* 11, 1 [1994]), argues that the Cosquer cave's three auks make up an actual scene. The two auks face to face, according to him, could be two males fighting, perhaps for a female, which would then be the bird below. In that case, the scene observed by the artist probably took place at the beginning of the breeding season of the great auk, between the end of May and the beginning of June.[4]

The three auks were painted on a ceiling nearly 6 feet (1.8 m) from the ground, that is to say, by a standing adult, in Chamber 2 just across from the narrow western passage between the two chambers (see fig. 135). Beneath them, the ground is an ancient stalagmitic floor on which there is a large rock attached by calcite, itself covered with pieces of charcoal under calcite, and the remains

116. The great auk (*Pinguinus impennis*), a species of bird exterminated in the middle of the nineteenth century

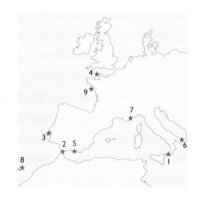

117. Sites in southern Europe with remains of great auks (*Pinguinus impennis*) dated to the Würm glaciation
1. Archi
2. Devil's Tower and Gorham's Cave
3. Figueira Brava
4. Cotte de St.-Brelade
5. Nerja cave
6. Romanelli cave
7. Les Arene Candide
8. Porto Santo
9. Téviec and Er Yoh

either of torches or of a small fire built to light the cave when the works were being done.

Gathering information, we learned to our surprise that auk bones had been discovered in several prehistoric habitats excavated fairly long ago on the shores of the Mediterranean, at the heel and toe of the Italian boot and, closer to France, in Liguria (see fig. 117). The sites in question were from different periods: that of Archi, near Reggio Calabria, dated to the Mousterian, in the first half of the Würm glaciation, but those of the Romanelli cave in Apulia and of Les Arene Candide in Liguria were dated to Dryas III, a severe cold spell a little after the end of the last glaciation, more recent by some 8,000 to 9,000 years than the paintings in the Cosquer cave. Other auk remains were also reported from the Mousterian at Gibraltar and from the Magdalenian in the cave of Nerja near Málaga in Andalusia.[5] This was the great auk (*Pinguinus impennis*). During all the last glaciation and even afterward, this species inhabited the Mediterranean, and at that time people were not averse to including them in their diet.

118. El Pendo (Spain): Prehistoric engraving of an auk (drawing)

The great auk was a large bird 27½ inches (70 cm) tall, with a massive body, a tail, wings, short legs, and a large head ending in a strong beak, recognizable by the large white patch beneath its eye (fig. 116). This patch gave the genus penguin its name, from the Gaelic "pen" (head) and "guyn" (white). In French, this name has been adopted and applies to auks, alcids, and the penguins of the Southern Hemisphere, the spheniscids, even though they belong to a quite different order.[6] Curiously enough, in English the process was reversed and only the latter are called "penguins," while the French *grand pingouin* is "great auk." When we published an article on the Cosquer cave in the journal *Antiquity* in 1992, we automatically used the word "penguin," never suspecting the semantic difference. This prompted several letters from specialists correcting us, at times ironically; they asserted that if it had really been a matter of *penguins*, we could well have been concerned about their authenticity since that bird never lived in the Mediterranean. Happily, it was, in fact, great auks that were represented.

119. Paglici cave (Apulia, Italy): Prehistoric engraving on a rock of a possible auk (drawing)

Until the nineteenth century, the great auk was found over a widespread area, in the islands off Great Britain, in Greenland and Iceland, as well as in the Gulf of Saint Lawrence. Adapted to a marine environment, this bird was extremely fast in the water, where it used its wings as flippers and its legs as rudder. On the other hand, it could not fly and so was very vulnerable when during its seasonal migrations it came ashore in large groups to nest. It usually returned to the same location, which the birds chose for ease of access because of their inability to fly. It was edible and appreciated by sailors, who also ate its eggs and used its fat; its feathers were used for pillows and mattresses.[7] This combination of predictable habits, ease of capture, and practical use brought about its demise. It was massacred in the millions by fishermen and sailors and disappeared definitively in 1844.

The great auk was thus a part of the environment of the people who visited the Cosquer cave. Perhaps there were colonies on the nearby shore that were exploited for meat and eggs, and even for feathers.

Seals

Two engraved seals were noticed at Cosquer during the dives of September 1991 and five others during the dives of June 1992. Because all these animals are engraved and so are less readily visible than the paintings, they were discovered in stages. Some are quite crudely executed as well, and only became identifiable when compared with their more successfully drawn fellow creatures.

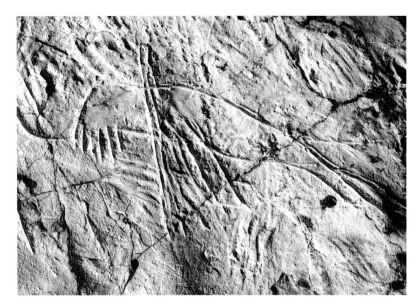

The Seals in the Cosquer Cave

Ph1 (fig. 120): Located on a ceiling, near the large shaft, immediately behind the ibex Bq4, which it seems to be following closely enough to touch. It is turned to the left, the body lying horizontally. It displays a long thick tail, a massive head with long, drooping mustache depicted in a cursory way with six parallel lines, and a flat belly. The body ends in three separate lines to suggest the hind flippers. A foreflipper is well indicated by two deep straight oblique lines, one of which is partially repeated at the top; they have been superimposed on the curve of the belly, and thus were done afterward. Two other lines of the same length are more or less parallel; perhaps they represent the other flipper? Lightly curved, they are also later than the line of the belly.

Two long parallel lines also cut completely through the animal at neck level. But they are located *beneath* the dorsal line, along with another, shorter line beside them at the top. That means the stages in depicting this ensemble were the following: first, the head and mustache, then the line of the belly, then the lines for the foreflippers—the one to the front is cut through by one of the long lines—then the two long lines and the third shorter one, and finally the dorsal line and the hind flippers. The lines seen *on* the animal are thus an integral part of its depiction and were not added at a later time. Length: 20⅞ inches (53 cm).

Ph2 (fig. 86): Located just above the ibex Bq5 on the same ceiling as the first seal (Ph1) and not far from it, but facing in the opposite direction, it resembles the first one very much, with similar dimensions, the same tapered body with

a flat belly, a long tail, and a drooping mustache. The mustache, apparently done with four short lines, displays a cursory technique often used in the Upper Paleolithic to depict the hand of human figures with little effort: the artist simply prolongs the exterior lines of the arms with a slight bend and contents himself with adding three or four parallel lines in the empty space between to depict the fingers. The foreflipper of Ph2 is fairly well indicated. The hind flippers are drawn with four lines. The line of the belly is interrupted on both sides by the foreflipper, which is also sketched with two parallel slanted lines. The back of the animal is crossed by a long sign in the form of an arrow with a forked base, that runs through the body. Length: 16⅛ inches (41 cm).

Ph3 (figs. 121, 122): This seal was engraved a few inches from the nose of a horse (Chv19), which it faces. In this case, even more perhaps than for the preceding seals, the association with another animal species is deliberate. Turned to the right, it is located 35⅜ inches (90 cm) from the ground, above the bison fault, in the northeast section of Chamber 1, a dozen yards from the first two seals. The technique and the look are the same, even if the head is made a bit more specific by a slanted line, to which the three short incisions depicting the mustache are not parallel. The belly is flat, the foreflipper disproportionate, done with the same technique used for the other seals discussed. The hind flippers are sketched with three lines. Two straight parallel lines, not barbed (projectiles?), one

touching the front flipper and the other the neck, showing deep impact. Length: 15 inches (38 cm).

Ph4 (fig. 124): This seal is also associated with a horse (Chv25), more closely still perhaps, in the sense that it has been deliberately engraved within the body of the equid. The lines of the seal's tail cut through the horse's underbelly, so that there is no question of chance superimposition. Like the horse, this seal is small in size and faces left. This ensemble is located on a ceiling entirely covered with finger tracings, in the east section of the cave at one of the highest points in the large chamber. The ground is 5¼ feet (1.6 m) below, covered with numerous pieces of charcoal. In relation to the horse, the seal is in a semierect position, slanted, as if it were lifting itself on its foreflippers. That aside, it very much resembles the preceding seals. It has been drawn with two partially repeated lines for the back and two others for the rounded belly. A central line sketches the hind flippers and two parallel slanted lines, fairly long, the foreflipper. The head is rounded, with four short lines for the mustache. Two long straight signs, not forked, strike the animal on the back and on the flank. The horse is hit by sev-

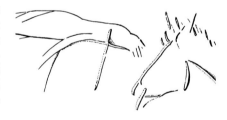

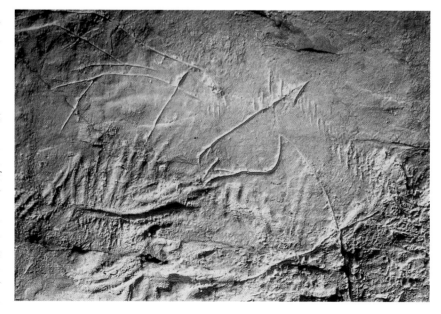

120. Seal Ph1

121. Drawing of the animals seen in figure 122

122. A seal (Ph3) at upper left faces a horse (Chv19)

123. The seals of the Cosquer cave
traced from photographs

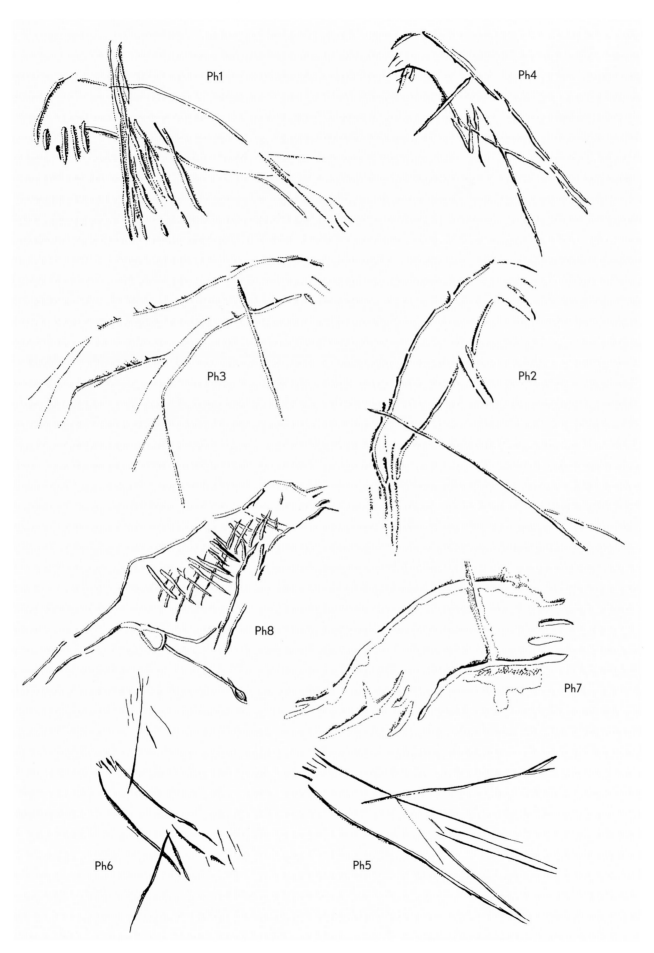

Ph1

Ph4

Ph3

Ph2

Ph8

Ph7

Ph6

Ph5

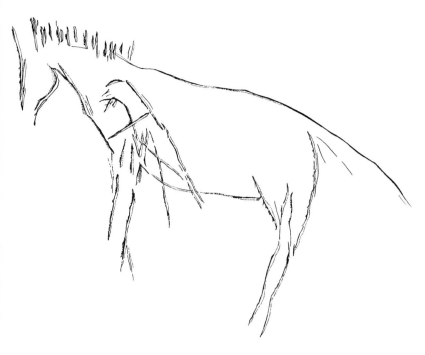

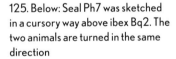

124. Seal Ph4 was drawn within the forequarters of horse Chv25 (drawing)

125. Below: Seal Ph7 was sketched in a cursory way above ibex Bq2. The two animals are turned in the same direction

126. Right: Drawing of the animals seen in figure 125

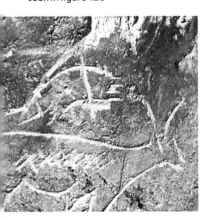

tered in a relatively flat strip bounded on top by a fissure and below by the uneven edge of the wall.

Ph7 (figs. 125, 126): On the east side of Chamber 1, this seal was engraved on a wall colored brick-red by iron oxide, just above the back of the ibex Bq2. We recognized it as a seal belatedly because of its crude aspect, partly due to the width of the engraved lines, which occasionally turn into scraping. At first, we thought it could be an indeterminate sign. It was only after we discovered the other seals that its resemblance to them became clear to us: mustache depicted with three parallel lines, two lines for the foreflipper. It is overlaid by a single long line that crosses it from one side to the other. It is distinguished from the first six seals by its coarse, more compact look, with a wider body that does not display the usual streamlined shape, a foreflipper moved toward the back, the mustache bracketed by the lines that form the extension of the head (different from Ph1 to Ph4 but like Ph5 and Ph6), and the very strong dorsal curve. However, the identification as seal is almost certain.

Ph8 (figs. 111, 127): Located on a ceiling covered with finger tracings, 3½ feet (1.1 m) from the ground, above and to the right of the small submerged shaft. Pieces of charcoal litter the ground, and in this area the walls are stained with torch rubbings. At first glance, this ani-

eral identical lines some of which partially cut through the seal, which means that the sequence of depiction was horse, seal, long lines. This sequence reinforces the cohesion of the ensemble. Length: 8¼ inches (21 cm).

Ph5 (fig. 123): The last animal on the right in a frieze of five animals and a large vertical sign (?) located not far from the horses Chv1 to Chv5, in the southwest corner of the cave (see fig. 102). All the animals are facing left. The seal Ph5 differs from the preceding seals in the long straight lines of its sides, which extend beside the mustache, done with four lines. The body is very tapered. It ends with two separate, diverging appendages, one done with two lines that connect, the other with three, representing most probably the flippers of the animal seen from above, as people would have seen it in the sea from a cliff. This schematic seal is hit not far from the head by a long line with a forked end. It is superimposed on what may be a vertical oval sign or an indeterminate animal, perhaps an erect (?) sea animal with an elongated head and a big belly. Length: 7⅞ inches (20 cm).

Ph6 (fig. 102): This seal is part of the same frieze as Ph5, which it very closely resembles. It also has a long body done with two more or less parallel lines, mustache sketched, and hind flippers diverging in an upside-down V. A feathered line strikes this one in the back of the body. It cuts through the ibex Bq14. The ensemble of the frieze is well cen-

mal has a strange look, with a rounded belly that gives it a bloated look, a large square head, and long thin hind flippers. The lines seem unsure. The identification is based on the general spindle shape, the mustache sketched with four lines, the foreflipper depicted, exactly like that of the other seals, with two parallel slanted lines. It displays crosshatching in the center of the body like some of the other animals in the Cosquer cave, as well as a kind of sign in the form of a long arrow with a sort of loop at the back end and a strong triangular head, the point of which strikes the seal at the back end of its body.

127. This seal (Ph8), turned right, badly drawn and barely recognizable, cuts through the legs of an animal that is just as much of a caricature (I6)

Characteristics of the Seals in the Cosquer Cave

These seals all bear a resemblance to one another (fig. 123). None is painted, all are engraved. Some (Ph1 to Ph4) appear so alike in technique and in physical position that one can reasonably assume that they were done by the same hand. Seals Ph5 and Ph6 differ from the preceding four but are very like one another. Numbers Ph7 and Ph8 betray one or more inept and untalented artists. All of them, however, possess common characteristics: the mustache is always present, as well as the usually exaggerated foreflipper, drawn in a slanted position. These are several distinctive characteristics that, along with the spindle-shaped body, make them recognizable. On the other hand, the eyes are missing and the hind end of the body is sketchy, done with converging lines to suggest the hind flippers. As with the other animals, the seals have very little detail and instead have been sketched with a few rapid strokes following a conventional scheme used by different artists and repeated from one drawing to the next. They do not occupy a special place in the cave but are found dispersed here and there.

At least two positions, and probably three, have been depicted. The seals Ph1, Ph2, and Ph3 (fig. 123) are shown in profile, lying on the ground, which is confirmed by their flat bellies. Ph5 and Ph6 are seen from above, perhaps swimming. Ph4 is halfway erect. Ph7 and Ph8 are too crude to permit the determination of a position.

All these animals are pierced by long lines, which are difficult not to see as thrown weapons, arrows or spears, though nowadays this hypothesis is no longer fashionable and people speak more willingly of "signs." Two animals, Ph3 and Ph4—and the seal Ph1, which is a special case—bear two of these lines. The others have only one. The lines touching seals Ph2, Ph5, and Ph6 are identical, with a forked end away from the animal. This identity is even more remarkable given that these three seals, by their position, belong to different groups. The signs that overlie them reinforce the similarity of the seals in the Cosquer cave.

The Cosquer seals display an additional common characteristic that is quite curious: unlike the other animals in the cave (bison, horse, ibex, deer, feline), they are never found in isolation; they have been drawn in intentional association either with a horse (Ph3, Ph4) or, more often, with an ibex (Ph1, Ph2, Ph5 to Ph7, and probably Ph8, since the animal near the seal Ph8 has been conservatively classified as indeterminate but more closely resembles an ibex than any other species). Why are the themes of seal and of ibex or horse linked in this way? These animals belong to different biotopes and so it cannot be a question of a real-life narrative theme. If they express one or more stories, legends, or myths of this human group from Provence, as is probable, we will never know the details.

The membership of these animals just described in the family of phocids is beyond the shadow of a doubt. It is impossible, however, to determine their particular species, these depictions being fairly crude and lacking in characteristic details. One can assume they are monk seals (*Monachus monachus*), well documented in the Mediterranean, where in former times they were even very common; some still remain around the Greek islands, on the coast of Libya, and in Sardinia. Teeth from monk seals have been found in the upper levels of the Grimaldi caves in Liguria, so it was occasionally hunted along the shores of the Mediterranean during the prehistoric period. The last seals disappeared from Corsica in the years 1970–75. The monk seal is the species of European mammal most threatened by extinction[8] from the effects of environmental pollution as well as from the blows of fishermen hunting them down. This beautiful aquatic mammal, 7½ to 9 feet (2.3 to 2.8 m) in length, weighing 650 to 700 pounds (300 to 320 kg), its head a bit flattened and its muzzle with a mustache of very stiff hair that plays a role in detecting prey and for orientation in deep water, must have been common on the coast beyond the Cosquer cave. Furthermore, according to old fishermen around Cassis, there were monk seals in Les Calanques area until World War II. The last of them were killed in 1945, at Cape Morgiou! They were still found in southern Corsica, around Bonifacio, thirty years ago.

Seals in Paleolithic Portable Art and Wall Art
Although they are not very numerous (on the order of a dozen), unquestionable representations of seals are not unusual in Paleolithic portable art. Some years ago, they were the subject of an excellent general article[9] that brought out several curious facts. First, there is the location of the sites where the objects came to light, all distant or very distant from the Atlantic coast: in the Pyrénées region, from the Ariège as far as the Basque country, in the Charente, and in the Dordogne. None was reported in the southeastern quarter of France. Recently there was added to this total one engraving that is certainly a seal and two others that are possibly seals, on schist plaquettes, found in the Rhine valley at Gönnersdorf, near Cologne.[10] Second, the chronological and cultural attribution of these seals is equally striking. They are all firmly dated to the Late Magdalenian, between 11,000 and 10,000 years B.P., with the exception of an engraved seal on a chisel made of reindeer antler, still unpublished, found at a Middle Magdalenian level of the cave of Enlène in the Ariège (Clottes, Bégouën, Giraud, Rouzaud excavation), thus older by several centuries.

128. La Peña de Candamo caves (Asturias, Spain): Two possible seals (drawings)

129. La Pileta cave (Andalusia, Spain): Possible seal (drawing)

The seals of the Cosquer cave, associated with ibex and horses that display all the stylistic characteristics common to the other animal representations in this cave, could not be distinguished from them stylistically. Like the other animals painted or engraved in Cosquer, they can be dated to about 19,000–18,500 B.P. They are thus the oldest representations of seals known in the world, earlier by at least 5,000 years than those known until now.

Paintings of seals were long ago reported on the walls of the caves of La Peña de Candamo (fig. 128) in the Asturias region of northern Spain, and of La Pileta in Andalusia. The former were often considered doubtful, although their poses are indeed those of a seal. The seal in La Pileta (fig. 129), shown within the body of an enormous fish, could in fact represent a half-erect seal because of its tapered body, but neither the head nor the front limb supports this supposition, and the animal, which is better classified as indeterminate, has also been identified as a possible horse[11] or even a human![12] Still in Andalusia, the cave of Nerja, near Málaga, is only about 760 yards from the present Mediterranean coastline. Among an important ensemble of paintings, it contains a group of six red, bullet-shaped images (fig. 130), which have been identified with some likelihood as seals.[13] Lya Dams, the author of a recent publication on the cave, even considers them to be monk seals. She attributes them, through stylistic comparisons, to the Middle to Late Solutrean. Present-day specialists increasingly distrust chronological attributions with only a stylistic basis since whenever absolute dates can be obtained, they frequently prove to be quite different. Nevertheless, if this hypothesis should be accurate, it would have the significance of placing the sea animals of Nerja, very different from those we have described, in about the same period as those of the Cosquer cave. Whatever their precise date, the presence of these sea animals confirms the importance of the surrounding environment in the choice of themes for Upper Paleolithic art.

130. Nerja cave (Andalusia, Spain): Six seals in vertical position (drawing)

Jellyfish, Octopus, or Signs?

Not far from the horses Chv1 to Chv5 and seals Ph5 and Ph6, a series of mysterious depictions was painted in black on a large stalagmitic mass (figs. 115, 131, and 132) and on a stalagmitic pillar a short distance away (see fig. 135). Several ensembles can be identified:

- First, a series of four figures in the shape of chevrons or eggs, each with a thick outer line open on the right. Each figure is filled in with a series of lines converging at the point of the chevron or oval. Even though very much eroded, these motifs have forms that remain recognizable even when—as is the case with the three aligned in a column—the internal details are a little vague (the fourth figure is clearer).
- Below the fourth figure are four horizontal lines, also black, and in their extension, on the main stalagmite, are two more lines.
- Still on the same stalagmite, just above where the sea presently washes it, are numerous black lines belonging to one or more motifs that have largely been erased.
- Finally, on another stalagmitic pillar about six feet away, a shape like the four chevrons or eggs can be made out, but this one is larger and vertical—that is, with the open part toward the bottom—and thickly filled in.

We know of no ensemble of depictions identical to this one. Some isolated semi-oval figures filled in with lines have indeed been reported in this or that cave, and they have generally been classified as "comet" signs: for example, a red painting at Les Combarelles and some engravings

131. "Jellyfish," "octopus," or signs in the southwest area of the cave (drawing)

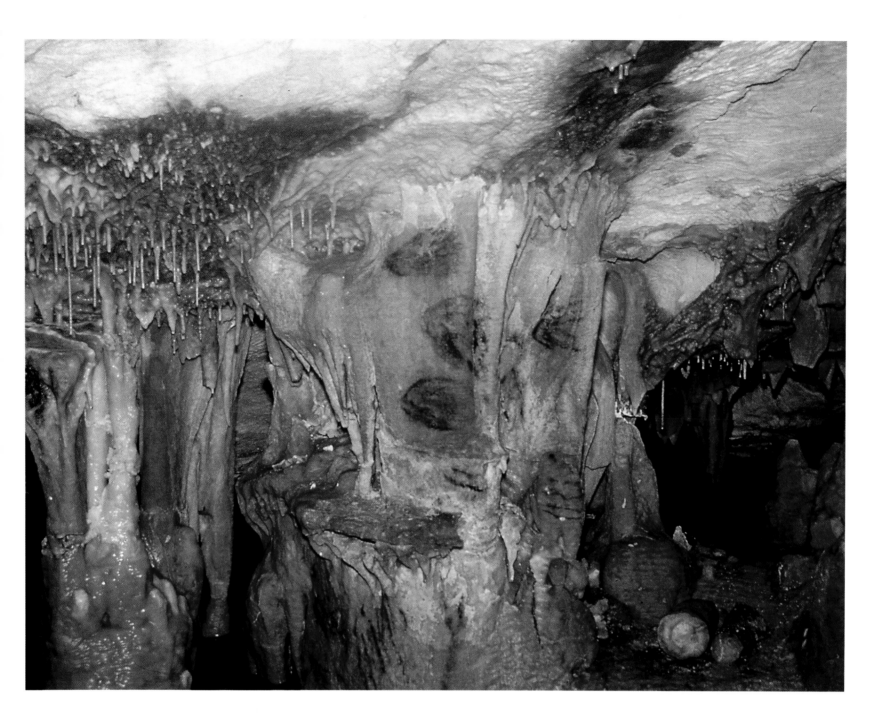

132. Paintings in black reminiscent of jellyfish have been done on a stalagmitic mass now bathed by the sea

at Lascaux (the latter, however, display a middle axis on which the interior lines converge, making them different from the Cosquer figures).[14] In the cave of Nerja, already mentioned in connection with the seals, groups of horizontal lines in bunches within a half-oval ending in a "tail" have been compared to the sign at Les Combarelles and to those of Cantal (Lot) and Las Herrerias in Asturias.[15] In all these caves, these figures have been considered signs, and by André Leroi-Gourhan as "full" signs with a female value.

 In the case of the depictions at the Cosquer cave, it might be different. In fact, we observe that in the same area four figures of the same type are open at the right, while a fifth is open at the bottom. That probably indicates that their position in relation to the ground carried no great significance. It would be different for female signs, or even for "huts," another possible category that has been considered for these signs.

We wondered, taking into account the environment and the importance of marine fauna in the cave, whether they might not be marine animals with tentacles, such as jellyfish or octopus, that change position in the water depending on their movements. Information obtained from specialists in marine fauna at the Center for Oceanology in Marseilles did not rule out the idea that octopus and jellyfish lived in the Mediterranean during the last glaciation, since they are still found at present in the English Channel and in the North Sea. Our hypothesis is not impossible, then, but it remains within the realm of conjecture. As a result we will classify these strange forms as indeterminate shapes, among neither the signs nor the animals.

Fish and Others

In a low area in the north part of the cave, not far from the painted megaloceros, three curious engravings have been done next to one another on a ceiling, a yard from the ground. They pose a problem. If they had been vertical, the one on the right could have been seen as a female outline with the breasts sketched, wide hips, and a line for the sex, and the two others classified as vulvas, with the largest one even having pubic hair and anus. However, their location on a ceiling does not allow for a definite orientation. We lean more toward depictions of fish and have thus arbitrarily oriented them as they are in figure 134.

The motif on the right, 7⅞ inches (20 cm) long, is quite typical. With the wide tail and the line for the mouth, it is reminiscent of a fish in Ardales, Spain (fig. 133), a cave whose art is attributed, furthermore, to the Solutrean[16] and which displays several other similarities with the Cosquer cave (zigzag signs, horns, and antlers). It can thus be classified among the fish without much risk.

The two other oval figures are a different matter. If the one on top, small in size—3⅛ inches (8 cm) long—had been alone, even more so had it been associated with the only fish (the one on the right in figure 134), it would without hesitation have been placed among the numerous fish-shaped motifs in Paleolithic art. On the other hand, the large figure below, 13¾ inches (35 cm) long,

133. Caves at Ardales (Asturias) and La Pileta (Andalusia), Spain: Fish (drawings)

134. Engravings of indeterminate motifs, with a possible fish on the right

throws doubt on this attribution through the details it displays, since the small upper motif does seem to be a reduced and simplified version of it. The juxtaposition of these motifs, of which at least one is almost certainly a fish, inspired us to look in this direction and to describe them in the chapter on sea animals. However, Jean Vacelet and his colleagues at the Center for Oceanology in Marseilles do not see in them identifiable fish or shellfish, even if the tail of the one on the right is reminiscent of certain fish. As a result, we will classify the central and left figures among the indeterminate motifs, being unable to recognize in them either animal or sign.

135. Location of painted and engraved sea animals in the Cosquer cave

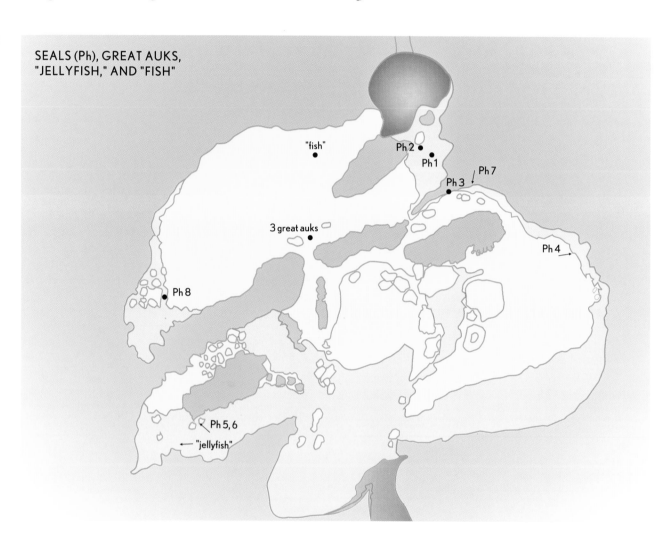

SEALS (Ph), GREAT AUKS, "JELLYFISH," AND "FISH"

The Influence of the Marine Environment on the Iconography of Paleolithic Wall Art

The extreme rarity of depicted sea animals in Paleolithic caves can, no doubt, be explained in several ways. Birds, like fish, are infrequent in the wall art; this is most likely an indication of their lack of prestige as prey. Even if the animals depicted were the elements of a bestiary and the subjects of myths, all the animals Paleolithic people hunted or saw daily were not used in the art. Certain animals, however common (fox, wolf, weasels and the like, snakes, and insects), were almost never depicted. The exceptions—that is to say, the animals drawn in particular instances—could express anecdotes or particular myths. Specific choices were made, for reasons we grasp badly. For example, why are there so many mammoths in the cave of Rouffignac and so few in the Pyrénées?

The quite particular interest of the Cosquer cave, with its auks and seals, is that it demonstrates the definite importance that a special biotope can assume in such choices. As a general rule we have no way to know if the preferential depiction of this or that animal species means that it was predominant in the area, that it indicates the existence of a microclimate, or simply that it results from an arbitrary choice. For the Cosquer art, we do know this, at least for the sea animals present in some numbers (as also at Nerja) but missing from the painted caves of the Pyrénées, Quercy, and Périgord regions. The surrounding environment clearly influenced the themes represented to a considerable degree.

In the case of Cosquer, however, we cannot stress often enough all that is definitively lost. The rise in sea level has submerged hundreds of square miles of coastline with all its caves and shelters. With a few very rare exceptions, such as the Cosquer cave, we know only the sanctuaries of those Paleolithic groups that lived inland. The people who lived along the coasts of France, Spain, Portugal, and Italy, who depended more closely on the marine environment and its resources, could not help but be influenced by that environment in their cultural choices and so display strong particularities. But we still understand them poorly.

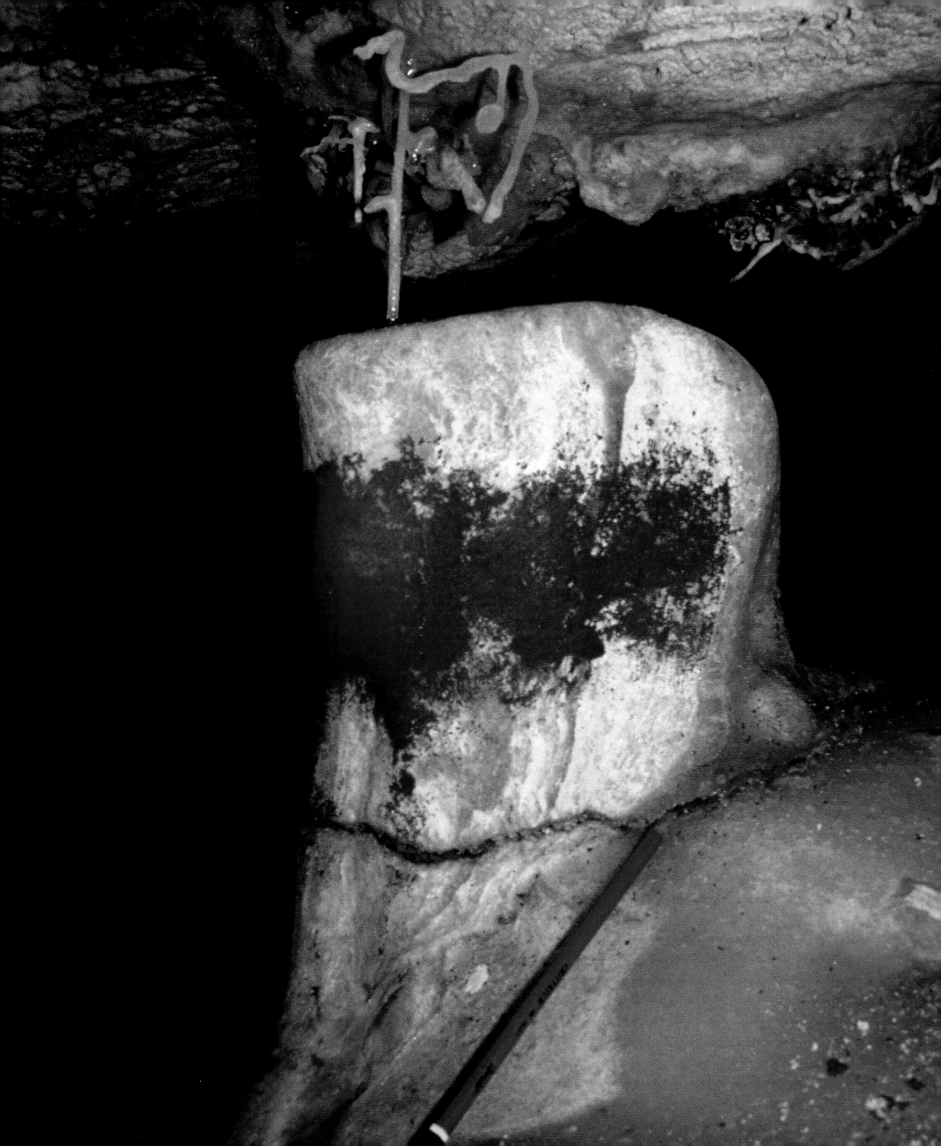

7. The Signs

Alongside the naturalistic animals portrayed with such accuracy they still move us after so many millennia, there are dots, slashes, geometric figures, and sometimes formless scribbling that the average person would not even notice, so simple it is to reduce to an abstraction any reality one does not understand. However, the poorly known graphics in the Franco-Cantabrian caves are attracting the interest of specialists, who divide them at the outset into two categories: signs and indeterminate lines. The signs are drawings of shapes, generally repetitive, that cannot be absorbed into any ready reality. This means that they cannot be identified as either humans or animals or any kind of object and yet they can be differentiated from unorganized lines.

Signs in Wall Art

In all the Paleolithic painted caves, signs abound. Overall they are two to three times more numerous than animal and human representations. Despite this profusion, and even though they were noticed from the beginning of the twentieth century by the first researchers,[1] they were neglected for decades, in fact until the 1950s, when André Leroi-Gourhan began to study them. Most authors more or less implicitly considered the signs to be the result of the final reduction of some reality through successive simplifications. Their names, some of which have entered into common usage, bear witness to this belief. Thus, "tectiform" came to designate signs that were believed to be roof-shaped; "naviforms" resembled boats; "aviforms" were like birds; and "claviforms" were like clubs. Names ending in "forms" proliferated.[2] The signs range from the simplest forms, such as dots, dashes, circles, and strokes, to the most complex geometric figures. The simplest are, of course, the most widespread in space as in time. With regard to these, the phenomenon of convergence (independent invention) is likely, and basic signs such as groups of dots must have been invented and reinvented at different times in different places, no doubt with different meanings.[3]

Before the signs can be studied, they must first be defined and classified. In this area, where we are not dealing with variations on an immediately recognizable theme, such as bison or horse, but with a purely arbitrary and conventional structure, any classification depends on the theory of interpretation that supports it. For the Abbé Breuil, looking through the lens of hunting magic, long or angular signs were arrows and claviforms were clubs. For André Leroi-Gourhan, who viewed the Paleolithic symbolic world in a binary way, as expressing opposition and complementarity between male and female principles, all long signs and dots were male while solid signs—ovals,

136. Opposite: Stalagmite striped in red (S22). Above, the ceiling is covered with small, odd-shaped stalactites. The pencil indicates the scale

137. Barbed and feathered signs engraved on indeterminate animal I2

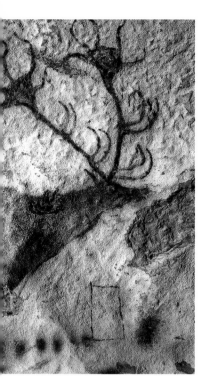

138. Lascaux cave (Dordogne): At Lascaux there are also signs of all kinds, like these dots and a rectangle in the immediate vicinity of the large red deer

circles, and squares—were female. These theories were violently criticized and ultimately abandoned because their premises were much too subjective. The present tendency, expressed by researchers such as Georges Sauvet and his colleagues,[4] Denis Vialou,[5] and Maria Pilar Casado López[6] is to classify signs in a more objective way, as a function of shape alone. For example, Georges Sauvet distinguished twelve categories of signs: (1) triangles, (2) circles and ovals, (3) quadrilaterals, (4) quadrilaterals with extensions, (5) claviforms, (6) pentagons, (7) arrows, (8) barbs, (9) chevrons, (10) crosses, (11) bars, and (12) dots. The researchers are aware[7] that any classification is subjective. For example, the Niaux type of claviform differs considerably from the Altamira type, and they could have had completely different meanings for the Magdalenians. In the other direction, might not certain "arrows" in category 7, certain barbs in category 8, and certain chevrons in category 9 include one and the same aspect of reality? Only those who used them could have told us.

Despite these uncertainties inherent in the subject, studying the signs provides all sorts of information as a function of their geographic distribution, their location in the cave, and their associations with other signs and with the animals depicted. In this way, certain more or less complex signs appear to have a regional value: tectiforms in the area of Les-Eyzies-de-Tayac (Bernifal, Font-de-Gaume); the claviforms of the Pyrénées; and the Le Placard type of sign found in the Lot (Pech-Merle, Cougnac) and in the Charente (Le Placard). André Leroi-Gourhan[8] deduced from this that these distinctive signs were "ethnic markers," in the sense that they belonged to one living human group in a limited space during a specific period. As for their precise meaning, it remains forever obscure whether they were, in fact, clan marks or symbols elaborated by particular groups. The latter hypothesis seems more likely since we know that these signs can be found fairly far from the area where they predominate. For example, claviforms typical of the Pyrénées are known at La Cullalvera and at Pindal on the coast of Cantabria, and the Le Placard type of sign occurs in the Charente (fig. 161) and in the Lot (fig. 162), nearly 100 miles (150 km) apart.[9] The dissemination of a symbol by one or more travelers would explain this spread more readily than the migration of an entire group.

In certain caves, the location of the signs structures the underground space. For example, in Niaux, after the first red signs that include bars and a claviform, 1,300 feet (400 m) from the entrance, the depictions come one after another as far as the back of the cave, which is also marked with signs of the same types. Furthermore, on either side of the gallery leading to the Salon Noir (Black Room) complex, panels of signs with dots, bars, and claviforms frame the passage. Finally, just at the entry to the Salon Noir, the dead end where the animal paintings are concentrated, facing one another exactly are a red claviform and bar on one side and, on the other, two red claviforms and two columns of red dots. The same framing device is thus repeated three times in the same cave, something that could not be a coincidence.[10] The signs can equally well be analyzed as a function of their associations in the cave. That a given type of sign appears either always on an animal or always outside any naturalistic depiction takes on definite importance and can give indications as to the sign's nature and meaning, as we will see below for the Cosquer cave.

Indeterminate Lines

It is another matter for the indeterminate lines. When they cover animals or lie beneath them, we practically never know whether the superimpositions are random or express some meaning in relation to the identifiable depiction.

By their apparently anarchic character, the indeterminate lines are set apart from the signs. They are the result, nonetheless, of a deliberate intention to leave a mark and in that sense differ from casual indeterminate marks, such as rubbings from torches. Among the indeterminate lines are included spots of paint, straight or curved lines, scraped strips, and lines of all sorts. The finger tracings are among these, even though we dealt with them for convenience' sake in an earlier chapter, during the study of Phase One.

The Abbé Breuil and his immediate successors felt only contempt for what they called "lines of interference," devoid of value, that at times obscured the "beautiful" Paleolithic images. Léon Pales was the first to trace completely all the lines drawn by the Magdalenians on the plaquettes of La Marche (Vienne). He deserves credit for that, so complicated were the tangles of lines. His position differed fundamentally from that of the Abbé Breuil, who postulated the "non-value" of these palimpsests that he called "graphic jumbles," and who on occasion would omit a good number of these lines in his tracings. André Leroi-Gourhan associated with each other indeterminate lines and cursory figures, which he called "unfinished outlines." According to him, these ensembles were most often found in the neighborhood of figures or of central panels and represented the work of less talented individuals, the faithful, rather than the high priests, who were presumably the artists who made the naturalistic animals.[11] These jumbles would thus have a certain role, but a minor one, in a sanctuary. Emmanuel Anati[12] interprets them as "psychograms" created under the influence of impulses, violent discharges of energy, that could express sensations such as hot and cold, light and dark, and love and hate, rather than serving as support for ideas and symbols. In this sense they would be placed at a level even more abstract than signs.[13]

With the concern for objectivity and exhaustiveness that more and more marks contemporary research, modern studies no longer neglect indeterminate lines. They are traced and studied with as much care as the beautiful animal images, even though they are much more difficult to interpret. Certain authors even go fairly far, perhaps too far, in their evaluation of a suitable position to assign them. Pascal Foucher, in a study of Marsoulas cave in the Haute-Garonne department,[14] notes that they are present everywhere on the walls and in proportions that are often predominant. He thinks they are "the expression of rites in relation to wall art" and so proposes to confer on them "a special place" in research. Michel Lorblanchet insists on connections between the animal figures and the unorganized lines. He sees in those lines a metaphysical intention, "a primeval magma where all living and imaginary beings merge in formal games." The indeterminate lines would conceal "many potentialities for latent images," which, let us add, was also Breuil's idea on the origins of art, and they could "be linked to a mythology of creation."[15]

From interference to pride of place is a long distance, and one may wonder if it is not a matter of the well-known pendulum, which, having swung too far in one direction, now swings too far the other way.

Provisional Inventory of Signs and Indeterminate Lines in the Cosquer Cave

For convenience but perhaps arbitrarily, we distinguish several categories, among them: isolated signs or groups of two or three, feathered or not, associated with animals, since up to now this type of sign has not been discovered alone; geometric signs; painted signs; and indeterminate lines. Figure 156 shows the location of engraved and painted geometric signs in the cave.

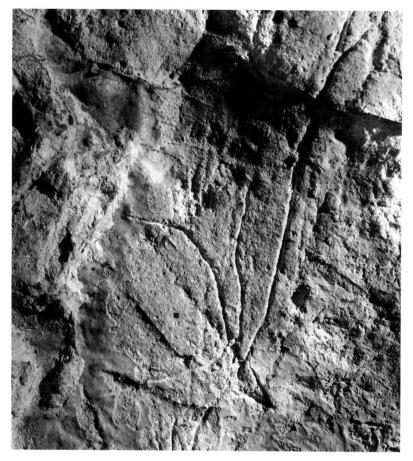

The Signs Associated with Naturalistic Depictions in the Cosquer Cave

139. Top right: Chamois Chm3 is touched by several lines

140. Above: Ibex Bq9 is struck high on the line of the nose by a very long barbed sign

141. Right above: These signs, traced from photographs, are engraved on (left to right) seal Ph8, horse Chv24, and doe C2

142. Right below: Detail of a frieze of engraved animals. Seal Ph5, pierced near the head by a feathered sign, can be seen at right (compare fig. 102)

HORSES

The line of the underbelly for horse Chv13 is superimposed on two long lines. The beginning of the underbelly of horse Chv14 is cut through by a vertical line. The horse Chv18 is overlaid by four long strokes. A line cuts through the breast of horse Chv23. The horse Chv24 is affected by: several lines that cross on its nostril; a large sign barbed at both ends that crosses the animal at breast level (fig. 141, middle); other, much shorter, signs, going in the other direction and feathered but not barbed, that run parallel to the last-mentioned sign. Long crossed lines are superimposed on horse Chv25. The underbelly of horse Chv31 is overlaid with a line.

BISON

They carry no long lines, feathered or not.

IBEX

The ibex Bq4 is superimposed on a feathered line (fig. 143g). The top of the back of ibex Bq5 is cut through by two long adjacent lines, one feathered, the other, not (fig. 143i). The ibex Bq8 has its hindquarters marked by a slanted stroke. The ibex Bq9 is cut through at head level by a long forked line (figs. 140, 143h). The ibex Bq17 displays a feathered line

beneath the underbelly; four others, identical, are in front of the animal. The ibex Bq18, near the horse Chv18, is also overlaid by slanted strokes.

CHAMOIS

A curved, feathered line (figs. 139, 143e) was drawn before the nostril and breast of Chm3, since it lies beneath those lines. Two lines are later: one, feathered, stops at the dorsal line (fig. 143f), the other, simple, crosses the body obliquely. A long feathered line strikes the top of the breast of Chm4 (fig. 143b).

CERVIDS

A long feathered line (fig. 141, right) cuts through the base of the neck of doe C2. On the animal itself, the neck from the head to the forequarters is marked by a series of three sets of two small parallel lines. We would tend to interpret them not as signs but as marks indicating the coat, especially since they are unique in the cave and since the interiors of the animals' bodies are generally depicted by crosshatching or by curved lines. The doe C3 is slashed on the neck by a red line. A small oval sign is superimposed on C5 at the edge of the underbelly, near the foreleg.

SEALS

The dorsal line for seal Ph1 has been engraved over two long lines and one shorter one. The hindquarters of the seal Ph2 are crossed by a long feathered sign (fig. 143d). Two parallel, straight lines, not feathered, hit Ph3, one at the foreflipper, the other at the neck. Two long straight

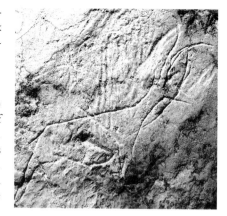

lines strike the back and the flank of seal Ph4, which is engraved inside the horse Chv25. Some additional lines that strike the horse also cut the seal, indicating this chronological sequence: horse Chv25, then seal Ph4, then long lines. The seal Ph5 is hit near the head by a long feathered line (figs. 142, 143c). The seal Ph6, its neighbor, also bears a feathered sign but on its hindquarters (fig. 102). A single long line crosses the seal Ph7 from one side to the other. The seal Ph8 is hit at the edge of the hindquarters by a sign in the form of an arrow with a loop at the base (fig. 141, left).

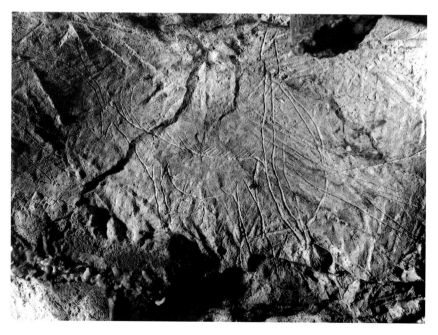

b c d e f g h i

143. Left: Tracings from photographs of engraved signs on the human (a); and on the animals (b) chamois Chm4, (c) seal Ph5, (d) seal Ph2, (e and f) chamois Chm3, (g) ibex Bq4, (h) ibex Bq9, and (i) ibex Bq5

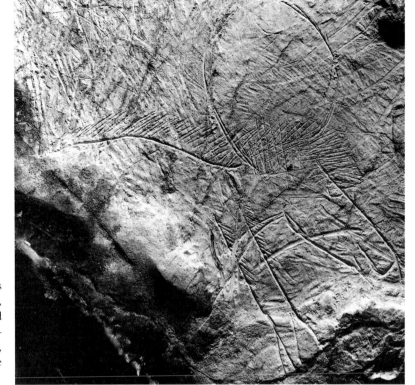

INDETERMINATES

I2, which resembles a horse equipped with horns or antlers, is overlaid on its breast by two similar parallel signs, feathered (Y-shaped at the base), but bearing numerous barbs on each side of the point (figs. 137, 144).

THE KILLED MAN

He is crossed by a large sign, feathered as is usual in the Cosquer cave (fig. 143a), but the point of which is unique: barbed on one side only, with two lines converging at an acute angle, one very elongated, the other, much shorter, between the long line and the shaft (see Chapter 8).

S1: Superimposed on the horse Chv18 and the ibex Bq18, there is a complex geometric sign made of a rectangle with three of the sides partially or entirely repeated, and in its interior two triangles on opposite sides with the points facing one another (fig. 146). This rectangle is superimposed on a sort of lozenge-shaped appendage that is extended at the bottom by two long, more or less parallel, lines. This same wall is entirely covered with finger tracings cut through first by three

engraved wavy bands, each done with two to four parallel lines. These bands are themselves overlaid by the black horse Chv18, by the ibex Bq18, and by a long series of engraved strokes, short and slanted, parallel to one another, in the form of an isolated mane. At least four long slanted parallel lines overlie the horse Chv18 and ibex Bq18. Thus, five phases of superimpositions can be distinguished: (1) finger tracings, (2) wavy bands, (3) Chv18, Bq18, and the "mane," (4) long slanted parallel lines, (5) complex sign.

S2: Another sign of the same type, but engraved more deeply and more apparent than the preceding one, is located on a ceiling, in the area of the megaloceros Mé1, not far from the "fish-vulvas." It is a rectangle, and in the middle of one of the long sides are eight short vertical strokes. This rectangle is cut through vertically by a lozenge extended by two long diverging lines (figs. 145, 154).

S3: Immediately above the hump of the bison Bi1 there is a large, engraved,

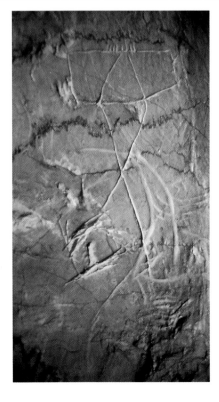

The Geometric Signs in the Cosquer Cave

144. Above: Indeterminate animal I 2 cut in the neck by two barbed signs, feathered at the base

145. Left: Complex geometric sign S2, the same type as S1

146. Far left: Tracing from a photograph of the engraved complex geometric sign S1

147. Sign S18, in the form of three Xs

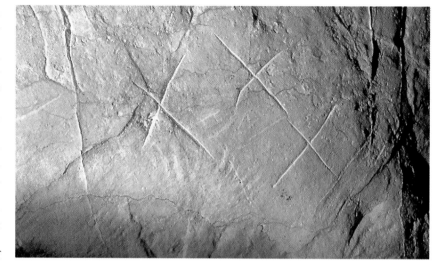

closed, vaguely fish-shaped, oval sign about 13¾ inches (35 cm) long, marked with seven slanted lines in its interior. The engravings are overlaid with red paint (figs. 150, 191). One may wonder whether at least some of the lines that overlie the bison B11, in particular two converging curved lines, do not constitute a sign of the same type.

S4: In the east area of the large chamber is a rectangular sign 11 x 3¹⁵⁄₁₆ inches (28 x 10 cm) in size, with repeated lines, 6¼ feet (1.9 m) from the ground, not far from the cervid C6 and the horse Chv25. Four slanted lines on the left touch it.

S5: In the eastern part of Chamber 1, 6 feet (1.8 m) from the ground, an engraved rectangle 7⅞ x 3⅛ inches (20 x 8 cm) in size is superimposed on finger tracings.

S6: In the same area as S5, on a ceiling covered with finger tracings 7¼ feet (2.2 m) from the ground, there extends a zigzag sign made with repeated lines, with seven segments depicted.

S7: Not far from the bison fault is

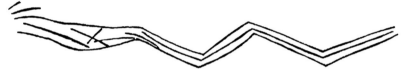

148. Sign S7

a slightly flattened zigzag, made of three parallel lines, with six segments depicted (fig. 148).

S8: On the east wall of the main chamber, superimposed on finger tracings, another band (figs. 149, 150) of zigzags with double lines (six or seven segments) can be seen, finely engraved, associated with long slanted parallel lines,

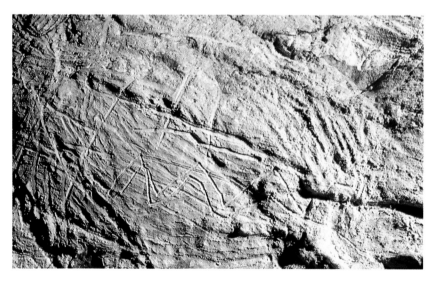

149. Sign S8, an engraved double zigzag

one of which cuts through a longer, slightly curved line.

S9: On the ceiling above the bison fault is a simple zigzag with six segments.

S10: Another simple zigzag, very long, is engraved on a ceiling between the great auks and the megaloceros Mé1.

S11: A right-angled sign cuts through a horn of the ibex Bq20 (fig. 94).

S12: Series of about thirty vertical strokes above the doe C4 (fig. 105).

S13: Between the seal Ph5 and the chamois Chm5 there can be seen a curious oval depiction with repeated lines (fig. 150), which cannot be positively identified as either an animal (marine?) or a sign.

S14: Not far from the ceiling with the "fish-vulvas" (see Chapter 6) is a complex geometric sign (fig. 150), roughly rectangular or trapezoidal, with an upper section demarcated by a line parallel to the top. Inside this narrow band, a zigzag with fourteen segments has

been engraved. Beneath, some lines twice as long form another zigzag with a dozen segments.

S15: On the panel of red hands on the east wall, just below the scratched hands, is a large, solid engraved sign very much resembling S14, with a narrow upper band decorated with a long zigzag. Beneath this band, the interior of the sign, a sort of half-oval, is entirely cross-hatched.

S16: Still in the east part of the cave, four straight parallel lines form an isolated motif.

S17: Farther to the south, two lines, one of which, clearly concave, converges with the other to form a sort of elongated oval.

S18: Three X-shaped signs have been engraved side by side above the bison fault, to the east of the megaloceros Mé2, to the west of the horse Chv11 (figs. 147, 150).

S19: In the area of the painted horses (Chv1 to Chv5), near the indeterminate animal I2 is a rectangular sign made with a single line, the base of which follows more or less faithfully the line of a naturally occurring relief. The upper part of this rectangle is superimposed on three converging lines, which give the figure the appearance of a "handle." Another line, slightly curved, is engraved inside the rectangle (fig. 151). In this area there can be seen wavy engraved bands done with four lines, numerous finger tracings, and several other rectangular signs that have not yet been copied.

S20: On a ceiling near the horse Chv14 and the large complex geometric sign, a long zigzag strip is engraved with three parallel lines and more than six segments.

S3

S8

S13

S14

S18

150. Principal engraved and painted geometric signs not directly associated with animals

S21: In Chamber 2, beside the great auks, Jacques Collina-Girard discovered branchlike vertical signs, on each side of which are numerous lines converging at the top.

151. Rectangular sign S19

The painted signs are found mainly on hand stencils or in their immediate neighborhood, in the form of either dots or strokes. Their color is black or red. These signs have been described with the hands, and so we direct the reader back to Chapter 4. We have interpreted these signs as the equivalent of breaking calcite draperies on which hands were painted or of making deep cuts to destroy hands—that is, as marks by new occupants of the cave during Phase Two who wanted to annihilate the ancient magic with which they found themselves confronted.

Of the 46 hands counted so far, at least 5 have been marked with signs: five blackish dots on M1; a red line slashing the wrist of M2; two red lines, perpendicular to each other, overlying M3; five red lines on M5; and a single line on MR7, with another horizontal red line just above its fingers.

Other painted signs are rare. Among them we have noted:

A red stroke, already mentioned, that cuts through the neck of the doe C3. This line has exactly the same look as those that touch the hands. When analyses are done, they will probably show them to be the same kind.

S22: Near the small submerged shaft, at the southwest end of Crab Boulevard (Chamber 2), not far from the double column of red dots (S23), a stalagmite was vertically striped with red, very crudely, by applying three large patches of paint that more or less touch (fig. 136). These were apparently done with ocher and not with clay from the cave.

S23: Two vertical columns of eight red dots have been painted on a stalagmitic mass in the northwest section of Chamber 2, near the small shaft.

Isolated red dots and red indeterminate lines were seen by one of the prehistorian-divers, Michel Girard, on a rocky bank situated among the fallen rocks in the middle of the north section, at the entry to narrow dead ends as yet unexplored. These numerous and widespread dots must be precisely pinpointed and have not yet been counted.

S24: A black circle, complete and regular (fig. 152), has been drawn around the upper half of a broken stalagmite in the north-central section of the cave near Crab Boulevard. The break has been hammered and on it smudges are visible (Michel Girard). This stalagmite circled in black marks a narrow passage that leads from Chamber 1 to Chamber 2 and is located right at its entrance.

S25: Almost under the auks, a

The Painted Signs in the Cosquer Cave

152. Stalagmite circled in black (S24)

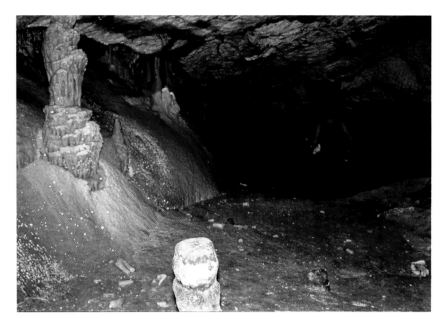

large piece of a stalagmite on the ground is marked with four parallel black slashes (fig. 153). The two top strokes join on the left; the two lower ones, much shorter, are located under the extreme right ends of the upper ones.

Indeterminate Lines in the Cosquer Cave

Indeterminate lines are very numerous in all parts of the cave, and an exact count will not be made until the cave has been studied exhaustively. We will content ourselves with noting some of them here:
• Engravings that repeat the lines of the mane on the horse Chv1 and that extend beyond the animal.
• The long parallel lines, at times cutting through other earlier lines, that touch the horse Chv5 are more like the indeterminate lines on horses Chv1 to Chv4 than the signs marking the

seals and other animals.
• Around the tail of the horse Chv13, numerous lines converge in a tuft.
• The bison Bi1 is overlaid with indeterminate engravings, as are the walls in its immediate vicinity.
• In front of the ibex Bq7 and the horse Chv13, some straight lines cut through one another, without there being any way to distinguish either an animal or an organized sign. Certain lines are beneath the ibex Bq7, which is itself earlier than the horse Chv13,

so that a sequence is observable in this area.
• Above the ibex Bq2 and seal Ph7 is a series of scraped engravings, deep and white, more or less parallel, that are neither finger tracings nor signs or animals.
• Above the bison fault, to the west of the simple zigzag S9, numerous lines cut through one another.
We could no doubt lengthen this list considerably.

The Signs in the Cosquer Cave

In a Paleolithic cave, a study of the signs can be carried out on different levels, as a function of the hypotheses on which the research is based and in search of answers to the questions to be resolved. Their shape permits the recognition of types that will be repeated with greater or lesser frequency. The danger at this stage is twofold: if the researcher who notices all the differences in minute detail makes discriminating criteria of them, he risks multiplying the categories unduly; conversely, if he attaches more importance to the general than to the particular, there is the risk of collecting under the same heading signs whose type and meaning are perhaps very different. For example, at Cosquer, among the elongated lines that touch the animals, we have chosen to distinguish between the simple strokes and the barbed and/or feathered signs, and among the latter to make four categories: (1) signs feathered at the end away from the animal; those feathered at one end, barbed at the other, with the barbs either (2) on both sides or (3) on one side touching the animal; and finally (4) the curious barbed projectile on the seal Ph8. But it is quite possible that all these signs have the same meaning.

The second stage involves researching the associations of recognized signs to establish consistencies, if possible. To be fully effective, this step requires a complete knowledge of the graphics in the cave—signs, animals, and indeterminate lines. Now the Cosquer cave is as yet only very imperfectly known. No thorough tracing of the animals and signs has been done there, and our eval-

uation is based on the photographs brought back, which represent a far from complete survey, and on the observations of the divers. The signs being a great deal less spectacular and discernible than the animals, it is clear that many must have escaped us and that only those directly connected to the naturalistic depictions and those remarkable for their size and form had any chance of being noticed and recorded. We have, then, only an abbreviated and partial view of the signs, no doubt distorted, and our provisional remarks about them will be submitted to revision when research at the site advances. As for the indeterminate lines, the present gaps in our knowledge are still greater, for obvious reasons, so that for the moment it is impossible for us to go beyond simply mentioning them.

That said, some consistencies do appear nonetheless, both in the category of the signs and in that of the animals, where we catch glimpses even now of a situation unusual from many points of view.

One result will hardly change, even when the cave has been studied extensively: the percentage of naturalistic depictions, animal and human, directly touched by long signs. We have counted 28 out of a present total of 100. In Paleolithic art this is certainly one of the highest percentages, perhaps even an absolute record, since André Leroi-Gourhan estimated that barely 4 percent of the animals bore "wounds" and that in the cave of Niaux, where "wounds" are particularly numerous, their proportion according to him is 25 percent.[16]

These 28 figures are associated with 48 signs, all engraved, with the exception of the red stroke on the cervid C3. Only 1 is oval, that on the cervid C5; the others are elongated, and half (24) are long single strokes, about half (22) are feathered and/or barbed. Among the latter, 18 are Y-shaped, with the feather always found at the end away from the animal. The 4 others are forked at both ends: at their base, they are Y-shaped, like the preceding ones, but the barbs at the tip are short, close together, and located on both sides of the line in three cases. In the one that pierces the Killed Man, there are 2 long barbs on the same side at the tip of the sign. Any classification includes exceptions: the "arrow" on the seal Ph8 thus confirms the rule. Only in 2 cases (the ibex Bq5 and the

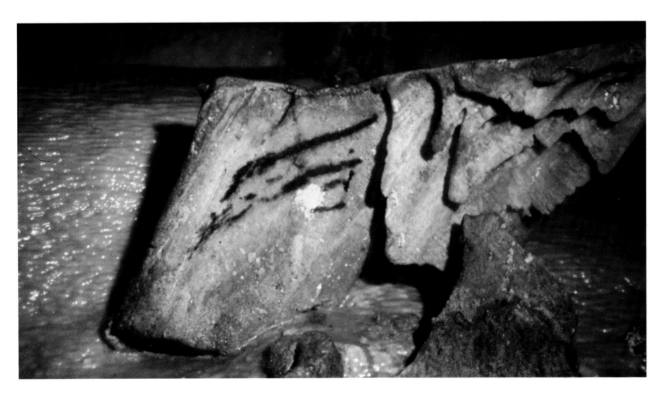

153. On the ground, beneath the painting of great auks, is this stalagmitic block with black stripes (S25)

chamois Chm3) do we find plain lines and feathered or barbed ones associated on the same animal. This is not many but poses the question, all the same, of the equivalence of plain and feathered or barbed signs. These 2 examples show that they are not mutually exclusive. Could the plain strokes be a simplified version of the feathered and/or barbed signs, or are their meaning and function different? Any answer can only be subjective.

The other geometric signs, as well, are more often engraved than painted, even though we count a set of 5 blackish dots on a hand (M1); another set of 8 red dots on a stalagmitic mass (S23); a set of 5 red lines on M5; 1 red line on M2; 2 red lines on M3; 1 red line on MR7 and another nearby; the stalagmite slashed with red (S22); the black circle (S24); the scattered red dots; and the black lines on a stalagmitic mass on the ground (S25).

The problems posed by the classification of the geometric signs are nearly insoluble. Rather than counting 8 units for the red dots superimposed on the stalagmitic mass, for example, we consider it preferable to speak of a "set," and we do the same for the 5 red strokes on the hand M5 and the 5 black dots on the hand M1. But perhaps the same rule should have been applied to the lines on and near the hand MR7? Or to the 3 large crosses that we have counted separately (S18)?

The engraved signs include 6 large zigzags, angular and at times quite long, drawn by means of single lines (2), double lines (2) or triple lines (2); 3 wavy bands of multiple lines; branch-like signs; 3 X-shaped crosses; 2 series of straight parallel lines; 2 lines that converge in a vaguely fish-shaped figure; a series of short parallel strokes, manelike; and at least 11 more or less complete rectangles or ovals. The latter are the most interesting figures. They range from a half-rectangle to a true rectangle, simple or with internal motifs. Two of these motifs (S1, S2) resemble one another: within the rectangle overlaid with lines there is a lozenge extended toward the bottom by 2 large parallel or diverging lines, but 1 of them has interior angles and the other has not. To our knowledge these 2 signs are unique in Paleolithic wall art, as are the large engraved oval with painted slanted lines inside (S3) and those with the inner zigzag section (S14, S15).

No characteristic association has appeared at the present time with regard to the most complex geometric signs, unless it is the reciprocal proximity of several rectangular signs. It is likely that, as with the animals and humans, they carried a precise meaning. On occasion, marks were made in relation to topographical accidents, to set off a space, to announce the passage to a different place, or for some other reason (the circle on the stalagmite). As for the series of strokes and the isolated dots, they could perhaps—a little like the finger tracings—express in a physical way the occupation of the cave, concretizing the human presence and human appropriation of the walls. In a certain way, this is also the sense we attribute to the painted dots and slashes that touch the hand stencils.

In addition to the hands overlaid with painted dots or lines, the only indisputable associations are those of the long signs with the animals. Their resemblance to projectiles striking the beasts, whether in a real or a metaphorical way, comes immediately to mind. If they were understood as projectiles, their position on the body of the animals apparently was of little importance, since they touch indiscriminately the head, the back, the underbelly, the flank, and the fore- and hindquarters. At times, moreover, the sign was engraved *before* the animal. We will observe this again in another Mediterranean Paleolithic cave, that of Le Cavillon, at Grimaldi on the Italian-French border: there, an engraved horse has parallel vertical lines crossing its body, some of which are later and others earlier than the depiction of the animal.[17] This suggests that what mattered was the association of the animal and the sign, and that it was not a matter of some magic ceremony where drawing the animal would probably have had to precede drawing the instrument meant to pierce it.

154. Tracing from photographs of large geometric sign S2

155. Opposite: Stalagmitic mass marked with numerous black stains. Should we consider them smudges from torches or an appropriation of space comparable to the finger tracings?

150

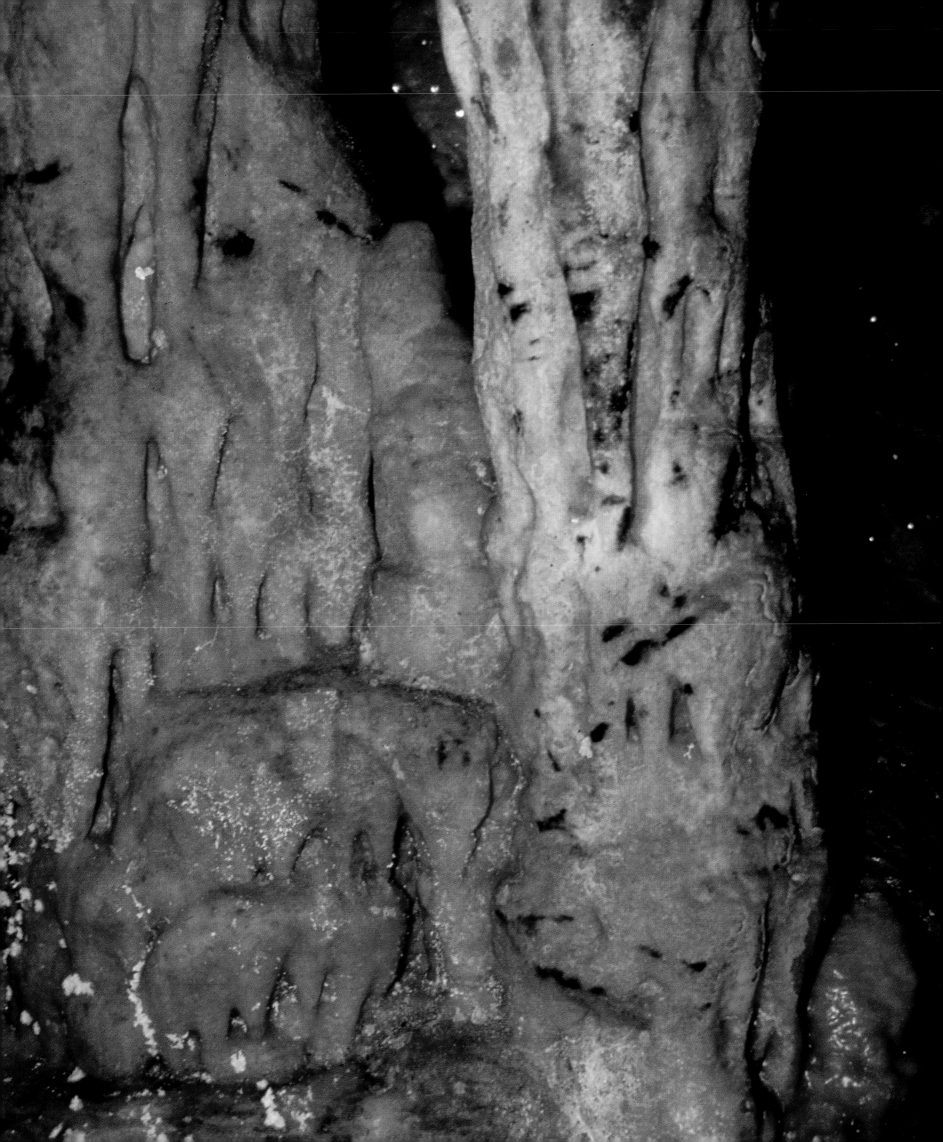

The hypothesis of projectiles, at least for the feathered and barbed signs, earns support through comparison with the scene in the shaft at Lascaux. There, a man falls backward in front of a wounded bison that is copiously losing its intestines and has been hit with a long, barbed, pointed sign. The scene in this respect is unequivocal: this sign is definitely a thrown weapon, as is shown by its association with the wounded bison. It very much resembles the sign that passes through the Killed Man at Cosquer (see Chapter 8), who, we will see, is falling backward. In both cases, we are dealing with a deadly weapon and with the outcome of its use. These hard-to-question observations can be extended to other barbed signs, as well as to the feathered signs, since the "feathering" of the sign on the Killed Man is identical to that found on the animals. We are thus convinced that it is best to see in these signs depictions of projectile weapons, which in the larger context of the great hunt in which Paleolithic art occurs, is not surprising.

What is more surprising is the small number of examples of this type recorded in the literature. If barbed or arrowlike signs are not rare on the animals, the feathered signs remain exceptional. We refer to those in the cave of Paglici in Apulia, Italy, where 27 signs in the form of what

156. Location of painted and engraved signs S1–S25 in the Cosquer cave

PRINCIPAL ENGRAVED (S1–S21) AND
PAINTED (S22–S25) GEOMETRIC SIGNS
NOT ASSOCIATED WITH THE ANIMALS
OR THE KILLED MAN

would nowadays be feathered arrows have been pointed out, 18 of which surround a horse engraved on bone. Geographically, the cave of Paglici also belongs to the Mediterranean sphere, but its art is attributed to the Late Epigravettian,[18] several thousand years later than the art of the Cosquer cave. This reminds us that the painted caves that have come down to us no doubt represent an infinitesimal part of Paleolithic art and that most of the links, geographical and temporal, are missing. It is not impossible that the depiction of feathered signs lasted a long time around the Mediterranean and that

these signs were repeated thousands of times in different contexts, even if we only know a few examples in just two caves.

We have said that the complex geometric signs are unique; identical signs have never been reported elsewhere, to our knowledge. That seems to be the rule for the most complex geometric signs, a specialty in certain caves in the Dordogne and in Spain. Most of the time these signs from Georges Sauvet's categories 3 and 4 (see above) belong to André Leroi-Gourhan's Style III, which includes the art of most of the Solutrean and the Early Magdalenian periods. It is not astonishing, then, that the Cosquer cave, well dated to a period that corresponds to the Late Solutrean, contains a rather important series of complex rectangular and oval signs. We note the identical form of the simple rectangles and those engraved on some plaquettes well dated to the Late Solutrean at Parpalló in Spain. On the other hand, at this same site, branchlike and zigzag signs appear later, during the Magdalenian,[19] and some typical zigzags have been found in equally recent levels (Romanellian) in the Polesini cave in Lazio, Italy.[20] However, these resemblances still reinforce the feeling that the Cosquer cave belongs to a Mediterranean province that includes Nerja and Parpalló.

As to the exact meaning of these signs, apart from those associated with the hands and those that touch the animals, we can only conjecture. As André Leroi-Gourhan assumed for certain complex signs, they could be exclusive to local ethnic groups and, in that case, would serve as specific support for their myths.[21]

The association of zigzags with at least 2 quadrangular signs, like the geometric figures themselves, brings to mind the entoptic phenomena described by David Lewis-Williams and Thomas Dowson, mentioned in Chapter 5 in connection with the fantasy and indeterminate animals.[22] These authors have put forward an attractive explanatory hypothesis based on both ethnological and neuropsychological research. The latter has universal application since in every instance, whether it be modern hunter-gatherers or Magdalenians, we are dealing with *Homo sapiens sapiens,* our own kind. This hypothesis has the advantage, then, of providing an explanatory framework rather than a ready-made solution. Shamans serve as intermediaries between the ordinary world and a world no less real to them, where they go for help during periods of trance. They perceive geometric forms then, some of which are identical to the signs we have described. Is this a simple coincidence, the chance recurrence of relatively simple themes, or is it rather the physical expression on walls of the visions experienced during the first stage of trance?

Whatever the case may be, the signs in the Cosquer cave, as is the case with the sea animals and with the Killed Man, which we will consider in the next chapter, make up an especially unusual set. They will serve as a reference point for future discoveries in the Mediterranean basin and elsewhere.

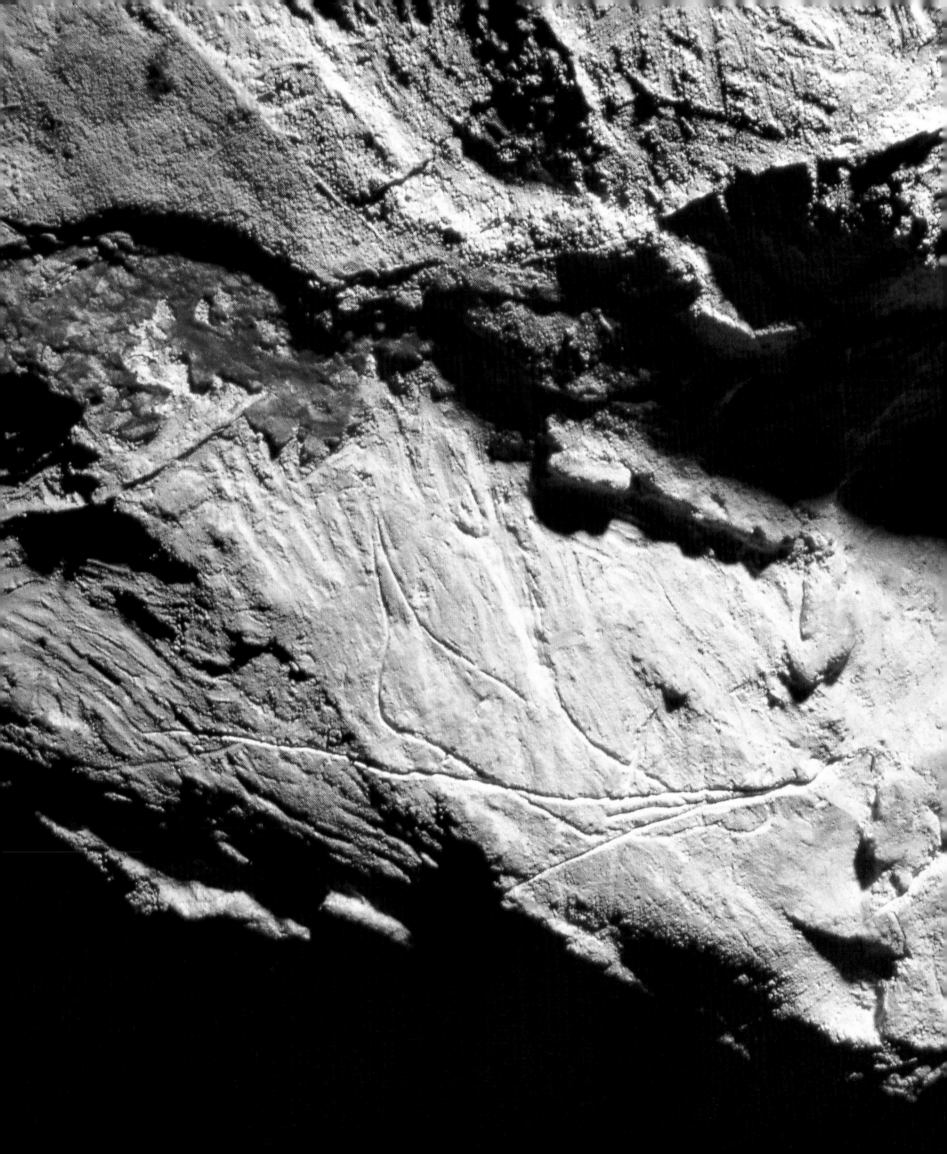

8. The Killed Man

In June 1992, when the divers saw this lone engraving on a ceiling overhang in the eastern area of Chamber 1 near the feline head, they took it to be a diving seal overlaid with a barbed spear. This intuitive identification, which everyone accepted at the time, was probably based on the elongated outline of the figure; on the three short vertical strokes above the head, interpreted as a mustache; and perhaps, too, on the sign marking it just as all the other seals are marked.

It was not until our study was underway that we became intrigued by the strange shape of the hindquarters. If this were a seal, they should have been tapered rather than curved. Comparing the slides and highly enlarged black-and-white photographs at our disposal, we then noticed that what we had at first taken to be an animal's foreflipper was in fact a very elongated arm ending in an obvious hand, with the fingers depicted by several deeply engraved parallel lines. We had to accept the evidence: this was not one more pinniped but a human. This made it much more interesting because of all the implications for possible relationships with other caves, as well as the ideas that a "killed" man suggests in the field of psychology and the area of Paleolithic rites and practices.

The Killed Man in the Cosquer Cave

The figure has been centered in the middle of an uncorroded part of the wall in a narrow area covered in earlier finger tracings. It takes up all the available space, measures 11 inches (28 cm) in length, and is about 5¼ feet (1.6 m) above the ground. The individual is depicted lying on its back but in a slightly slanted position, with arm and leg extended upward (figs. 157 and 158). The head is small, rounded or oval in shape, and the nose can just be made out beyond the enormous spearhead that crushes the whole front of the skull. As we mentioned, there are three very small vertical lines above the front of the head. The body has a roughly rectangular shape, with a clearly indicated curve in the back. A pronounced curve shapes the rump. The lower limb, much shortened, is sketched in a cursory way with two converging lines, partially repeated, to evoke the other limb. It extends forward. In the middle of the body, at stomach level, a disproportionate arm, done essentially by scraping, is extended parallel to the legs. No sexual characteristic, either primary or secondary, allows us to say whether this is a man or a woman. It is therefore a sexually indeterminate "human," as are two-thirds of the human representations in the Upper Paleolithic.

After the figure was drawn, it was marked by a lightly engraved straight line, drawn slightly on the oblique from top to bottom, that cuts through at chest level, below the shoulder. Then

157. Engraving of a probable human overlaid with a barbed line (the Killed Man)

155

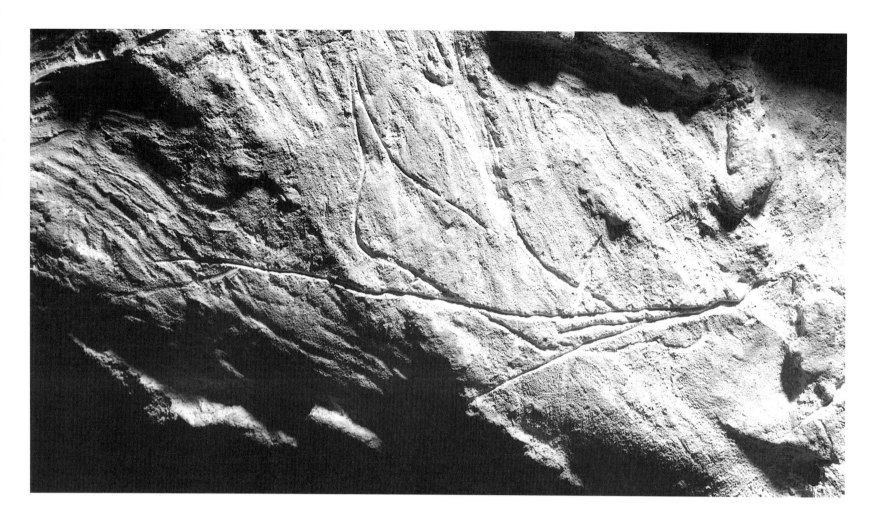

158. The Killed Man

a long projectile weapon—arrow, spear, or harpoon—was engraved just as deeply as the human beneath it. The weapon hits the figure in the back, passes through the body, cuts off the front of the head, and extends considerably beyond it. The lines are particularly vigorous at the level of the head. Signs with Y-shaped ends occur on a number of animals in the Cosquer cave (seals, doe, horse, caprids); however, this one is unique both because of its dimensions (almost twice as long as the motif on which it has been superimposed), and because of the shape of its head, barbed on one side only, with two lines converging in an acute angle, one of them quite elongated and the other, much shorter, located between the first line and the shaft.

 The scene is thus unambiguous. A human figure has been represented on its back, arms and legs extended, as if it were falling. It was first overlaid by a light mark, before being annihilated by a terrible weapon. It represents a human killed, or rather the *idea* of a human killed, and is not a naturalistic depiction. There are two reasons for saying this: first, a person hit in the back by such a weapon would fall forward; second, the position of the raised limbs is that of an animal with four paws in the air but not that of a dead human. There could be in this a more or less conscious identification with animals that is of considerable psychological interest. The three light but clear marks on top of the head that are reminiscent of a seal's mustache, and the lower limb that has been shortened and tapered, may equally well have been intended to make this human more like a pinniped, a type of animal also killed symbolically by projectile weapons. We will see that among comparable scenes in other caves involving humans, some also borrow animal characteristics: for example, the "bird-men" of Pech-Merle, Cougnac, and Lascaux.

Comparable Themes

This theme calls to mind that of the wounded or endangered man that André Leroi-Gourhan termed "probably the most pictographic theme in Paleolithic art."[1] By this he meant that it is the theme that comes closest to telling a story. He saw in it three groups: that of men knocked down or threatened by a bison, such as in the celebrated scene in the shaft at Lascaux and in those at Villars and Roc de Sers; that of a bear against a man at Le Mas d'Azil and Péchialet; and the humans of Cougnac and Pech-Merle pierced by lines, felled by the blows of their fellow humans (figs. 162–165).

In fact, the theme of a human as the victim of an animal, whether actual (Lascaux) or potential (Roc de Sers), is completely different from the theme at Cosquer, Pech-Merle, and Cougnac, except on the most general level (both bring into play humans and their assumed death). In the first case, the scene is probably anecdotal, at least when it first originated, no matter what meaning it may ultimately have assumed. Hunting accidents must have been commonplace among people who undertook this activity out of necessity on a daily basis. The theme of death at the hands of other humans involves quite different concepts, to which we will return.

When Pech-Merle was discovered, in 1922, a strange human depiction painted in red attracted attention. It had a round head with a sort of muzzle or beak, minuscule arms and legs curiously sketched, with a curved line in front of the thigh that might represent the sex. Above it was a distinctive geometric sign, and on it were eight lines, straight or more often a bit curved, four on each side of the body (figs. 162 and 163). Amédée Lémozi, who first published it, interpreted the figure as an "archer armed with bows, equipped with a mask, and his arrows or javelins."[2] Later, Henri Breuil prudently offered two hypotheses about this "masked man with a pointed muzzle, riddled with arrows, unless he is carrying them."[3] The hypothesis of the "archer" was only very rarely taken up after that.[4]

In fact, in 1952, with the discovery of Cougnac (unbelievably, following directions given by a dowser), two new human figures riddled with spears, in this case done in black, came to light only about 25 miles from Pech-Merle. They left no room for doubt. One, without head or arms, was turned toward the right, its body bent and struck by three long, slightly curved lines in the upper thigh, the rump, and the middle of the back (figs. 164 and 165). The other, facing the other way, was strongly reminiscent of the Pech-Merle individual, its head with a painted muzzle, its shortened arms, and the eight lines, mostly straight, that struck it in the stomach (three), thigh (two), back (one), and chest (two). The body, supported on two bent legs, was bending far over backward and was endowed with a tail-like appendage (figs. 159 and 160). A third human depiction, in very faint blackish brown lines, its body pierced by three spears, was also reported but not traced.[5] This would have been most interesting to compare with the Killed Man in the Cosquer cave since it too had its head down and its feet in the air. However, it could not be made out sufficiently well at the site, and so we mention it only for the sake of accuracy. Michel Lorblanchet considers it so doubtful and hard to decipher that it cannot be classified among the human figures.[6]

From the start, comparisons were made between Cougnac and Pech-Merle, especially because the two caves also had in common some unusual signs, identical to the one touching the head of the man in Pech-Merle (see fig. 162). The unanimous conclusion was that these were humans wounded or killed and that they dated from the same period. This has recently been supported by discoveries made about 90 miles away, in the cave of Le Placard in the Charente department. In 1990 and 1991, a dozen signs similar in every way to those we have mentioned were discovered there (fig.

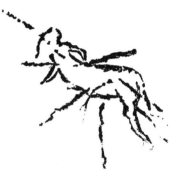

159, 160. Cougnac cave (Lot): Photograph and drawing of one of the depictions of wounded men

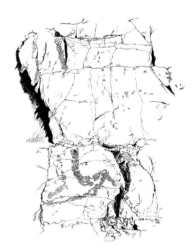

161. Le Placard cave (Charente): This sign is identical to the sign near a Wounded Man in Pech-Merle cave (see fig. 162) and to signs in Cougnac cave

161). They could be dated by various methods to at least 20,000 B.P.[7] Their being identical to those in Pech-Merle and Cougnac eliminates the hypothesis of chance convergence, and their particular type makes very likely their attribution in all three caves to one chronological period, within one or two thousand years, or probably even less.

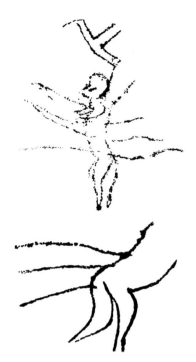

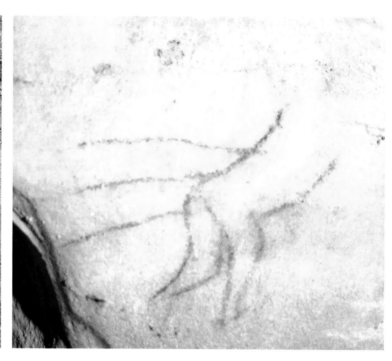

162–165. Pech-Merle cave (top, near right), Cougnac cave (above, far right): Paintings of wounded men

Other human figures found in caves may have been overlaid with lines, but they are more doubtful than the preceding instances; that of Sous-Grand-Lac in the Dordogne does, however, appear quite convincing.[8] In this small cave with depictions that are impossible to date, a man has been engraved, upright, turned to the left, arms outstretched, with a sizable erect penis and a possible tail-like appendage (fig. 166). He seems to have been struck at chest level by three spears, at least two of which are barbed on one side; two others cut through his penis and a third through his hip. The engraving is done with fine lines. The spears in the upper body are extended beyond it by a set of lines equally fine and straight but interrupted in places. These engravings are heavily patinated, encrusted with the "dust of centuries," as the Abbé Breuil put it, which makes the intersecting lines difficult to decipher, so that we do not know if the man is earlier or later than the sheaf of lines. To put it another way, was there really an intention to represent the human figure in association with these lines, and must we connect him with the humans of Pech-Merle and Cougnac, as we tend to believe,[9] or is it a matter of a more or less chance superimposition?

In the cave of Gabillou, also in the Dordogne, three engraved individuals (figs. 167 and 168) also bear spearlike signs.[10] One of these is a small upright human, headless, who seems to be holding a weapon in his left hand, unless he, too, has been struck by a projectile at waist level. He faces a much larger composite being leaning over horizontally, whose body and arm display human characteristics, while the head is that of a bovid. This creature is marked in the chest area by a set of indecipherable lines, one of which comes out of the body. Another composite being in the same cave is the famous "Sorcerer" (fig. 168), with its trunk almost straight but its legs half-flexed and arms extended, and endowed with a tail-like appendage and the head of a bison. It has a line cutting across

166. Sous-Grand-Lac (Dordogne): Engraving of a human (tracing)

its thighs and another on its nose, beneath the eye. Yet another long line, somewhat curved, cuts through its muzzle and connects it to a set of signs. André Leroi-Gourhan placed it in his group of wounded men.[11]

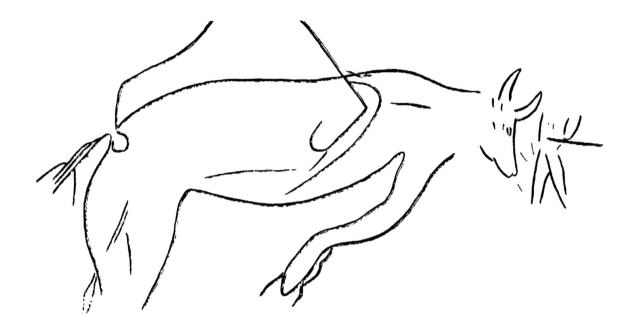

167, 168. Gabillou cave (Dordogne): Engravings of humans (tracings)

The Importance and Meaning of This Theme

André Leroi-Gourhan often stressed the recurrence of the theme of the Wounded Man and therefore its importance in the Paleolithic iconography. In 1962,[12] Annette Laming-Emperaire called attention to what she termed "bird-men" because of the curious shape of their heads and their short, winglike arms. They were, she said, always in a difficult situation, wounded or struck dead, and must represent a mythical or legendary Paleolithic character. Even if only those of Cougnac and Pech-Merle are unquestionable,[13] the fact that the same theme was repeated and has come down to us in several caves, to which the Cosquer cave has just been added, suggests that it must have been depicted a considerable number of times. We must never forget, in fact, that the known painted caves most likely account for only an infinitesimal part of the art of the glacial period: all the paintings done in shelters or in exposed cave entrances and all those done in the open air on rocks have long since disappeared, and many painted caves no doubt remain hidden behind scree, narrow openings, and other natural blockages. A theme known to us through a few examples may well have been depicted hundreds or thousands of times.

At Pech-Merle we have seen that the figure of a wounded man is closely associated with a Placard-style sign and that the dates obtained for the latter cave, at least 20,000 years B.P., are thus applicable to the Pech-Merle figure and, by extension, to the signs and humans of Cougnac. Now, the dates for the Cosquer cave during Phase Two (animals and signs) fall within the years 19,200 to 18,500 B.P. Taking into account the statistical uncertainty for the radiocarbon method, this is not far off. Even if these precise dates are correct, it would mean that this theme persisted a few hundred years, if not one or two millennia. This does not seem extraordinary. The closeness of these dates strengthens the probability of the existence of a theme common to groups that, as we are now dis-

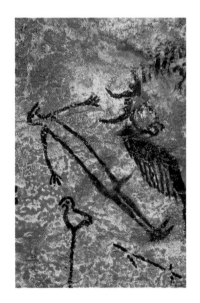

169. Lascaux cave (Dordogne): Painting of a wounded man

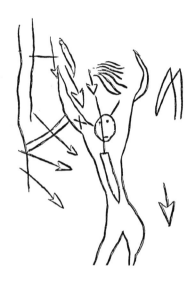

covering, lived considerable distances apart, whereas until now the Wounded Men seemed restricted to Quercy and perhaps the Périgord region. Just what could this distinctive theme mean?

Interpretations

Various hypotheses have been put forward as to the meaning of these figures, and they depend on the interpretation given to the lines that overlie the individuals. Some have thought that the humans were voluntarily carrying weapons, and perhaps this is true of the little human of Gabillou, but certainly it is not of the others. These lines do not at all resemble spears or javelins, and to call them such without formal proof is completely subjective, especially because a good number of them are not even straight. Rather than see them as projectiles wounding these humans, Noel Smith, from the perspective of shamanistic religions, suggests they may be signs that indicate forces emanating from their bodies.[14] If we knew only the figures from Pech-Merle and Sous-Grand-Lac, this hypothesis would be highly appealing. It would explain why the multiple lines, representing forces radiating beyond the body, extend far outside the man at Sous-Grand-Lac. The same author thinks that in the case of the humans at Cougnac, the lines touching them would be a manifestation of life forces between them and the animals on which they are inscribed.[15] Shamans believe that when they are in an altered state of consciousness, they travel outside their bodies and meet animals. It is known that these experiences play an important part in the life of the group as well as in rock-art depictions.

Whatever the case may be, the little fellow in Cougnac cave (figs. 164 and 165) irresistibly brings to mind a man struck from behind by projectiles, either fleeing or falling. This is how he has been understood by most scholars ever since his discovery and how he continues to be thought of. If one allows that he is wounded, his neighbor at Cougnac and, by extension, the man at Pech-Merle must be interpreted similarly. The discovery of the Cosquer cave provides considerable support for this hypothesis and should eliminate all doubt, for now we finally have evidence that a killed man was depicted. The large sign that overlies him could not in any way be a symbol of forces emanating from within the body: the sign is outside the body and crosses it from one side to the other.

It remains to be seen what this theme could mean, and here we find ourselves in the domain of speculation. Three main hypotheses have been suggested. Paolo Graziosi[16] has mentioned two: destructive magic and a commemorative scene. When the theme seemed to be confined to the Lot and perhaps to the neighboring Dordogne region, it could have referred to a local event. Now, to postulate an anecdotal explanation would mean that this theme acquired sufficient strength to be common to widely distant groups. This cannot be excluded. After all, the theme of the Crucifixion, originating in Palestine two thousand years ago, is recognized around the world. In the same vein, Annette Laming-Emperaire proposed, as we have seen, that the theme had to do with a mythic or legendary character.[17]

Destructive magic, casting a spell on the enemy that one wishes to destroy, is the most popular explanation and without a doubt, the least plausible. It assumes not a common theme but rather the coincidence of unrelated actions: here, a spell is cast on one person and, there, on another. The recurrence of the theme would then be a matter of simple convergence. There is no lack of ethnographical evidence to support this hypothesis from every continent where rock art has been explained by those who still practice it. However, it has been justly noted[18] that in ceremonies where destructive magic plays a part, an effort is made to have the effigy resemble as closely possible the man

or woman threatened, and these Paleolithic wounded or killed humans are completely lacking in detail and remain unindividualized. In fact, they are identical to most of the human representations in Paleolithic art, the awkwardness of which is in contrast to the life, beauty, and precise characterization of the animal figures. Both the Abbé Breuil and Georges-Henri Luquet thought that the artists were more used to sketching animals and that the humans were simply badly drawn, an explanation that hardly seems likely. The evidence must speak for itself. These human figures, either caricatures or barely recognizable as human, were intentionally drawn in an obviously crude way. Perhaps they represented extraordinary beings, shamans or spirits in human form who could be depicted only in a somewhat indirect way? But that hypothesis accepts the unexplained absence of actual humans. Perhaps it would be more plausible to suppose a fear of giving too much precision to faces and outlines lest certain contemporaries be recognized. In that case, a rule requiring imprecisely conceived human figures would constitute a kind of safeguard, an intentional anonymity that would allow the transcription of certain themes without harming anyone through the power of the image.

The Abbé Breuil[19] suggested a variation on the destructive magic hypothesis: the beings on whom it was exercised would be evil spirits or genies, whose powers had to be neutralized by a sort of exorcism, which would explain the nonhuman faces at Pech-Merle and Cougnac.[20]

Without some extraordinary discovery, it is an illusion to think that we will one day arrive at certainty in this area or in so many others. The Killed Man of the Cosquer cave tells us one thing certainly, that in this Paleolithic world so often painted in idyllic colors, the idea of murder or of execution, of whomever for whatever reason, was a familiar one.

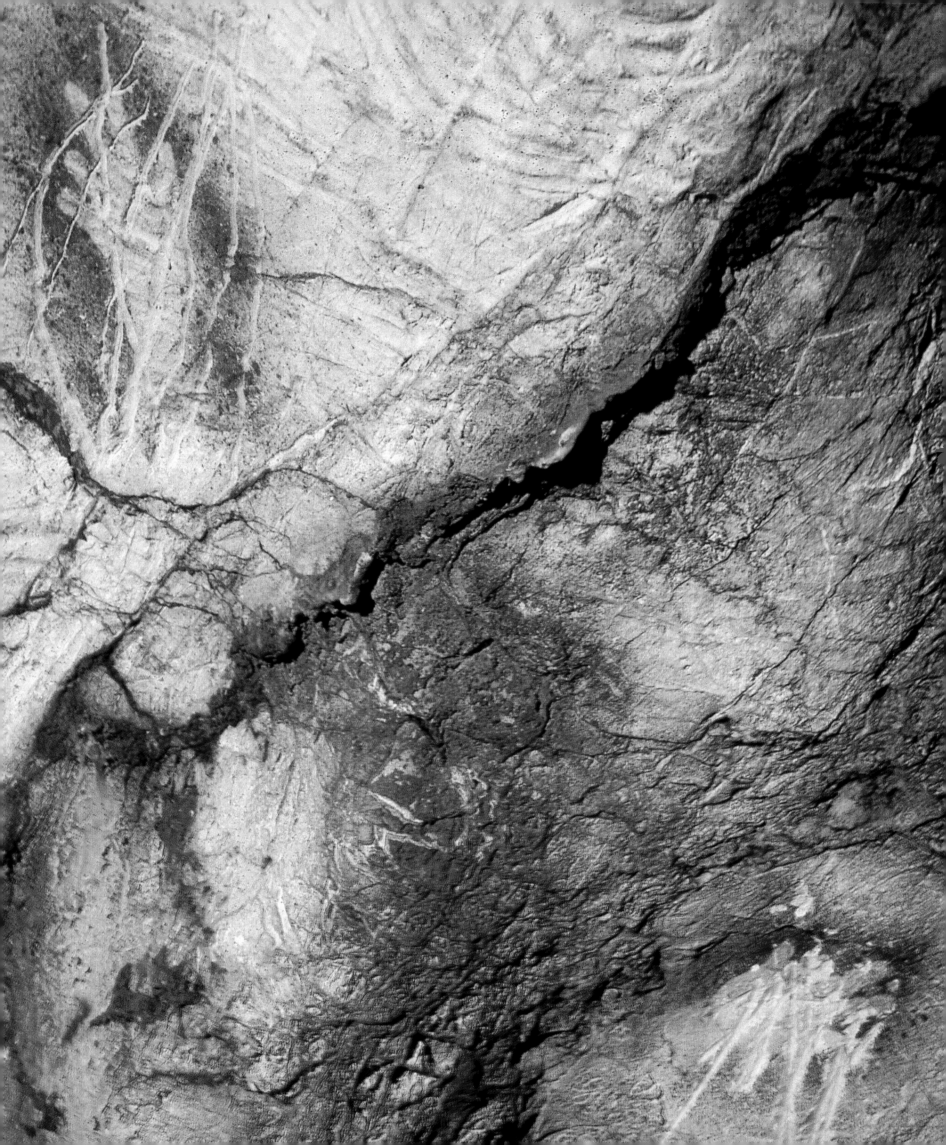

9. Chronology and Meaning

Chronology

At first glance, European cave art seems homogeneous. These animals—horses, bison, mammoths, ibex, and reindeer—painted or engraved in deep caves, speak one language, that of the great ice age hunters. As a result, much like children for whom prehistory goes back to the time of their grandparents, we have a tendency to contract the immensity of past time and to give it a false unity. Paleolithic art was made over a period of almost 25,000 years. This means that, despite appearances, the Magdalenians who painted in the caves of Niaux or Font-de-Gaume 13,000 or 14,000 years ago were somewhat more removed from the first Aurignacian artists, who lived about 35,000 B.P., than they are from us.

It is true that religious beliefs last very much longer than such material aspects of a civilization as tools, weapons, or ornaments. The great monotheistic religions, sometimes several thousand years old, are proof of this. But the religions themselves evolve over time and change not only in their practices but in their dogma as well. During the Upper Paleolithic, life was short. Almost a thousand generations succeeded one another in different environments, ones that were imperceptibly transformed over several centuries, what is more, as a function of warming trends or cold spells. Tools and ways of living changed. Must we assume that religion alone stayed the same everywhere during these millennia? That seems very unlikely, even if some of the best-known specialists in prehistory took this to be so and proposed universal theoretical interpretations as a result.

The Abbé Breuil explained prehistoric art as hunting magic: the purpose of this magic was to cast a spell on the animals the people wanted to kill and so to foster successful hunts; fertility magic to increase their numbers; and destructive magic against animals dangerous to humans. From this point of view, the parameter of time lost much of its importance. The sorcerer-artists, according to him, drew animals on cave walls as need dictated in order to control them. The fact that the caves were conducive to conservation accomplished the rest: images accumulated over the centuries and were superimposed on each other; each was distinct, the outcome of a particular ceremony. The painted caves as we know them today are the result of this cumulative process.

Breuil tried to discern a stylistic evolution and proposed that Paleolithic art be divided into two periods, the Aurignacian-Perigordian Cycle, from 32,000 to 21,000 B.P., and the Solutrean-Magdalenian Cycle, from 21,000 to 11,000 B.P., each evolving from the simple to the more complex (see fig. 188). He based this scheme on the recorded superimpositions, attempting to determine which were older and which were more recent images. This relative chronology was supported by

171. Opposite: The hand stencils of the Cosquer cave are well dated, both by superimpositions and by a radiocarbon date. The hands that have been crossed out are one of the unusual features as well as one of the most fascinating enigmas of the cave

172. Le Portel cave (Ariège): Magdalenian horse painted in black outline with lines on the shoulder and shading on the underbelly

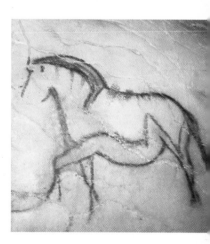

173. Niaux cave (Ariège): Painted bison overlaid with arrow-shaped signs

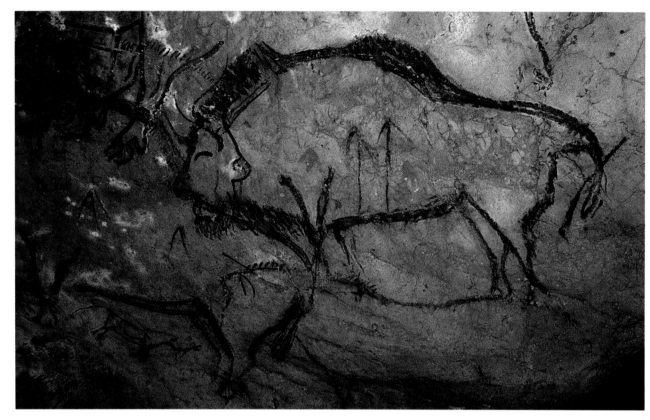

174. Niaux cave: Branched sign near a crack. According to André Leroi-Gourhan it is a male symbol, the fissure having female value

stylistic comparisons with portable art objects found in well-dated habitat layers, or by circumstantial factors that furnished an archaeological context, such as cave entries blocked by layers of debris, or habitat levels covering paintings so as to provide a minimum cut-off date. In spite of all this, it made little difference if a particular painted or engraved animal was Magdalenian or Gravettian since any error involved just one image and did not affect the deep meaning of the art.

Since Breuil, discoveries have continued and research has multiplied. The theory of hunting magic has been discredited because of its somewhat simplistic nature, as well as contradictions such as the very small number of animals marked with "arrows" (fig. 173). The chronological edifice has shown itself to be fragile, built on an unstable base. For example, Lascaux is not Aurignacian, as was once supposed, but is more recent by almost 10,000 years.

André Leroi-Gourhan, to whom we owe the renewal of research after Breuil, did not stray far on one essential point. He also put forward a universal explanation of Paleolithic art. This explanation called for an art based on a primordial duality, that of male and female principles, opposite and complementary, to which the animals and signs referred. They were invested with symbolic sexual value and were organized into complex groups arranged deliberately as a function of the topography of the cave. Leroi-Gourhan differed radically from Breuil on the idea of the sanctuaries. Instead of seeing images unrelated to one another, thrown on the walls haphazardly, Leroi-Gourhan suggested studying each cave as a whole, constructed in such a way that the cavity itself played a role. According to him, the artists intentionally structured the underground space through their depictions. The association of animals was not random but a reflection of complex mental schemas. Thus, bison (female principle) and horse (male principle) were side by side on the same central panels, flanked by complementary animals such as ibex and reindeer. The signs were endowed with sexual value as well (fig. 174).

Problems of chronology assumed crucial importance with this theory, since it was no longer a matter of dating separate figures but of dating entire sets. Leroi-Gourhan thus paid particular attention to these problems and subdivided Paleolithic art into four successive styles. As it happened, his methods were not very different from those of the Abbé Breuil, except that he used statistics and had at his disposal many more elements for comparison. This encouraged greater rigor and more reliable results, so that Leroi-Gourhan's chronological system is still widely used today (see fig. 188).

However, thirty years have passed since it was first worked out, and research has taken giant strides. The major advances involve several areas. Newly discovered caves are not looted as was the rule in the past. Those caves that have come to us intact have allowed in-depth studies not only of their paintings and engravings but also of the remains and traces left by Paleolithic people (Fontanet, Bidon, Le Réseau Clastres, Tito Bustillo, Llonín, La Viña). This recent interest in the archaeological context has inspired new studies, conducted with the meticulous care of modern research, in caves discovered long ago whenever the state of conservation allowed it (Lascaux, Les Trois-Frères, Le Tuc d'Audoubert, Montespan, Le Portel, Bédeilhac, Pech-Merle, and others). As a result, dating possibilities have multiplied and little by little human activities in the caves are becoming clearer.

Two examples will illustrate modern methods and results. In the cave of La Tête du Lion (fig. 175) at Bidon in the Ardèche region, careful excavation of the Paleolithic floor led to the discovery of drops of red paint that had fallen from the wall at the time the paintings were done. Charcoal found in this thin layer, contemporaneous with the paint, yielded a radiocarbon date of 21,650 ± 800 B.P. (Ly 847), thus indirectly dating the works of art.[1] In the cave of Le Placard in the Charente, engraved blocks fallen from the walls were found in a layer dated 20,210 ± 260 B.P. (Gif A 92,084), a date confirmed by the analysis of a burned bone (19,970 ± 250 B.P.; Gif A 91,184) found in the calcited remains of a layer that had covered the engravings.[2] In the latter case, the works of art are earlier than the dates obtained, but it is not yet known by how much.

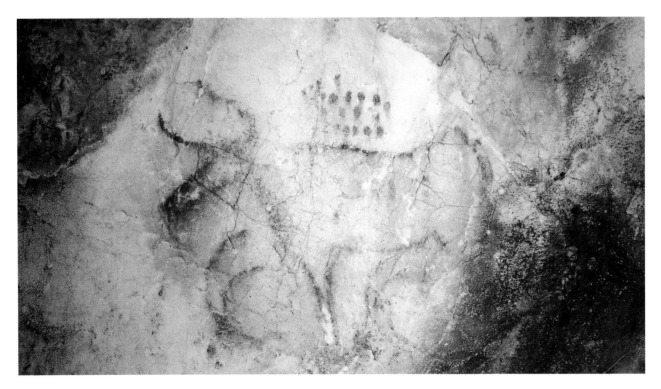

175. La Tête du Lion cave, Bidon (Ardèche): This painted panel is one of the best dated in Franco-Cantabrian art. A rare radiocarbon date, obtained from charcoal in a thin archaeological layer next to drops of paint from the wall art, places this painting of an aurochs at about 21,650 ± 800 B.P.

Finally, in just the last few years, advances in nuclear physics have come to the rescue of prehistorians. The use of much more powerful accelerators than existed in the past now permits the analysis of minute (0.5 mg) quantities of carbon. This makes direct sampling from charcoal drawings possible under certain conditions, for example, when pigment has accumulated in cracks. Some twenty dates have thus been obtained in France and Spain. Their increasing number will soon provide the necessary base for a solid chronology.[3] These discoveries and results illuminate ever more brightly a somewhat hazy landscape and modify several points in Leroi-Gourhan's chronological system.

Dating methods are thus multiple: some are relative, such as the superimpositions, and others, like direct dating, are absolute. They are used in the study of archaeological contexts as well as in stylistic comparisons. The latter, whether of portable art or wall art from other caves, rest on observation and a good hypothesis. What is observed are strong resemblances from cave to cave in the subjects (themes) chosen and especially in the manner of treating them (styles), with conventions repeated so frequently as not to be the result of chance resemblances. The hypothesis is that of the contemporaneous nature of such conventions. What is contemporary is relative, moreover, since dating methods are not sufficiently precise to determine the exact duration of conventions. In the best of cases this is estimated to within several centuries.

Regarding the Cosquer cave, one of the main problems to be resolved is whether or not the different works found there are contemporaneous. From the start, we have forced ourselves not to succumb to the specialist's temptation of relating this depiction to that cave in France or Spain; there is a natural tendency based on training to classify the works at the outset according to what is known elsewhere. Our knowledge of 25,000 years of Paleolithic art, based on just 300 caves distributed from the Urals to the southern regions of the Italian and Spanish peninsulas, is still too fragmented for this method to be risk-free. It implies that the essential knowledge of the art has been acquired and that there is no room for the unfamiliar.[4] Applying this method automatically led some of our colleagues into serious error when the discovery was announced.

We have thus attempted to use objective elements in our analysis of whether figures are to be grouped or separated in terms of time. Two phases have been determined empirically, based on inspection of the superimpositions.

Phase One

This phase definitely includes the hand stencils and finger tracings. Superimpositions are frequent, since the finger tracings are everywhere in the cave, and each time there is a superimposition, in fact, the finger tracings are beneath the animal engravings and paintings and beneath the signs. It is the same for a number of hands that are overlaid by animals. The reverse situation, animals cut through by hands or finger tracings, has not once been observed. The hands often overlie, and thus are later than the finger tracings. A number of them, such as M20 and M21, are partially erased by parallel grooves or by scraping. In the beginning[5] we concluded that some finger tracings had been drawn over the hands, making them contemporaneous. After we noticed the hands "killed" by deep scratches, we were less sure. They could well be the same phenomenon: it is possible that the finger tracings were done first and then, later, the hand stencils.

We certainly have no way of telling if these two activities, assuming they are distinct, occurred in rapid succession or if they were separated by long periods of time. Neither do we know if the hand stencils were done all at once or during ceremonies conducted in stages. Phase One is only the framework within which further subdivisions may still be made.

Phase One could be set within an absolute chronology thanks to four radiocarbon analyses done at the Centre des Faibles Radioactivités of the CNRS, CEA at Gif-sur-Yvette. A black hand stencil (MR7), as we have seen (Chapter 4), was the subject of two analyses that yielded the same result: 27,110 ± 350 B.P. (Gif A 92,491) and 27,110 ± 390 B.P. (Gif A 92,409). Furthermore, pieces of charcoal found on the ground near the great auks have been dated to 26,360 ± 400 B.P. (Gif A 92,349), and other pieces of charcoal from the ground near the feline head were dated to 27,870 ± 430 B.P. (Gif A 92,350). These analyses must not be interpreted literally, taking the difference between the dates at the two extremes to mean that Phase One extended over a period of 1,500 years: the statistical uncertainties of ± 400 years overlap, so that all the dates may well refer to a very short lapse of time or even to just one visit.

Four separate analyses, the results of which all fall within, at the outside, 1,500 years of each other, are sufficient to assign Phase One a relatively precise date, somewhere between 27,500 and 26,500 B.P. A single radiocarbon dating must be treated with caution and requires confirmation, but a set of results that agree as these do is much more reliable. Further confirmation was recently obtained from the cave of Gargas, where dozens of hand stencils with incomplete fingers have been known since the beginning of the century. A bone stuck in a crack very near the hand stencils (fig. 177) yielded a date of 26,860 ± 460 B.P. (Gif A 92,369). This date falls exactly within the range obtained for Phase One. Applied to the hand stencils with incomplete fingers, it reinforces the validity of the analyses cited for the Cosquer cave.

In addition to dating Phase One, the importance of these analyses is twofold: the black hand stencil dated 27,110 B.P. is at present the oldest painting in the world to have been dated directly. Furthermore, a very early date for this distinctive phenomenon of hand stencils has now been observed. This will be very useful, as hand stencils by the thousands are known in all parts of the world and some are still being drawn by Australian aborigines. Among the rare European Paleolithic hand stencils that have been dated are those of La Fuente del Salín in Cantabria, where an archaeological layer related to the hands yielded a date of 22,340 ± 510/480 B.P. (Gr 18,574),[6] as we have seen. This is notably later than the dates for Cosquer and Gargas. It is true that the hands from La Fuente del Salín are complete and so their thematic meaning could differ from that of the incomplete hands in caves just mentioned. The complete hands at Pech-Merle could also be Perigordian and still be fairly early. Several frame the panel of the Spotted Horses at Pech-Merle, and on that same panel there is stenciled a row of folded thumbs. This unusual theme is repeated at Gargas in the Sanctuary of the Hands (fig. 176). In the case of a specific technique, in this instance stenciling, applied to the depiction of an equally specific subject, that of a row of folded thumbs, there cannot possibly be a question of convergence. These representations are the work of people who shared the same symbols and the same techniques, probably at one period in time.

The possibility that certain signs from Cosquer and even certain painted or engraved animals belong to Phase One cannot be ruled out. It seems rather unlikely, however, given their stylistic homogeneity, as we will see. Whatever the case may be, hand stencils and finger tracings constitute the essence if not the totality of Phase One, and the finger tracings begin undoubtedly somewhat earlier than the hands.

Phase Two

Once two broad phases had been discerned at Cosquer, the question arose as to homogeneity or lack of it among the animal depictions. In response to the use of black outline, many colleagues thought

176. Gargas cave (Aventignan, Hautes-Pyrénées): Above these hand stencils is a frieze of thumbs also outlined by the stenciling technique

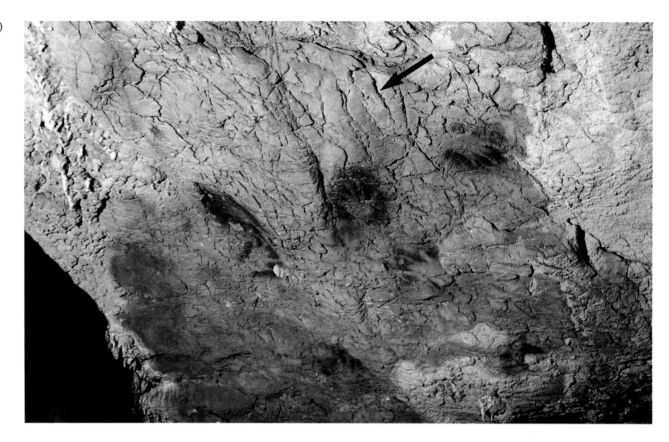

automatically of Niaux cave and the caves of the Pyrénées. They also noted resemblances between the Cosquer engravings and those of Ebbou cave in the Ardèche, attributed to a decidedly earlier age. Could the techniques used have a distinctive chronological value? Another question: are the individual paintings and engravings homogeneous?

The fact that the animal paintings are all done with black outlines seemed to imply homogeneity but was not conclusive proof. The frontal perspective of horns and antlers on the painted animals gave considerable support to this idea but left out the horses, although one horse (Chv5) does have ears seen from the front, for example, as does the feline.

An important detail allowed us to compare the painted horses Chv1 to Chv4 with the engravings: this was the sex of one of the horses (Chv3), very typical in that it was drawn with two converging lines in a wide V shape, open at the top and perpendicular to the line of the underbelly (fig. 61). The sex of male animals is more usually indicated by one or more parallel slanted lines. It happens that another horse (Chv11) had been engraved with the sex shown in the identical way (fig. 64), as was the chamois Chm1 that is superimposed on it, as was ibex Bq4 (fig. 97).

Other details confirmed the unity of the paintings and engravings: cervids with bulging withers (eland and megaloceros) are extremely rare. There are two in this cave, one painted and the other engraved (Mé1 and Mé2); as we have said, this could not be a coincidence. The leg of the painted megaloceros, furthermore, like those of cervid C1 and horse Chv11, had all been sketched in the same cursory manner, with two lines giving them a Y shape. The line of the breast on the megaloceros extends without curving to depict the front line of the foreleg (fig. 109); this is also true for painted horse Chv8 (fig. 75), for deer C1 (fig. 103), and for several engraved animals: chamois Chm1 and Chm4 (figs. 64 and 96), megaloceros Mé2 (fig. 108), and others. Finally, the way the deer antlers are set with blank spaces on either side to indicate the top of the skull (C1) is extremely rem-

168

iniscent of several engraved animals: ibex Bq2 and Bq4, chamois Chm1, Chm5, and especially Chm4 (figs. 88, 89, 64, 102, and 96).

These similarities to the engravings are not found in all the painted animals but are limited to some of the horses (those on the large panel), the bison, the feline, the deer, and the megaloceros. They occur often enough to make it likely that the animal art is homogeneous, done either by one artist or at least by people sharing the same conventions and several idiosyncrasies.

The same is true of the superimpositions. A megaloceros (Mé1) and a horse (Chv18) were painted over engravings. Conversely, two ibex (Bq2 and Bq3) overlie two painted bison (Bi4 and Bi5, respectively), and an ibex (Bq10) was engraved after two painted horses (Chv2 and Chv3) on the large panel (fig. 178). Ibex Bq10 displays the same conventions for legs and horns as do all the other engraved animals, and so could not be later. The fact that it was done after the painted horses indicates clearly that they do not belong to a recent phase of the art, as the first comparisons with Niaux and Ekain caves would have led us to assume.

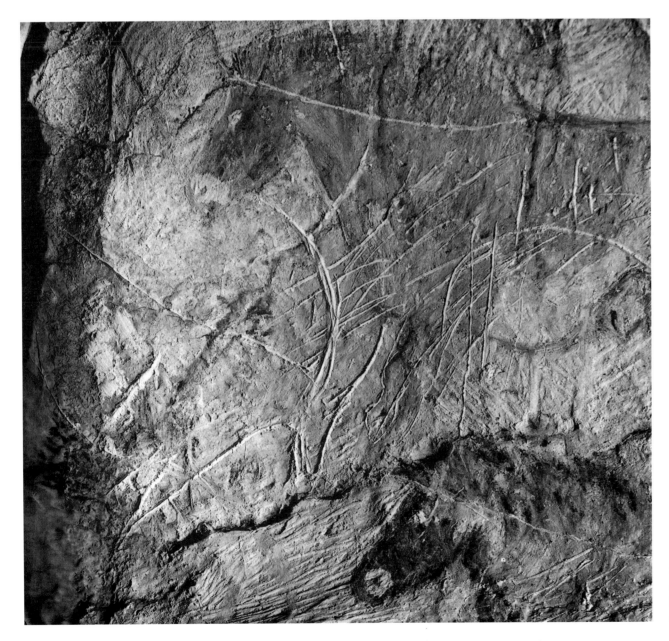

178. An ibex (Bq10) has been engraved directly on top of the large panel of horses (Chv1–Chv4) in the southwest area of the cave

Definite confirmation of these observations once again comes from the radiocarbon analyses. Simple visual inspection of the black lines revealed the presence of charcoal fibers. In cases such as the feline, it was even evident that the figure had been drawn with an actual piece of charcoal, and fragments of the charcoal had remained stuck in the *mond-milch* that covers the wall. Samples for dating were gathered by Jean Courtin in June 1992. Two separate analyses were done on both a horse (Chv1) and a bison (Bi1), and another on the feline. The results were: 19,200 ± 220 B.P. (Gif A 92,418) for the feline; 18,820 ± 310 B.P. (Gif A 92,417) and 18,840 ± 240 B.P. (Gif A 92,416)

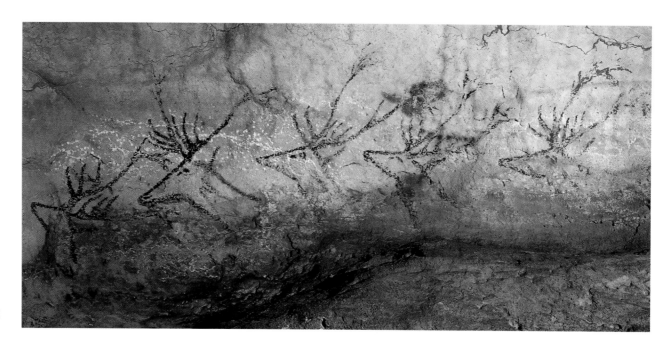

179. Lascaux cave: Frieze of swimming red deer, painted in black outline

for the horse Chv1; 18,010 ± 190 B.P. (Gif A 92,419) and 18,530 ± 180 B.P. (Gif A 92,492) for the bison Bi1. Physicists consider the second date obtained for the bison more plausible than the first because the chemical purification of the first sample had been less thorough than that of the second. These dates agree perfectly. In addition, there is that of 18,440 ± 440 B.P. (Ly 5,558), obtained earlier for a piece of charcoal found on the ground and two less reliable dates obtained from a contaminated sample that was not representative: 20,370 ± 250 B.P. (Gif A 92,348) and 15,570 ± 150 B.P. (Gif A 92,446).[7] These numerous dates fix Phase Two between 19,000 and 18,500 B.P. and show that the animals outlined in black are not more recent than the engravings, thus confirming our first observations on the superimpositions and the details of the representations.[8]

At the beginning of the study, before some firm dates had been obtained, stylistic comparisons with other caves could have been seriously misleading, given the degree of subjectivity that enters into finding such resemblances. Thus, when we focus on the details, as we are now at liberty to do, it quickly becomes obvious that what is reminiscent of the art of Niaux and of the Pyrénées in Cosquer as in several other caves of the Pyrénées and Cantabria is just the systematic use of the one technique, that of simple black outlines. This technique is so widespread in the Pyrénées and Cantabria that Ann Sieveking grouped together all the caves where one can find it and called the examples the black outline group.[9] Depictions using the identical technique are found elsewhere and in earlier periods, however: for example, the frieze of swimming deer and the shaft scene at Lascaux (figs. 179 and 169). The panel of horses (Chv1 to Chv4) is superficially reminiscent of Ekain, mainly because of the grouping of animals of one species in one area of the cave, as well as the shading of

the underbelly on one horse. However, the equids of Ekain are much more supple of line and more detailed, which in the end makes them quite different.

The systematic use of twisted perspective would have been sufficient reason for the Abbé Breuil to classify Phase One at Cosquer in his Aurignacian-Perigordian style, an identification that would have been supported by the finger tracings and the hand stencils. This convention certainly does not have the absolute discriminating character ascribed to it by Breuil: it can be found in a Magdalenian context (Sanctuary, Les Trois-Frères). However, when used in a repetitive and exclusive way, it takes on temporal meaning and supports such an assessment, especially when other archaic conventions were used concurrently.

Now three such conventions can be observed in numerous animals in the Cosquer cave. The first is the depiction of legs as Y-shaped, in the form of crutches. This schematization of the limbs is used in the Late Perigordian at Gargas, but it is more common in the caves assigned to Leroi-Gourhan's Style III—at Ebbou, Nancy, Gabillou, and El Castillo, for example. In the portable art of Parpalló, Solutrean animals are depicted this way[10] (fig. 180). The second is a crude but typical technique for rendering horns. The head is sketched with a single line for the nose and one horn, and another for the second horn and the dorsal line. The two lines do not touch and leave a space on top of the skull. The Gravettians of Gargas and Isturitz used this technique, which persisted until the end of the Solutrean, for example at Las Chimeneas[11] and, above all, at Parpalló in the Early, Middle, and Late[12] Solutrean. In the Cosquer cave, a variation consisted of placing the horns on top of a skull that is not depicted, so that there is a blank space between the two horns and on either side of each one. The third convention was pointed out by Jean Combier for the Solutrean in the gorges of the Ardèche.[13] It consists in using a single line to depict both the chest and the front line of the foreleg. This convention, known from the Early Solutrean of Chabot (Gard), was used at Ebbou.

180. Parpalló (Spain): Does and red deer of the Solutrean and Gravettian periods are engraved on plaquettes (drawing). Notice the convention of Y-shaped legs and the treatment of the horns, identical to horns of some of the animals of the Cosquer cave

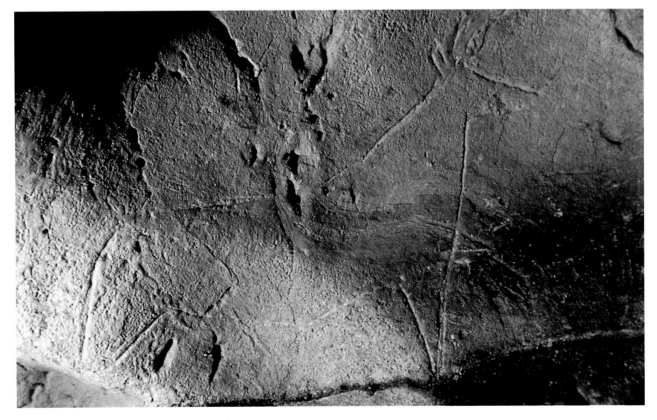

181, 182. Ebbou cave (Ardèche). Left: Like the animals of the Cosquer cave, this engraved bovid is stiff and motionless, with no details given for the legs. Below: An engraved ibex done similarly to some in the Cosquer cave

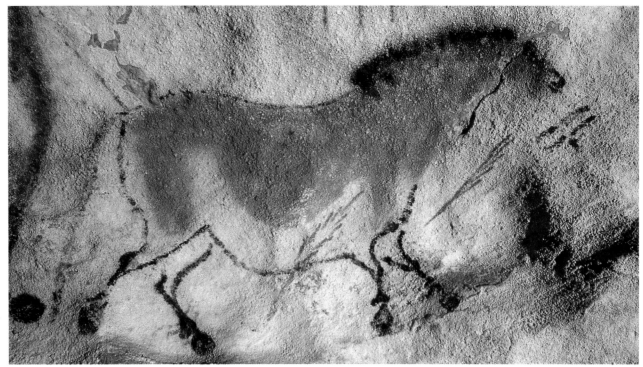

183. Lascaux cave: One of the "Chinese Horses," dating from the Early Magdalenian period. The shaded underbelly is well indicated. This technique, used in the Cosquer cave during the Solutrean period, became current in the caves of the Pyrénées and Cantabria during the Middle Magdalenian period

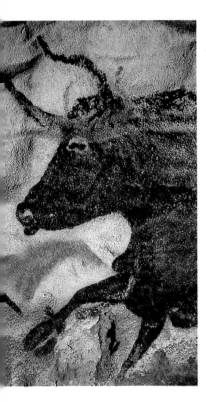

184. Lascaux cave: A painted aurochs on which the eye and nostril have been left blank, a technique used often in the Cosquer cave

Furthermore, it is the art at Ebbou that comes closest to the works presented here both because of the use of the conventions mentioned and because of the fixed, stiff stance of the animals, the absence of anatomical detail, and the treatment of the legs (figs. 181 and 182). Ebbou and Cosquer are just 90 miles apart as the crow flies, the Ardèche group being the closest to Cosquer, which may explain the commonalities. At Ebbou, as well, the animals have naturalistic proportions, and this exception to the canons of Style III in a cave with homogeneous art provoked astonishment in André Leroi-Gourhan[14] at the time. Jean Combier also thinks that the Ardèche group is "stylistically very isolated"[15] and that even though its chronological position has not been fixed with certainty, it would date before early Style IV and "would derive from the local evolution of Solutrean art."[16] It would then be Late Solutrean, rather comparable to the art of Parpalló. The comparisons most often made to the animals of Cosquer (Ebbou, Baume-Latrone, and Parpalló) lead us back to Paolo Graziosi's "Mediterranean province,"[17] into which the Cosquer cave fits without any difficulty, despite its unusual features and some details that are found elsewhere, in particular at Lascaux. These details are as follows:

- When the heads of the painted horses in the Cosquer cave are painted a solid color, the nostril and eye are generally left blank. This technique is found with some frequency only at Lascaux (compare figs. 61 and 184).
- The three-quarters perspective of the feline, of engraved ibex Bq4, and of the bison (Bi1) whose eyes are out of line and, in this instance, whose right eye is drawn in relief on and outside the line of the nose, are found at Lascaux on the oldest of the small horses partly covered by the Black Cow[18] (compare figs. 110, 89, 191, and 190).
- Finally, an underbelly shaded along a line like a flattened M (for example, Chv3) is found on the "Chinese Horse" at Lascaux[19] (compare figs. 61 and 183).

These similarities with Lascaux, commonly dated to 17,000 B.P.[20] led us at first to place Phase Two of Cosquer in a period "near Lascaux or a bit earlier" and to date it from 20,000–19,000

to 17,000 B.P.[21] Since then, with absolute dates in hand that are in complete conformity, we have been able to reduce this range to 19,000–18,500 B.P. The distance in time between Lascaux and Cosquer is at least a millennium and a half. Two hypotheses are possible. Either this interval is real, in which case the techniques used and the conventions mentioned were invented early on by the Solutreans or the Salpêtrians of Provence and then dispersed in space and time to Lascaux; or else Lascaux, either wholly or in part, is older than is now believed for reasons based on its archaeological context and the dates yielded by it and actually goes back to the Solutrean. We have to wait for new absolute dates, taken if possible from paintings done with charcoal, in order to arrive at any certainty on the subject.

Meaning

Here, we are on much less solid ground than with the chronology. Unlike colleagues in South Africa, America, or Australia, where human groups have retained their traditions until very recent periods or, in some cases, even until now, we are without direct evidence as to the meaning of the images in front of which we find ourselves. To interpret Paleolithic art without the support of the cultural context that inspired it is an undertaking full of pitfalls. We do not know all the myths, beliefs, and social and religious rules from which these representations arose. To try to decipher the meaning in the absence of this fertile base, now forever lost, we must rely on empirical study of the works and on more or less logical theories derived from direct knowledge of this art and of the practices of modern hunter-gatherer groups in other parts of the world.

During Phase One, as we have seen, the Gravettians left their mark even in the farthest corners of the Cosquer cave. Whenever the surface of the walls and ceilings proved sufficiently soft, it was covered with innumerable finger tracings. This concern with covering all available surfaces was shown in two ways. In some cases, for example near the ibex Bq9, they reached as high as 13 feet (4 m) to inscribe their tracings; this required either a rough ladder or some very unlikely acrobatics. Throughout the cave, furthermore, the finger tracings intertwine, intersect, or entirely cover whole panels, with no blank spaces. This is not art: there is no creation in these tracings, no transposition of the real or the imaginary. The intention of those who did them can only have been the appropriation of underground space, the intention to make the appropriate surfaces theirs in their entirety. The meaning of these tracings seems completely different in this case from that of the animal and human depictions or the signs. If the possibility of a communication system in some form[22] exists for the signs, it does not exist for the tens of thousands of interlaced lines, except in the elementary form of one single idea—that humans had taken possession of the cave.

The hand stencils that accompany the finger tracings probably express the similar intention of appropriating underground space. The symbol of a hand, wherever it occurs, marks taking possession, if only at an extremely basic level. The hand expresses personality, the presence of an individual. It can simply mean, "I was here," like the modern graffiti that cover so many cave walls. Among certain indigenous groups in South America, young people who have undergone initiation rites spend the night in a cave and leave their hand imprint there. In the context of Paleolithic art, which specialists agree to consider religious-magical, these hand stencils are no doubt filled with the deepest significance, but they are fundamentally identical, an affirmation of power. In the Cosquer cave, they are the work of adults; no children's hands have been discovered.

At least 8,000 years intervened between Phase One and Phase Two. Nothing indicates that the cave was visited in all that time. Perhaps the narrow entrance was blocked by scree or hidden beneath bushes? In any case, time passed and the cave was undoubtedly forgotten.

When the people of Phase Two entered the cave, they could not help but be struck by the images of the hands. Henri Cosquer himself noticed a hand stencil before anything else. For people living in a world where magic practices were part of everyday life, these hands no doubt symbolized ancient power, some magic the memory of which was lost, potentially dangerous. They then tried to neutralize it. To do that, they broke certain calcite draperies covered with hands, near the large submerged shaft; they overlaid some hands with dots or painted lines and obliterated others with deep strokes before placing their own depictions on the walls and ceilings.

Given the present state of technology, it is impossible to date the red paintings (those not done with charcoal) and the engravings directly. We thus have no formal proof that the superimpositions date from Phase Two. Our hypothesis is based on direct observation: a good number of hand stencils are covered by various marks, something unique in European wall art. In other caves it is rare that two periods of graphic expression, separated by several millennia, should be confirmed in such an uncontestable manner. Finally, the engraved lines that have destroyed certain hands are much less patinated than the finger tracings present in the same areas. If these finger tracings are relatively close in time to the hand stencils, as we believe, that means that the engraved lines are far later, and thus attributable to Phase Two. On the other hand, the frame of mind that moves people to destroy the testimony of a past religion or to replace it with their own symbols is witnessed by innumerable examples in all ages, in all places. The destruction of menhirs in Europe by order of the bishops, the erection or the sculpting of crosses on dolmens or menhirs up until recent times, like the construc-

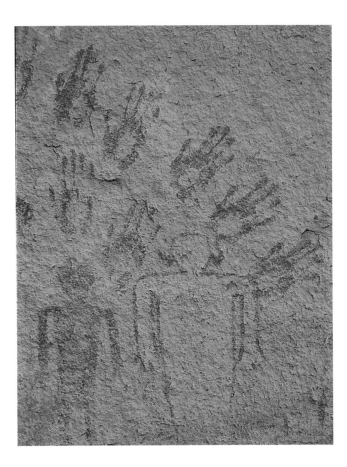

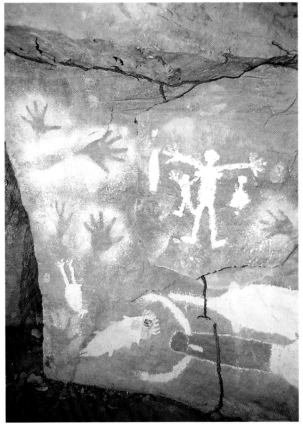

185. Pictograph cave (Canyon de Chelly, Arizona): Painted hands of unknown date

186. Garfish shelter (Laura area, Australia): These hands of unknown date—stenciled rather than drawn as the hands in figure 185—also express the idea of possession or of presence

tion of churches over pagan temples, are all evidence of this intention to substitute or to destroy.

In European Paleolithic art, there are two categories of sites: those in daylight—cave entrances or shelters—and deep caves, where darkness is total. The former most often served as habitats so that all members of the group—men, women, and children—lived in the immediate vicinity of engraved, sculpted, and/or painted walls. Little by little, debris mounted, matter accumulated from erosion, and layers of sediment were laid down, until the decorated walls were covered. Their religious value and meaning became obscure and then was entirely forgotten. On the other hand, Paleolithic people did not usually make more than very short trips into the farthest galleries. They left their drawings there, where they have been preserved (willful destruction such as that of the hands in the Cosquer cave remains a very rare event). Thus, we are observing two different ways of thinking. No doubt, as Annette Laming-Emperaire suggested, "[different] ceremonies . . . were carried out in one place or another, accompanied by other songs and other stories."[23]

The Cosquer cave was a deep sanctuary, far from the light of day. There is no evidence of a habitat there, only signs of humans passing through, whether 19,000 or 27,000 years ago. The decorated sites of those eras are quite often in daylight or near entrances. During the Perigordian period there are Pair-non-Pair (Gironde) and La Grèze (Dordogne); in the Solutrean, Le Placard, Le Roc de Sers (Charente), and Le Fourneau du Diable (Dordogne). However, some sanctuaries, at times important ones, are in complete darkness, for example, Gargas and Tibiran (Hautes-Pyrénées) during the Perigordian, and several caves in the southeast (Bidon, Oulen, Les Deux-Ouvertures) and in the Lot (Cougnac, Pech-Merle) during the Solutrean. The two ways of thinking have thus coexisted in the same periods.

People came into the deep caverns for ceremonies, no doubt, whatever their nature. To judge from the traces and remains of these events, they stayed only briefly, and these sanctuaries must have been visited only sporadically, for short periods. Footprints (fig. 187), when they have been preserved, show that women and children, sometimes very young ones (three years old at Le Tuc d'Audoubert, five or six at Fontanet), had access along with the men. In the Cosquer cave, prints unfortunately could not be preserved on the calcite-covered ground, so that information of this kind is not available to us. Certain hand stencils could be female, but nothing indicates the sex or age of the artists of Phase Two, except for the numerous drawings that could only have been done by adults standing upright.

Perhaps, however, it is possible to examine the problem from another angle. The unusual abundance of elongated signs, often barbed, on the animal figures is striking. Interpreting this type of sign as a projectile weapon, as was done long ago by the Abbé Breuil and Count Bégouën, fell into disfavor as a result of André Leroi-Gourhan's work and is hardly more acceptable today among specialists. However, we have seen that in the Cosquer cave, the form itself of such signs, with what very much resembles feathering at one end and at times one or more barbs at the other, calls to mind real images of arrows or spears, just as some animal images can be identified as bison or ibex. Refusing to accept them as such because of preconceived theories about their supposed symbolic value in either case could be unfortunate. Accepting them as identifiable images, furthermore, does not in any way compromise their possible symbolic value. Imposing the image of a javelin on that of a seal does not necessarily mean that the artist was a sorcerer practicing hunting magic, casting a spell on the seal so as to kill it successfully the following day. This type of simplistic explanation is certainly unrealistic. One can think of many other meanings: the weapon could symbolize a hunter or a sorcerer affirming his power over the spirit of the animal to assure its assistance, or the image could set down a shaman's

187. Fontanet cave (Ariège): Magdalenian period footprint

Upper Paleolithic Chronologies

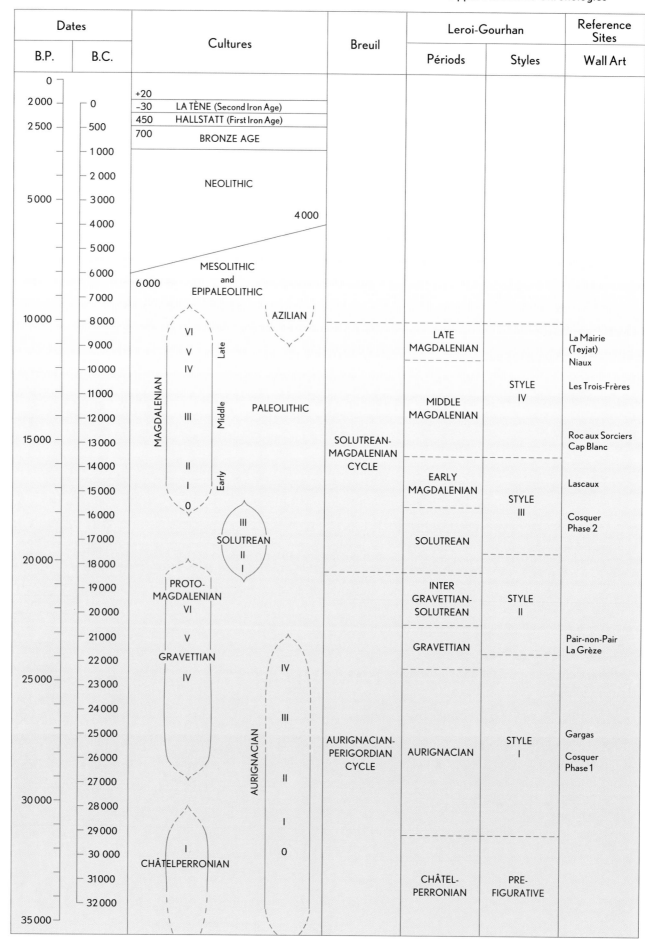

188. European Upper Paleolithic cultures and the chronological systems of Henri Breuil and of André Leroi-Gourhan. The column labeled "Reference Sites" shows where Phase One and Phase Two at the Cosquer cave stand in relation to some of the best-dated and/or best-known French caves with Paleolithic art

vision during a trance state, and so on. All these hypotheses are possible—and each one is as unprovable as the next.

We have mentioned the differences at Cosquer between paintings and engravings: the former are generally larger and fewer in number, while the latter often bear engraved signs, which the paintings lack. Weapons, especially those that cut or pierce causing blood to flow, are almost always the prerogative of men in hunter-gatherer societies.[24] The question then arises as to appropriation of images and maybe of techniques as a function of the artist's gender. Dale Guthrie, a biologist specializing in animal behavior, has for a long time insisted on the fundamentally masculine nature, in his eyes, of the Paleolithic symbols directly connected with hunting.[25] Ethnographical research has shown that even if most of the time shamans are men, it does happen that women as well go into trance states and do rock art. Perhaps one could consider the hypothesis that in the Cosquer cave it was men who drew the engraved animals often bearing arrows, and that the animal paintings without them were the work of woman artists? It is doubtful that conclusions can ever be reached in this area, but the question is worth raising as a matter for discussion.

Finally, it would be desirable to determine the season or seasons when the art was done. There again, ethnographical examples of specialized ceremonies as a function of the season of the year, with different rites and motivations, are plentiful. It is very rare to have information on this subject for the Paleolithic. In the case of Fontanet cave, analysis of pollen preserved in sediment from around a hearth showed that Magdalenians had stayed in this cave briefly right at the beginning of summer and that they had carried in armfuls of grass, probably for making beds near the fire.[26]

There is nothing like this in the Cosquer cave, where pollen is less plentiful. However, the depictions themselves give some seasonal indications. The deer have full racks of antlers, which rules out the shedding period in spring (March to May). As for the painted horses, several of them have white nostrils. This detail can be observed among wild horses only in winter,[27] while blackening of the coat around the nostrils occurs in summer. For the great auks, on the other hand, if it is indeed a scene of males competing for access to a female, this would indicate the end of May or the beginning of June. The depictions of at least some animals during identifiable seasons—in these cases winter and the end of spring—thus seems probable. That does not necessarily mean that the drawings were *done* during one of these seasons, but that the artists wanted to depict the animals with seasonal characteristics.

The information available at present about the chronology and meaning of the images is obviously of different orders and at different levels of importance. The fixing of the two phases and their dates leaves no ambiguity. The Cosquer cave is presently the best-dated rock-art sanctuary in the world.

On the other hand, we are far from understanding the reasons behind these depictions. Their preliminary study has certainly provided much information on the choices made and, at times, some insight. The deep motives for the hands and finger tracings of Phase One, when humans took possession of the cave, seem quite clear, although we will undoubtedly never know the details of those beliefs in all their complexity. The probable reactions of the people of Phase Two when faced with these images are just as self-evident. The idea of seasons, conveyed through horses, great auks, and deer, is equally so. The repeated use of signs in the form of spears on the engraved animals, more frequent here than in most Franco-Cantabrian caves, is ambiguous and more difficult to decipher. As for the possibility of distinguishing the images on the basis of gender, it remains a speculative hypothesis. Finally, the conditions of preservation in the cave and the degree of progress of the research does

not permit any remarks on a possible structure in the distribution of the wall art in Phase Two. In this vast chamber, the animals apparently do not present repeated groupings. However, we are far from knowing all we might, and prudence demands that we wait where this subject is concerned.

Some light has been shed, then, on certain aspects of this art, seen through the heavy fog of bygone millennia, but the cloud of fog persists. Will future studies allow us to disperse it?

189. Cave of the Children, Grimaldi caves (Liguria, Italy): Double burial, Gravettian period, contemporary with the hands in the Cosquer cave. This tomb contained the skeleton of an old woman buried with an adolescent boy of about fifteen, placed, like the woman, in a contracted position

10. The Singularity, Significance, and Future of the Cave

Whenever we give a conference on the Cosquer cave, and that must have happened a good forty times in the past three years, the same questions are asked. What is the real significance of this cave in prehistoric art? What does it mean to you personally? Is it really as unusual as all that? Will we be able to visit it one day? How do you plan to protect it? All these questions are linked.

The Cosquer Cave's Place in Paleolithic Art

Within broad outlines, the Cosquer cave conforms to the common context of Franco-Cantabrian painted caves. Their conventions and techniques have become so familiar to us that from the outset specialists and the public at large were struck more by its unusual aspects than by the basic qualities that link this Provençal cave to the other Paleolithic caves. And yet in the Cosquer cave, as elsewhere, the themes consist of animals and signs, with perhaps the unobtrusive presence of a human in an ambiguous role. Among the animals at Cosquer, the horse predominates as it does in most caves. The majority of the fauna are large herbivores; after the horses, the caprids, bovids, and cervids are most numerous. Even the indeterminate, composite, and fantasy animals, few in number, are not exceptional since they occur in almost all the important caves. Here again, the unusual animals, several chamois, a feline, and two megaloceros, are represented by only a few examples.

The methods of depiction are within the norms, whether for techniques of black outline painting and simple engraving or for conventions of representation. The bodies of the animals are always seen in profile. They appear to be suspended in midair with no base line depicted, outside any context—no landscape, no housing, no scenes involving people and animals so familiar in later periods, for example, in the art of the Spanish Levant (eastern Spain) that followed Paleolithic art in that area. Even if the drawing is cursory at times, the animals are well proportioned and are for the most part quite recognizable. Finally, as was true for almost all the deep caves, the Cosquer cave was not used as a habitat, at least the painted chambers were not. It was indeed a sanctuary; that is, a place of importance with limited access where only certain people came, perhaps on special occasions, to take part in ceremonies (this term being understood in its widest sense as any activity of a cultural nature having nothing to do with the immediate physical necessities of existence).

To this common heritage in all the painted caves, so familiar as to be no longer note-worthy, have been added some singular themes and techniques of unequal importance that are found elsewhere only rarely. The one that has aroused the most interest and inspired the most comment was the depiction of the bison Bi1 in three-quarters perspective (fig. 191). It is true that this particular point of view, used also for the neighboring bison Bi2 and for the feline head, remains exceptional, since we know of only one other example, a horse at Lascaux (fig. 190). It is evidence of the early appearance of a certain artistic procedure for rendering perspective, but there is really nothing extra-ordinary about that. We know that the Upper Paleolithic artists were like us, with similar abilities in all areas of perception and thinking. Innovations of this kind, selective departures from a well-estab-lished tradition, must have been introduced many times over, then to be forgotten before reappear-ing elsewhere. It is impossible to know if these repetitions were the result of direct contact or of chance occurrences.

While the Killed Man, the incomplete hands, and the finger tracings are themes found in other caves, the discoveries in the Cosquer cave shed new light on the subject and raise more ques-tions. Until now a certain ambiguity prevailed with regard to the human figures at Cougnac and Pech-Merle, and the lines touching them have even recently been interpreted, as we have seen, as vital forces radiating from their bodies.[1] Now, the figure in Cosquer leaves no room for doubt either from its position or from the terrible weapon running through it. These various depictions have been dated to periods close in time; this strange theme became stronger and more specific as it spread to Provence. From what it tells us about certain practices of Paleolithic people in relation to their own kind, it allows us to see them through less idealizing eyes.

Until now, the hand stencils with incomplete fingers at Gargas and Tibiran have posed an unresolved problem. While the hypothesis of ritual mutilation was judged quite unlikely among hunters for whom physical integrity was basic to survival, researchers were divided between the hypothesis of necrotic disease and that of fingers bent in a language of gesture. Now that we know the incomplete hands of Cosquer, it becomes much more difficult to believe that pathological disfigurement could affect people living such a distance apart during the same period, and lead to identical ritual and artistic consequences (see Chapter 4). This very old controversy, one that has caused much ink to flow since prehistoric hand stencils were first recognized in Gargas in 1907, is now on the way to being resolved.

Paleolithic finger tracings are much more widely distributed in space and time than hands. Nevertheless, it is not often that finger tracings cover such extensive surfaces, that they have been so systematically applied to all reachable walls and ceilings, and that they are also so well dated. Their location in the Cosquer cave provides confirmation that they are earlier than 27,000 B.P. and that their primary purpose was to occupy as much space as possible, in this way taking possession of the cave. These two substantial advances in our knowledge will shed light on the meaning and age of finger tracings in other caves, such as Gargas, where they also occur near hand stencils.

The circumstances of its discovery also place the Cosquer cave among a very small num-ber of caves where the archaeological context fortunately escaped both human and natural destruc-tion and came down to us intact. This is only true, of course, for the chambers above water. In those chambers the ground was protected right from the start but the calcite covering them prevented pre-historic footprints from being preserved there. On the other hand, some flint blades, small hearths, charcoal smudges on the cave walls and concretions, and numerous pieces of scattered charcoal have been preserved. These traces tell us things. They have already been the object of studies, and other

studies will follow. For now, they have allowed us to know how the prehistoric people who came to the cave provided light by building fires on the ground and burning torches, and what was used for the torches. They give us an idea of the landscape outside the cave and show us that the deep chambers were not inhabited and that human visits there were few and brief. Too often in the past, chance discoveries of painted caves resulted in the almost immediate destruction of such modest but eloquent vestiges through which we grasp the actions of Paleolithic people in the caves.

Finally, the Cosquer cave displays some truly unusual features, characteristics found nowhere else. First and most obvious, the feature that made it the subject of international journalistic attention, is its location. Until now, no painted cave has ever been found beneath the sea. Beyond anecdotal interest, this discovery makes real to us something known theoretically but difficult to take in accurately, the disappearance of all the prehistoric coastal sites over hundreds of square miles because of the rise in sea level since the end of the last glaciation. The Paleolithic landscape, includ-

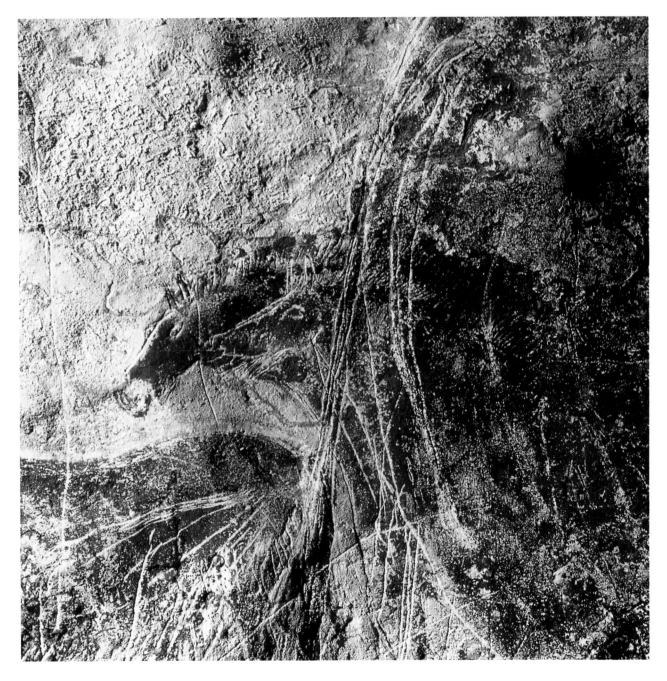

190. Left: Lascaux cave (Dordogne): The perspective of the first horse's head, with one eye outside the line of the nose, is like that of the bison Bi1 in the Cosquer cave (fig. 191)

191. Overleaf: Bison Bi1, the body seen in profile, horns in frontal perspective, and head in three-quarters view

ing the shoreline, was vastly different from what it is today. These changes have allowed only a minute and biased sample of habitats and sanctuaries to survive, so that our knowledge includes enormous gaps and is no doubt marred by errors in judgment. From this point of view, the Cosquer cave provides a salutary warning against blind confidence in the accepted theories. Furthermore, it may prompt new discoveries. A young Spanish colleague, an archaeologist and diver, told us recently that in his country he knew of many submerged caves also partly above water but that he had never thought of examining the walls for prehistoric engravings, and that he certainly intended to do that as soon as possible.

The location of the Cosquer cave in Provence is just as singular, since before 1991 no Paleolithic painted cave had been known there. The nearest are to the northwest, those of the Ardèche valley around Vallon-Pont-d'Arc, and to the east, the caves of Grimaldi in Liguria, on the Italian coast near the French border.[2] Isolated painted caves, far from the large, well-known wall-art regions, have been found a number of times, the most outlying being Kapovaya and Ignatiev in the Urals. This phenomenon can be explained in two ways. Either it only goes to show the extent of our ignorance about the loss of sites, and not just coastal sites, or else in some regions local traditions favored media other than cave walls. Art there may have been done on bark, on wood, on sand, or on rocks exposed to the elements, in which case, caves would only rarely have been painted. Nor are these two hypotheses incompatible.

Whatever the case may be, the discovery of the Cosquer cave supports the hypothesis of Paolo Graziosi,[3] who detected a Mediterranean province in Paleolithic wall art. This interesting suggestion—postulating the existence of different stylistic traditions from those of Périgord, the Pyrénées, and Cantabria for people living along the north shore of the Mediterranean and from Andalusia to the south of Italy and Sicily—was not entirely persuasive.[4] Not only did it imply relationships between groups living far apart, but, above all, it included sites distant from one another in time. The Cosquer cave now revives the theory, since in addition to its location, which fills the gap between Baume-Latrone (Gard) and Ebbou (Ardèche) and the Italian caves, the themes and techniques recorded fit very well into a Mediterranean provincial framework. As defined by Graziosi, this framework includes many geometric signs such as zigzags and curves, and for the depicted animals, a stiff stance as well as no bodily detail, with hoofs not shown and legs drawn in a cursory way.[5]

If this Mediterranean stylistic province really corresponds to some reality, it would mean that for about 10,000 years certain traditions endured in the depiction of animals as in the choice of more abstract symbols. This is not, after all, impossible. The Paleolithic world changed little over a long time. The evidence for local traditions disappearing very slowly exists (by coincidence?) in this same Mediterranean province, at Parpalló, near Valencia. This cave of modest dimensions revealed a stratigraphy more than 23 feet (7 m) deep, with an uninterrupted series of engraved plaquettes from the Gravettian period to the Late Magdalenian. For 8,000 or 9,000 years, successive groups of humans in this place used the same artistic technique, drawing on plaquettes. This clearly does not mean there were no connections between Parpalló and other art centers of the time, nor any local dynamics and development. It simply shows that the hypothesis of habits enduring over numerous millennia is not indefensible.

Among the particular features of the Cosquer cave, certain signs stand out, especially the barbed and feathered signs and the complex geometric figures. The red dots, the short straight lines, the zigzags, and the rectangles occur frequently elsewhere, but the series of feathered and, at times, barbed signs is unique. The angular signs, V-shaped or arrowlike with a line that varies in length in

the middle—frequent, for example, at Niaux—have given rise to controversy, from the theories of Henri Breuil, who saw them as weapons, to those of André Leroi-Gourhan, who interpreted them as wounds with a sexual connotation. Present-day specialists are careful and confine themselves to speaking of "signs." In the Cosquer cave, their sufficiently explicit shape, along with their repetition and their regular association with the animals—often on the chests of herbivores—leaves no doubt as to their wounding character. A corner of the veil has been lifted: these are indeed signs, but ones that probably evoke a certain reality linked to weapons, hunting, and the idea of prey and of gaining control over game and certain humans. This is already a large step forward. The singularity of the complex geometric figures, on the other hand, provides no clarification of their function or meaning.

The same is true for the sea animals, astonishingly varied and numerous. Seals are extremely rare in wall art, and the Cosquer auks are unique, as are the "jellyfish," if that is what they are. Their depiction was an interesting surprise, as happens each time a new animal appears in the repertory of Quaternary art. That was the case, for example, with the weasel in Le Réseau Clastres in the Ariège. But the importance of the sea animals goes well beyond the initial curiosity and astonishment they evoked. They open our eyes to the significance of local circumstances in the choice of images and probably in the nature of the ceremonies conducted in the caves. The artists of Phase Two were perfectly familiar with sea animals, their characteristic poses, and their habits. To draw them as convincingly as they have required long observation and, no doubt, hunting them. We still know practically nothing of the people of that period in Provence. It is surprising that the first information we obtain concerns their familiarity with the sea. In this respect, it is doubly unusual.

So are the hands that have been destroyed, slashed, and marked with dots or lines. To our knowledge, this is the first time that something like this has been reported. However, other caves do have artistic phases unquestionably separated by thousands of years. For example, in the cave of Les Trois-Frères in the Ariège, Perigordian engravings 24,000 to 25,000 years old were followed by Magdalenian paintings only 13,500 to 14,000 years old. In that case, the Magdalenians did not disfigure the marks of their predecessors. They were content either to paint on the untouched walls or to superimpose their work on earlier ones. Superimpositions are legion in the painted caves. They are usually not the sign of a break but rather of a continuation of traditions and rituals. In the Cosquer cave the phenomenon is fundamentally different. It expresses an intention to destroy, to substitute one magic for another that was considered strange or dangerous. Perhaps this was because the symbol of hands had a greater value than that assigned the animals? Because hands represent power and taking possession? We are in the realm of hypotheses here, and yet this uncommon destruction appeals to the imagination and expresses a reality that calls for interpretation, however daring.

The last unusual feature, one that returns us to the solid ground of certainties, is the fact that the Cosquer cave, as we have said, is the most solidly dated painted cave in the world. Cultural and chronological attributions are usually based on stylistic comparisons with the wall art of other groups more or less well characterized from the archaeological context or from similarities with portable art (see Chapter 9). We did not proceed any differently right at the beginning when confronted with animal images that reminded us of Ebbou and with hand stencils identical to the hands at Gargas. We have also clarified the archaeological context thanks to the pollen and charcoal analyses, and we have dated it by obtaining five radiocarbon dates for pieces of charcoal from the ground. Above all, the seven distinct dates yielded by charcoal used to paint the animals and hands constitute the most important series yet published. These, then, are twelve radiocarbon dates at our disposal for

the same cave from different sources. They fix the framework for Phases One and Two firmly, as well as the works belonging to them. Very few painted caves provide such an opportunity.

The Cosquer cave is certainly not the "underwater Lascaux" hailed in the popular press. The relatively small size of the figures, the sure but cursory technique, their apparent lack of sophistication and the visual impact of notably lesser degree all negate this type of comparison. The aesthetic quality of Lascaux remains unparalleled. These journalistic exaggerations do, however, express a vaguely perceived reality. The Provence cave displays an ensemble of the first order of importance. It is a major discovery, comparable to that of Pech-Merle in 1922, that of Rouffignac in 1956, and that of Tito Bustillo in 1968. Few painted caves pass the test of discovery with such flying colors. Still fewer display so many singular features and provide such a wealth of information.

The Future of the Cave

We are far from knowing all there is to know about this astonishing cave. Throughout this study, which force of circumstances has made preliminary, we have tried to make clear the limits of our research and of our knowledge. We are just at the beginning. Low passageways have not been explored: it seems likely that they will reveal new engravings, as will certain high walls. Signs and even animals were noticed at the last minute but were not photographed, measured, or described. Above all, no real tracings have been done. Working conditions, not to mention access, explain these gaps. We now have a good overall knowledge of the cave, with the general setting fixed in broad outline, but an enormous amount of work remains to be done. As long as the paintings and engravings have not all been traced in every detail and the archaeological context meticulously studied, we will have an incomplete view of the cave and of the activities of its visitors.

We cannot be satisfied with relative ignorance for two equally important reasons. This major sanctuary has already greatly enriched our knowledge, but studying the ensemble in depth with modern techniques will allow us to go much farther in understanding. Furthermore, an unstudied archaeological site has only a virtual existence. It can be seriously damaged or destroyed at any moment either by nature or by vandals. If such a thing were to happen before a complete study had been carried out, it would be as though it had never existed. Such a study is essential, then, within a reasonable space of time.

Modern studies, as we know, involve a team working over a long period, with prolonged visits to the cave, multiple camera shots, maps, cross sections, perhaps excavations—all work requiring time and a certain ease of access. The obvious solution to the problem of access, suggested to us again and again, would be to pierce a shaft through the top of the sanctuary, where the ceiling vault is closest to the surface. This would pose no insurmountable technical or financial problem. The cave would then become again an aboveground cave, and it could be entered by going down a ladder, avoiding the risks of diving and the enormous inconveniences of mounting such a complex operation with the accompanying considerable loss of time. Specialists could then have direct access to the unsubmerged chambers without having to know how to dive and could study them at leisure.

This solution involves two grave disadvantages. First, it would create a constant temptation for amateurs to make clandestine visits in search of underground adventure and unusual photographs. The strongest gates can be forced and the location presents major drawbacks: it is deserted, well known, attractive, and very near a large city. It is impossible to have it guarded twenty-four

hours a day throughout the year. Perhaps the solution to this problem would be to block the opening with a concrete slab weighing several tons, so that it could only be opened with heavy machinery during annual campaigns. This is the means of protection in force at present, with the submerged entrance artificially sealed off with blocks of concrete and with grills that can only be removed with specialized equipment.

The second disadvantage is more insidious. An opening in the ceiling, whatever precautions are taken (a hermetically sealed closing, an airlock), would inevitably disturb the equilibrium of the underground climate. Each cave is alive and has its own character, so that observations made in one cannot be extrapolated to another except in broad outline. At the present time, we have no idea how the walls of the cave would react to such changes in the short term, let alone the medium and long term. We do not have the right to play sorcerer's apprentice and take the ill-considered risk of putting the works found there in danger, perhaps after a lapse of only several dozen years.

On the advice of the Scientific and Technical Committee for the Henri Cosquer Cave, the Minister of Culture decided to undertake a study of the cave's climate. This is being conducted by Jacques Brunet from the Research Laboratory for Historical Monuments at Champs-sur-Marne. A new diving expedition took place in 1994, when measurement apparatus was installed in the chambers of the cave. Since the end of December 1994, the different climate variables, such as temperature, humidity, and carbon-dioxide levels, are being recorded and transmitted electronically to meters placed in a small laboratory built outside. After two or three years, it will become possible to develop a model to simulate the outcome of creating an artificial entrance. It is only after such studies, crucial to the future of the cave, that decisions will be made about a possible entrance shaft.

Even if this opening should be decided upon, it will still be necessary to wait several years before having a convenient entrance at our disposal. That will not prevent research from being undertaken. It was during the dives of 1994 that the unexplored passages as well as the submerged chambers were examined; photographic coverage as complete as possible was carried out; and some of the gaps noted in the present study have begun to be filled through tracings, observation, measurements, and new analyses, now in progress. An exhaustive study of the cave and the most complete knowledge possible are still distant objectives. The research already carried out in 1994 and that planned for the two or three years following is and will remain partial and insufficient, but it will add indispensable information to our understanding of this highly important cave. Between opening a shaft from above to permit normal tracings and an immediate study with modern methods, with the risks noted to conservation, and a freeze on all research for years to come in the interest of conservation, a middle path has been chosen. While preserving the cave, it will allow for the collection of documents and a better approach to this art, which still has so much more to teach us. In the words of Peter Ucko, "particular research strategies are sometimes forced on the researcher by the nature of the data itself as well as by considerations of time and expense involved."[6]

If an upper entrance were to be constructed, it would be reserved exclusively for researchers for relatively brief, planned periods; the cave would never be open to the public. In fact, taking into account its particular structure, the indispensable arrangements for the comfort and security of tourists would completely disrupt conditions in the cave and change the climate fundamentally. It would require as well a new road along the Massif des Calanques, a site that is protected and that should remain so. In order for this exceptional discovery to survive for future generations, who will always find in it material for research and new knowledge, it must be preserved in its natural state as carefully as possible.

On the other hand, the public has a right to information. This has been made widely available already, through the activity of the media, by means of exhibitions and conferences, thanks to a film on the subject, as well as through the books and articles cited in the Bibliography at the end of this book. It is possible to go further and foresee a large permanent exhibit, preferably in Marseilles, where the Cosquer cave would be reconstructed along broad lines with life-size photographic panels, maps, cross sections, mock-ups, and even facsimiles. Modern techniques, including three-dimensional reconstruction of the walls by photogrammetry and duplication of the paintings by artists using photographic projections, would allow whole sections of the cave to be reproduced exactly, as was done for Lascaux at Lascaux II and more recently for the cave of Niaux in the Prehistoric Park at Tarascon-sur-Ariège in the Pyrénées. Projects such as these, if desirable, take a lot of time and money and would be undertaken only after the imperatives of conservation, which has precedence, and of research have been met.

The discovery of the Cosquer cave rightly propelled its discoverer into the spotlight; his find brought him celebrity and fortune. It also upset the authors' lives to some extent. Each of us has his own long-established research program and, like all veteran researchers, a full load when it comes to time. All of a sudden, we had to absorb these new finds, size them up, and take a quick position on their authenticity and significance, respond to the pressing demands of the public, and above all deal for months on end with an extremely unpleasant public controversy, which took its toll in energy. The study, properly speaking, with its meticulous work, its revelations and its joys, came only afterward. But this is what occupies us now, allowing the difficulties and pettiness to fade. Given the exceptional importance of the subject, it will occupy our attention for years to come. What does the Cosquer cave mean to us? The answer to this personal question we are frequently asked is that when fortune provides an ensemble as complex, fascinating, and mysterious as this to study, one can only be a happy and fulfilled researcher.

Acknowledgments

After the discovery of the Cosquer cave, our publishers, the Editions du Seuil, proposed publishing a large hardcover book with beautiful photographs, meant for the general public and readable by anyone, while maintaining a solid scientific approach. They interested Christian Dupavillon, then Directeur du Patrimoine at the Ministry of Culture, in this idea, and he in turn asked us to develop and write this book. That was in the autumn of 1992.

We had to assess our knowledge at that point, even though the study of the cave had only just begun, and do it fairly quickly. Happily, the two series of dives in September 1991 and June 1992 had reaped a considerable harvest of information, documents, and samples. The results of the analyses confirmed our first observations, and a broad outline was firmly in place. The project would now take shape, delivering to the scientific world and the general public an account of what was known to date about a major archaeological discovery, despite the inevitable gaps in our knowledge, of which we were very aware. It will, no doubt, take many years to fill these in. While waiting, we have taken a first step, as complete as possible.

We shared the work: the first four chapters were written by Jean Courtin and the last six by Jean Clottes. Of course, we agreed on a way of working and writing so that the different chapters would have a common shape, style, and point of view. We were in constant touch at all stages of the research and the writing, and each read the other's finished text. It was a true collaboration, all the more enjoyable and fruitful because it was done in a spirit of friendship.

The photographs in this book are for the most part those of Antoine Chêné, of the Centre Camille-Jullian at CNRS in Aix-en-Provence. Jacques Collina-Girard (CNRS Bordeaux) provided us with a set of the slides taken during the dives of June 1992, and Norbert Aujoulat (Centre National de Préhistoire, Périgueux) provided photographs of other caves for comparison. Valérie Feruglio drew a number of figures from the photographs and painted various subjects with obvious talent. Many colleagues (Brigitte and Gilles Delluc, Francesco d'Errico, Maria del Mar Espejo and Pedro Cantalejo, Henry de Lumley, Jean Gaussen, Michel Lorblanchet, Cécile Mourer-Chauviré, Gérard Onoratini, and Arturo Palma di Cesnolo) allowed us to reproduce previously published illustrations.

Henri Cosquer participated in all the expeditions and gave us access to the documents he himself had collected. Luc Long (DRASM Marseilles), Michel Girard (CRA, CNRS) and Jacques Collina-Girard actively participated in collecting scientific information in the cave. Various analyses were carried out by Jacques Evin (Lyons); by Hélène Valladas and her colleagues Hélène Cachier, Nicole Mercier, and Maurice Arnold, from the Laboratoire des Faibles Radioactivités at Gif-sur-Yvette, for the radiocarbon dating; Michel Girard (CRA Valbonne) for the pollen analyses; Stéphanie Thiébault (CNRS Montpellier) for identification of the charcoal; Pamela Vandiver (Smithsonian Institution) for the pigment analysis; and Hugues Plisson (CRA Valbonne) for analysis of the microtraces on the flint blades. Eugène Bonifay (CNRS Luminy) and Jacques Collina-Girard shared with us their knowledge of local geology, including marine geology.

Of course, none of this could have been done without the consent and financial backing of the Ministry of Culture (Direction du Patrimoine, Sous-Direction de l'Archéologie) and without the logistical support of the Département des Recherches Archéologiques Sous-Marines (DRASM) directed by Robert Lequément, with the divers Guy Dauphin, Albert Illouze, Luc Long, and Jo Vicente. The cave is located beneath the Forêt Domaniale des Calanques, which belongs to the state and is administered by the Office National des Forêts, which gave the requisite authorizations. The French navy with its Groupe d'Intervention sous la Mer (GISMER) gave their help during the first dives.

During trying moments in the initial controversy over the Cosquer cave we were very aware of the support given us and our position, publicly and without ambiguity, by our colleagues Professor Antonio Beltrán (University of Saragossa) and Professor Henry de Lumley (Muséum National d'Histoire Naturelle de Paris).

As soon as the discovery of the Cosquer cave was announced, there were eager expressions of interest around the world. It was not a French discovery only: countless people on all continents felt that it was also theirs, that some of the older roots of humankind had been brought to light. To make the information we had collected available to a much wider audience, our book had to be published in English. The Editions du Seuil decided to do so and contacted Harry N. Abrams, Inc., who agreed to have the book translated and published. The excellent translation, which is faithful to our meaning to the slightest detail, is the work of Marilyn Garner. Ellyn Allison edited our text with extreme care, pointing out errors and suggesting improvements. We are very, very grateful for all the help received that made this English-language edition possible.

To everyone, our warmest thanks.

Notes

Only author's name, date of publication, and (when appropriate) page numbers are given for books and articles that are cited in full in the Bibliography.

Chapter 1: Background
1. Bonifay 1973; Bonifay 1989; Bonifay, Courtin, and Thommeret 1971; Lumley 1976; Froget 1974; Collina-Girard 1992; Collina-Girard 1994.
2. Bonifay, Courtin, and Thommeret 1971; Bonifay 1989.
3. Lumley 1976.
4. Bonifay 1989.
5. See Harmelin, Vacelet, and Vasseur 1985.
6. Cosquer 1992.
7. Combier 1981.
8. Collina-Girard 1994.
9. Jean Vacelet, unpublished report, 1992.
10. Michel Girard, letter, 1992.
11. Siffre 1992.
12. Clottes, Beltrán, Courtin, and Cosquer 1992.
13. Clottes and Courtin 1992.
14. Cartailhac 1902.
15. Bourdial 1992:77.
16. Ibid.:79.
17. Philippe Renault, letter, 1991.
18. Ibid.
19. Bourdial 1992:77.
20. Combier 1984b.
21. Bourdial 1992:78–79.
22. Ibid.:79.
23. Delluc and Delluc 1991:516.
24. Gilles Delluc and Brigitte Delluc, in Bourdial 1992:76.
25. Cartailhac 1902.
26. Valladas, Cachier, Maurice et al. 1992.
27. Clottes, Courtin, Valladas, Cachier et al. 1992.
28. Escalon de Fonton 1970; Escalon de Fonton 1975; Onoratini 1984; Onoratini and Raux 1993.

Chapter 2: The Natural Setting
1. Bellaiche 1972.
2. Lumley 1976.
3. Aloisi et al. 1978.
4. Collina-Girard 1992; Collina-Girard 1994.
5. See map in Collina-Girard 1992.
6. Lumley 1976.
7. Lumley 1976; Aloisi et al. 1978; Bellaiche 1972.
8. Blanc, Degiovanni, Poydenot et al. 1992; Collina-Girard 1994.
9. Aloisi et al. 1978.

10. Bourdial 1992.
11. Onoratini, Arnaud, Degiovanni, and Vicino 1992.
12. Froget 1974.
13. Stéphanie Thiébault, letter, 1992; Michel Girard, letter, 1992; see Chapter 1.
14. Collina-Girard 1994; see map.
15. Michel Girard, letter, 1992; see Chapter 1.
16. Crégut-Bonnoure 1991.
17. Escalon de Fonton, Bonifay, and Onoratini 1977; Bonifay and Lecourtois-Dugoninaz 1977.
18. Crégut-Bonnoure 1991.
19. Escalon de Fonton 1970, 1975; Escalon de Fonton and Onoratini 1976; Onoratini 1982.
20. Escalon de Fonton and Onoratini 1976.
21. Escalon de Fonton and Bazile 1976.
22. Onoratini 1982; Onoratini 1984; Onoratini and Raux 1993.
23. Stecchi and Bottet 1950; Onoratini and Raux 1993.
24. Escalon de Fonton 1975.
25. Ibid.
26. Onoratini and Da Silva 1978.
27. Escalon de Fonton, Bonifay, and Onoratini 1977; Onoratini 1982.
28. See Onoratini 1982.
29. Mussi 1992; Onoratini and Da Silva 1978.

Chapter 3: Description of the Cave
1. Jean Vacelet, report, 1992.
2. Jean Vacelet, report, 1992; Harmelin, Vacelet, and Vasseur 1985.
3. Collina-Girard 1994.
4. Jean Vacelet, report, 1992.
5. Hugues Plisson, letter; see report, 1992.
6. Hugues Plisson, report, 1992.

Chapter 4: The Finger Tracings and the Hands
1. Lorblanchet 1992.
2. Ibid.
3. See Plassard and Plassard 1989.
4. Wright 1971.
5. Hugues Plisson, report, 1993; see Chapter 3.
6. Lorblanchet 1992.
7. Drouot 1984.
8. Garcia and Duday 1993; Duday and Garcia 1990.
9. Groenen 1986–1987.
10. Lorblanchet 1985.
11. Lavallée 1986.
12. Huard 1968; Le Quellec 1993.
13. Strecker 1982.
14. Baffier and Girard 1992.
15. *L'Art des cavernes* 1984.
16. Palma di Cesnola 1987.
17. Delluc and Delluc 1982–1983.

18. Baffier and Girard 1992.
19. The count is 250 according to *L'Art des cavernes* 1984.
20. Barrière 1976.
21. Barrière and Suères 1993; Groenen 1986–1987; Groenen 1988; Groenen 1990.
22. Baffier and Girard 1992; information from Michel Girard.
23. Cartailhac 1906; Breuil 1952.
24. André Leroi-Gourhan 1967.
25. Janssens 1957.
26. Sahly 1966.
27. Nougier 1966; Barrière 1976; Barrière and Suères 1993.
28. Groenen 1986–1987.
29. Tardos 1987.
30. Capitan 1911.
31. André Leroi-Gourhan 1967:122.
32. Lorblanchet 1980.
33. Groenen 1986–1987; Groenen 1988; Groenen 1990.
34. Barrière and Suères 1993.
35. Groenen 1986–87.
36. Delluc and Delluc 1993.
37. Clottes, Beltrán, Courtin, and Cosquer 1992.
38. Barrière 1984:518.
39. André Leroi-Gourhan 1965.
40. Bourdial 1992.
41. Barrière 1984; Groenen 1986–87.
42. Barrière 1976.
43. Groenen 1986–87.
44. Barrière 1976.
45. Clottes and Courtin 1992.
46. Breuil 1952.
47. Delluc and Delluc 1982–1983.
48. Clottes, Courtin, Valladas, Cachier et al. 1992.
49. See Onoratini 1982; Onoratini and Raux 1993.
50. Clottes, Valladas, Cachier, and Arnold 1992.
51. André Leroi-Gourhan 1965.
52. Moure Romanillo and Gonzalez Morales 1992.
53. Clottes, Courtin, Valladas, Cachier et al. 1992.

Chapter 5: The Land Animals
1. André Leroi-Gourhan 1965.
2. Ibid.
3. Clottes 1989.
4. André Leroi-Gourhan 1965:96.
5. Baffier 1984.
6. Clottes 1989.
7. Ibid.
8. Lorblanchet 1984b:44.
9. For this, see Clottes 1989.
10. Bahn 1978; Bahn 1984.
11. Hainard 1989:94.
12. Ibid.:97.
13. G. Maury, in Clottes, Garner, and Maury 1994.

14. Ibid.
15. Hainard 1989:106.
16. Ibid.:131.
17. Clottes, Courtin, Valladas, Cachier et al. 1992.
18. Michèlle Crémadès, in GRAPP 1993:137–50.
19. Clottes, Courtin, Valladas, Cachier et al. 1992.
20. Saint-Périer 1932:51–52.
21. Pales 1969:47–48.
22. Simonnet 1980.
23. Méroc 1974.
24. On this, see Jean Clottes, in GRAPP 1993:193–96.
25. Lorblanchet 1989.
26. Robert Bégouën, in GRAPP 1993:201–6.
27. Ibid.
28. Lewis-Williams and Dowson 1988.
29. Lorblanchet 1989.
30. See Clottes, Courtin, Valladas, Cachier et al. 1992.

Chapter 6: The Sea Animals

1. Alcalde del Rio, Breuil, and Sierra 1912.
2. Mezzena and Palma di Cesnola 1984.
3. d'Errico 1994.
4. Ibid.
5. Mourer-Chauviré and Antunes 1991.
6. *Grande Encyclopédie Larousse* 1975.
7. Teares 1980.
8. Hainard 1989.
9. Sonneville-Bordes and Laurent 1983.
10. Bosinski and Bosinski 1991.
11. Dams 1978.
12. Espejo and Cantalejo 1992:111.
13. Dams 1987.
14. André Leroi-Gourhan 1979:18–19 and figs. 370, 376.
15. Dams 1987:246–47.
16. Espejo and Cantalejo 1992:87.

Chapter 7: The Signs

1. Breuil and Capitan 1902.
2. On this, and on the problem of signs in general, see Georges Sauvet, in GRAPP 1993:219–34.
3. Ucko 1992:153.
4. Sauvet, Sauvet, and Wlodarczyk 1977.
5. Vialou 1986.
6. Casado Lopez 1977.
7. Georges Sauvet, in GRAPP 1993:219–34.
8. André Leroi-Gourhan 1981:125.
9. Clottes, Duport, and Feruglio 1990.
10. Clottes 1988–1989.
11. André Leroi-Gourhan 1965:125.
12. Anati 1989:162.
13. Anati 1989.
14. Foucher 1991:91.
15. Michel Lorblanchet, in GRAPP 1993:217.
16. André Leroi-Gourhan 1975:391.
17. Leonardi 1988:184, fig. 84.
18. Leonardi 1990.
19. Villaverde Bonilla 1992:393.
20. Leonardi 1988:162, fig. 49.
21. André Leroi-Gourhan 1981.
22. Lewis-Williams and Dowson 1988.

Chapter 8: The Killed Man

1. André Leroi-Gourhan 1976:430.
2. Lémozi 1929:120.
3. Breuil 1952:272–73.
4. Sieveking 1979:114.
5. Méroc and Mazet 1956:19.
6. Lorblanchet 1984a:487.
7. Clottes, Duport, and Feruglio 1990; Clottes, Duport, and Feruglio 1991.
8. Delluc and Delluc 1987.
9. See also Delluc and Delluc 1971:252 and Bahn and Vertut 1988:152.
10. Gaussen 1964.
11. André Leroi-Gourhan 1965:265.
12. Laming-Emperaire 1962:287.
13. Hadingham 1979:226.
14. Smith 1992:109.
15. Ibid.:84–85.
16. Graziosi 1960:158.
17. Laming-Emperaire 1962:287.
18. Méroc and Mazet 1956:37.
19. Breuil 1959:77.
20. See also Méroc and Mazet 1956:37.

Chapter 9: Chronology and Meaning

1. Combier 1984b.
2. Clottes, Duport, and Feruglio 1990; Clottes, Duport, and Feruglio 1991.
3. Valladas, Cachier, Maurice et al. 1992; Clottes 1993; Lorblanchet 1990.
4. Clottes and Courtin 1993.
5. Clottes, Beltrán, Courtin, and Cosquer 1992:126.
6. Moure Romanillo and Gonzalez Morales 1992.
7. Clottes, Courtin, Valladas, Cachier et al. 1992.
8. Clottes, Beltrán, Courtin, and Cosquer 1992.
9. Sieveking 1979.
10. Villaverde Bonilla 1990: 234, fig. 10.
11. Gonzalez Echegaray 1974:15, fig. 5.
12. Villaverde Bonilla 1988. Early Solutrean, 14: fig. 1, no. 7. Middle Solutrean, 14: fig. 1, no. 8. Late Solutrean, 14: fig. 4, no. 12.
13. Combier 1984c:321.
14. André Leroi-Gourhan 1965:328.
15. Combier 1984d:614.
16. Ibid.:615.
17. Graziosi 1964.
18. *L'Art des cavernes*:v, fig. 3.
19. Clottes, Beltrán, Courtin, and Cosquer 1992:126–27.
20. Arlette Leroi-Gourhan and Allain 1979.
21. Clottes, Beltrán, Courtin, and Cosquer 1992.
22. Ucko 1992.
23. Laming-Emperaire 1962:293.
24. Testart 1986.
25. Guthrie 1984.
26. Arlette Leroi-Gourhan 1981.
27. R. D. Guthrie, private correspondence.

Chapter 10: The Singularity, Significance, and Future of the Cave

1. Smith 1992.
2. Vicino and Simone 1972.
3. Graziosi 1964.
4. See also, recently, Villaverde Bonilla 1992:394–95.
5. Graziosi 1964:38–41.
6. Ucko 1992:160.

Bibliography

ABBREVIATIONS:

AFAS: *Association Française pour l'Avancement des Sciences*

AMG: Arts et Métiers Graphiques

AURA: Australian Rock Art Research Association

Bull. Soc. études litt., sc. et art. du Lot: *Bulletin de la Société des études littéraires scientifiques et artistiques du Lot*

Bull. Soc. préhist. Ariège: *Bulletin de la Société préhistorique de l'Ariège*

Bull. Soc. préhist. Ariège-Pyr.: *Bulletin de la Société préhistorique Ariège-Pyrénées*

Bull. Soc. préhist. fr.: *Bulletin de la Société préhistorique française*

CNRS: Centre National de la Recherche Scientifique

EHESS: Ecole des Hautes Etudes en Sciences Sociales

ERAUL: Etudes et Recherches archéologiques de l'Université de Liège

Géog. Phys. Quat.: *Géographie Physique Quaternaire*

GRAPP: Groupe de Recherche sur l'Art Pariétal Paléolithique

INRDP-CDDP: Institut National de Recherche et de Documentation Pédagogique–Centre Départemental de Documentation Pédagogique

ALCALDE DEL RIO, H.; BREUIL, H.; and SIERRA, L. 1912. *Les Cavernes de la région cantabrique*. Monaco: Imprimerie Chêne.

ALMAGRO, M. 1969. *Las Pinturas rupestres de la Cueva de Maltravieso en Cáceres. Guía del visitante*. Madrid: Ministerio de Educación y Ciencia.

ALOISI, J.-C. et al. 1978. "The Holocene transgression in the Golfe du Lion, Southwestern France. Palaeogeographic and palaeobotanical evolution." *Geogr. Phys. Quat.*, XXII, 2, pp. 145–62.

ANATI, E. 1989. *Les Origines de l'art et la formation de l'esprit humain*. Paris: Albin Michel.

APELLANIZ, J. M. 1982. *El Arte prehistórico del País Vasco y sus vecinos*. Bilbao: Desclée de Brouwer.

L'Art des cavernes. Atlas des grottes ornées paléolithiques françaises. 1984. Paris: Ministère de la Culture, Imprimerie nationale.

BAFFIER, D. 1984. "Les caractères sexuels secondaires des mammifères dans l'art pariétal paléolithique franco-cantabrique." In H.-G. Bandi et al., *La Contribution de la zoologie et de l'éthologie à l'interprétation de l'art des peuples chasseurs préhistoriques*, pp. 143–54. Fribourg (Switz.): Editions Universitaires.

BAFFIER, D., and GIRARD, M. 1992. "La grande grotte d'Arcy-sur-Cure (Yonne), nouveau sanctuaire paléolithique. Résultats préliminaires." *Revue archéologique de l'Est*, 43, fasc. 2, pp. 195–205.

BAHN, P. G. 1978. "The 'unacceptable face' of the West European Upper Palaeolithic." *Antiquity*, LII, pp. 183–92.

———. 1984. *Pyrenean Prehistory. A Palaeoeconomic Survey of the French Sites*. Marminster (Wiltshire, Eng.): Aris and Phillips.

BAHN, P. G., and VERTUT, J. 1988. *Images of the Ice Age*. London: Windward, Smith and Son.

BARD, E.; HAMELIN, B.; and FAIRBANKS, R. G. 1990. "U-Th ages obtained by mass spectrometry in corals from Barbados: sea level during the past 130,000 years." *Nature*, 346, pp. 456–58.

BARRIÈRE, C. 1973. "Les gravures en tracé digital de Gargas." *Bull. Soc. préhist. Ariège*, XXVIII, pp. 79–102.

———. 1976. *L'Art pariétal de la grotte de Gargas*. Mémoires de l'Institut d'art préhistorique de Toulouse. *British Archaeological Reports*. Supplementary Series 14. 2 vols.

———. 1984. "Grotte de Gargas." In *L'Art des cavernes*, pp. 514–22. Paris: Ministère de la Culture, Imprimerie nationale.

BARRIÈRE, C., and SAHLY, A. 1964. "Les empreintes humaines de Lascaux." In *Miscelánea en Homenaje al Abate Henri Breuil*, 1, pp. 173–80. Barcelona: Diputación provincial de Barcelona, Instituto de Prehistoria y Arqueología.

BARRIÈRE, C., and SUÈRES, M. 1993. "Les mains de Gargas." In *Les Dossiers de l'archéologie*, no. 178: *La Main dans la Préhistoire*, pp. 46–54. Dijon: Editions Faton.

BELLAICHE, G. 1972. "Les dépôts quaternaires immergés du golfe de Fréjus (Var), France." In *The Mediterranean Sea: A Natural Sedimentation Laboratory*, pp. 171–76. Washington, D.C.: Smithsonian Institution.

BELTRÁN, A.; CLOTTES, J.; COURTIN, J.; and COSQUER, H. 1992. "Une grotte ornée paléolithique sur le littoral méditerranéen: la grotte Cosquer à Marseille." *Comptes rendus de l'Académie des sciences de Paris*, tome 315, ser. II, pp. 239–46.

BLANC, J.-J.; DEGIOVANNI, C.; POYDENOT, F.; ROUX, M.-R.; and WEYDERT, P. 1992. "Les escarpements sous-marins de la marge continentale de la Provence, étude géomorphologique." *Géologie méditerranéenne*, XIX, 1.

BOHIGAS ROLDAN, R., and SARABIA ROGINA, P. 1988. "Nouvelles découvertes d'art paléolithique dans la région cantabrique: La Fuente del Salín à Muñorrodero." *L'Anthropologie*, 92, 1, pp. 133–37.

BONIFAY, E. 1973. "Données géologiques sur la transgression versilienne le long des côtes françaises de la Méditerranée." In *Le Quaternaire. Géodynamique, stratigraphie et environnement. Travaux français récents*, pp. 137–42. Ninth International Congress of INQUA (Christchurch).

———. 1989. "Plages fossiles des régions littorales de la Méditerranée française." *Le Temps de la Préhistoire*, vol. I, pp. 112–13. Dijon: Société préhistorique française and Archeologia.

———. 1993. "Approche paléoécologique et paléoclimatique du Plio-Pléistocène méditerranéen." In *Paléoclimats* (special volume), *Cahiers du Quaternaire*, Bordeaux, pp. 187–98.

BONIFAY, E.; COURTIN, J.; and THOMMERET, J. 1971. "Datation des derniers stades de la transgression versilienne dans la région de Marseille." *Comptes rendus de l'Académie des sciences de Paris*, 273, p. 2042.

BONIFAY, M.-F., and LECOURTOIS-DUGONINAZ, A. 1977. "La faune des niveaux inférieurs de l'abri Cornille à Istres," in *XX^e Congrès préhistorique de France* (Martigues), pp. 228–47.

BOSINSKI, G., and BOSINSKI, H. 1991. "Robbendarstellungen von Gönnersdorf." In *Sonderveröffentlichungen*, 82, pp. 81–87. Geologisches Institut der Universität zu Köln.

BOURDIAL, I. 1992. "Une grotte bien ténébreuse." *Science et Vie*, 894, pp. 74–79, 164.

BREUIL, H. 1952. *Quatre Cents Siècles d'art pariétal*. Montignac: Centre d'Etudes et de Documentation Préhistoriques.

———. 1959. "Notre art de l'Epoque du Renne." In C. Zervos, *L'Art de l'Epoque du Renne en France*, pp. 13–109. Paris: Editions Cahiers d'Art.

BREUIL, H., and CAPITAN, L. 1902. "Les gravures sur les parois des grottes préhistoriques: la grotte des Combarelles." *Revue de l'Ecole d'anthropologie de Paris*, 12, pp. 45–46.

CAPITAN, L. 1911. "Les empreintes de mains sur les parois de la grotte de Gargas." *Bulletin anthropologique*, pp. 87–88.

CARTAILHAC, E. 1902. "*Mea culpa* d'un sceptique." *L'Anthropologie*, 13, pp. 350–52.

———. 1906. "Les mains rouges et noires de la grotte de Gargas." Lyons, *AFAS*, II, pp. 717–20.

CASADO LOPEZ, M. P. 1977. *Los Signos en el arte paleolítico de la Península ibérica.* Saragossa, Monografías arqueológicas, XX.

CLOT, A. 1990. Review of M. Groenen, "Les représentations de mains négatives dans les grottes de Gargas et de Tibiran (Hautes-Pyrénées)." *Bull. Soc. préhist. Ariège-Pyr.*, XLV, pp. 267–69.

CLOTTES, J. 1988–1989. "Niaux: Magdalénien moyen ou récent?" *Ars praehistorica*, VII–VIII, pp. 53–67.

———. 1989. "The identification of human and animal figures in European Palaeolithic art." In H. Morphy, ed., *Animals into Art*, pp. 21–56. *One World Archaeology*, 7. London: Unwin Hyman.

———. 1994a. "Who painted what in Upper Palaeolithic European caves." In D. Whitley and L. Loendorf, eds., *New Light on Old Art: Recent Advances in Hunter-Gatherer Rock Art Research*, pp. 1–8. Los Angeles: UCLA Institute of Archaeology Monographs, 36.

———. 1994b. "Post-Stylistic?" In P. G. Bahn and M. Lorblanchet, *The Post-Stylistic Era: Where Do We Go from There?*, pp. 19–25. Symposium A, Second AURA Congress (Cairns, Australia), 1992.

CLOTTES, J.; BELTRÁN, A.; COURTIN, J.; and COSQUER, H. 1992. "La grotte Cosquer (cap Morgiou, Marseille)." *Bull. Soc. préhist. fr.*, 89, 4, pp. 98–128.

CLOTTES, J., and COURTIN, J. 1992. "La grotte Cosquer un an après." *Archeologia*, 283, pp. 14–19.

———. 1993. "Dating a new painted cave: The Cosquer Cave, Cape Morgiou, Marseille (France)." In J. Steinbring and A. Watchman, *Time and Space*, pp. 22–31. Symposium F, Second AURA Congress (Cairns, Australia), 1992.

CLOTTES, J.; COURTIN, J.; and VALLADAS, H. 1992. "A well-dated palaeolithic cave: The Cosquer Cave at Marseille." *Rock Art Research*, 9, 2, pp. 122–29.

CLOTTES, J.; COURTIN, J.; VALLADAS, H.; CACHIER, H.; MERCIER, N.; and ARNOLD, M. 1992. "La grotte Cosquer datée." *Bull. Soc. préhist. fr.*, 89, 8, pp. 230–34.

CLOTTES, J.; DUPORT, L.; and FERUGLIO, V. 1990. "Les signes du Placard." *Bull. Soc. préhist. Ariège-Pyr.*, XLV, pp. 15–49.

———. 1991. "Derniers éléments sur les signes du Placard." *Bull. Soc. préhist. Ariège-Pyr.*, XLVI, pp. 119–32.

CLOTTES, J.; GARNER, M.; and MAURY, G. 1994. "Bisons magdaléniens des cavernes ariégeoises." *Bull. Soc. préhist. Ariège-Pyr.*, XLIX, pp. 15–49.

CLOTTES, J.; VALLADAS, H.; CACHIER, H.; and ARNOLD, M. 1992. "Des dates pour Niaux et Gargas." *Bull. Soc. préhist. fr.*, 89, 9, pp. 270–74.

COLLINA-GIRARD, J. 1992. "Présentation d'une carte bathymétrique au 1/25,000ᵉ du précontinent marseillais." *Géologie méditerranéenne*, XIX, 2, pp. 77–87.

———. 1994. "La grotte Cosquer: cadre géologique d'un sanctuaire préhistorique englouti." *Bulletin de la Société linnéenne de Provence*, 45, pp. 13–22.

COMBIER, J. 1981. "La protection des grottes isolées." In *Monuments historiques*, vol. 118: *Grottes ornées*, pp. 54–74.

———. 1984a. "Rhône-Alpes. Ardèche." In *L'Art des cavernes*, pp. 588–94. Paris: Ministère de la Culture, Imprimerie nationale.

———. 1984b. "Grotte de la Tête-du-Lion." In *L'Art des cavernes*, pp. 595–99. Paris: Ministère de la Culture, Imprimerie nationale.

———. 1984c. "Grotte Chabot." In *L'Art des cavernes*, pp. 317–22. Paris: Ministère de la Culture, Imprimerie nationale.

———. 1984d. "Grotte d'Ebbou." In *L'Art des cavernes*, pp. 609–16. Paris: Ministère de la Culture, Imprimerie nationale.

———. 1989. "Gravettien et Solutréen dans la vallée du Rhône." In *Le Temps de la Préhistoire*, vol. I, pp. 286–89. Paris: Société préhistorique française.

COSQUER, H. 1992. *La Grotte Cosquer, plongée dans la Préhistoire.* Editions Solar.

COURTIN, J. 1978. "Direction des recherches préhistoriques sous-marines." *Gallia Préhistoire* (Paris), 21, 2, pp. 735–46.

CRÉGUT-BONNOURE, E. 1991. "L'environnement animal dans le midi de la France." In *Les Dossiers de l'archéologie*, no. 156: *L'Homme de Cro-Magnon*, pp. 48–63. Dijon.

DAMS, L. 1978. *L'Art paléolithique de la caverne de La Pileta.* Graz: Akademische Druck und Verlagsanstalt.

———. 1987. *L'Art paléolithique de la grotte de Nerja (Málaga, Espagne). British Archaeological Reports.* International Series 385.

DELLUC, B., and DELLUC, G. 1971. "La grotte ornée de Sous-Grand-Lac (Dordogne)." *Gallia Préhistoire* (Paris), 14, 2, pp. 245–52.

———. 1982–1983. "La main négative gravettienne de l'abri Labattut à Sergeac (Dordogne)." *Antiquités nationales*, 14–15, pp. 27–33.

———. 1987. "Quelques gravures paléolithiques de la Petite-Beune (grottes de Sous-Grand-Lac, de Vielmouly II et du Charretou)." *Actes du XXXIXᵉ Congrès d'études régionales* (Sarlat), pp. 163–84.

———. 1991. "A propos de la découverte de la grotte de Sormiou à Cassis, dite grotte Cosquer." *Bulletin de la Société historique et archéologique du Périgord*, CXVIII, 4, pp. 516–17.

———. 1993. "Images de la main dans notre préhistoire." In *Les Dossiers de l'archéologie*, no. 178: *La Main dans la Préhistoire*, pp. 32–45. Dijon: Editions Faton.

DROUOT, E. 1984. "Grotte de La Baume-Latrone." In *L'Art des cavernes*, pp. 333–39. Paris: Ministère de la Culture, Imprimerie nationale.

DUDAY, H., and GARCIA, M.-A. 1990. "Empreintes et traces humaines." In *L'Archéologie des grottes ornées*, Colloque de Montignac.

D'ERRICO, F. 1994. "Birds of the Grotte Cosquer: the great auk (*Pinguinus impennis*) and its significance during the Upper Palaeolithic." *Rock Art Research*, 11, 1, pp. 45–57.

ESCALON DE FONTON, M. 1970. "Le Paléolithique supérieur de la France méridionale." In *L'Homme de Cro-Magnon*, pp. 177–95. Paris: AMG.

———. 1975. "Problèmes relatifs à la position géochronologique de l'Arénien, du Salpêtrien et du Magdalénien." *Cahiers ligures de préhistoire et d'archéologie*, 24, pp. 85–109.

ESCALON DE FONTON, M., and BAZILE, F. 1976. "Les civilisations du Paléolithique supérieur en Languedoc oriental." In H. de Lumley, ed., *La Préhistoire française*, tome 1, pp. 1163–73. Paris: Editions du CNRS.

ESCALON DE FONTON, M.; BONIFAY, M.-F.; and ONORATINI, G. 1977. "Les industries de filiation magdalénienne dans le sud-est de la France." In *La Fin des temps glaciaires en Europe*, pp. 269–86. Talence and Paris: Editions du CNRS.

ESCALON DE FONTON, M., and ONORATINI, G. 1976. "Les civilisations du Paléolithique supérieur en Provence littorale." In H. de Lumley, ed., *La Préhistoire française*, tome 1, pp. 1145–56. Paris: Editions du CNRS.

ESPEJO, M. DEL M., and CANTALEJO, P.

1992. "Cueva de Ardales. Arte rupestre paleolítico." In *Cueva de Ardales: su recuperación y estudio*, pp. 67–116. Málaga: Ayuntamiento.

Faure, H., and Kéraudren, B. 1987. "Variations du niveau des mers et dépôts sous-marins." In J.-C. Miskovsky, ed., *Géologie de la Préhistoire*, pp. 225–40. Paris: Géopré.

Février, P.-A.; Bats, M.; Camps, G.; Fixot, M.; Guyon, J.; and Riser, J. 1989. *La Provence des origines à l'an mil.* Evreux: Editions Ouest-France.

Foucher, P. 1991. "Expérience en double aveugle sur l'art pariétal de la grotte de Marsoulas." *Bull. Soc. préhist. Ariège-Pyr.*, XLVI, pp. 75–118.

Froget, C. 1974. "Essai sur la géologie du précontinent de la Provence occidentale," Ph.D. diss., University of Aix-Marseille II, UER des Sciences de la mer et de l'environnement.

Garcia, M.-A., and Duday, H. 1993. "Les empreintes de mains dans l'argile des grottes ornées." In *Les Dossiers de l'archéologie*, no. 178: *La Main dans la Préhistoire*, pp. 56–59. Dijon: Editions Faton.

Gaussen, J. 1964. *La Grotte ornée de Gabillou.* Vol. 3. Bordeaux: Institut de Préhistoire de l'Université de Bordeaux.

Gonzalez Echegaray, J. 1974. *Pinturas y Grabados de la cueva de Las Chimeneas (Puente Viesgo, Santander).* Barcelona: Monografias de Arte rupestre. Arte paleolítico, 2.

GRAPP. 1993. *Art pariétal paléolithique. Techniques et méthodes d'étude.* Paris: Comité des travaux historiques et scientifiques.

Graziosi, P. 1960. *Palaeolithic Art.* London: Faber and Faber.

———. 1964. "L'art paléolithique de la 'province méditerranéenne' et ses influences dans les temps post-paléolithiques." In L. Pericot Garcia and E. Ripoll Perello, *Prehistoric Art of the Western Mediterranean and the Sahara*, pp. 35–46. Viking Fund Publications in Anthropology, 39. New York: Wenner-Gren Foundation for Anthropological Research.

Groenen, M. 1986–1987. *Les Représentations des mains négatives dans les grottes de Gargas et de Tibiran (Hautes-Pyrénées). Approche méthodologique.* 2 vols. Mémoire d'Histoire de l'Art et d'Archéologie, Université Libre de Bruxelles.

———. 1988. "Les représentations de mains négatives dans les grottes de Gargas et de Tibiran (Hautes-Pyrénées)." *Bulletin de la Société royale belge d'anthropologie et de préhistoire*, 99, pp. 81–113.

———. 1990. "Quelques problèmes à propos des mains négatives dans les grottes paléolithiques. Approche épistémologique." *Annales d'histoire de l'art et d'archéologie* (Université Libre de Bruxelles), XII, pp. 7–29.

Guery, R.; Pirazzoli, P.; and Trousset, P. 1981. "Les variations du niveau de la mer depuis l'Antiquité à Marseille et à la Couronne." *Histoire et Archéologie*, 50, pp. 8–27.

Guthrie, R. D. 1984. "Ethological observations from Palaeolithic art." In H.-G. Bandi et al., *La Contribution de la zoologie et de l'éthologie à l'interprétation de l'art des peuples chasseurs préhistoriques*, pp. 35–74. Fribourg (Switz.): Editions Universitaires.

Hadingham, E. 1979. *Secrets of the Ice Age: The World of the Cave Artists.* London: Heinemann; New York: Walker.

Hainard, R. 1989. *Mammifères sauvages d'Europe.* 2 vols. Neuchâtel-Paris: Delachaux et Niestlé.

Harmelin, J.-G.; Vacelet, J.; and Vasseur, P. 1985. "Les grottes sous-marines obscures: un milieu extrême et un remarquable biotope refuge." *Téthys*, 11 (3–4), pp. 214–29.

Hirsch, J.-F. 1991. "A Gargas, la main de l'homme." *Pyrénées Magazine*, 17, pp. 22–29.

Huard, P. 1968. "Les mains à doigt manquant ou incomplet sur les peintures rupestres du Tibesti." *Bull. Soc. préhist. fr.*, 65, pp. 19–20.

Janssens, P. A. 1957. "Medical views on prehistoric representations of human hands." *Medical History*, I, pp. 318–22.

Laming-Emperaire, A. 1962. *La Signification de l'art rupestre paléolithique.* Paris: Picard.

Lavallée, D. 1986. "Cultures préhistoriques de Méso-Amérique et d'Amérique du Sud." In *La Préhistoire d'un continent à l'autre.* Paris: Larousse.

Laville, H. 1991. "Le climat à l'époque des Cro-Magnons." In *Les Dossiers de l'archéologie*, no. 156: *L'Homme de Cro-Magnon*, pp. 42–46. Dijon: Editions Faton.

Lémozi, A. 1929. *La Grotte-Temple du Pech-Merle. Un nouveau sanctuaire préhistorique.* Paris: Picard.

Leonardi, P. 1988. "Art paléolithique mobilier et pariétal en Italie." *L'Anthropologie*, 92, 1, pp. 139–202.

———. 1990. "Bases objectives de la chronologie de l'art mobilier paléolithique en Italie." In J. Clottes, ed., *L'Art des objets au Paléolithique*, vol. 1: *L'Art mobilier et son contexte*, pp. 121–32. Paris: Ministère de la Culture.

Le Quellec, J.-L. 1993. "Les figurations de mains au Sahara central." In *Les Dossiers de l'archéologie*, no. 178: *La Main dans la Préhistoire*, pp. 60–71. Dijon: Editions Faton.

Leroi-Gourhan, André. 1964. *Les Religions de la Préhistoire.* Paris: Presses Universitaires de France.

———. 1965. *Préhistoire de l'Art occidental.* Paris: Mazenod. American edition. *Treasures of Prehistoric Art.* New York: Abrams, 1967.

———. 1967. "Les mains de Gargas. Essai pour une étude d'ensemble." *Bull. Soc. préhist. fr.*, 64, 1, pp. 107–22.

———. 1975. "Résumé des cours de 1974–1975." *Annuaire du Collège de France*, 75th year, pp. 387–403.

———. 1976. "Résumé des cours de 1975–1976." *Annuaire du Collège de France*, 76th year, pp. 421–34.

———. 1979. "Les animaux et les signes." In Arlette Leroi-Gourhan and J. Allain, eds., *Lascaux inconnu*, pp. 343–66. Paris: Editions du CNRS.

———. 1981. "Les signes pariétaux comme 'marqueurs ethniques'." In *Altamira Symposium*, pp. 289–94. Madrid: Ministerio de Cultura.

Leroi-Gourhan, Arlette. 1981. "Pollens et grottes ornées." In *Altamira Symposium*, pp. 295–97. Madrid: Ministerio de Cultura.

Leroi-Gourhan, Arlette, and Allain, J., eds. 1979. *Lascaux inconnu* (XIIᵉ supplèment à *Gallia Préhistoire*). Paris: Editions du CNRS.

Lewis-Williams, J. D., and Dowson, T. 1988. "The signs of all times: entoptic phenomena in Upper Paleolithic art." *Current Anthropology*, 29, 2, pp. 201–45.

Livache, M. 1976. "Les civilisations du Paléolithique supérieur en Haute-Provence et dans le Vaucluse." In H. de Lumley, ed., *La Préhistoire française*, tome 1, pp. 1157–62. Paris: Editions du CNRS.

Lorblanchet, M. 1970. "La grotte des Merveilles à Rocamadour et ses peintures préhistoriques." *Bull. Soc. études litt., sc. et art. du Lot*, XCI, 4, pp. 117–48.

———. 1980. "Peindre sur les parois de grottes." In *Les Dossiers d'archéologie*, 46, pp. 33–39.

———. 1984a. "Grotte de Cougnac." In *L'Art des cavernes*, pp. 483–87. Paris: Ministère de la Culture, Imprimerie nationale.

———. 1984b. "Les relevés d'art préhistorique." In *L'Art des cavernes*, pp.

41–51. Paris: Ministère de la Culture, Imprimerie nationale.

———. 1985. "Le symbolisme des empreintes en Australie." In *Les Dossiers d'Histoire et d'Archéologie,* pp. 63–76. Dijon: Editions Faton.

———. 1989. "From human to animal and sign in Palaeolithic art." In H. Morphy, ed., *Animals into Art,* pp. 109–43. *One World Archaeology,* 7. London: Unwin Hyman.

———. 1990. "L'art pariétal. De nouvelles méthodes de datation de l'art préhistorique." *Pour la science,* 156, pp. 10–12.

———. 1992. "Finger markings in Pech-Merle and their place in Prehistoric art." In M. Lorblanchet, ed., *Rock Art in the Old World,* pp. 451–90. New Delhi: IGNCA.

LUMLEY, H. DE. 1976. "Les lignes de rivage quaternaire de Provence et de la région de Nice." In H. de Lumley, ed., *La Préhistoire française,* tome 1, vol. 1, pp. 311–25. Paris: Editions du CNRS.

MÉROC, L. 1974. *La Faune et la Chasse au cours des temps préhistoriques dans la France méridionale.* Foix: INRDP-CDDP.

MÉROC, L., and MAZET, J. 1956. *Cougnac, grotte peinte.* Stuttgart: W. Kohlhammer Verlag.

MEZZENA, F., and PALMA DE CESNOLA, A. 1987. "L'arte paleolitica nel Gargano." *Atti 6° convegno sulla Preistoria, Protostoria, storia della Daunia* (San Severo, 1984), 2, pp. 18–21, plates XI–XXVI.

MOURER-CHAUVIRÉ, C., and ANTUNES, M.-T. 1991. "Présence du grand Pingouin, *Pinguinus impennis* (*Aves,* Charadriiformes) dans le Pléistocène du Portugal," *Géobios,* 24, 2, pp. 201–5.

MOURE ROMANILLO, A., and GONZALEZ MORALES, M. 1992. "Datation ^{14}C d'une zone décorée de la grotte Fuente del Salín en Espagne." *International Newsletter on Rock Art,* 3, pp. 1–2.

MUSSI, M. 1992. *Il Paleolitico e il Mesolitico in Italia.* Popoli e Civiltà dell'Italia Antica, vol. 10.

NOUGIER, L.-R. 1966. *L'Art préhistorique.* Paris: Presses Universitaires de France.

ONORATINI, G. 1982. "Préhistoire, climats, sédiments, du Würm III à l'Holocène dans le Sud-Est de la France," Ph.D. diss., University of Marseilles III.

———. 1984. "Les industries du Paléolithique supérieur et de l'Epipaléolithique en Provence." *Cahiers ligures de préhistoire et de protohistoire,* new ser., 1, pp. 12–43.

———. 1992. "La grotte sous-marine du cap Morgiou (Marseille), premier sanctuaire peint et gravé salpêtrien." *Bulletin de la Société linnéenne de Provence,* 43, pp. 29–34.

ONORATINI, G.; ARNAUD, P.-M.; DEGIOVANNI, C.; and VICINO, G. 1992. "L'Eoversilien du précontinent provenço-ligure, source de mollusques 'nordiques' pour les Aréniens (20,000 BP) des cavernes de Grimaldi." *Comptes rendus de l'Académie des sciences de Paris,* tome 315, ser. II, pp. 645–51.

ONORATINI, G., and DA SILVA, J. 1978. "La grotte des Enfants à Grimaldi, les foyers supérieurs." *Bulletin du musée d'anthropologie préhistorique de Monaco,* no. 22, pp. 31–71.

ONORATINI, G., and RAUX, A. 1993. "Les cultures du Paléolithique supérieur ancien de Provence orientale." *Bulletin du musée d'anthropologie préhistorique de Monaco,* no. 35, pp. 65–114.

PALES, L. 1975. "Les mains incomplètes de Gargas, Tibiran et Maltravieso." *Quartär,* 26, pp. 159–66.

PALES, L. (with M. Tassin de Saint-Péreuse). 1969. *Les Gravures de La Marche.* Vol. I: *Félins et Ours.* Bordeaux: Imprimerie Delmas (Institut de Préhistoire de l'Université de Bordeaux, mémoire 7).

PALMA DI CESNOLA, A. 1987. "La posizione cronologica delle principali manifestazioni d'arte di Grotta Paglici e del Gargano." *Atti 6° convegno sulla Preistoria, Protostoria, storia della Daunia* (San Severo, 1984), 2.

PLASSARD, M.-O., and PLASSARD, J. 1989. *La Grotte de Rouffignac.* Bordeaux: Editions Sud-Ouest.

SAHLY, A. 1966. *Les Mains mutilées dans l'art préhistorique.* Toulouse: privately printed by Tunisian Publishing.

SAINT-PÉRIER, R. DE. 1932. *L'Art préhistorique.* Paris: Rieder.

SAUTER, M. 1968. *Préhistoire de la Méditerranée.* Paris: Payot.

SAUVET, G. 1990. "Les signes dans l'art mobilier." In J. Clottes, ed., *L'Art des objets au Paléolithique,* vol. 2: *Les Voies de la recherche,* pp. 83–99. Paris: Ministère de la Culture.

SAUVET, G., and SAUVET, S. 1979. "Fonction sémiologique de l'art pariétal animalier franco-cantabrique." *Bull. Soc. préhist. fr.,* 76, pp. 340–54.

SAUVET, G.; SAUVET, S.; and WLODARCZYK, A. 1977. "Essai de sémiologie préhistorique (pour une théorie des premiers signes graphiques de l'homme)." *Bull. Soc. préhist. fr.,* 74, pp. 545–58.

SIEVEKING, A. 1979. *The Cave Artists.* London: Thames & Hudson.

SIFFRE, M. 1992. "Deux prises de position sur la grotte Cosquer." *Grottes et Gouffres* (Paris, Club alpin français), 123, pp. 7–9.

SIMONNET, R. 1980. *L'Emergence de la Préhistoire en pays ariégeois. Aperçu critique d'un siècle de recherches.* Mémoire de l'EHESS, Toulouse.

SMITH, N. W. 1992. *An Analysis of Ice Age Art, Its Psychology and Belief System.* New York: Peter Lang. (American University Studies, Series XX, Fine Arts, vol. 15.)

SONNEVILLE-BORDES, D., and LAURENT, P. 1983. "Le Phoque à la fin des temps glaciaires." In *La Faune et l'Homme préhistoriques. Dix études en hommage à Jean Bouchud,* pp. 69–80. Mémoire de la Société préhistorique française, 16.

STECCHI, H., and BOTTET, B. 1950. "La Baume-Périgaud, commune de Tourrettes-Lévens (Alpes-Maritimes)." *Bull. Soc. préhist. fr.,* 47, 1–2, pp. 89–93.

STRECKER, M. 1982. "Representaciones de manos y pies en el arte rupestre de cuevas de Oxkutzcab, Yucatán." *Boletín Escuela de Ciencias Antropológicas.* Universidad de Yucatán, año 9, no. 52.

TARDOS, R. 1987. "Problèmes posés par les mains mutilées de la grotte de Gargas." In *Archéologie et Médecine,* pp. 211–18. VIIᵉ Rencontres Internationales d'Archéologie et d'Histoire (Antibes). Juan-les-Pins: Editions APDCA.

———. 1993. "Les mains mutilées: étude critique des hypothèses pathologiques." In *Les Dossiers de l'archéologie,* no. 178: *La Main dans la Préhistoire,* p. 55. Dijon: Editions Faton.

TEARES, J. K. 1980. *The Audubon Encyclopedia of North American Birds,* s.v. "auk family."

TESTART, A. 1986. *Essai sur les fondements de la division sexuelle du travail chez les chasseurs-cueilleurs.* Paris: Editions de l'EHESS. (Cahiers de l'Homme, new ser., XXV.)

UCKO, P. J. 1992. "Subjectivity and the recording of Palaeolithic cave art." In T. Shay and J. Clottes, eds., *The Limitations of Archaeological Knowledge,* pp. 141–79. ERAUL, 49.

VALLADAS, H.; CACHIER, H.; and ARNOLD, M. 1990. "Application de la datation carbone 14 en spectrométrie de masse par accélérateur aux grottes ornées de Cougnac et du Pech-Merle, Lot." *Bull. Soc. études litt., sc. et art. du Lot,* CXI, pp. 134–37.

VALLADAS, H.; CACHIER, H.; MAURICE,

P.; Bernaldo de Quiros, F.;
Clottes, J.; Cabrera Valdes, V.;
Uzquiano, P.; and Arnold, M.
1992. "Direct radiocarbon dates for
prehistoric paintings at the Altamira, El
Castillo and Niaux caves." *Nature,* 357,
pp. 68–70.

Verbrugge, A.-R. 1965. "Les mains
mutilées en ethnographie comparée."
In XVI^e *Congrès préhistorique de France*
(Monaco, 1959), pp. 1047–55.

Vialou, D. 1986. *L'Art des grottes en Ariège
magdalénienne* (XXII^e Supplement à
Gallia Préhistoire). Paris: Editions du
CNRS.

Vicino, G., and Simone, S. 1972. "Les
gravures rupestres paléolithiques des
Balzi Rossi (Grimaldi, Ligurie itali-
enne)." *Bull. Soc. préhist. Ariège,*
XXVII, pp. 39–58.

Villaverde Bonilla, V. 1988.
"Consideraciones sobre la secuencia de
la Cova del Parpalló y el arte paleolíti-
co del Mediterráneo español." *Archivo
de Prehistoria Levantina* (Valencia),
XVIII, pp. 11–47.

———. 1990. "Animation et scènes sur les
plaquettes du Parpalló (Gandia,
Espagne): quelques considérations sur
la pictographie dans l'art mobilier." In
J. Clottes, ed., *L'Art des objets au
Paléolithique,* vol. 2: *Les Voies de la
recherche,* pp. 227–41. Paris: Ministère
de la Culture.

———. 1992. "Principaux traits évolutifs
de la collection d'art mobilier de la
grotte de Parpalló." *L'Anthropologie,* 96,
2–3, pp. 375–96.

Villeneuve, L. de; Boule, M.;
Verneau, R.; and Cartailhac, E.
1906–1919. *Les Grottes de Grimaldi
(Baoussé Roussé).* Imprimerie de
Monaco.

Wright, R. V. S. 1971. "Archaeology of
the Gallus site Koonalda Cave."
Australian Institute of Aboriginal Studies
(Canberra), vol. 26, pp. 133 *sq.*

Photograph Credits

Glossary

The terms in this glossary are defined not exhaustively but as they are used in this book.

absolute dating. Refers to dates obtained by laboratory analyses of ancient remains or deposits, as opposed to relative dating. *See* **radiocarbon dating, relative dating.**

alcid. The family (or a member of the family) to which auks belong.

alluvial. Deposited by water.

Altamira cave. The first cave with paintings recognized as dating from the Paleolithic period. It was discovered in 1879 by Sainz de Sautuola on the northern coast of Spain, near Santander. A heated debate ensued, and eventually Altamira was hailed (in 1902) as one of the major Upper Paleolithic cave sanctuaries in Europe.

aragonite. A mineral consisting of calcium carbonate found in deposits on cave walls and ceilings.

Arenian culture. One of the local cultures of the Upper Paleolithic period in western Mediterranean Europe. Dating between c. 21,000 and 17,000 B.P.—and thus contemporary with the Solutrean culture—it later changed into the Bouverian culture *(see below)*.

artifact. An object made or worked by humans.

Aurignacian culture. The first culture of the Upper Paleolithic period in Europe, that of *Homo sapiens sapiens,* our direct ancestor, who coexisted for millennia with *Homo sapiens neanderthalensis (see* **Neanderthal humans**). It lasted from c. 38,000 (new dates recently published in Spain) to c. 25,000 B.P.

Azilian culture. At the end of the last ice age (the Epipaleolithic period), the people of western Europe whose culture we call Magdalenian had to change their mode of life. Their tools also changed. The Azilian culture (c. 11,500–c. 9,000 B.P.) was the result of their adaptation to new conditions.

B.C. Abbreviation for "before the Christian era," a conventional way of counting past time. (*See also* **B.P.**)

bifacial. A stone tool retouched on its two main sides.

biotope. A geographical area with a particular climate, plants, and animals.

blade. A product of knapping flint. A blade, contrary to a flake, is at least twice as long as it is wide.

Bouverian culture. Following the Arenian culture *(see above)*, the Bouverian occupied Mediterranean Provence in France and southern Liguria in Italy from c. 17,000 to c. 11,500 B.P. It is characterized by different tools than those used by the Magdalenians, who lived in other regions of Europe at the same time.

B.P. Abbreviation for "before the present." The "present" has been arbitrarily fixed at A.D. 1950, because absolute radiocarbon dates were first obtained in the early 1950s (*see* **absolute dating**). Like "B.C.," this is a conventional way of counting past time. By preference, archaeologists use "B.P.," particularly when referring to older periods.

Breuil, Henri (the Abbé Breuil). This eminent French scholar, who has been called "the Pope of Prehistory," lived from 1877 to 1961. His interpretation of Paleolithic cave art (*see* **hunting magic**) was dogma for nearly half a century before being challenged by André Leroi-Gourhan. Breuil's chronology of Upper Paleolithic art involved two "cycles": the Aurignacian-Gravettian Cycle (ended 21,000 B.P.) and the Solutrean-Magdalenian Cycle (ended 11,000 B.P.).

Bronze Age. At the end of the third millennium B.C., the people of western Europe began making weapons—mostly daggers at first, but later swords—of bronze instead of copper, by adding a measure of tin to copper. The Bronze Age ended with the advent of the Iron Age, c. 800 B.C.

burin. A stone tool with a narrow working edge obtained by a particular method of knapping or chipping. Burins were mostly used to work on bones or antlers.

calanque. A synonym for "fjord" in Provence, i.e., a narrow inlet between steep cliffs.

calcite. A mineral often deposited in thin coatings or in the form of stalagmites and stalactites on cave walls and floors by water that has seeped through the limestone and is saturated with calcium carbonate.

caprid. The subfamily (or a member of the subfamily) to which goats belong. During the Upper Paleolithic, species included ibex and chamois.

Cantabria. A region along the north Atlantic coast of Spain that is rich in Upper Paleolithic sites.

carbon 14. A radioactive isotope of carbon used to measure the age of organic material. (*See* **radiocarbon dating**.)

Cartailhac, Emile. He lived from 1845 to 1921 and was for many years one of the leading and most influential French prehistorians. At first he strongly denied the authenticity of the paintings found in Altamira cave, but eventually he acknowledged his error in a famous article, "*Mea culpa* d'un sceptique" (1902).

cervid. The family (or a member of the family) to which deer belong. During the Upper Paleolithic, species included reindeer, red deer, megaloceros deer, and moose.

Châtelperronian culture. Dating from c. 37,000 to c. 32,000 B.P., contemporary with the Aurignacian, this was the culture of the last Neanderthals. It preserved strong affinities with the Mousterian culture, from which it developed. (*See* **Neanderthal humans, Mousterian culture**.)

claviform. A geometric sign often represented in caves during the Magdalenian period, mostly in the Pyrénées. It consists of a vertical bar with a small knob on one side near the top. Its meaning is unknown.

concretions. Calcite deposits that assume many different shapes according to the place where they are formed. Stalactites, stalagmites, and draperies are all concretions.

cortex. The weathered exterior of a nodule of flint.

Cousteau-Gagnan Aqualung. Diving equipment consisting of a face mask, flippers, and compressed air in bottles carried on one's back. It enables divers to reach depths of 300 feet and to move around freely underwater without the impediment of an air tube to the surface.

Cro-Magnon humans. They are our direct ancestors (*Homo sapiens sapiens*). Their name comes from the Cro-Magnon shelter at Les-Eyzies-de-Tayac (Dordogne, France), where their bodies were found in Aurignacian burials. Cro-Magnon humans were exactly like us, with the same physique and abilities.

cryoclastic. Broken up by the cold.

culture. Determined and defined by tools, weapons, and adornments. All together, these objects form distinctive assemblages that may have been made for hundreds or thousands of years. A culture may be restricted to a small region or may have spread over immense areas.

demolition diver. An army or navy diver trained in underwater work or combat.

deposit. A geological term for whatever is deposited by water or wind.

dorsal. Located on the back of a living creature or of an inanimate object.

drapery, calcite drapery. A particular form of stalactite that is both wide and very thin, like a curtain.

Ebbou cave. A cavern with Paleolithic paintings and engravings at Vallon-Pont-d'Arc, in the Ardèche River valley (France). The artworks are in many respects very similar to the ones made in Phase 2 of the Cosquer cave, and they probably belong to the same period.

electronic scanning microscope. A powerful microscope using an electron beam. It currently allows magnifications between 50 and 10,000 times actual size.

end scraper. A flint tool retouched at one end to make a sort of small arc.

epi-. Prefix meaning "next to." For example, the Epipaleolithic is the period right after and developing out of the Paleolithic. (*See* **Azilian culture.**)

ethology. The study of the behavior of animals in their natural environment.

Eyzies, Les. This small village in the Dordogne region of France, nowadays called Les-Eyzies-de-Tayac, achieved fame because of the numerous Upper Paleolithic discoveries that were made there (the remains of Cro-Magnon humans, Les Combarelles cave, Font-de-Gaume cave, the Pataud shelter, La Mouthe cave, etc.).

fault, faulting. Important fracture(s) in rock.

fauna. Animals.

finger tracings. Marks (generally doodles) made by running the fingers over a soft surface like clay. Also called "macaroni."

flint. A compact quartz that can easily be worked by knapping. It was commonly used during the Upper Paleolithic for making tools.

flora. Plants.

Franco-Cantabrian art. The Upper Paleolithic art mostly of southern France and of the Cantabrian (i.e., Atlantic) coast of Spain.

Gargas cave. In the heart of the French Pyrénées, this cavern is known for its very numerous (about 250) Upper Paleolithic hand stencils, many of which have incomplete fingers.

glaciation. An ice age. A period lasting tens of thousands of years, during which the temperature was on average 7° to 11°F (4° to 6°C) below what it is nowadays. As a consequence, ice collected in enormous masses on mountains and on both poles, and the sea was about 360 feet below the present level.

Gravettian culture. Sometimes called "Late Perigordian," it followed the Aurignacian and preceded the Solutrean in western Europe, between c. 28,000 and c. 21,000 B.P. It is characterized by tapering flint spearheads called La Gravette points. Most "Venus" statuettes belong to this culture.

hand stencils (also called "negative hands"). They were made by placing a hand flat against a wall and blowing paint against it. The outline of the hand then appeared as a negative image on the wall.

Holocene. The geological era following the Pleistocene. It started at the end of the last glaciation, about 10,200 B.P. We are still living in the Holocene.

Homo sapiens sapiens. The species we belong to. Modern humans first appeared in Africa about 150,000 to 200,000 years ago. They then spread to the Middle East, about 90,000 to 100,000 years ago, and then to the rest of the world at various times.

hunting magic. Abbé Henri Breuil and Count Henri Bégouën were the first proponents of the hunting-magic theory as an explanation of Upper Paleolithic art. They believed that in those early times, art was used as a kind of sympathetic magic; that is, by drawing the likeness of an animal and by ritually killing it, the artist-sorcerer ensured that a hunt would be successful.

indeterminate lines. Paintings or engravings that cannot be identified as either animals, humans, or geometric signs.

industry. Prehistoric cultures are determined and defined by their artifacts, such as worked bones and antlers and flint and other stone tools. An industry is the sum total of a culture's tools, weapons, and adornments.

interstadial. During each glaciation, there are climatic fluctuations. An interstadial is a relatively short, warm period in between two short, cold periods (stadials).

interglacial. A long period of warm and often wet climatic conditions between two glaciations. We are now in an interglacial.

Iron Age. *See* **Bronze Age.**

karst. A limestone region that includes many caves, potholes, and surface irregularities due to erosion. A **karstic network** is a system of caves and fissures in that sort of area.

knap. To chip stone into a desired shape by striking a stone or bone hammer against it.

La Gravette points. Narrow and tapering flint blades with an abrupt back, probably used as spearheads during the Gravettian period.

Languedoc. One of the historical regions of southern France, bordered by the Mediterranean and the province of Roussillon to the south, Gascony to the west, and Provence to the east.

Lascaux cave. The most famous of all the Paleolithic painted caves of Europe and probably of the world because of the number, size, and aesthetic quality of its paintings and engravings. It was discovered in 1940, near the town of Montignac, in the Dordogne department of France.

Leroi-Gourhan, André. This French archaeologist's interpretation of Upper Palaeolithic cave art superseded Henri Breuil's hunting-magic theory after Leroi-Gourhan published his important book *Préhistoire de l'Art occidental* in 1965. He died in 1986.

lithic. Of stone, made from stone.

loess. Loamy sediment mostly deposited by the wind.

macaroni. Synonym for **finger tracings.**

Magdalenian culture. One of the most important and best-known cultures of the European Upper Paleolithic. Started between 17,000 and 16,000 B.P. and ended about 11,000 B.P. Many painted and engraved caves as well as most of the portable art recovered in excavations are attributable to the Magdalenian culture.

mass-spectrometry accelerator. A powerful instrument that enables scientists to detect isotopes even in extremely small quantities. When applied to radiocarbon dating, its main advantage over traditional methods lies in the minuteness of the sample required to obtain a date.

Mesolithic cultural period. In western Europe, a transitional interval after the big-game-hunting Upper Paleolithic period and its sequel, the Epipaleolithic, and before the agricultural Neolithic period, i.e., between 9,000 and 7,000-6,500 B.P.

microclimate. The particular climate of a restricted region. It may be quite different from the overall climate of the time in other areas. One may also speak of the microclimate in a cave.

microgravette. A diminutive La Gravette point.

microlith. A diminutive stone tool or weapon.

mond-milch. In caves, a millimeters-deep alteration of the limestone surface due to weathering may create a sort of thin

Rouffignac cave. Art was discovered in this cave in the Dordogne region of France in 1956. It was challenged for a while, some people claiming that it was fake, but is now accepted as genuine. The numerous Magdalenian paintings and engravings include the images of about 150 mammoths, a unique occurrence in Paleolithic art.

Roussillon. The southernmost historical region of France, bordering on the Mediterranean and Spain. A local language, Catalan, is still widely spoken there.

Salpêtrian culture. Limited to eastern Languedoc and southern Provence, this Upper Paleolithic culture seems to have evolved from the Late Solutrean about 18,500 B.P. and lasted until the Middle Magdalenian, about 15,000 B.P.

sedimentary. Refers to material deposited by wind, water, or glaciers, or to the depositing process.

shaman. A person able to achieve altered states of consciousness during which he or she "travels" in another world and has visions of people and/or animals and spirits that can be approached for help with life's problems.

shelter. A shallow cave illuminated by daylight.

sign. A geometric shape (dot, bar, wavy line, rectangle, oval, etc.) that is either constructed (as a rectangle) or repetitive (as dots). Shapes designated as signs are believed to be symbols.

Solutrean culture. The remains of this Upper Paleolithic culture, dating from 21,000 to 18,000 B.P., have been found in France, Spain, and Portugal. It is characterized by beautifully worked stone tools with very flat and extensive retouch. The bone needle was first invented during the Solutrean.

stalactites and stalagmites. Water dripping in a cave may slowly deposit small quantities of calcium carbonate (calcite) that will eventually grow into elongated formations called **stalagmites** if they rise from the ground and **stalactites** if they hang down from the ceiling.

stratigraphy. Geological deposits of sediments or of rocks often form successive layers on top of one another. Humans may leave traces of habitation (bones, ashes, tools) in different layers. A study of the stratigraphy, i.e, the succession of such layers and their contents, enables geologists or archaeologists to determine a relative chronology for the inorganic materials or the cultures represented, the ones at the bottom being earlier than the ones at the top.

stylistic conventions in Paleolithic art. The ways animals were represented in Paleolithic art changed over time and differed according to culture or region. Recurring conventions have been studied in order to determine the relative chronology of cave paintings and engravings and the spread of influence from one group to the other. Examples of stylistic conventions include twisted perspective (*see* **perspective**) and certain characteristic ways of rendering the body parts of animals, as for example Y-shaped legs.

tectiform. A geometric sign more or less in the form of the roof of a modern house.

tectonic. Refers to geological phenomena affecting the crust of the earth, such as earthquakes, subsidence, faulting, etc.

unifacial. A stone tool retouched on only one of its two main sides.

Urgonian. One of the limestone facies present in southern France.

Valorguian culture. This Epipaleolithic culture on the Mediterranean coast of Provence corresponds to the Azilian culture (*see above*) elsewhere in France.

Versilian (Flandrian) transgression. This rise in sea level began toward the end of the Pleistocene (after 20,000 B.P.), when the climate started warming up and the ice caps began to melt. It is still going on.

weathering. Physical and chemical processes that change the surface of rocks over time.

Würm glaciation. The final glaciation of the Pleistocene, lasting from 70,000 to 10,200 B.P. Within this generally cold period, several especially bitter periods (stadials) have been identified—for example, Würm III (c. 35,000 to 17,000 B.P.) and Würm IV (c. 14,000 to 10,200 B.P.)—as have several periods of relatively warm weather (interstadials). These large fluctuations provide a general framework for analyzing Paleolithic cultures; however, as climatologists refined their study of Würm, they identified many minor cold-warm oscillations within the main subdivisions, and these have complicated the picture considerably.

and soft skin called *mond-milch* (moon-milk) because of its whitish appearance.

morphology. Form and/or structure.

Mousterian culture. A Middle Paleolithic culture of Neanderthal humans (*see below*) existing from about 200,000 to about 40,000-37,000 B.P. The main stone tools are scrapers and Mousterian points. Burials are known. No art is indisputably attributable to the culture.

naviform. A geometric sign in the shape of a boat.

Neanderthal humans. This subspecies of *Homo sapiens* (*Homo sapiens neanderthalensis*) lived from c. 200,000 to c. 35,000 B.P. We are not directly linked to them.

Neolithic period and cultures. An economic stage during which humans mastered agriculture and animal husbandry. As a consequence, they became sedentary. They also began to make pottery. Dates for the Neolithic vary widely according to the different areas considered.

ocher. A brownish red or brownish yellow iron ore used as pigment.

orogeny. Refers to the processes by which mountains are formed.

paleobotany. Study of the plants that grew in prehistoric times.

Paleolithic cultural periods. The term "Paleolithic" (*Paleo* = "old"; *lith* = "stone") was coined in 1865 to distinguish the ancient way of knapping stones from the "new" way (i.e., polishing them), in the Neolithic. Nowadays, three main stages are still distinguished in the Paleolithic, mostly for Europe: Early, Middle, and Upper. The Early Paleolithic lasted for more than 2 million years, from the time the first stone tools were worked in Africa to the beginning of the Middle Paleolithic, about 200,000 years ago, when the more sophisticated method of flaking chips off a stone core and reworking them came into use. The Upper Paleolithic succeeded this stage about 38,000 B.P. and lasted until the first climatic break, toward the end of the Pleistocene glaciation (11,800 B.P.). The Upper Paleolithic is a particularly important period because of the prevalence of modern humans (*Homo sapiens sapiens*) and the beginnings of art.

palynology. The study of preserved pollens. Palynologists try to reconstruct prehistoric landscapes and climates.

▪▪a. With age and weathering, rock sur-▪es become covered with a sort of film, ▪▪ may take the form of a rather thick ▪▪ arid climates. In caves, fine

engravings that were originally white may over time assume the same color as the rock around them; then, they are **patinated**.

Pech-Merle cave. Situated at Cabrerets, in the Lot department of France, it was discovered in 1922. Numerous Upper Paleolithic paintings and engravings have been found there, including hand stencils and images of cervids (including megaloceros deer) and bovids, horses, mammoths, and other animals. At least two periods have been distinguished at Pech-Merle, based on stylistic criteria. One is Solutrean and the other Magdalenian.

Perigordian culture, Late. *See* **Gravettian culture**.

perspective. The way animals were represented on the more or less flat surface of a cave wall. Generally, their bodies are shown in profile, but their heads and/or their horns or antlers may be shown either from the front (in "twisted" or frontal perspective) or from the side (in true perspective, as the eye naturally perceives them).

photogrammetry. The technique of obtaining accurate measurements from photographs. In archaeology, by using photographs taken from different standpoints it is possible to reconstruct the form, position, and localization in space of an object, a cave wall, a landscape, or a monument.

pictograph. A rock painting.

pigment. Any colored substance that can be used to make paint, such as charcoal or manganese oxides for blacks, or iron oxides for reds.

pinniped. The family of sea mammals to which walruses, sea lions, and seals belong.

plaquette. A generally flat, portable stone on which engravings have been made. A common art medium during the Upper Paleolithic.

Pleistocene. The longer and earlier period of the Quaternary geological era. The Pleistocene was marked by several major advances of continental glaciers. The Early or Lower Pleistocene may have begun before 1,800,000 B.P. and lasted until 700,000 B.P. The Middle Pleistocene lasted from 700,000 to 130,000 B.P. The Late or Upper Pleistocene lasted from 130,00 to 10,200 B.P.

point. A weapon or tool with an end shaped by a human hand into a point. All sorts of types have been defined by archaeologists, according to the technique used to make them and to the shape of the point.

pollen analysis. Pollens may be preserved for

thousands and even millions of years. Their study (*see* **palynology**) can reveal much about climate change over time and even the variations in climate introduced by human action. Palynologists have established a broad history of climates, which helps in establishing the chronology of prehistoric settlements and cultures.

portable art. Art made on small objects like plaquettes (*see above*) and tools or weapons made of bone or antler.

Preboreal. The first period of warm climate following the Würm glaciation (*see below*), lasting from 10,200 B.P. to 8,800 B.P.

Provence. One of the historical regions of southern France. It is bounded on the south by the Mediterranean and on the east by Italy.

Quaternary era. The fourth and most recent geological era, characterized by a cold climate as compared to the preceding Tertiary era. The Quaternary began c. 1,800,000 years ago. It is divided into two unequal periods, the Pleistocene and the Holocene (*see above*).

radiocarbon dating. An important method of obtaining accurate dates for fossils and artifacts made of organic materials. At death, the quantity of carbon 14 present in each living organism starts decreasing at a regular rate. The time it takes for half of the atoms of a radioactive isotope like carbon 14 to disintegrate is called its half-life. The half-life of carbon 14 is 5,730 years. It is thus possible to arrive at the age of death and obtain a date by measuring the amount of radiocarbon left in the sample. There is a statistical uncertainty linked to the date, however. For example, 20,000 B.P. \pm 300 means that the organism died between the years 20,300 B.P. and 19,700 B.P.; moreover, the chances of the date's being within this range is 67%. To have a 95% chance of accuracy, one must double the uncertainty. In this case, the "real" date could be anywhere between 20,600 and 19,400 B.P.

relative dating. For archaeological cultures, relative dates are obtained from stratigraphy and comparisons of industries and for Paleolithic art from analysis of stylistic conventions. *See* **absolute dating**.

retouch. The intentional modification of a stone by flaking in order to make a tool or to finish one.

rock art. Paintings, engravings, or carvings made on rock faces, either in caves, in shelters, on cliff faces, or on isolated rocks.